D1500971

11/95

*The Tokugawa Collection*
THE JAPAN OF THE SHOGUNS

WITHDRAWN

St. Louis Community College
at Meramec
Library

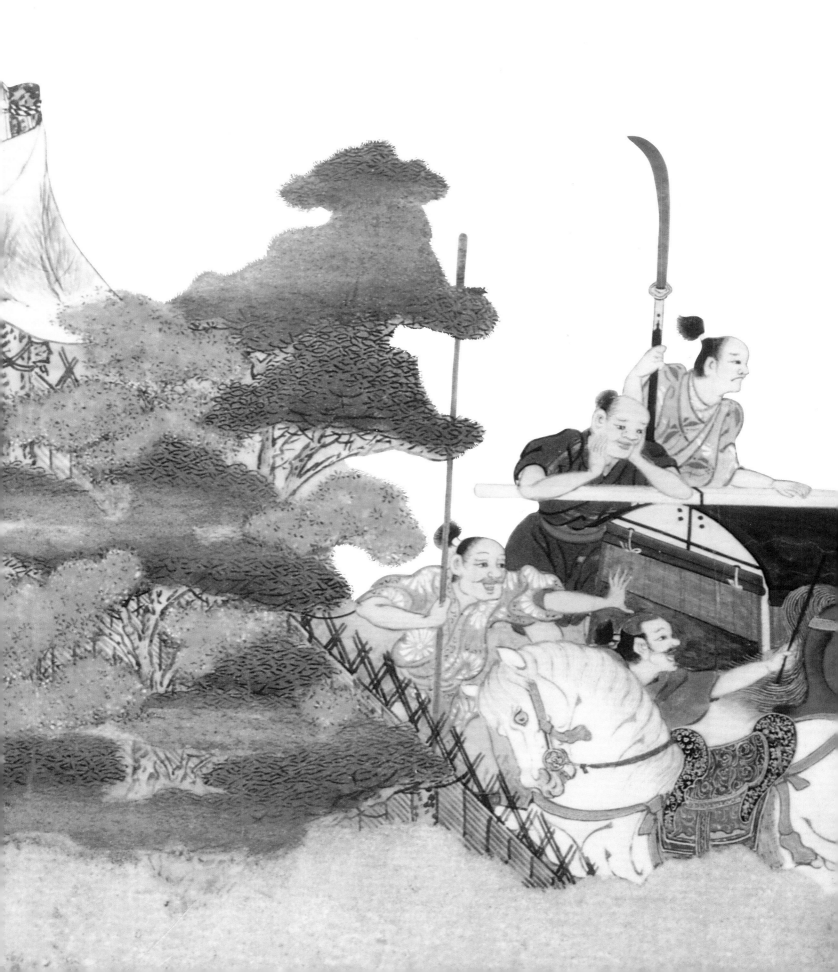

# THE TOKUGAWA COLLECTION

# THE JAPAN OF THE

# SHOGUNS

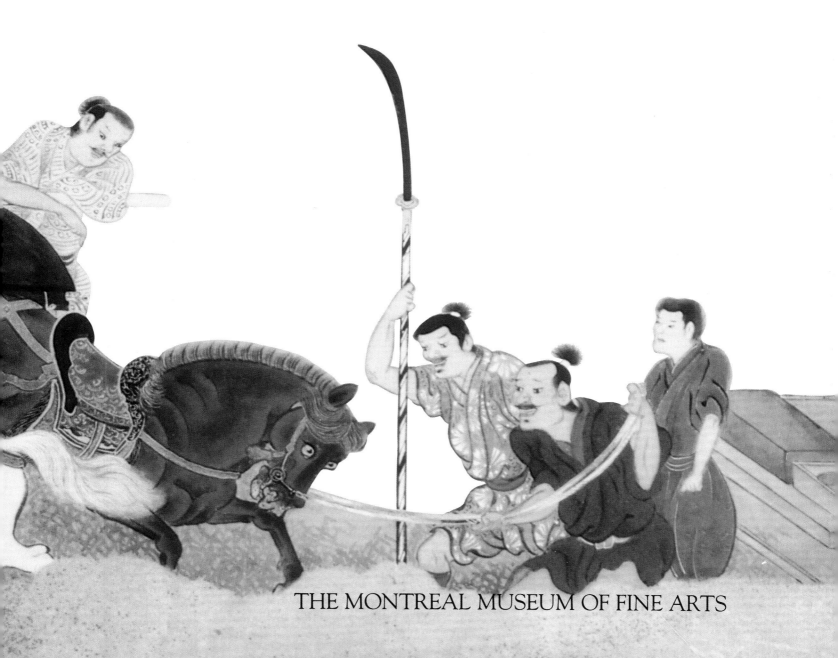

THE MONTREAL MUSEUM OF FINE ARTS

This catalogue was published on the occasion of the exhibition
*The Tokugawa Collection: The Japan of the Shoguns*
presented at the Montreal Museum of Fine Arts
from June 21 to September 10, 1989.

A production of the
Publications Service of
The Montreal Museum of Fine Arts

*Co-ordination*: Denise L. Bissonnette
*Translation*: Judith Terry, Shiro Noda
*Revision*: Judith Terry, Donald Pistolesi,
            Jacqueline Chossat-Golay
*Design*: Dufour & Fille Design
*Photocomposition*: Caractéra
*Photo-engraving and Printing*: Graphiques H.I. Ltée, Le Groupe C.I.G. Inc.

*Catalogue entries*:
Tomio Koike (cats. 34-59, 61-80, 83-96, 183-191, 196-208)
Kumiko Mori (cats. 81-82, 159-182, 192-195)
Toyozō Satō (cats. 28-33, 60, 121-136)
Satoshi Watanabe (cats. 1-27)
Yasukazu Yamamoto (cats. 104-105, 119, 152-158)
Hideki Yotsutsuji (cats. 97-103, 106-118, 120, 137-151)

*Photographic Credits*
All the photographs in this catalogue were supplied by the
Tokugawa Art Museum, with the following exceptions:
Guth essay:    Fig. 3  Nagoya City, Aichi Prefecture
Morse essay:   Fig. 1  Kadokawa Shoten
               Fig. 2  Kobe City Museum of Namban Art
               Fig. 3  Kasuga Shrine, Gifu Prefecture
               Fig. 4  Ura Shrine, Kyoto
               Fig. 5  Tokyo National Museum
Wilson essay:  Fig. 9  Freer Gallery of Art, Arthur M. Sackler Gallery,
                       Smithsonian Institution
               Fig. 10 MOA Museum of Art, Atami

All rights reserved.
The use of any part of this publication without the
prior consent of the publisher is an infringement of
the Copyright Act, Chapter C-30, R.S.C., 1970.

© The Montreal Museum of Fine Arts, 1989

Legal deposit — 2nd trimester 1989
Bibliothèque nationale du Québec
National Library of Canada
ISBN 2-89192-116-X

THE MONTREAL MUSEUM OF FINE ARTS
3400, avenue du Musée
Montreal, Quebec, Canada
H3G 1K3

PRINTED IN CANADA

Cover: *Portrait of Tokugawa Ieyasu*, 17th century (cat. 1)

## Note to the Reader

All the objects and documents in this catalogue are part of the collection of the Tokugawa Art Museum. The catalogue entries for each object or group of objects follow the same sequence as the presentation of the works in the exhibition galleries. For conservation reasons, certain of the artifacts can be put on display for only short periods of time. As a result, these objects are being periodically replaced in the exhibition by others of a similar type.

In general, Japanese terms have been romanized in accordance with the practices followed in the 1974 edition of Kenkyūsha's *New Japanese-English Dictionary* and P. G. O'Neill's *Japanese Names* (New York and Tokyo: John Weatherhill, 1972), with the exception of well-known place names such as Tokyo and Kyoto, and commonly used terms such as "shogun" and "daimyo", which have been rendered unitalicized and without macrons. All Chinese terms have been romanized according to the *pinyin* system.

Historical Japanese names have been rendered in the Japanese manner, with the surname followed by the given name (e.g., Tokugawa Ieyasu). In the case of contemporary individuals, however, the Western practice of placing the surname last has been adopted.

Where dates have been given according to the lunar calendar, the corresponding year in the Western calendar follows in parentheses.

*The Tokugawa Collection*
# THE JAPAN OF THE SHOGUNS

The Montreal Museum of Fine Arts
June 21-September 10, 1989

This exhibition has been organized by Pierre Théberge,
Director of the Montreal Museum of Fine Arts,
Yoshinobu Tokugawa, Director of the Tokugawa Art Museum,
in Nagoya, and Robert Little, Curator of Decorative Arts
at the Montreal Museum of Fine Arts.

Insurance for this exhibition has been provided in part by Communications Canada
through the Insurance Program for Travelling Exhibitions.

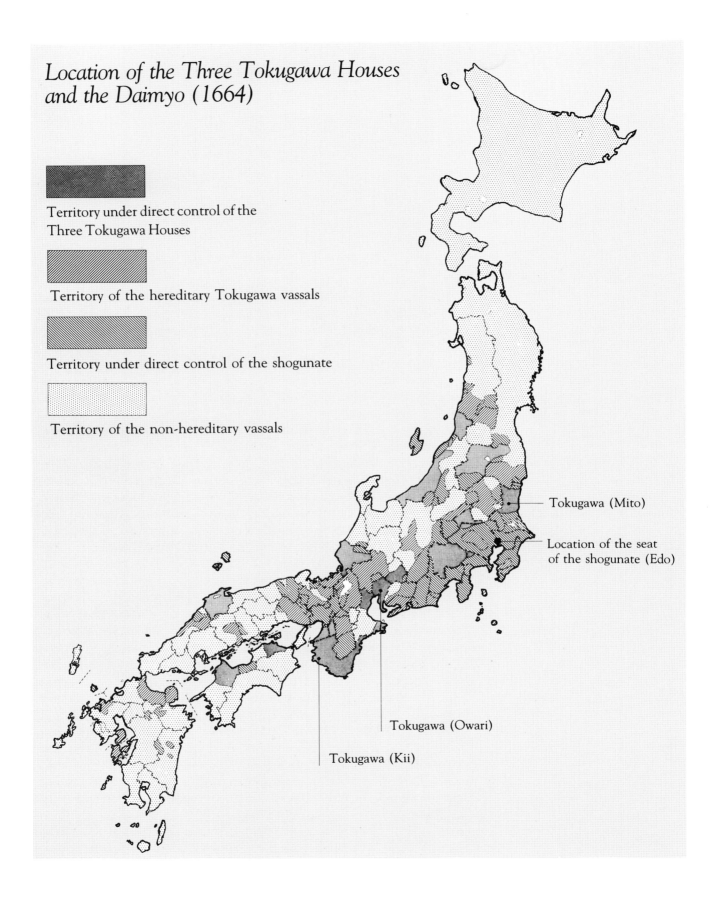

## Location of the Three Tokugawa Houses and the Daimyo (1664)

Territory under direct control of the Three Tokugawa Houses

Territory of the hereditary Tokugawa vassals

Territory under direct control of the shogunate

Territory of the non-hereditary vassals

Tokugawa (Mito)

Location of the seat of the shogunate (Edo)

Tokugawa (Owari)

Tokugawa (Kii)

# Acknowledgements

THIS catalogue is based in part on the one that accompanied *The Shogun Age Exhibition*, from the Tokugawa Art Museum, which was presented in Los Angeles, Dallas, Munich and Paris between December 1983 and May 1985. There have been, however, a number of significant changes. For this unique Canadian presentation, Yoshinobu Tokugawa, Director of the Tokugawa Art Museum, has substantially augmented the texts he originally prepared for the *Shogun Age Exhibition* catalogue. The essays as they appear here provide an essential intellectual and historical framework for the Montreal exhibition catalogue. A somewhat different selection of artifacts was made for the Montreal presentation by Mr. Tokugawa and members of the curatorial staff of the Tokugawa Art Museum. The catalogue entries were written by Yasukazu Yamamoto, Chief Curator; Toyozō Satō, Curator; Tomio Koike, Assistant Curator; Hideki Yotsutsuji, Assistant Curator; Satoshi Watanabe, Assistant Curator; and Kumiko Mori, Assistant Curator. We are grateful to these individuals for having shared with us the fruits of their scholarly research into the outstanding objects in their care. We are also much indebted to Yoriko Naito, secretary to Yoshinobu Tokugawa, for her valuable assistance.

It was suggested by Mr. Tokugawa and by Pierre Théberge, Director of the Montreal Museum of Fine Arts, that the scope of the *Shogun Age Exhibition* catalogue be expanded to include essays by North American authors. The present volume thus contains five essays on various aspects of Japanese culture by the following renowned scholars: Harold Bolitho, Professor of Japanese History, The Edwin O. Reischauer Institute of Japanese History, Harvard University; Christine Guth, specialist in the history of Japanese art; Anne Nishimura Morse, Curatorial Assistant, Asiatic Department, Museum of Fine Arts, Boston; Richard Wilson, Assistant Professor, Department of Art and Art History, Rice University; and Ann Yonemura, Assistant Curator of Japanese Art, Freer Gallery of Art, Arthur M. Sackler Gallery, Smithsonian Institution. The studies by these scholars provide us with a basis for the understanding of issues too often inaccessible to Western audiences and complement admirably the catalogue entries provided by their colleagues at the Tokugawa Art Museum.

We have also greatly benefited, in the preparation of this catalogue,

from the wise counsel of Yutaka Mino, formerly Associate Curator of Asiatic Art at the Montreal Museum of Fine Arts and currently Curator of Chinese and Japanese Art at the Art Institute of Chicago; Yoshiaki Shimizu, Department of Art and Archeology, Princeton University; and Louise Alison Cort, Museum Specialist for Ceramics, Freer Gallery of Art, Arthur M. Sackler Gallery, Smithsonian Institution.

Robert Little
*Curator of Decorative Arts at the Montreal Museum of Fine Arts*

# Contents

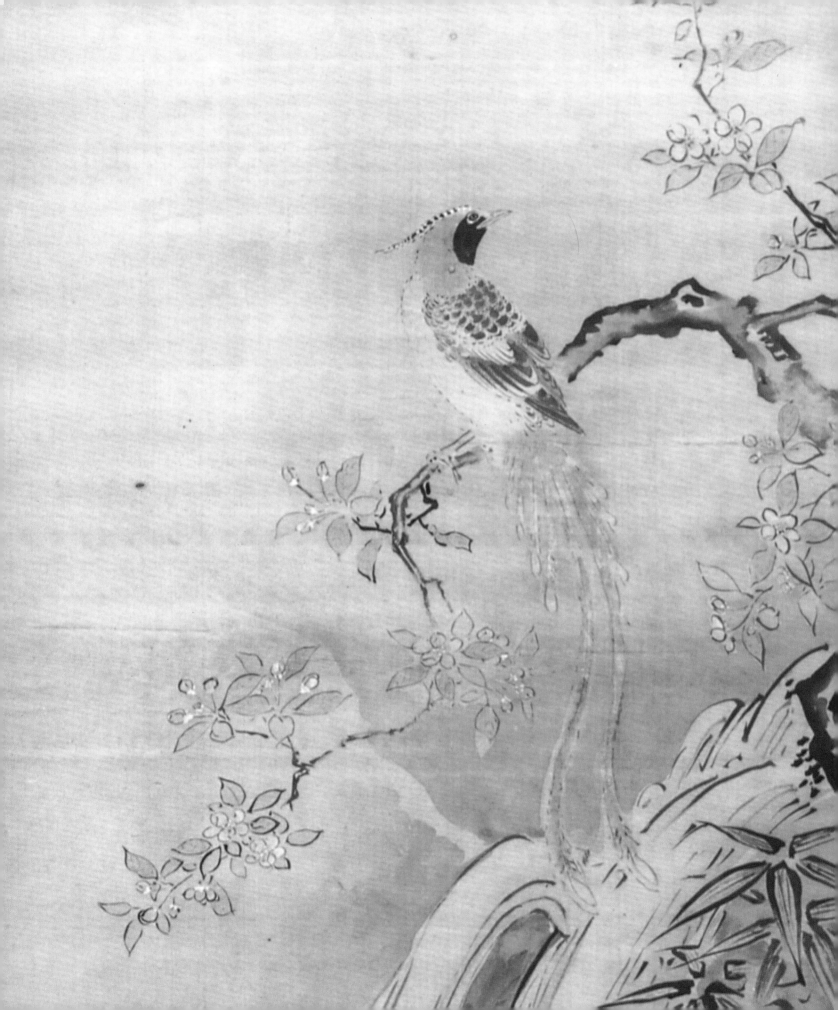

# Preface

THE project for this exhibition grew out of the desire expressed by the members of the Programming Committee of the Montreal Museum of Fine Arts, under the chairmanship of Michel Blouin, to include as part of our programme of major exhibitions selections of non-Western art that would render the programme a more adequate reflection of the international and encyclopedic nature of both our collection and our museological goals.

While all recognize that present-day Japan has become a major industrial and financial power, regrettably few of us have had the opportunity to come to know the age-old culture and traditions of this great country.

The collection belonging to the Tokugawa Art Museum in Nagoya, Japan, is one of the world's most important collections of traditional Japanese art. The museum holds the heritage of the Tokugawa family, rulers of Japan for more than two and a half centuries. The Tokugawa period, which lasted from 1603 to 1868, was a time of unprecedented peace and prosperity for Japan and also a time of enormous artistic activity.

Owing to the generosity and benevolence of the Director of the Tokugawa Art Museum, Yoshinobu Tokugawa, the Montreal Museum of Fine Arts has been offered the great privilege of hosting these remarkable works, which reflect the tastes, the outlook and the culture of traditional Japan. We are extremely grateful to him. We feel sure that this exhibition will enable visitors to better understand the spirit of the Japan of days gone by, that same spirit that forms the cultural and historical foundation of the extraordinarily vital Japan of today.

The selection of works was undertaken by the expert staff of the Tokugawa Art Museum, and we are grateful to Yasukazu Yamamoto, Chief Curator, and to Tomio Koike, Assistant Curator, for their unstinting collaboration.

An exhibition such as this one cannot take place without the co-operation and good will of a large number of individuals and institutions. Gratitude is due to the Mayor of Montreal, Jean Doré, for his encouragement right from the start of the negotiations resulting in the presentation of this exhibition. The former Ministre des Affaires culturelles du Québec, Clément Richard, also offered us his judicious and

*JUROJIN, THE GOD OF LONGEVITY, WITH BIRDS AND FLOWERS* (detail)
Cat. 123

11

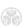

efficient support. We thank him, as we do Tanaka Sendo, who facilitated our first contacts with the Tokugawa Reimeikai Foundation. The Consul General of Japan in Montreal, Tsukasa Abe, and Katsuyoshi Tamura, Consul and Cultural Counsellor, also lent us their generous support. The help of Jean-Claude Couture, Counsellor to the Quebec Delegation in Tokyo, was most valuable.

The exhibition is receiving the financial support of the Japan World Exposition Commemorative Fund (JEC Fund) and of the Volunteer Committee of the Montreal Museum of Fine Arts, and we are grateful to both these organizations. We are also very glad of the collaboration of *La Presse* and of the CKAC, Radio-Cité and CJAD radio stations, who together will ensure that the Museum's exhibition receives a good deal of media coverage.

Finally, we wish to acknowledge the members of the Museum's Board of Trustees and its President, Bernard Lamarre, together with the members of the Programming Committee, for their enthusiastic support.

The organization of a presentation on this scale requires the collaboration of virtually all the Museum's staff, as well as the help of a number of outside individuals and institutions. I have had the pleasure of co-ordinating the project as a whole and have been gratified by the dedication and efficiency of those involved.

We are confident that all the Museum's visitors will be struck with admiration when faced with the splendour and refinement of the works in this outstanding exhibition and that it will bring each and every one of them to a deeper understanding of this truly great civilization.

Pierre Théberge
*Director of the Montreal Museum of Fine Arts*

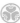

# Foreword

THERE are many different ways for a Museum to approach an exhibition. It is possible to organize an exhibition of landscapes or porcelain, for example, without attempting to represent the works of any particular country or period. Or an exhibition may be designed to focus on a specific school of painting or on the works of an individual painter. All these types of exhibition have as their main theme a particular category of works of art or a particular artist: they do not attempt to throw light on the cultural and historical background out of which the works and the artists emerged, nor do they aim to illustrate an entire page from the cultural history of a country or a period.

The exhibition *The Tokugawa Collection: The Japan of the Shoguns* endeavours to re-create a whole culture: that of Japan's most powerful daimyo, regional leaders closely allied to the family of shoguns who breathed new life into the country from the early seventeenth century until the mid nineteenth — the Tokugawa. Through the wide range of objects it contains, the exhibition conjures up these great leaders' vision of the world and of art, thus helping visitors to better understand the aesthetic criteria by which they evaluated their surroundings.

All the objects in the exhibition, including those from Korea and China, are true reflections of Japan's particular aesthetic sensibility, which was cultivated over the centuries and into which foreign elements were so harmoniously integrated.

I sincerely hope that as many visitors as possible will be encouraged to step, for a while, into the marvellous world of traditional Japanese culture.

In closing, I would like to express my deepest gratitude to Pierre Théberge, Director of the Montreal Museum of Fine Arts, and to Bernard Lamarre, President of the Museum's Board of Trustees, together with all those who have contributed towards the realization of this exhibition.

Yoshinobu Tokugawa
*Director of the Tokugawa Art Museum*

# Genealogy of the Tokugawa Family

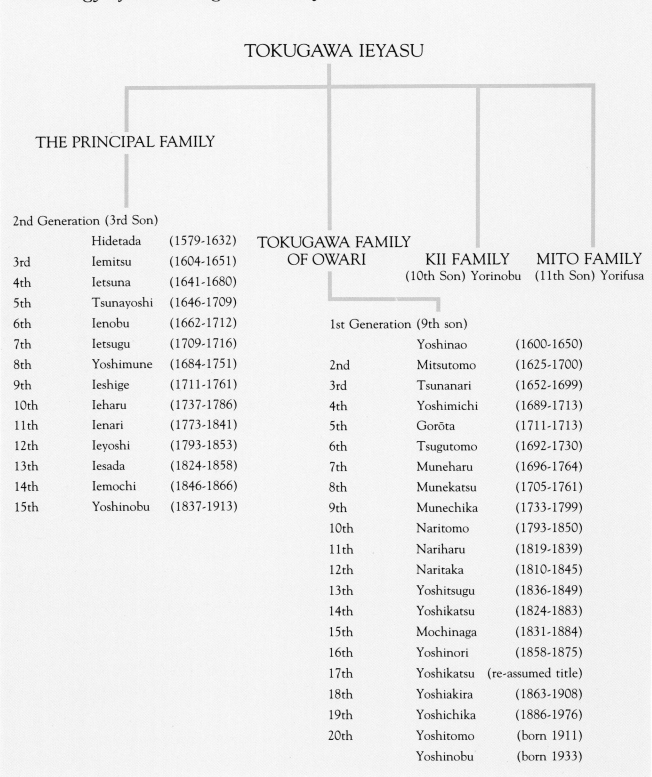

TOKUGAWA IEYASU

THE PRINCIPAL FAMILY

TOKUGAWA FAMILY OF OWARI

KII FAMILY
(10th Son) Yorinobu

MITO FAMILY
(11th Son) Yorifusa

2nd Generation (3rd Son)

|      |            |             |
|------|------------|-------------|
|      | Hidetada   | (1579-1632) |
| 3rd  | Iemitsu    | (1604-1651) |
| 4th  | Ietsuna    | (1641-1680) |
| 5th  | Tsunayoshi | (1646-1709) |
| 6th  | Ienobu     | (1662-1712) |
| 7th  | Ietsugu    | (1709-1716) |
| 8th  | Yoshimune  | (1684-1751) |
| 9th  | Ieshige    | (1711-1761) |
| 10th | Ieharu     | (1737-1786) |
| 11th | Ienari     | (1773-1841) |
| 12th | Ieyoshi    | (1793-1853) |
| 13th | Iesada     | (1824-1858) |
| 14th | Iemochi    | (1846-1866) |
| 15th | Yoshinobu  | (1837-1913) |

1st Generation (9th son)

|      |            |                     |
|------|------------|---------------------|
|      | Yoshinao   | (1600-1650)         |
| 2nd  | Mitsutomo  | (1625-1700)         |
| 3rd  | Tsunanari  | (1652-1699)         |
| 4th  | Yoshimichi | (1689-1713)         |
| 5th  | Gorōta     | (1711-1713)         |
| 6th  | Tsugutomo  | (1692-1730)         |
| 7th  | Muneharu   | (1696-1764)         |
| 8th  | Munekatsu  | (1705-1761)         |
| 9th  | Munechika  | (1733-1799)         |
| 10th | Naritomo   | (1793-1850)         |
| 11th | Nariharu   | (1819-1839)         |
| 12th | Naritaka   | (1810-1845)         |
| 13th | Yoshitsugu | (1836-1849)         |
| 14th | Yoshikatsu | (1824-1883)         |
| 15th | Mochinaga  | (1831-1884)         |
| 16th | Yoshinori  | (1858-1875)         |
| 17th | Yoshikatsu | (re-assumed title)  |
| 18th | Yoshiakira | (1863-1908)         |
| 19th | Yoshichika | (1886-1976)         |
| 20th | Yoshitomo  | (born 1911)         |
|      | Yoshinobu  | (born 1933)         |

# The Tokugawa Art Museum

BY
YOSHINOBU TOKUGAWA

THIS exhibition is a collaborative effort of the Montreal Museum of Fine Arts and the Tokugawa Art Museum. All the works on display have been drawn from the Tokugawa collection.

The collection of the Tokugawa Art Museum is composed of the treasures and documents belonging to the Tokugawa family of the Owari domain, a family of daimyo founded in 1607 by Tokugawa Ieyasu, first shogun of the Tokugawa family. Ieyasu appointed his ninth son, Tokugawa Yoshinao, as the founder of the Owari domain. There exist two other cadet branches of the Tokugawa family — that of the Kii domain,[1] founded by Ieyasu's tenth son, Tokugawa Yorinobu, and that of the Mito domain,[2] founded by Ieyasu's eleventh son, Tokugawa Yorifusa. These three branches of the Tokugawa family are known collectively as *Go-sanke*, meaning literally the "Three Honourable Families".

These three families remained distinct from Japan's other daimyo families, of which there were approximately 280 across the country, as the result of their ties with the family of the shogun. Ieyasu himself had commissioned them to serve as the mainstays of the shogunate, and they enjoyed special status and received preferential treatment.

The Owari Tokugawa headed this group of three families and thus naturally filled the highest of the posts immediately beneath the shogun. Owari was one of the seventy independent administrative districts into which Japan was divided from the seventh century until 1871; the area corresponded to the western half of what is now the Aichi Prefecture. The Owari Tokugawa were the rulers of an area that included the province of Owari itself plus parts of several other provinces. The lord of the Owari domain lived at Nagoya Castle (*Nagoya jō*), the third largest castle in Japan after those at Edo and Osaka.

The annual income of the Owari domain was evaluated at 619,500 *koku*.[3] It is thought, however, that the domain's real income sometimes reached figures close to a million and a half *koku* — the highest income of all Japan's domains, including those ruled by the other two families of the *Go-sanke*.

Tokugawa Ieyasu adopted a number of measures designed to ensure the protection and stability of the new regime he had established. Following his death in 1616, Ieyasu's enormous fortune, kept in his usual place of residence at the castle of Sumpu (*Sumpu jō*), was divided among the three

[1] Now Wakayama Prefecture.

[2] Now Ibaragi Prefecture.

[3] A *koku* was a unit of volumetric measure, used in Japan during this period, equivalent to 180 litres. During the Edo period (1603-1867), the *koku* was generally considered to be the annual rice consumption of one individual.

Tokugawa families. This legacy, known as *Sumpu Onwakemono*, was in fact the source of most of the treasures inherited by the Owari Tokugawa.

Yoshinao, the first daimyo of the Owari domain, was something of a scholar and had a particular interest in Confucianism. He owned a large collection of books on the subject and actually wrote and edited works on Confucianism. Although over the years a certain number of treasures were lost, the main Tokugawa collection was considerably enriched between the seventeenth and nineteenth centuries. Acquisition was usually through purchase or gifts received as part of dowries. Objects disappeared from the collection mostly as the result of deterioration or fire, or through presentation as gifts.

After the Meiji Resoration of 1868, the Tokugawa shogunate came to an end and the title of daimyo was abolished. Those who had held the post were integrated into the new aristocracy, or *kizoku*. The daimyo of the Owari domain was given the new title of marquis.

The rapid modernization of Japan after 1868 resulted in economic changes that led to the fall of several of the old daimyo families. Furthermore, the major earthquake that devastated the Kantō region in 1923[4] caused fires that destroyed the houses and valuables of many of these families, and the depression that followed obliged a number of them to sell the treasures they had inherited from their forefathers.

Seriously disturbed by this trend, the Marquis Tokugawa Yoshichika, direct nineteenth-generation descendant of the Owari Tokugawa, established in 1931 the Tokugawa Reimeikai Foundation to which he donated all his family's treasures. The Marquis thus ensured the conservation of his ancestral heritage while making the precious objects it comprised accessible to the public. Immediately after the establishment of the Foundation, work began in Nagoya on the construction of the museum building, and in 1935 the Tokugawa Art Museum was inaugurated. The Tokugawa Art Museum was one of Japan's first private museums and the only one to have been founded by a daimyo family.

In 1945, during the final stages of the Second World War, many daimyo families lost their treasures to bombing. Furthermore, the combined effects of the very heavy taxation of private property, the country's state of economic exhaustion and the abolition of the aristocracy (*kazoku seido*) forced a number of other daimyo families to sell their treasures or to hand them over to the state. The treasures of the Owari Tokugawa, however, already donated to the Tokugawa Reimeikai Foundation, were safely ensconced during this period in a solid storeroom inside the Tokugawa Art Museum. Owing to this safety precaution — and in spite of a bomb that exploded only ten metres from the museum, seriously damaging the exhibition galleries — the treasures were preserved. In addition, the collection was exempted from the new tax laws concerning private property and thus escaped sale and dispersal.

Today, the Tokugawa Art Museum houses the only high-quality collection of any size that once belonged to an old daimyo family.

In the 1960s, the Tokugawa Reimeikai Foundation began to explore new ways of responding to the needs of a new era. Thus, in addition to the traditional objectives related to the conservation and exhibition of works, the Foundation set itself fresh goals in the following areas:

[4] The Kantō region includes the capital, Tokyo, and the prefectures of Kanawaga, Saitama, Gunma, Tochigi, Ibaragi and Chiba.

1. Study and research
2. Conservation and collections management
3. Exhibition and explanation
4. Education and popularization.

Study and research have in fact become the foundation for all the museum's activities and are at the source of its conservation and collections management techniques. Since 1962, the programme of exhibitions held both in Japan and abroad has been considerably augmented, and from 1974 the Foundation has published an annual monographic research journal entitled *Kinko Sōsho*.

The Tokugawa Art Museum has collaborated on several occasions with the Japanese government by allowing the presentation of certain of its works in government-organized exhibitions held abroad. It is the first Japanese museum, however, to have held exhibitions outside the country without the support of the government. Among these presentations are:

1. 1970-1971   Exhibition of Nō theatre costumes and masks (Rome, Milan and Cologne)

2. 1977   Exhibition of Nō theatre costumes and masks (Washington, New York and Fort Worth)

3. 1983-1985   *The Shogun Age Exhibition* (Los Angeles, Dallas, Munich and Paris)

The exhibition of Nō theatre costumes and masks was an enormous success, particularly during its showing at the time of the United States' bicentennial celebrations, when it attracted a large number of visitors. We had the honour, on that occasion, of welcoming President Carter and his wife to the presentation.

The concept adopted for the *Shogun Age Exhibition* attracted public attention to such a degree that the attendance figures for each of the host cities were far higher than predicted. The exhibition was also extremely well received by specialists in the field of Japanese studies, who emphasized its contribution to the dissemination of traditional Japanese culture at the international, academic and educational levels.

In November 1985, to celebrate the fiftieth anniversary of its foundation, the Tokugawa Art Museum undertook the expansion and renovation of its building. Six new exhibition galleries were constructed, audio-visual rooms were added, and the galleries built at the time of the museum's creation were entirely renovated. The work was completed in October 1987, and the museum reopened its doors as the best-equipped and technically most sophisticated of all Japan's traditional museums. The number of objects in the Tokugawa collection is in the tens of thousands: in the size of its holdings, the Tokugawa Art Museum is second only to the National Museum in Tokyo. As to the content of the collection, it is made up of some of the oldest art objects to be found in Japanese museums. The museum itself is the third oldest of all Japan's private museums, and the edifice is the second largest private museum building in Japan.

The Tokugawa Art Museum is situated in what was once the domain of the Owari Tokugawa, in Nagoya, the fourth largest city in Japan. The museum, surrounded by a wood, stands on the site occupied since the seventeenth century by the Tokugawa family mansion.

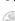

# Shogun and Daimyo

BY
YOSHINOBU TOKUGAWA

## JAPAN BEFORE THE ESTABLISHMENT OF THE TOKUGAWA SHOGUNATE

According to legend, the enthronement of the first emperor of Japan, Jinmu, took place in 660 B.C. However, this legend appears in a historical document not written until the early eighth century A.D., and it is generally believed that the unification under the rule of an emperor of the many small countries that once formed Japan occurred in the fourth or fifth century A.D.

The Fujiwara family, aristocratic members of the imperial court, became influential during the seventh century and took over full political power during the Heian period (9th-12th century). In fact, from the ninth century until 1868, the end of the Edo period, the emperor had no economic power and no personal army. Imperial succession in Japan is hereditary, and the present Emperor is 125th in direct line.

For a period of a thousand years, from the ninth century to the nineteenth, the history of Japan unfurled as a series of political struggles, coups d'état and civil wars. Nevertheless, the basic institution that designated the emperor as head of the government was never abolished, and the emperor's offical status remained intact. Although the emperor possessed no real political or military power, he was respected by those who held effective control of the country. Indeed, the emperor, as the symbol of national unity and the heir to the traditional culture of Japan, has always been — and is still — deeply honoured by the Japanese people.

By the twelfth century, the nobles of the imperial court had begun to lose some of their power, and the warrior class, or *bushi*, were gradually taking over political control. In 1192, Minamoto no Yoritomo — the victorious leader of two warring clans — was named "shogun". He established the shogunal government at Kamakura, five hundred kilometres east of Kyoto, then the country's capital. From that time until 1868, Japan's political power was in the hands of the warrior class.

The period of Japanese history running from the twelfth century to the sixteenth is known as the "middle ages", or *chūsei*, while the following period, from the seventeenth century to the nineteenth, is called the "modern age", or *kinsei*. Until 1219, the Kamakura shogunate was ruled by the Minamoto (or Genji) family. They were supplanted by the Hōjō

family, who fell from power in 1333. At that time, each of Japan's many territories was controlled by a warlord who maintained his power through military force. Among these warlords, those who ruled over a group of some considerable size — made up of family members, vassals and the general population — took on the title of "daimyo". A daimyo, then, can be defined as a member of the warrior class who ruled at the regional level and whose authority was exerted over his own private domain and the subjects who inhabited it.

With the support of the emperor, the Ashikaga family took power in 1338 and established the shogunate at Muromachi, near Kyoto. Their dominance ended in 1573. The relationship between the Ashikaga shoguns and the daimyo was similar to the one that had existed during earlier periods: the shogun did not possess absolute power, but was rather the leader of the daimyo. The political structure in the Japan of the middle ages was thus feudal. Interestingly, while in fact members of the warrior class could aspire to government posts, and even to the post of shogun, in theory the power to bestow official nominations remained with the imperial court and its leader, the emperor.

The sixteenth century was a period of fierce civil war in Japan, with daimyo constantly attempting to seize their rivals' territories by force. Oda Nobunaga, one of the most noted leaders of these warring factions, died in 1582, when the unification process was half complete. Total unification was accomplished under his successor, Toyotomi Hideyoshi, who had been one of Nobunaga's vassals. Hideyoshi attempted — as Nobunaga had before him — to break up the old feudal system and to replace it with a solid, fully centralized regime. But Hideyoshi died in 1598, before this new regime could be established.

## THE FOUNDATION OF THE TOKUGAWA SHOGUNATE

Tokugawa Ieyasu, the most powerful of the daimyo under Toyotomi Hideyoshi's rule, was victorious in the decisive battle against the allied forces of the other daimyo that took place at Sekigahara, in 1600. Thus, only shortly after the death of Hideyoshi, Ieyasu was in a position to impose his own absolute authority. After being named shogun in 1603, he established his capital at Edo (present-day Tokyo), the largest city of his domain. The period that began at this time — Japan's modern age — is known as either the Tokugawa period or the Edo period.

The shogunate instituted by Tokugawa Ieyasu was fundamentally new in structure, particularly regarding the relationship between the shogun and the daimyo. The shogun was now more than simply the leader of the daimyo: he was the holder of absolute national authority, to whom the daimyo were obliged to swear complete allegiance. Within this new context, a daimyo's territory, and the warriors (*bushi*) and subjects that dwelt there, were no longer the daimyo's exclusive property. In fact, the daimyo, once a feudal lord, had now become a hereditary regional governor. With the aid of his subjects and within the limits imposed by the shogunate, he oversaw the judicial, legislative and administrative systems of his region (which included responsibility for tax collection and the police). Clearly, it is not appropriate to use the term "feudal" in the Euro-

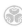

pean sense to describe the Tokugawa period of Japan's modern age. The political structure that held sway in Japan during these centuries was unique, nothing similar having ever existed elsewhere in the world.

## THE ECONOMIC POLICIES OF THE TOKUGAWA SHOGUNATE

Tokugawa Ieyasu, who was appointed *Seii-taishōgun*, in 1603, implemented the following four economic policies in order to establish absolute command over the numerous daimyo in the new administration:

1) Agricultural land survey
2) The separation of soldier from farmer
3) Monopoly over the right to mint coinage
4) Monopoly over the right to foreign trade

### 1) Land Survey

The Tokugawa shogunate undertook a survey of Japan's total cultivated land area using a standard unit of measure. The combined agricultural production of the country was then measured in terms of rice yield, or *koku* (see n. 3 of "The Tokugawa Art Museum"), using the village, or *mura*, as the smallest administrative unit. Agricultural output was measured in *koku* of un-husked rice, or *genmai*. Wheat and other agricultural crops were converted into *genmai* using conversion tables, and the resulting sums were then added to the rice production to arrive at the total agricultural production in *koku*. In this way, the central government was able to calculate precisely the output of each daimyo's domain and hence to establish the status of that daimyo and his obligations to the shogunate regarding military service and other public services.

During the seventeenth century, the rate of taxation on newly cleared farm land was reduced for a fixed period of several years, a measure that had the effect of increasing the total area of cultivated land by eighty percent. The title of "daimyo" was given to any samurai (member of the warrior class) who controlled a domain of which the total agricultural yield exceeded ten thousand *koku*. Within the daimyo group, however, there existed a strict hierarchy based both on financial criteria (that is, on the annual revenue in *koku* of each daimyo's domain) and on the closeness and duration of their links with the Tokugawa family (for example, a daimyo who was actually a Tokugawa family member would be superior to one who was not, and those who had been loyal Tokugawa vassals since before 1600 were placed above those whose allegiance was more recent).

### 2) The Separation of Soldier from Farmer

The farmers who were responsible for the agricultural production that constituted the bulk of national production were forbidden to bear arms and were made to reside on the land they tilled. The samurai were not permitted to reside on their land but had to live in the castle towns (*jōka-machi*) of the daimyo. This policy gave rise to a four-class social structure known as *shi-nō-kō-shō*, which consisted of the samurai (*shi*), farmers (*nō*), artisans (*kō*) and tradesmen (*shō*), and which served to promote the development of cities, industry and trade.

21

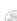

### 3) Monopoly over the Right to Mint Coinage

Gold and silver mines throughout Japan were placed under the direct administration of the shogunate. The circulation of ancient coinage, private coinage and Chinese Ming coinage of non-standard weight and value was forbidden. Gold and silver coinage, with bronze coins as supplementary currency, were minted according to standardized weights, and an official exchange rate was established for the different coinages. This measure permitted the controlling of prices according to a nationally unified standard and greatly hastened the development of a money economy, which in turn encouraged commerce, the distribution of goods, the development of commercial capital and even, to a certain extent, the establishment of industrial capital.

### 4) Monopoly over the Right to Trade

The Tokugawa shoguns, by establishing their own exclusive right to foreign trade, prevented the daimyo from accumulating any wealth except that which derived from agricultural production in their own domains. This trade monopoly also enabled the shogunate to prevent both the development of commercial forces based on the accumulation of large amounts of capital and the manipulation of prices by foreign merchants, and thus to ensure a steady supply of goods at stable prices. These policies were certainly of benefit to the shogunate, but, more importantly, they encouraged the stable development of domestic manufacturing and commercial industries.

The effect of these measures was to greatly reduce the authority of the daimyo, leaving them with merely administrative power over the domains they had once owned outright. Furthermore, the power lost by the daimyo was transferred to the shogunate; in fact, the shogun's power was such that he could, through a simple order, transfer a daimyo from a domain situated one hundred kilometres north of Edo, with a revenue of ten thousand *koku*, to another domain with a similar revenue situated one hundred kilometres to the south. The shogun also retained the right to reduce — or even confiscate — a daimyo's domain at will, and could order a daimyo to regulate his own retainers in the same manner.

At the end of the sixteenth century, the domain of the daimyo consisted of lands either passed down from their forebears or acquired by force. The land and its inhabitants were at that time the property of the daimyo, and he defended both against the military aggression of other daimyo. The position of the daimyo under the Tokugawa shogunate, however, was of a completely different nature. Under their administration, if a daimyo opposed the dictates of the shogun he would not be allowed to retain the lands that had been handed down to him by his ancestors: as a punishment, his fief would be confiscated, or at least reduced, and in extreme cases he would be stripped of his warrior status, thus losing both his domain and his home.

A daimyo was strictly forbidden to wage war against another daimyo, and if he mobilized his warriors of his own accord, he was immediately subdued by the troops of other daimyo under the command of the shogunate. When a daimyo was transferred to another fief, the samurai who

served as his retainers were permitted to follow him, but the farmers and townspeople were not allowed to move. It can be said, then, that the status and authority of a daimyo, to whom the shogunate granted administrative powers but not ownership rights, were closer to those of a regional civil administrator than of a feudal lord.

## THE CIVILIAN ADMINISTRATION OF THE TOKUGAWA SHOGUNATE

Once the Tokugawa shogunate had established absolute dominance over the daimyo through its economic policies, it sought to establish a civilian administration by which to govern its people. During the turbulent hundred-year period of war that had preceded, the only means by which a daimyo could protect his territory and his subjects was his private army, which represented the only forms of justice and administration. The Tokugawa shogunate, however, replaced the daimyo armies by the absolute power and military strength that were embodied in the shogun himself. And, in fact, the two hundred and sixty-five years of the Edo period, running from 1603 to 1868, can be quite accurately described as the "Pax Tokugawana".

Tokugawa Ieyasu valued highly certain principles of morality and social order and advocated the pursuit of both through a study of the teachings of Shintoism, Confucianism and Buddhism — all philosophies in which ideals of justice and social structure take the place of any concept of military force. Ieyasu had applied himself assiduously to scholarship from his early boyhood. From 1592 onward, especially, after he had passed the age of fifty, he strove to cultivate himself with a view to eventually heading the next administration — an aim that became a reality when he acceded to the post of shogun in 1603. After he abdicated in 1605, at the age of sixty-four, in favour of his third son Hidetada, he immersed himself in scholarship, collecting a vast number of books, having them transcribed and printed using wood and bronze characters, and gathering together outstanding scholars in order to listen to their lectures and discussions. Needless to say, Ieyasu's enthusiasm for scholarship did not stem simply from a casual interest: it was the result of his keen desire to discover the political and ethical ideals that could serve well into the future as the foundations of the newly established Tokugawa shogunate.

## RESPECT FOR TRADITIONAL AESTHETICS

Ieyasu did not search for the foundations of the newly created system in scholarship alone. His letters and the many memoirs he left indicate that, after the age of sixty, he would occasionally lecture to his retainers and their wives and children, in simple language, on the daily practice of the mental discipline and behaviour required of them as members of the samurai class and as human beings. He would even sometimes expound on more profound philosophical matters. That Ieyasu was a man of enormous self-discipline, a discipline based on a philosophy of stoicism, is clear from the advice he offered others: "Patience and forbearance — One must endure to the end, without selfishness, without succumbing to the desire for gain, with frugality and thrift".

Ieyasu felt that the new administration, centered on the person of the shogun, necessarily required a new etiquette and new standards of personal cultivation. He carefully studied the ancient customs of the Ashikaga shoguns of the Muromachi period and instituted a systematic mode of appreciation of the traditional arts, which had been in a state of some confusion at the end of the sixteenth century. He tempered the extravagance shown in receiving guests and also in daily life, which had become ostentatious and subject to the vagaries of fashion. As part of this new etiquette, he adopted the tea ceremony known as *wabi no cha*, which had existed since the fifteenth century and which was to become, in the sixteenth, one of the purest expressions of the new Japanese aesthetic. In addition, Ieyasu adopted the fifteenth-century etiquette of samurai hospitality, according to which a *tokonoma*[1] was decorated with a Chinese hanging scroll from the Song or Yuan period, with a Chinese flower vase, an incense burner and a candleholder arranged in front of the painting; displayed on the *chigai-dana*[2] would be articles of Chinese or Japanese lacquerware of the highest quality, such as tea caddies, incense containers and tiered boxes; the *shoin-doko*[3] would be adorned with writing implements. A Nō drama would be performed, to be appreciated by the host and his guests as they exchanged cups of sake and shared an exquisitely prepared banquet. Such was the protocol followed by the samurai of the fifteenth century.

The tea ceremony called *Sōan-no-cha*, a form of tea etiquette that focused on the simple, austere spirit of wabi and that was strongly influenced by the teachings of Zen Buddhism, had attained sudden popularity among the merchant class from around the beginning of the sixteenth century. This etiquette was based on the concept of receiving a guest by sharing a cup of tea, without regard to status, thereby transcending the notion of rank in the relationship of host and guest. This form of tea had been altered, however, by the great warlords Oda Nobunaga and Toyotomi Hideyoshi, who changed it into a luxurious pastime in which individuals vied to outdo one another in splendour. Daimyo, samurai and merchants all competed in the sumptuousness of their accoutrements for this basically simple *suki-no-cha*, or "tea of the grass hut". Ieyasu adopted the receiving etiquette that was the most positive aspect of this form of tea; he also adopted the tea utensils that already reflected a fixed set of aesthetic values, thus reinforcing the traditional character of the ceremony. However, he rejected the innovative element that was part of the spirit of this form of tea, as being a potential source of social disorder.

Thus, the shogunate, headed by Tokugawa Ieyasu, created a new etiquette, suited to the new administrative order and regulated by both the samurai etiquette of the fifteenth-century Ashikaga shogunate and the conventions of *suki-no-cha* developed during the latter half of the sixteenth century.

The daimyo of the Tokugawa clan, led by the Owari Tokugawa, together with all the other daimyo, adopted these forms of etiquette, thereby consolidating the culture of the samurai and the daimyo, who formed the ruling stratum during the Edo period.

---

[1] *Tokonoma*: an alcove in a reception room used for the display of decorative objects.

[2] *Chigai-dana*: staggered shelves.

[3] *Shoin-doko*: a writing alcove on one side of a reception room or study, containing decorative objects related to calligraphy and writing.

# A Daimyo's Possessions

BY
YOSHINOBU TOKUGAWA

A DAIMYO is, of course, a samurai and a military leader. In the centuries preceding the Edo period — that is to say, up until the battle of Sekigahara, in 1600 — a daimyo acquired and maintained his status primarily through force, relying on the fighting ability of the retainers under his command.

However, with the appointment of Tokugawa Ieyasu as *Seii-taishōgun* in 1603 and the establishment of the shogunate in Edo, daimyo were no longer permitted to mobilize their armed forces without the instruction of the shogun. In the new order, if a daimyo disobeyed the shogun's commands in this respect, he was forced to relinquish his fief and lose his status as a daimyo. The two hundred sixty-five years of peace that continued until 1868 were maintained through the absolute authority of the Tokugawa shogun.

The foundations for this two and a half centuries of peace were laid by Ieyasu who, in the opening articles of his last instructions to the daimyo, admonished them to "strive to excel with both the pen and the sword". With the advent of peace, the daimyo were no longer simply military commanders; they were also required to be competent administrators. To successfully accomplish this double task, they had to apply themselves not only to the military arts, but also to the various scholarly fields that would serve as the basis for their administrative duties.

The peace endured, then, and — in tune with the daimyo's aspirations and to the satisfaction of the general population — the policies instituted by the early Tokugawa shogunate led to the precedence of literary pursuits over military ones. As the middle ages (*chūsei*) were left behind and Japan moved into the modern era (*kinsei*) or "Edo" period, the role of the daimyo underwent a fundamental change: once feudal lords, they were now regional administrators under the absolute authority and firm direction of the shogun. The government's central aim was to establish a morally sound social structure rather than to increase its military force. Such a basic change of approach inevitably led to changes in the type of articles employed by the daimyo for daily use and in the decorative objects with which they surrounded themselves. It is interesting to examine the general character of these articles in the light of the altered role of the *kinsei* daimyo serving under the Tokugawa shogunate.

A daimyo's possessions can be divided into the two principal categories of *omote-dōgu* and *oku-dōgu*. The *omote-dōgu* consisted of arms and armour kept by the daimyo that reflected his status and his income, together with books and accoutrements for actual use or for the ornamentation required on formal occasions. The *oku-dōgu* consisted of articles used in the daimyo's private life and pastimes.

## I. OMOTE-DŌGU

### 1. Arms and Armour

a. *Tachi* (long sword), *katana* (sword), *wakizashi* (short sword), *shōtō* (short sword), *sō-ken-gu* (sword fittings), *naginata* (Japanese halberd), *yari* (spear), *teppō* (musket) and *taihō* (cannon)

According to Japanese tradition, swords symbolized and embodied the "soul of the samurai". Great importance was attached to the spirituality and aesthetic sensibility of the master swordsmiths who created them. Among the broad range of articles included in a daimyo's possessions, swords were decidedly of the first rank, and they were the most highly regarded and most precious of all the gifts exchanged between shogun, daimyo, and their retainers. In terms of their destructive potential and thus as weapons of war, swords were less effective than spears, which had been in use since the fourteenth century. They were also clearly far inferior in this respect to the muskets and cannon that were introduced in the latter half of the sixteenth century. However, these forms of weaponry were ranked only as functional arms, while the sword had traditionally occupied the highest status owing to its outstanding spiritual qualities.

The *koshirae* (sword scabbard and hilt), *tsuba* (sword guard), *menuki* (hilt ornament), *kōgai* (scabbard ornament) and *ko-gatana* (small knife attached to the scabbard) were all components of the sword mounting and, as accessories of an article of such exalted status, were crafted using the most sophisticated and refined techniques of the period. The decorative elements are particularly notable; for despite the fact that they adorn weapons, they rarely evoke power or violence. Most of the images are highly poetic, representing such motifs as irises (*shōbu*) and autumn plants (*aki-kusa*). These decorations are a clear expression of the aesthetic sense and taste that were part of a daimyo's attitude towards his arms. Muskets and cannon were often similarly embellished with elegant designs.

b. *Katchū* (*yoroi* and *kabuto*: armour and helmet), *hata* (banner), *nobori* (battle standard), *maku* (tent), *umajirushi* (marker standard positioned next to the horse of the commander of a group of warriors), *horo* (device for protection against arrows, attached to the back of the armour), *hora-gai* (a large conch shell used for giving the signal to attack or retreat), *gunbai* (commanding officer's fan), *jin-daiko* (battle drum) and *dora* (gong)

The *katchū* is the ensemble, consisting of protective armour and helmet, worn by the warrior. The *hata* and the *nobori*, along with the other battle articles, were used to decorate the commander's camp and to demonstrate the ferocity of the troops. It was not considered sufficient, however, for armour to be simply effective during battle. All the warrior's accoutre-

ments, particularly those of a daimyo, had to be of the finest craftsmanship and of an aesthetic level that would adequately express the "soul of the samurai". Every year on January 11, even during the period of peace, each daimyo's armour and helmet would be put on display in the *shoin* of his house, and his battle standard and banner would be erected in the garden in order to invoke military success during the coming year.

c. Horse trappings, falconry accessories, etc.
Horses were of prime importance to a daimyo, even in peacetime. As well as the decorated saddle and stirrups in keeping with his status, the daimyo also possessed a pair of battle stirrups. Grand hunts (*maki-gari*) and falconry were not simply undertaken for the pleasure of the sport, but were organized by the daimyo as a form of military training during peacetime and as a way of assessing popular attitudes towards authority.

2. Decorative Objects
a. Objects for decorating the *shoin*
Since Japan's feudal period, official receptions given by a daimyo were held either in the main reception room of his house (*dai-shoin*) or in one of a number of other rooms of varying sizes. Each of these rooms contained an alcove (*tokonoma*), staggered shelves (*chigai-dana*), tripartite shelves (*seiro-dana*) and a desk alcove (*shoin-dana*), all designed to hold a variety of decorative objects. In the residences of the families of the shogun, the three Tokugawa families and the most influential daimyo, the objects employed were the predominantly Chinese pieces demanded by the traditional ornamentation based on the ancient customs of the Ashikaga shoguns of the Muromachi period.

In the large alcove, or *tokonoma*, of the *shoin*, a Chinese painting of the Song, Yuan or Ming dynasty was hung. In front of the *tokonoma*, on a stand, were displayed three objects, all in bronze, that formed a set: an incense burner, a candleholder and a flower vase. Flowers were arranged in the vase according to the *shin* style. On the upper and middle shelves of the *chigai-dana* and *seiro-dana*, to the side of the large alcove, were placed incense instruments, a *tenmoku* or tea bowl, a tea caddy, an incense container and a basket. On the lower shelves were placed trays bearing natural stones (*bonseki*) or a bowl of flowers. A set of portable shelves (*daisu-kazari*) was kept in the corner of the room.

In the waiting room (*yasumi-dokoro*), there was a small brazier over which was placed a kettle. Finally, the *shoin-dana* was decorated with writing implements such as an ink stick, inkstone (*suzuri*) and brushes, and a scroll (painting or calligraphy) that symbolized the cultivation and aspirations (*kokorozashi*) of the particular daimyo.

b. Utensils for decorating the tea hut
The reception ceremony was part of the tea ceremony known as *wabi-cha* — an etiquette to be followed during a meeting between a small number of people that had become extremely popular in the latter half of the sixteenth century. It was eventually adopted by the daimyo for official formal ceremonies called *o-sukiya-no-cha*. In a small room, only about three

metres square, the daimyo received a guest accompanied by no more than three attendants. The participants sat on *tatami* mats on the floor, removing their *wakizashi* (short swords) before entering, so as to be entirely at their ease. In the small flower-decorated alcove was displayed a calligraphic or painted scroll by a Zen monk. The kettle was placed upon the tea hut's brazier, and the daimyo himself, as host, prepared the tea and offered it to the guests, using the simple, austere utensils of the *wabi-cha*: early Chinese tea caddies and incense containers, Korean tea bowls of the Yi period, water containers from Europe, and bamboo ladles and tea scoops. It was considered an essential part of a daimyo's education that he possess the knowledge necessary to be able to appreciate, both as host and as guest, the spirituality hidden within each of these utensils, together with its historical origin and the *wabi* aesthetic embodied in its deceptively simple appearance.

### 3. The Accoutrements of the Nō Drama

In the grand audience hall known as the *shoin*, the official reception commenced with the ceremonial exchange of *sake*, called *shiki-sankon*. Numerous gifts changed hands, including swords and gold. Then, individual trays bearing delicious dishes were presented three times to each participant. In conjunction with these proceedings, performances of Nō and Kyogen\* were presented on a specially constructed Nō stage located just across a small garden from the *shoin*. The performances were accompanied by flutes, *tsuzumi* (small, hour-glass shaped hand drums), *taiko* (stick drums) and *utai* (chanting of Nō texts). The plays to be performed were selected to suit the particular reception. The actors performed wearing exquisite costumes kept for this purpose in the daimyo household. The host and his guests were equally entertained by these presentations.

The daimyo was expected to possess an extensive knowledge of the plays, musical accompaniments, dances, costumes and masks used in these Nō performances and, if asked to do so, had to be able to chant, play the *tsuzumi* and dance the *shimai* (a Nō dance executed without theatrical costume). For this reason, the accoutrements of Nō were required to be on hand at all times in a daimyo household, and the daimyo were expected to employ and support Nō actors.

### 4. The Library

As well as being a keen scholar himself, Ieyasu collected a vast number of books on a variety of academic subjects and conserved a number of libraries that dated back to the middle ages. In addition, he had rare books transcribed, and if any volumes of a series in his possession were missing, he would seek them all over Japan. He enriched his own collection, those of the Shintoist and Buddhist temples, and the one used by the nobles (*kuge*) of the imperial court. He ordered the publication of treatises on the art of war, Confucianism and history, using the recently introduced printing technique that employed characters in wood and bronze as well as the traditional wood-cut method.

The Tokugawa shoguns were the heirs to this tradition established by Ieyasu, and for two and a half centuries they strove to compile, write and

---

\*Kyōgen: a comical play presented during a Nō programme.

publish texts and books of all sorts. In the process, the shogunate inevitably invested a good deal of money, employed many experts and collected an enormous number of documents. The daimyo, following Ieyasu's example, also acquired an impressive number of books for their own learning and cultivation, as well as those they used for ornamental purposes or for everyday entertainment. Among the volumes in a daimyo's library there might be works on Japanese and Chinese history, the teachings of Confucianism, Buddhism and Shintoism, books on the military arts, geography and astronomy, medical tomes and countless volumes of classical literature. This library was provided for the scholarly pursuits of the daimyo and the members of his household, but was also made widely accessible to the scholars in his employ and his retainers. A number of daimyo themselves edited volumes on history, philosophy and economics, and ordered the scholars and retainers under their command to compile a variety of documents, such as topographical treatises and genealogies, some of which were published and presented to the public. This situation, in which a government or ruling power was responsible for the editing, writing and publication of a quite extraordinary number of books and documents, does not seem to have been paralleled anywhere else in the world prior to the nineteenth century.

## II. OKU-DŌGU

1. Household Furnishings and Objects of Daily Life

A broad variety of furniture and personal effects were used in the daily life of a daimyo household. Although most of the objects actually employed during the Edo period no longer exist today, many of the articles owned by Tokugawa Ieyasu and some that were part of the dowries of the shoguns' wives were not subjected to constant use and have been carefully preserved in an almost perfect state. These household articles can be categorized in the following manner.

a. Shelf ornaments

*Zushi-dana* (two-doored shelves), *kuro-dana* (black shelves), and *sho-dana* (shelves for writing materials), forming a set called the *san-dana* (literally "three shelves"); *kō-dōgu* (incense instruments), decorative items such as boxes, scrolls, books and writing materials.

b. Personal effects

This category includes personal toilet articles such as the dressing table, cosmetic cases, rectangular or two-handled (*mimi-darai*) basins, a latticed box on which to drape garments for perfuming with incense, a rack for hanging a kimono, special cosmetic boxes for travelling, portable dressing tables and small pieces of portable furniture such as armrests (*kyōsoku*) and backrests (*yorikakari*).

c. Pastimes and amusements

These include articles used in such pastimes as Japanese chess (*shōgi*), go, backgammon (*sugoroku*), the incense-identifying game (*kō-awase*), the shell-matching game (*kai-awase*) and card games. Although they were associated with amusements, the boxes (*kai-oke*) containing the shells used in the shell-matching game were considered among the most important of the articles included in a bride's dowry. The articles for the incense-

identifying game were sometimes used to decorate the shelves, for they were prized more as symbols of rank than as practical objects.

## 2. Clothing

While clothing was a necessary part of daily life and served the basic function of keeping the wearer warm, it was also a form of personal ornament that was used to indicate status. There were a number of prescribed types of clothing for the daimyo and the members of his family. Since clothing wears out relatively quickly, very few garments worn frequently during this period have come down to us. Ieyasu's clothing, however, was carefully preserved even after his death and now provides rare examples of everyday garments that have survived. Garments for special occasions and ceremonial functions were worn infrequently and carefully preserved, and as a consequence many examples in this category still exist today. Nō costumes were not intended, of course, as garments for daily use, but were part of the accoutrements of the Nō theatre. As such, they were classified as belonging to the *omote-dōgu* (official articles) and many have been carefully preserved to the present day.

## 3. Medicines and Medical Instruments

Many daimyo kept a garden of medicinal plants in order to produce and stock their own medicines. The medical instruments were used in the preparation of these medicines.

## 4. Paintings

### a. *Yamato-e* (Japanese paintings)

Illustrated handscrolls of the Heian or Kamakura periods, such as *Genji monogatari* (the Tale of Genji), *monogatari-emaki* (scroll paintings illustrating literary narratives) and *engi-emaki* (narrative scroll paintings recounting the legendary origins of Shintoist or Buddhist temples) were not part of the *omote-dōgu* (official articles), despite the fact that they are well known today and are frequently registered as National Treasures or Important Cultural Properties. In the daimyo household, such scrolls were used for the private amusement and personal cultivation of the daimyo and his family.

### b. *Ukiyo-e*

The folding screens depicting festivals, amusements or genre scenes produced in the early seventeenth century are known as *nikuhitsu-ukiyo-e*, or "hand-painted *ukiyo-e*". The objects were strictly reserved for use in private, and it would have been unthinkable to display them as official ornaments in the *shoin* or in the tea-room. Nonetheless, *ukiyo-e* paintings were highly regarded and preserved accordingly. *Ukiyo-e* prints, on the other hand, were not considered important, though they were probably a source of pleasure for the daimyo household; and since they were not highly valued, there are virtually none extant today.

### c. *Jihitsu-kaiga* (Paintings by members of the household)

Tokugawa Ieyasu, together with many Edo period daimyo and their families, practised painting as a hobby and an amusement, but also as a serious accomplishment and a means of self-cultivation. Among these practition-

ers of high social rank, there are quite a few who actually became professional painters or whose talent rivalled that of professional painters.

As long as they remained in the artist's home, paintings executed by the daimyo or members of his family were considered part of the *oku-dōgu* and thus unsuitable for official display. If the paintings were presented to retainers, or Buddhist or Shintoist temples, however, they were treated as objects of an official nature (*omote-dōgu*) that bestowed honour on the recipient.

d. Other styles of painting

Chinese paintings and monochrome ink paintings (*suiboku-ga*), bird-and-flower screens from the Muromachi or Momoyama periods, works of the Chinese-influenced Kanō or Unkoku schools, and wall paintings (*shōhei-ga*) in the native Japanese traditional modes practised by the Tosa and Sumiyoshi schools may sometimes have been used in the private quarters, but they were considered to be part of the *omote-dōgu* and were often displayed on official occasions.

5. Calligraphy

The calligraphy of a Zen master or the thirty-one syllable Japanese poems known as *waka* written on paper such as *kaishi* (Japanese), *shikishi* (coloured and decorated) or *tanzaku* (bound heavy paper conceived especially for poems and calligraphy) — or even letters, if they were by a famous poet, calligrapher, warrior or tea master and framed in a *kakejiku* (hanging wall frame) — could all be put on display in the alcove of the *shoin* or tea room, and thus become part of the *omote-dōgu*. When calligraphy of this type was mounted to form an album (*tekagami*) or mounted on a folding screen, these objects were counted among the official articles. The calligraphy albums, however, were not only considered as articles for official decoration; they were also often part of a dowry and thus, as private articles, classified under the *oku-dōgu*.

The daimyo and his family studied calligraphy as a matter of course from the earliest age. This was not simply to learn how to read and write: they were required to be able to write beautiful, accomplished calligraphy. Among daimyo and their families can be counted numerous talented calligraphers of great fame whose work was highly regarded even during their lifetimes. Calligraphic studies and works produced within the family were preserved in the private quarters, where they were prized and appreciated as works of art. Like paintings, such examples of calligraphy were considered *oku-dōgu* while in the possession of the family, but were treated as official articles once they were presented to retainers or temples.

Since *omote-dōgu* were embodiments of rank used on official occasions, there were rules and regulations governing them that reflected the status of the individual daimyo. As *oku-dōgu* were used as private effects, however, there were no rules governing them and they varied greatly from family to family. But even though these private articles served largely for amusement and entertainment, they also indicated the status of the family that used them in the same way as the official articles and were, for the daimyo and his family, a source of culture, scholarly enrichment and inspiration in the successful accomplishment of their administrative tasks.

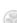

# Civilizing Warriors

BY
HAROLD BOLITHO

THE period covering the end of the sixteenth century and the beginning of the seventeenth represents one of the major turning points in Japanese history. Just how much of a turning point can best be seen by comparing the Japan of 1550 with the Japan of only a hundred years later. In 1550, the country was caught firmly in the grip of internecine warfare of a kind which, for a hundred years and more, had set warlord against warlord, warrior against master, and citizen against the authorities. Law and order had vanished and, in a land with no effective political centre, no one could rely on anyone else for protection, security or livelihood. It was an age when alliances were forged and broken with ease, and when violence, treachery and assassination were integral elements in the standard political vocabulary. Within a century, however, this situation had been completely reversed: by 1650, Japan was more firmly unified than ever before. There had been no major military confrontation for over thirty years, and indeed no warfare of any kind for more than a decade. There was also a real political centre — not Kyoto, where the Emperor had his residence, but a new city, Edo (to be renamed Tokyo more than two hundred years later); in 1650, Edo was well on its way to becoming one of the largest cities in the world and was already recognized throughout Japan as the seat of military and administrative authority. The system of regional warlords still existed, but in a considerably attenuated form, these leaders having surrendered much of their military strength and their capacity for independent action, but also having received in return guarantees of a security — against their own vassals as well as against their neighbours — of a kind they had never before known. The countryside was at peace and, after centuries of war and destruction, was enjoying a surge of prosperity in which both an agricultural revolution and a commercial revolution played their part.

Much of this change can be associated with the name of one man: Tokugawa Ieyasu (1542-1616) (see cat. 1), who took the title of shogun in 1603 and passed it on to successive generations of his family in a line extending down to 1868, when the office was abolished. Ieyasu, born into a family of minor warlords in 1542, out-fought, outlived and, incidentally, out-sired all of his competitors (he had sixteen children, including eleven sons, of whom five survived him) to gain control of what was by then a

*UNEME KABUKI* (detail)
Cat. 157-158

33

largely united Japan. Of course, he did not achieve this single-handedly. Tokugawa Ieyasu was lucky enough to be born at a time, and in a place — the east coast of Honshu, not far from what is now the city of Nagoya — that allowed him to take advantage of the social, economic and military forces that were pushing Japan towards unification. In particular, Ieyasu had the good fortune to live within the orbit of the one man who, more than any other, can be credited with initiating Japan's movement towards unification — his neighbour, Oda Nobunaga. Allying himself to Oda Nobunaga in 1562, Ieyasu and his vassals fought beside the Oda armies in a number of important campaigns, including the famous Battle of Nagashino in 1575 (see cats. 75, 77), at which firearms were used for the first time in Japan, to devastating effect. By the time of his death in 1582, Nobunaga had become master — directly in some cases and indirectly in others — of more than half of Japan's provinces, including the economically and strategically vital provinces of central Honshu. Ieyasu, as one of his most trusted lieutenants, was well placed to inherit Nobunaga's mantle. This was not to be, however, or not immediately: Oda Nobunaga's empire was to pass first to another major military figure, Ieyasu's colleague and rival, Toyotomi Hideyoshi (1536-1598). For a time Ieyasu resisted, fighting against Hideyoshi at Nagakute, among other places, in 1584 (see cat. 76). He ultimately submitted, however, co-operating with Hideyoshi as he pushed the process of unification first into Shikoku, then into Kyushu, and finally into eastern Honshu.

Hideyoshi died in 1598, leaving behind him a country on the very brink of unification, a five-year-old son and a perfect opportunity for Tokugawa Ieyasu to take control of the one by pushing aside the other. Ieyasu performed both tasks with relative ease. At the Battle of Sekigahara (see cat. 78) in 1600, Ieyasu, together with an army of 104,000 vassals and allies, defeated a rival force of 85,000 and took control of Hideyoshi's empire. Once this degree of military pre-eminence had been achieved, Ieyasu was perfectly placed to begin solidifying and institutionalizing the control his two great predecessors had won. To the imperial court in Kyoto, he was generous but firm, providing the emperor and his courtiers with a degree of material comfort, while at the same time hedging them about with restrictions, enforced by his own officials, in an effort both to keep them docile and to prevent their participation in national politics. To his enemies, those who had fought against him at Sekigahara, he was far less generous, confiscating the estates of some and the heads of others — perhaps, if the records are to be believed, as many as 35,000. To his allies, he was magnanimity itself, rewarding them for their help with gifts of land expropriated from his enemies. Of course it was not by accident that many such allies were in the process removed from domains in central Japan — an area Ieyasu wanted to maintain under the closest possible control — and set at a safe distance. Closer to hand, in locations of strategic significance, he placed his most trusted vassals and his relatives, hoping thereby to build up a *cordon sanitaire* between the great warlords — whose intentions, despite their tokens of submission, he mistrusted — and his own power base.

This power base consisted essentially of two adjacent areas. The first, the Kanto plain, had been given to Ieyasu by Hideyoshi in 1590. It was here, at a village called Edo on the edge of a salt marsh, that Ieyasu set up his administrative capital, dredging streams, draining swamps, building canals and, in a process not completed until well after his death in 1616, undertaking the building of a great castle to house his administration. Following the Battle of Sekigahara, Ieyasu began to govern Japan from Edo, informally at first, but then formally, having received in 1603 the ancient and venerable title of *Seii-taishōgun*, or Commander-in-Chief of the Pacification of Barbarians. The title itself he passed on almost immediately to his son Hidetada, who became the second Tokugawa shogun in 1605. However, Ieyasu, as *Ō-gosho*, or Retired Shogun, continued to direct and monitor affairs of state. In his retirement, Ieyasu moved down the coast to Sumpu, but Edo remained the centre of Tokugawa Japan, and no effort was spared to preserve that position for it. As home of the shogun's administration — the largest bureaucracy in Japan — and of his army, which by 1633 numbered some 60,000 strong, the predominance of Edo among Japanese cities was virtually assured. But Tokugawa Ieyasu and his immediate successors — Hidetada, the second shogun (r. 1605-1623), and Iemitsu the third shogun (r. 1623-1651) — left nothing to chance in this regard. Ieyasu initiated a campaign to attract a community of merchants and artisans, and his successors continued it until Edo, achieving a momentum of its own, had become Japan's largest and busiest city, wresting that title from Osaka early in the eighteenth century. In 1635 Tokugawa Iemitsu, the third shogun, issued instructions to each of Japan's daimyo, or regional overlords, imposing on them what became known as the *sankin-kōtai* system. This had a profound effect on Edo's physical development, for it was a system under which each daimyo was obliged to spend every alternate year in Edo, arriving at a specified time and with a specified number of retainers, to pay symbolic homage to the shogun. Every daimyo, therefore, needed to maintain a number of residences in Edo, at least one of which had to be big enough to accommodate a large number of men-at-arms, officials of various sorts and servants. Every year, half the daimyo in Japan, each escorted by an impressive retinue (see cat. 15), would converge on Edo from all points of the compass, departing twelve months later to be replaced by the other half. More than anything else this system, which gave Edo a permanent annual population of over a million people, transformed the city into the political, commercial and, increasingly, cultural centre of Japan.

Edo, then, was a major part of the Tokugawa power base. But it was by no means the only one. Almost as important was the coastal area which stretched away westwards from Edo towards Kyoto and Osaka, and which made up the old Tokugawa heartland. Ieyasu had been born there, had grown to maturity there, and had fought battle after battle and forged alliance after alliance there. He knew it better than any other part of his empire, for until 1590 it had been his personal domain, and its claim on his sentiments was clearly greater, for when he retired in 1605 he chose to withdraw to precisely this part of Japan, to the castle town of Sumpu where

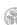

he had lived as a child. These personal links, however, important as they obviously were to Tokugawa Ieyasu, were underlined by more practical concerns. The area was fertile — one of the four largest tracts of rich agricultural land in Japan, in fact — and it lay on the most direct route from Edo, the shogun's administrative capital, to Kyoto, the imperial city. It was therefore important for Ieyasu to have as much direct control as possible of this region — known to the Japanese as the Tokai, or Eastern Seaboard — and to that end he filled it with daimyo he considered trustworthy. The province of Owari (now Aichi Prefecture) was the key to this area, and accordingly far too important to be placed in the hands of any but the most reliable. Ieyasu was not the only one of Japan's three unifiers to have thought this way. Toyotomi Hideyoshi had given the province to his nephew and designated successor, Hidetsugu, who held it until his uncle, in one of the abrupt changes of mind that were so characteristic of Hideyoshi in his later years, forced him to commit suicide. Ieyasu, immediately after the Battle of Sekigahara, gave it to his fourth son, Tadayoshi, then just twenty years old, but his hopes for stability there suffered a setback in 1607, when Tadayoshi died unexpectedly. Ieyasu, however, had more sons. Of those remaining to him, Hidetada was clearly out of the question, since he already occupied the office of shogun and had done so for nearly two years. Tadateru, another of the surviving sons, was already daimyo of an even larger and equally important province on the Japan Sea coast. This left three younger children — Yoshinao, then six and a half years old, Yorinobu, who was a year younger, and Yorifusa, who was then four. Faced with this choice, Ieyasu decided to give Owari to Yoshinao, his son by Sōō-In (also known as Okame) and one of the eleven women recorded as having borne him children.[1] The two younger boys were later to be given domains of their own in Kii Province and Hitachi Province. These three cadet branches of the Tokugawa family, known as the *Go-sanke*, came to hold a special relationship to the main line, giving counsel to it and offering a pool for adoption in case the main line should falter, as it occasionally did. All three domains were considerable, but there is no doubt that Owari, the art treasures of which make up this exhibition, was by far the largest and the most important.

Tokugawa Yoshinao, then, was only six and a half years old when he was given his new domain, and only a year older when he received official notification of the grant, in a deed (see cat. 12) signed by his elder brother the shogun, conferring upon him "the entire province of Owari". Clearly he was far too young to be expected to take up administrative burdens of any kind, so he continued to live with his father at Sumpu. Only after Ieyasu died did the youthful Yoshinao, then sixteen years old and newly married, move into the province entrusted to his care. On his arrival, he found everything in readiness. His father had taken great pains to see that this should have been so. Back in 1607, Ieyasu had assigned a group of his own assistants to the task of organizing the Owari domain, a task that included a land survey, initiated in 1608, and the formation of a vassal band, which by 1650 numbered over 1,300 samurai assembled from thirty-two different provinces.[2] These samurai, maintained at first by grants of land (see cat. 13), but increasingly thereafter by stipends, formed the

[1] Saiki Kazuma, "Tokugawa shōgun seibo narabini saishō kō", in Nihon Rekishi Gakkai (eds.) *Rekishi to jimbutsu* (Tokyo, 1964), pp. 421-426.

[2] Maeda Hiroshi, "Jū-nana seiki no Owari han kashindan", *Chihōshi Kenkyū*, 12: 2-3 (April-June, 1962), p. 54.

Owari domain's standing army. The most spectacular achievement of these early years, however, took the form of a castle at Nagoya, which had been selected as the location of the domain's administrative centre (see cat. 11). Ieyasu had set his men to work on the project in 1610, and within four years they had built an enormous fortress, second in size only to the shogun's own castle in Edo. The scale was deliberate. The building of so imposing a castle — a five-story keep, topped by two golden dolphin finials and set in grounds covering several acres — was no accident. Nor were the great stone walls and the moat behind which it sat. Tokugawa Ieyasu may have won a dramatic victory at Sekigahara, but there still remained one major obstacle to complete security. This was Toyotomi Hideyori, Hideyoshi's son, who had taken up residence in the castle at Osaka, and whose existence was a continued threat to Tokugawa control. Japan in the early seventeenth century was full of discontented people to whom Hideyori, as Hideyoshi's legitimate successor, offered a cause around which to gather. Ieyasu needed no crystal ball to see that trouble would come sooner or later and to recognize that it was only prudent to have a major fortress between Hideyori and himself. As it happened, the issue was finally resolved in 1615 by a campaign in which Nagoya Castle played no part; but the castle remained throughout the Tokugawa period to impress and intimidate resident and traveller alike.

Tokugawa Yoshinao (see cats. 3,4), presiding over his domain until his death in 1650 at the age of fifty, was to see a great many changes as the Owari region, along with the rest of Japan, gradually adjusted to peace and stability. The Owari domain, one of the four largest of Tokugawa Japan's 265 daimyo domains, began to blossom under the favourable conditions the seventeenth century offered. Fertile already, it became even more so through a programme of land reclamation in which swamps were turned into productive farmland, and it was not long before Owari products — rice, cotton, porcelain — were being sent for sale to the markets at Osaka, just a short distance down the coast. The castle town of Nagoya, too, was transformed. Until 1610 there had been little there except a small fortress, deserted for more than fifty years, but once the castle had been built and the domain's samurai, or men-at-arms, had taken up residence around it, it began to change. By 1650 it comprised a population of 55,000 commoners, made up of merchants attracted both by the prospect of samurai business and by offers of tax-free sites for their shops, and also of people from all over the surrounding countryside who had come to seek work as labourers, porters, shop assistants and servants. By the eighteenth century — owing largely to the influence of the free-spending Tokugawa Muneharu, the seventh daimyo — Nagoya had become a very different city from the one it had been a hundred years earlier. Its many brothels, its fifty-seven theatres, and Muneharu's encouragement of festivals, restaurants and wrestling matches turned the city into the country's most noted entertainment centre, and a graphic symbol of just how far Japan had moved from its stern and frugal civil war origins.

Peace, indeed, was to bring a great many changes to the way in which Japan was governed. Yoshinao's deathbed instructions to Mitsutomo, his son and successor, and to his retainers (see cats. 8,9) show how the preoc-

cupations of the ruling class had already changed. Now daimyo justified their position not by how many battles they had won, or how many enemy heads they had taken, but rather by how efficient they were at the peace-time tasks of government, and how solicitous they were of the people in their care — both their samurai and the common people inhabiting their domains. In this Yoshinao, born in 1600, the year of Sekigahara, really represented the wave of the future. He had never fought in battle (although in 1615 his father had taken him along to watch part of the first siege of Osaka Castle, and the last two days of the second and final siege).[3] Consequently Yoshinao, like all the daimyo of his generation and later, had a frame of reference quite different from that of his father (or even, in his case, of his elder brothers). With the enormous pressures of warfare lifted and the need for constant vigilance gone, Yoshinao and his fellow daimyo could give more attention to the arts of government. Now, instead of soldiers with skills limited to warfare, Japan's regional overlords had need of magistrates, clerks and accountants, men with talents of a kind more fitted to a nation at peace. Yoshinao accordingly steered his samurai towards literacy and acquainted himself with the vocabulary of civilian government by turning to the model closest to hand, the Confucianism of Japan's neighbour, China.

This does not mean, however, that the rulers of Tokugawa Japan were willing to deny their military heritage. On the contrary, as warfare receded into the distance, and as generation upon generation of samurai came and went without seeing a blow struck in anger, so did the shogun, the daimyo, and their vassals cling all the more tenaciously to those objects which symbolized their right to rule. Every daimyo had his suit of armour. One of those shown here (cat. 17) was made for Tokugawa Yoshinao, who might actually have worn it and played his battle drum (cat. 20) when, as a fifteen-year-old, he sat with his father watching the fighting at Osaka. But all Yoshinao's descendants possessed suits of armour as well, and armour was still being made in the eighteenth century (cats. 16,18) when warfare had passed from living memory. By the time fighting broke out again in the nineteenth century, armour of the tradi-tional sort (cat. 19) would not have been able to withstand new weapons of war like the Minié rifle and the Gatling gun.

Swords also played an extremely important symbolic role in the life of Tokugawa Japan. The sword — several examples of which are displayed in this exhibition, together with their various accessories (cats. 24ff.) — was an important badge of rank, since only members of the samurai class were permitted to carry it. Every samurai, at some stage in his education, was coached in one of the many styles of sword-fighting then in vogue. But he would have practised with a bamboo or wooden replica, and it was most unlikely that he would ever be required to test his skill against a real oppo-nent. Nevertheless, while little used, these long swords were highly prized, and every daimyo had a collection of them. Tokugawa Yoshinao, for example, was given thirty-nine swords of various sizes by successive shoguns in the years between 1615 and 1650.[4] Obviously, this number was rather more than he needed; more, in fact, than he could keep track

---

[3] Nagoya-shi Kyōiku Iinkai (eds.), *Nagoya sōsho* (Nagoya, 1962) vol. 5, p. 5.

[4] *Ibid.*, pp. 3-25.

of, since he was obliged to hire a curator for them in 1641.[5] In a land at peace, ruled by a military class that had long since ceased to fight, where the bonds of personal loyalty linking lord and vassal had loosened with the passage of time, the sword, with its echoes of a vanished heritage, was the most potent of all symbols.

The military trappings, however, served to mask a much gentler reality. Peace was to transform the entire Tokugawa samurai class — shogun, daimyo and vassals alike — into a civil bureaucracy whose members lived in company towns (in this case Nagoya), made frequent visits to the head office in Edo, worked regular office hours and attended many committee meetings. The more active members of this bureaucracy sometimes amused themselves with such vigorous pursuits as hunting and hawking — Yoshinao himself is known to have done so on a couple of occasions[6] — but for the most part their leisure time was occupied with more sedentary diversions. The objects displayed in this exhibition testify eloquently to this propensity of the successive rulers of the Owari domain. We see an example of the work of the second Tokugawa daimyo of Owari, Tokugawa Mitsutomo (r. 1650-1693), as an artist (cat. 99) — a role in which, given his reputed fondness for wine and women,[7] he was presumably more at home than that of soldier. The ninth daimyo, Munechika (r. 1761-1799), who lived a hundred years later, was active as a *waka* poet and calligrapher (see cat. 100). Calligraphy was one of those artistic accomplishments traditionally associated with Japan's courtly and priestly classes; but it was not long before members of the military aristocracy came to take as much pride in writing a fine hand as any nobleman or priest (see cats. 137-146). An interest in the ritual and accoutrements of the tea ceremony also very quickly became the hallmark of a gentleman. Both Oda Nobunaga and Toyotomi Hideyoshi had taken pains to acquire this taste, so it is not to be wondered at that their Tokugawa successors were similarly attracted to the tea ceremony's mock rusticity (cats. 102ff.), spending large amounts of money to acquire deceptively simple and understated pots, jars and bowls from China, Korea and the modish kilns of Seto and Mino (cats. 102-104, 114, 120). An interest in tea developed especially quickly in the Owari domain, for Tokugawa Yoshinao was most decidedly an enthusiast. As early as 1617 he had added tea ceremony functionaries to his payroll, and in 1623 he employed them to entertain the shogun and over a hundred distinguished guests at a lavish three-day ceremony in Edo. Twenty years later, still as fascinated as ever by the subject, he built himself a special tea house complex at Sendagaya.[8] Music was also an abiding passion of Tokugawa Yoshinao. His interest began in 1631, when he employed thirteen musicians as his vassals,[9] and eventually led to the formation of a private troupe of Nō players capable of mounting a performance of these medieval morality plays, complete with music, masks and costumes (cats. 159-182) for the daimyo's own personal entertainment. In keeping with these tastes, the various daimyo of the Owari domain became collectors of works of art, some imported from China (cats. 110, 111, 121, 124) and others, like the paintings of the Kanō school (cats. 122, 123, 155), produced much closer to home. Collecting the calligraphy of famous fig-

[5] *Ibid.*, p. 20.

[6] *Ibid.*, pp. 11, 12, 15.

[7] Kanai Madoka (ed.), *Dokai kōshūki* (Tokyo, 1967), pp. 104-105.

[8] *Nagoya sōsho*, vol. 5, pp. 8, 10, 23; Satō Toyozō, "Shōgun no onari to cha no yu", Buke Shidan Kai (eds.), *Buke sadō no keifu* (Tokyo, 1983), pp. 171 ff.

[9] *Nagoya sōsho*, vol. 5, p. 11.

ures of the past — emperors, courtiers and priests (cats. 97, 98, 106, 107) — was yet another of the marks of the civilized ruler, and the Owari daimyo, in this as in much else, conformed very closely to the norm.

Collections such as this one were built up in every major daimyo domain, and even the smaller ones, if they could not equal the magnificence of the Owari Tokugawa holdings, went as far as their budgets would allow. The peace and security that were established under the rule of the Tokugawa shogun, allowed men like the successive daimyo of Owari — who would otherwise have been military leaders and nothing more — both the time and the resources needed to become supporters and practitioners of the arts. This was perhaps just as well, for the imperial court and the great monastic institutions were no longer able to fill this role as they once had. Both were firmly under Tokugawa control and had little discretionary income. The shogun and the daimyo, however, had the means that enabled them to assume the mantle of patrons of the arts and arbiters of taste. It is in this role, rather than that of battlefield butchers and despoilers, which under different circumstances they might so easily have adopted, that we appreciate them today — the preservers of a culture that might otherwise simply not have survived.

# The Tokugawa as Patrons and Collectors of Painting

BY
CHRISTINE GUTH

AS one of the few great art collections of the Edo period to have survived into modern times, the Tokugawa collection records the way the shogunal family helped shape and was itself shaped by taste during its two and a half centuries of rule. This collection, like those of the great ruling houses of Europe, was not assembled by an individual, but rather by successive generations of the Owari branch of the Tokugawa family. Also like its European counterparts, the collection includes many works of art acquired by marriage or gift, as well as works selected by members of the family.

Not all the heads of Owari Tokugawa were equally interested in artistic matters. Some collected acknowledged masterpieces or patronized celebrated painters because of their own personal inclinations, while others did so merely because their social position demanded it. For those with a genuine commitment, the patronage of the arts provided a measure of personal expression and freedom from the rigid demands of their administrative duties. But if art collecting received official sanction, it was less for the personal pleasure it afforded than for the cultural cachet it conferred. Aesthetic discernment was one of the means through which the Tokugawa and their feudals lords could demonstrate the personal cultivation that was expected of the ruling elite.

Although art collecting is universal, cultural factors play an important role in determining what is collected. The market for all forms of art during the Tokugawa period (1603-1868) was fueled largely by the requirements of castle decoration and the tea ceremony. The paintings most in demand were those on the sliding doors (*fusuma*) and folding screens (*byōbu*) essential to the interior decor of palatial residences, and on hanging scrolls that could be displayed in the painting alcoves of rooms where guests were received and tea ceremonies were held. Painting in formats such as the handscroll or album leaf were not totally overlooked, but works that could not serve as part of a decorative ensemble were generally considered to be of secondary importance.

## CASTLE DECORATION

The demand for screen painting was strong throughout the Tokugawa period, but especially so in its early years, as the newly empowered shoguns and their daimyo sought to create physical surroundings that symbolically reinforced their political authority. The first Tokugawa shogun, Ieyasu (1542-1616), ordered the construction of three castles: one in Edo, the shogunal headquarters, another in Nagoya, the seat of the Owari branch of the Tokugawa family, and a third, Nijō Castle, the shogun's official residence in Kyoto. The third shogun, Iemitsu (1604-1651), expanded Nijō Castle in 1624 by the addition of Ninomaru Palace. The interior decor of these castles established norms that would prevail throughout the period of Tokugawa rule.

Today, Ninomaru Palace is the best preserved of the many Tokugawa residences. Laid out in accordance with the *shoin*-style of residential architecture that had evolved in the Ashikaga period (1338-1573), the palace comprises five adjoining buildings arranged in zigzag fashion beside a large garden.[1] The three larger buildings at the front of the complex served for public audiences; the two smaller ones at the back were intended for private use. Despite differences in decor and function, each room has the distinguishing features of the *shoin*-style residence: tatami-matted floor, sliding door screens, a painting alcove, adjoining staggered shelves and built-in cabinets with decorative doors. The *fusuma*, or sliding door screens, serve as partitions that can be opened, closed or even removed altogether, so that the size of a room can be adjusted according to need. The *tokonoma*, or alcove, and the adjoining built-in shelves and cabinets are areas set aside for the display of one or more paintings and assorted *objets d'art*. In the palace's immense audience halls, the floor of the area before the alcove is raised higher than that of the rest of the room. It was here that the shogun, his presence dramatically set off by the ornately furnished *tokonoma* behind him, received official visitors.

The paintings on the *fusuma* helped to define the function of a particular chamber. Audience halls were intended to impress visitors with their owner's power and prestige, and the pictorial themes and styles adorning them were chosen accordingly. Preferred motifs included colossal trees, flora and fauna of the four seasons, stalking tigers, and paragons of virtue and loyalty from Chinese history or literature. The Main Audience Hall (Ō-hiroma) of Ninomaru Palace, for instance, features a combination of aged pines, hawks and stately peacocks. The exceedingly large scale of audience halls — Ninomaru Palace's Ō-hiroma is forty-eight tatami mats (approximately 29 by 26 metres) — dictated that painters render these themes in large scale and strong colours. To give an aura of opulence and brightness to rooms that often had little natural light, gold leaf was applied to the background of the screens. Rooms decorated in this way had a sumptuous magnificence wholly suited to their owner's exalted status (fig. 1).

As the residences of the Tokugawa generally housed an extended family and their many retainers, portable folding screens — *byōbu* — of two, six or eight panels each were used, usually in pairs, to provide privacy, prevent draughts or serve as additional backdrops for host and guest. On occasion, screens were even set up out of doors to protect women from

[1] Fumio Hashimoto, *Architecture in the Shoin Style: Japanese Feudal Residences.* Mack Horton, trans. and ed. Japan Arts Library no. 10 (Tokyo and New York: Kodansha International, 1981), pp. 118-124.

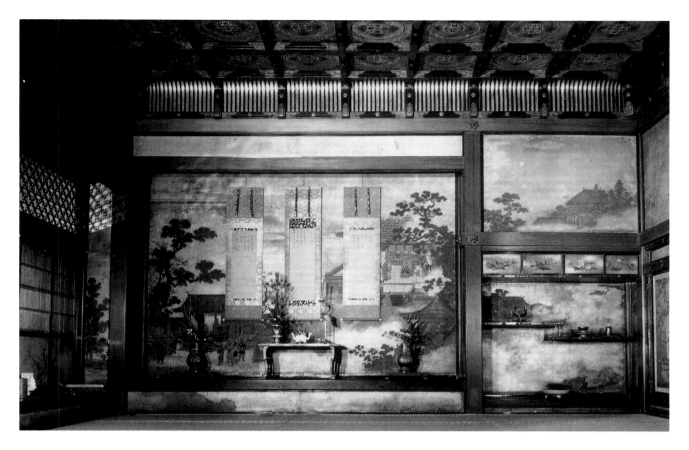

Fig. 1. View of the Shiroshoin of Nishi Hongan-ji showing the location of the *tokonoma*, staggered shelves and writing alcove.

[2] From *Hayashi Razan bunshū*, quoted in *Sources of Japanese Tradition*, Tsunoda, de Bary and Keene, comp. (New York: Columbia University Press, 1958) vol. 1, p. 347.

[3] The *Gyomotsu on'e mokuroku* is reproduced in Tani Shin'ichi, *Muromachi bijutsu-shi ron* (Tokyo: Tōkyōdō, 1942), pp. 116-142. The *Kundaikan sayū chōki* in *Gunsho ruijū*, Gunsho ruijū kankokai, comp. (Tokyo: 1937), vol. 19, pp. 648-670. For a discussion of their influence see Gail Weigl, "The Reception of Chinese Painting Models in Muromachi Japan", *Monumenta Nipponica*, vol. XXXVI, no. 3 (Autumn 1980), pp. 257-272.

sight during outings to view cherry blossoms or maple leaves. Their themes and styles, although varied, often follow those of *fusuma*. The Chinese-inspired theme of rice cultivation painted in ink monochrome by Kanō Tan'yū (1602-1674), for instance, had figured earlier on the *fusuma* of Daisen-in, a sub-temple of Kyoto's Daitokuji (cat. 155).

The choice and arrangement of paintings and other *objets d'art* in the *tokonoma* of the formal audience hall served to highlight their owner's character and aesthetic cultivation. To the extent that such a distinction is possible, one might say that the *fusuma* framing the room symbolized its owner's military might, while the arrangement in the *tokonoma* symbolized his personal intellectual and cultural authority. In the Neo-Confucian concept of government both were equally important, for as Hayashi Razan, Confucian advisor to Tokugawa Ieyasu, declared: "How can a man discharge the duties of his rank and position without combining the peaceful and military arts?"[2]

While the paintings on the *fusuma* were a permanent part of the castle's interior decor, the arrangement in the *tokonoma* could be changed according to seasonal or functional requirements. The aesthetic and decorative conventions that governed the *tokonoma* display derived from the *Gyomotsu on'e mokuroku*, an annotated catalogue of the shogunal art collection compiled by Nōami (1397-1471), and the *Kundaikan sayū chōki*, a guide to the display of paintings and other *objets d'art* compiled by Nōami and expanded by his grandson Sōami (d. 1525).[3] Nōami and Sōami had

served as cultural advisors to the Ashikaga shoguns, whom the Tokugawa took as their role models in most cultural matters.

The *Gyomotsu on'e mokuroku* was influential as a record of the paintings owned by Ashikaga shoguns and as a guide to the relative merits of the painters whose works were represented therein. The Ashikaga collection was composed principally of paintings by or in the style of Chinese masters of the twelfth and thirteenth century, especially Ma Yuan, Xia Kuei, Mu Qi and Liang Kai. Chinese and Japanese paintings featuring the themes and styles of these painters were the preferred choices for *tokonoma* display.

While the *Gyomotsu on'e mokuroku* influenced the choice of painting themes and styles, the *Kundaikan sayū chōki* dictated the way they were displayed. For Nōami and Sōami, painting was just one component of the artistic ensemble in the *tokonoma* and its adjoining shelves. They advocated arrangements that centred on a limited number of paintings, especially favouring sets of three paintings of figural themes flanked by birds or flowers. The Tokugawa collection includes several such sets (cats. 121-123). The items arranged in front of these generally included writing implements, an incense burner, a lacquer box, a flower vase and a candle holder (fig. 2). Works of Chinese origin were preferred, but Japanese copies were also acceptable. In either case, articles were chosen so as to complement or contrast with other constituents of the ensemble, and their placement was determined with overall symmetry and balance in mind. The resulting display conveyed a sense of order and tasteful harmony. This integrated approach to the selection and arrangement of diverse works of art was central to Tokugawa art patronage and collecting.

## PATRONAGE OF THE KANŌ SCHOOL

Painters of the Kanō school were the chief beneficiaries of major commissions from the Tokugawa. A hereditary line of artists that had first come into prominence during the rule of the Ashikaga shoguns, the Kanō had originally gained acclaim for their adaptation of the subtly nuanced monochrome ink painting styles and themes practised by Chinese painters of the Song and Yuan dynasties to the decorative requirements of large-scale screen painting. This process, involving simplification, clarification and magnification of pictorial motifs, as well as the addition of colour and gold, was begun by Masanobu (1434-1530) and his son Motonobu (1476-1559), and culminated under Eitoku (1543-1590) and his grandson Tan'yū. Eitoku evolved a personal idiom that had a dramatic flair and direct visual appeal particularly well suited to the life-style and character of his chief patrons, the aggressive warlords of the sixteenth century. The modes of painting favoured by their Tokugawa successors evolved largely from this Eitoku idiom. The screens in the Ō-hiroma of Ninomaru Palace — screens designed by Tan'yū — share the heroic quality but do not display the same unbridled energy that distinguishes Eitoku's compositions. Tan'yū's more restrained approach to the decoration of large wall spaces may reflect his Tokugawa patrons' preference for a more controlled and structured environment.

Tan'yū, often considered the foremost painter of the Tokugawa period, was the first Kanō artist designated *goyō-eshi*, painter-in-residence

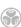

Fig. 2. *The Ornamentation of the Tokonoma*, Muromachi period, 1540, handscroll, colours on paper. Private collection, Osaka.

[4] Tsuneo Takeda, *Kanō Tan'yū. Nihon bijutsu kaiga zenshū*, vol. 15 (Tokyo: Shueisha, 1978), p. 101.

[5] The three branches are the Kobikichō, descended from Tan'yū's brother Naonobu (1607-1650) and his son Tsunenobu (1636-1717); the Nakabashi, descended from his brother Yasunobu (1613-1685); and the Hamachō, descended from Munenobu, the second son of Tsunenobu. On the development of the Edo Kanō, see Konō Motoaki, "Edo Kanō zatsu-ko", (Studies on the Edo Kanō) *Kobijutsu*, no. 71 (July 1984), pp. 4-35 and Hosono Masanobu, *Edo no Kanō-ha. Nihon no bijutsu*, no. 262 (Tokyo: Shibundo, 1988).

[6] Takeda, *op. cit.*, pp. 102-106.

to the shogun. He received this appointment in 1617, when he was only fifteen years old by Japanese count. Four years later he established an atelier in Edo at the site of the residence bestowed upon him by the shogun.[4] Its success later prompted the setting up of three other branches of the Kanō school in the shogunal capital.[5] Still other branches flourished in Kyoto, as well as in the feudal domains of powerful daimyo. By disseminating the themes and styles of painting endorsed by the ruling elite throughout the country, Kanō painters symbolically reinforced the Tokugawa's authority over the nation.

The duties of the painter-in-residence to the shogun were extremely wide-ranging. While he was free to take on outside commissions, his chief duty was the design and execution of the large cycles of paintings required as part of the interior decor of the residences, temples and shrines belonging to or patronized by the Tokugawa. Tan'yū's activities alone give some idea of the scope of this work. In addition to Nijō Palace, he directed the decoration of the main palace of Edo Castle, the main palace of Osaka Castle, the Jōraku Palace of Nagoya Castle (fig. 3), the Tokugawa Mausoleum at Nikkō, and the Kyoto Imperial Palace.[6] Since such projects were too large and time-consuming to undertake alone, the *goyō-eshi* employed numerous assistants. Generally, the master himself only laid out the composition and painted the central motifs, leaving the rest for the members of his workshop. The efficient organization of the Kanō workshop was an important factor both in its rise and its pre-eminence throughout the Tokugawa period.

The *goyō-eshi* was of necessity master of many themes and styles. He might be required to paint religious icons for use in his patrons' private chapels or portraits of deceased Tokugawa leaders for use in the family's ancestral shrines. The portrait of Ieyasu, seated god-like on a platform in a

Shinto shrine, exhibits the characteristics of this formal class of portraiture (cat. 1). He might also be required to paint screens depicting the horses or hawks that were a source of great pride among the Tokugawa and their daimyo (cats. 79, 80). Like the depictions of people, these animal portraits are not based on personal observation and tend to be highly conventionalized. Or he might even be required to supply the armourers or lacquerers also retained by the Tokugawa with pictorial designs for decorative sword guards, lacquered writing boxes and the like.

The goyō-eshi also served as official connoisseur and authenticator of paintings. Of the many painters-in-residence to the Tokugawa shoguns, Tan'yū was the most gifted and influential in this domain. Although he did not compile an annotated catalogue of his patrons' collections, as Nōami and Sōami had done, he did leave quantities of sketches and notes on the paintings he had the opportunity to study. On occasion, he saw as many as ninety paintings belonging to various collectors in a single day. His notes and sketches provide a wealth of information about the kinds of painting in favour in the early seventeenth century and about the criteria used in evaluating their relative merits; they include the names and seals of Chinese and Japanese artists, inscriptions, the identities of collectors and even the prices paid.[7] In an age when all major works of art were either in temples or in private collections, the goyō-eshi was among the few individuals who could examine a range of paintings sufficiently large to enable him to develop the combination of intuition and skill essential to connoisseurship.

Still another duty of the goyō-eshi was that of serving as painting teacher to the shogun and his family. Painting, together with calligraphy, music and poetry, was one of the artistic accomplishments expected of all educated men. Since the education of the samurai class consisted chiefly in the study of the Confucian classics and other writings of Chinese origin, their preferred pictorial themes and styles tended to reflect this Chinese bias. Their Kanō teachers, who increasingly considered themselves the guardians of the Chinese tradition of painting in Japan, reinforced this sinocentrism. Both Yoshinao and his son Mitsutomo, the first and second lords of Owari, are thought to have studied under Tan'yū. Like all painting students they began by copying the works of the great masters: Mitsutomo's *Dancing Hotei* (cat. 99) was copied from a painting by Liang Kai that was then in the family collection.

The leading artists of the Kanō school exerted an artistic influence and enjoyed a social status and financial security shared by few other painters of the Tokugawa period. Because of the large number, geographic distribution and official nature of their decorative projects, their themes and styles became the standard for other painters. The Kanō were in many respects the Japanese counterparts of the academic painters of Europe: their workshops were bastions of time-honoured, conservative painting styles, where many gifted painters who went on to found their own studios were first trained. Like their European counterparts, also, the Kanō school had many critics, particularly among Bunjin school artists promoting more recently imported Chinese-inspired styles that threatened Kanō authority. The Kanō's association with the Tokugawa government, however,

[7] Rosenfield and Shimada, *Traditions of Japanese Art* (Cambridge, Mass.: Fogg Art Museum, 1970), p. 200 and *Tan'yū shukuzu* (Tanyū's Sketches) Kyoto National Museum, comp. (Kyoto, 1982).

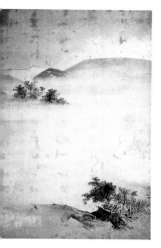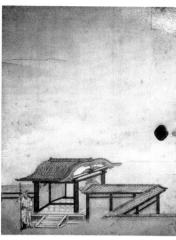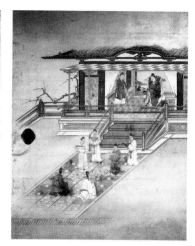

Fig. 3. Kanō Tan'yū, *Exemplary Emperors*, Edo period, 1634, set of four sliding door panels, ink, colours and gold leaf on paper. Nagoya City, Aichi Prefecture.

guaranteed their authority even after creative artistic leadership had passed to other hands.

PATRONAGE OF OTHER SCHOOLS

Although their taste was overwhelmingly sinocentric, the Tokugawa also patronized artists who specialized in Yamato-e style painting. Yamato-e originally referred to paintings of Japanese themes popular among courtiers of the Heian period (794-1192), but by the Tokugawa period the term had also come to denote a highly conventionalized pictorial style using thick, bright mineral pigments and gold and silver accents. Artists of the Tosa and Sumiyoshi schools were its foremost exponents. The Tosa school had first gained prominence in the fourteenth century when its leading members were named painters-in-residence to the Imperial family (*edokoro azukari*). They lost this hereditary post during the turbulence of the sixteenth century, but Tosa Mitsuoki (1617-1691) regained it in 1654. The Sumiyoshi school was an offshoot of the Tosa formed by Sumiyoshi Hirozumi, also known as Gukei (1631-1705). In 1662 Gukei was appointed the first Sumiyoshi school *goyō-eshi*, which entailed duties related to the shogun and his family analogous to those of his Kanō counterpart.[8]

While the demands of their imperial patrons had initially led Tosa artists to emphasize themes and styles associated with the Heian court, during the sixteenth century they had begun to expand their pictorial repertoire, styles and formats to suit the tastes of a more diversified clientele. So intense was competition for patronage during this unsettled period that, in a process similar to that undergone by the Kanō school, Tosa artists developed a new style that fused the aesthetic traditions of Japan and China. A pair of screens by Tosa Mitsuoki depicting Matsushima and Itsukushima, two Japanese landmarks celebrated in the painting and poetry of the Heian period, is typical of this Tosa synthesis (cat. 154).

Tosa and Sumiyoshi painters often painted *byōbu*, but rarely *fusuma*, since the painting style at which they excelled was ill-suited to the decoration of large rooms. Their minute, stylized figures set against richly orna-

[8] For background on Gukei see Sakakibara Satoru, "Sumiyoshi Gukei kenkyū noto, — Empō nana-nen Genzan Daishi engi-e seisaku o megutte" (Research Notes on Sumiyoshi Gukei — Centering on the Creation of the Genzan Daishi Scroll of 1679), *Kobijutsu* no. 73 (January 1985), pp. 29-46.

mented architectural backdrops painted in lush mineral pigments with gold and silver highlights were best appreciated in the form of albums and handscrolls that could be examined at close range. Their treatment of courtly literary themes, such as the *Tale of Genji*, in these formats was especially admired.[9] Since such works were thought to be appropriate reading for women, albums with delicate yet sumptuously painted illustrations of the *Tale of Genji* were often included as part of a trousseau. So, too, were narrative handscrolls with illustrations in the Tosa style, such as *Bunshō zōshi*, a popular tale of social ascent and prosperity achieved through marriage (cat. 156).

While albums and handscrolls could be arranged as part of an ensemble on the staggered shelves of the *tokonoma*, they were not seen to their best advantage in this way. Consequently, works in these traditional formats were commissioned by the Tokugawa chiefly for their personal enjoyment, for instructing children, for entertaining women or for use in temples and shrines. Unlike paintings that fulfilled a recognized public function, called *omote-dōgu* (official possessions), these paintings, called *oku-dōgu* (private articles), remained part of the private world of the ruling elite.[10]

Their status as official painters gave the Tosa and Sumiyoshi, like their Kanō counterparts, considerable economic security and social prestige. But they, too, soon became guardians of tradition rather than innovators, and their themes and styles were often borrowed by other painters. The time-honoured Yamato-e themes and styles, of which the Tosa were the official exponents, were often treated in more innovative ways by painters of the Kyoto-based Rimpa school. Since artists of the Rimpa school were culturally and politically allied with the aristocracy and the merchant class, they tended to be viewed with suspicion and were little patronized by the Tokugawa.

The school founded by Maruyama Ōkyo (1733-1795), one of the first Japanese painters to experiment with Western-style chiaroscuro and one-point perspective, was also little patronized by the Tokugawa. Ōkyo's chief supporters were the courtiers and wealthy merchants of Kyoto.[11] The Tokugawa collection, however, does include two notable examples of his work: a set of two handscrolls illustrating *Pastimes and Observances of the Four Seasons* and a pair of screens of *Pine Trees by the Sea* (cat. 153). The handscrolls were presented to the Owari Tokugawa by the Kujō, a prominent Kyoto court family, but it is not known how the screens entered the collection.[12]

## PAINTING AND THE TEA CEREMONY

During the rule of the Tokugawa shoguns, the Japanese tea ceremony, *cha-no-yu*, became a part of official protocol when guests were received. *Cha-no-yu* strengthened the personal ties between the shogun and his feudal lords while allowing each participant to demonstrate the personal taste and aesthetic refinement expected of the ruling elite. Competition to acquire the precious tewares that were its material symbols was intense. Since mastery of tea etiquette was a social necessity, the shoguns and daimyo retained tea masters to instruct them in the proper performance of

[9] There is a fine example of such an album by Tosa Mitsunori (1583-1638) in the Tokugawa collection. See *The Shogun Age Exhibition*, The Shogun Age Exhibition Executive Committee, comp. (Nagoya: The Tokugawa Art Museum, 1983), cat. 204, pp. 202-203.

[10] *Ibid.*, p. 28.

[11] Sasaki Jōhei, *Maruyama Ōkyo and the Maruyama-Shijō School of Japanese Painting* (St. Louis: St. Louis Art Museum, 1980), p. 48.

[12] *The Shogun Age Exhibition*, cat. 296, pp. 208-209.

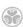

cha-no-yu and to guide them in their selection of tea utensils and other required works of art. The selection of the hanging scroll that served as the centrepiece in the *tokonoma* arrangement was especially important.

The works of art required for the tea ceremony were, of course, valued for their inherent aesthetic attractions. In addition, because of the importance of the tea ceremony among the Tokugawa and daimyo, as well as among courtiers and wealthy merchants, they were valued as portable assets. Their small size and the ease with which they could be converted into cash made them valuable possessions that could serve as rewards, tributary gifts and — in an emergency such as a crop failure — even as collateral for loans.[13] Articles used in *cha-no-yu* were also treasured heirlooms. Many of the finest tea utensils and paintings in the Owari Tokugawa collection were bequeathed to Yoshinao by his father Ieyasu. The *Sumpu Onwakemono-chō*, exhibited here, lists the works of art included in Yoshinao's inheritance (cat. 7).

While the decoration of castles and palaces promoted the patronage of contemporary painters, the tea ceremony tended to promote the collection of paintings and calligraphy from earlier periods. Paintings that did not call too much attention to themselves and thus contributed to the overall effect of the *tokonoma* arrangement were preferred. Suitable painting themes included birds and flowers or revered personalities from the Zen Buddhist tradition. Only works in ink monochrome or in ink with the addition of light colours were acceptable. Yamato-e paintings in bright colours or polychrome Buddhist and Shinto devotional paintings were considered inappropriate.

The choice of paintings for the tea ceremony was not determined solely by aesthetic considerations, however. Pedigree and personal connections also entered into the equation. Chinese paintings of the Song and Yuan dynasties from the celebrated Ashikaga collections of Yoshimasa and Yoshimitsu were especially coveted. The Owari Tokugawa inherited a number of works listed in the *Gyomotsu on'e mokuroku* or known to have been in the shogunal collection due to the presence of seals reading "Dōyū" or "Tensan", affixed to them by their Ashikaga owners (cat. 121). The most famous of these — possibly among the most influential of all Chinese paintings in Japan — were pictures from the two series of "Eight Views of the Xiao and Xiang Rivers" painted in muted ink washes by Zen monks Mu Qi and Yu chien (cat. 110).

As part of their effort to imbue *cha-no-yu* with the spiritual values of Zen Buddhism and to encourage the use of Japanese rather than Chinese works of art, tea masters beginning with Murata Jukō (1422-1502) had promoted the display of paintings by amateur Japanese Zen monk artists. A work by Jukō's own Zen teacher, the Daitokuji monk Ikkyū (1391-1481), is included in the present exhibition (cat. 113). Monochrome ink paintings by monk painters of the Muromachi period whose styles were based on those of Mu Qi, Liang Kai and other painters of the Southern Song and Yuan dynasties were especially favoured.

Jukō also set the precedent for the display of hanging scrolls featuring calligraphy rather than painting. This trend in *tokonoma* display was further encouraged by tea master Sen no Rikyū (1522-1591), who thought

[13] The devastating crop failure of the Temmei era (1781-1788), for instance, saw a dramatic rise in the market for teawares. The noted tea aficionado and able administrator Matsudaira Fūmai, ninth son of shogun Ieshige, acquired many treasures at this time. See Oda Eiichi, "Chadōgu-sho no seiritsu", (The Rise of Teaware Merchants), in *Chadō shukin*, vol. 5, *Chanoyu no hatten* (Tokyo: Shogakukan, 1985), pp. 246-247.

49

the spiritual content and aesthetic directness of calligraphy most expressive of the essence of the austere form of tea he promoted. As a result of this twin impetus, by the opening years of the Tokugawa regime, *bokuseki* — literally "ink traces" — by both Chinese and Japanese monks had outstripped painting in popularity among many aficionados.[14] Calligraphic scrolls by Xutang Zhiyu and Yishan Yining (Kidō Chigu and Ichizan Ichinei in Japanese) in the present exhibition are representative examples of *bokuseki* (cats. 108, 106).

In keeping with the general tendency towards codification of existing practices that marked the official culture of the Tokugawa, tea masters retained by the shoguns and daimyo tended to be less creative and innovative than their predecessors. Kobori Enshū (1579-1647), tea master to Tokugawa Iemitsu, was a rare exception. His personal flair, artistic taste and connoisseurship have had a lasting impact on the patterns of collecting and display in the tea ceremony.[15] It was through his influence that paintings featuring Japanese themes, such as the Thirty-six Immortal Poets, and Japanese *waka* poetry inscribed by Japanese courtiers first came to be displayed in the tearooms of the ruling elite. The fragment of the *Ogura hyakunin isshu*, an early thirteenth-century compilation of verse by one hundred aristocratic poets, is but one of many examples of calligraphy in the Tokugawa collection that exemplify the courtly aesthetic fostered by Enshū (cat. 107). The poem, now mounted as a hanging scroll, is inscribed on a multi-coloured square of paper decorated with bits of cut silver leaf in the angular style originated by Fujiwara no Teika (1162-1241), the court calligrapher most admired by Enshū. While *bokuseki* featured pithy sayings or inspirational verse inscribed in Chinese characters alone, Japanese poetry displayed in the tearoom often treated the seasons, love or other secular themes and was written in a combination of Chinese characters and Japanese *kana* syllabary.

The requirements of the tea ceremony have had a profound impact on the form in which paintings in the Tokugawa and other traditional collections have been preserved. Art collecting by the ruling elite was sanctioned chiefly because it had a recognized social function, and since only paintings and calligraphy that could be accommodated in the *tokonoma* could fulfil that function, suitable handscrolls, album leaves and fans were often cut and remounted as hanging scrolls. The Tokugawa collection's two pictures from the series "Eight Views of the Xiao and Xiang Rivers", for instance, were originally sections of handscrolls.[16] Even calligraphy was not exempt from this practice. The writings of eminent Chinese monks and poetry compilations by Japanese courtiers were in such demand that long scrolls were cut into many small sections — sometimes with the result that their original meaning was distorted or lost altogether. Conversely, since the subjects and styles of old narrative handscrolls in the Yamato-e style, such as the Tokugawa's treasured twelfth-century *Tale of Genji* scroll, were unsuitable for the tea ceremony, they remained in their original form (fig. 4).

The patterns of patronage and collecting of the Tokugawa rulers testify to a fundamental characteristic of the Japanese aesthetic outlook that

[14] Nagashima Fukutaro, "Word Versus Picture: Trends in Tokonoma Display", *Chanoyu Quarterly*, no. 35 (1983), p. 8.

[15] On the characteristics of Enshū's taste see Hayashiya Seizo, "Kobori Enshū's Chanoyu", in *Chanoyū Quarterly*, no. 44 (1985), pp. 38-40.

[16] Painter Hasegawa Tōhaku (d. 1610) relates that a scroll of the "Eight Views of the Xiao and Xiang Rivers" was cut and remounted at the order of Ashikaga Yoshimasa. Since the Ashikaga owned both Mu Qi's and Yu chien's versions, it is not clear which one is being referred to. See *Tōhaku gasetsu* (Notes on Painting), Minamoto Toyomune, ed. (Kyoto: Wakō shuppansha, 1963), p. 7.

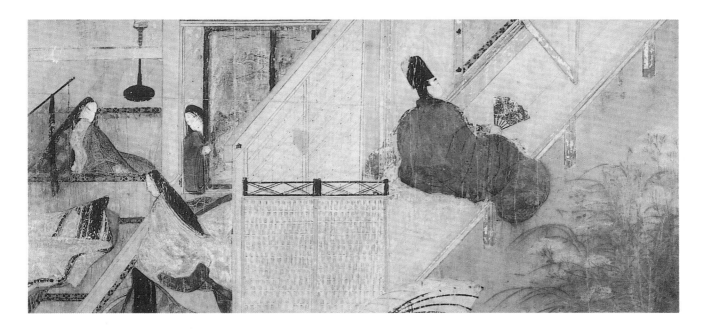

Fig. 4. *Tale of Genji*, Chapter 50, "Azumaya", section II, late Heian period, 12th century, segment of a scroll painting now mounted as separate sheets, colours on paper. Tokugawa Art Museum, Nagoya.

is apt to be forgotten when their treasures are viewed in a museum. In Tokugawa Japan, where decorative and social functions were determining factors in painting appreciation, patrons and collectors tended to have a more integrated approach to the arts than their Western counterparts. They did not distinguish between the "fine" arts of painting and calligraphy and "decorative" or "applied" arts of ceramics and lacquer. In Japan, all works of art that could be incorporated into a harmonious artistic ensemble were equally valued. The influence of that outlook endures even today.

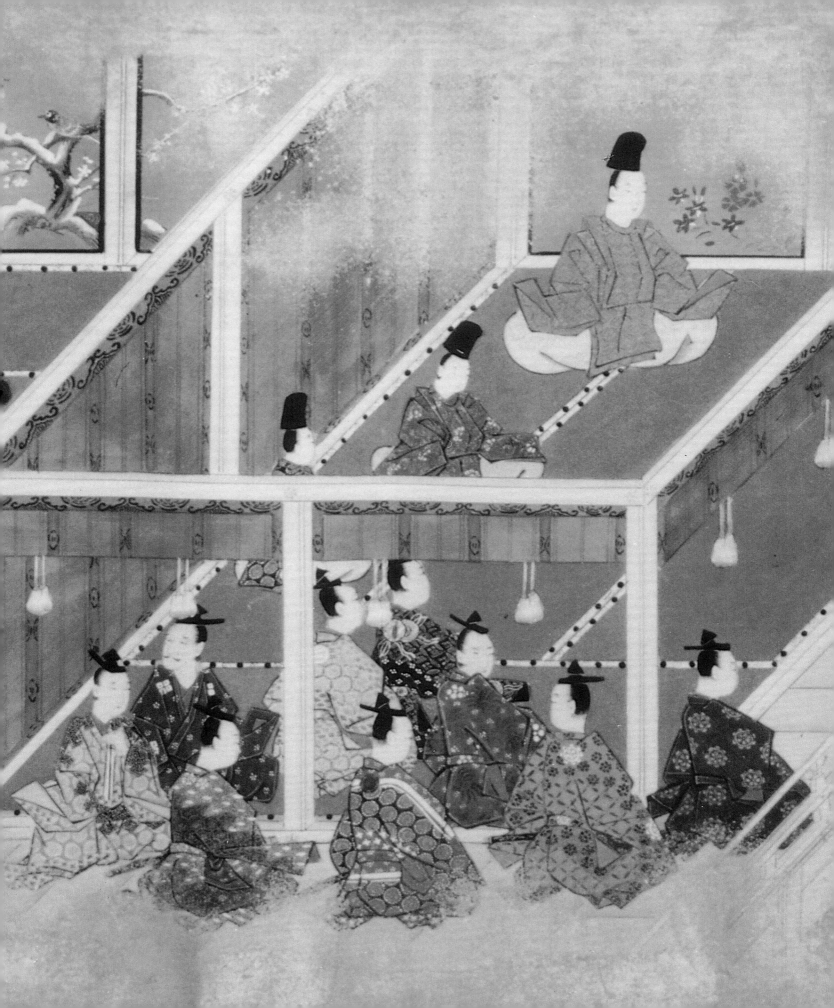

# Textiles and the Nō Theatre: Private Language, Public Statement

BY
ANNE NISHIMURA MORSE

THE Irish playwright and poet William Butler Yeats (1865-1939) was one of the first Westerners to appreciate the Japanese Nō theatre, a theatre characterized by extreme simplicity and understatement. Commenting on his intention to transform the Irish theatre of his day, Yeats wrote, "With the help of these plays 'translated by Ernest Fenollosa and finished by Ezra Pound' I have invented a form of drama, distinguished, indirect and symbolic, and having no need of mob or press to pay its way — an aristocratic form".[1]

Although the narrow appeal of the drama to "a score of people of good taste" attracted Yeats, Nō, as the theatre of the cognoscenti, is inaccessible to most Westerners and remote to many contemporary Japanese.[2] Nō is simple in its dramatic structure, which focuses on the separate entrances of the secondary (*waki*) and main (*shite*) actors, and on the ensuing dialogue and dance that reveal the central theme of the work. It is also minimalist in its cypress-bark roofed stage and painted pine tree backdrop. The essence of Nō is manifested in the multiplicity of poetic images in the texts, the studied movements of its actors and the careful selection of its masks and costumes. To the uninitiated these elements are similar to a private language, a language whose meaning cannot be comprehended, but whose beauty can nonetheless be appreciated simply for the sonority of its sounds.[3]

## THE DEVELOPMENT OF THE NŌ THEATRE AND ITS RELATIONSHIP TO ITS AUDIENCE

From the mid-seventeenth century until the dissolution in 1868 of the Tokugawa *bakufu*, or military government, Nō was the almost exclusive domain of the military class. Declared an official state ceremony by the shogunate in 1615, Nō became an essential part of important receptions hosted by the shogun and his retainers. Except in the case of occasional subscription performances designed to raise funds for public projects, commoners were strictly prohibited from attending the Nō theatre. Within this sequestered environment, a shared understanding of its allusions was a basic element in the development of Nō.[4] In its early history, however, Nō was a much more public theatre.

[1] William Butler Yeats, "Introduction to *Certain Noble Plays of Japan* by Pound and Fenollosa", in *The Classic Noh Theatre of Japan*, Ezra Pound and Ernest Fenollosa, eds. (New York: New Directions, 1959), pp. 151-152. Ernest Fenollosa, the one-time Curator of Japanese Art at the Museum of Fine Arts, Boston, and Imperial Commissioner for Fine Arts in Japan, studied Nō under Umewaka Minoru, the man credited with reviving Nō in the nineteenth century. Following Fenollosa's death, his widow approached Ezra Pound to complete a manuscript Fenollosa had begun on the theatre and a translation of some of the plays.

[2] *Ibid.*

[3] Unlike the term as used by Ludwig Wittgenstein in his *Philosophical Investigations*, where he draws the conclusion that a private language, in being intelligible only to the user, is no language at all, "private language" is used in this essay to denote a language that is understood by a select few.

[4] Ezra Pound, like Yeats, was also impressed that Nō was an aristocratic form. He wrote in his own book, "The art of allusion or this love of allusion in art, is at the root of Noh. These plays, or eclogues, were made only for the few; for the nobles; for those trained to catch the allusion".

[5] "When the Senior Grand Empress watched, a procession of fifty or sixty pretty young girls filed past, dressed in white hats and snow-white garments called skirt-trousers, with their teeth dyed jet-black and their lips red with rouge... Then a field music troupe of some ten jolly, cocky fellows came walking along. One of them carried an odd drum tied to his waist, another blew a flute, another rubbed a whisk. Others performed various kinds of dance movements, and still others — strange looking fellows — were singing songs... When the workers had assembled at the field, they busied themselves with the planting. The distinguished spectators found their actions most entertaining. The field music performers had seemed subdued during the procession, but now they apparently felt quite at home, shouting and playing with amusing gusto... By that time a great many spectators were standing about — people who had somehow heard of the affair and assembled." William H. and Helen Craig McCullough, trans., A Tale of Flowering Fortunes, vol. II (Stanford: Stanford University Press, 1980), pp. 589-592.

[6] Jacob Raz, Audience and Actors: A Study of their Interaction in the Japanese Traditional Theatre (Leiden: E. J. Brill, 1983), p. 47.

[7] Ibid., p. 48.

[8] "Around that time in the capital, men made much of the dance called field music, and high or low there was none that did not seek after it eagerly. Hearing of this the Sagami lay monk [Takatoki] called down the New Troupe and the Original Troupe to Kamakura, where he amused himself with them day and night and morning and evening, with no other thought in his mind." Helen Craig McCullough, trans., The Taiheiki: A Chronicle of Medieval Japan (New York: Columbia University Press, 1959), p. 131.

The refined Nō theatre we are familiar with today did not emerge until the fourteenth and fifteenth centuries. Its forerunners were street entertainments (sarugaku) and agricultural festivities (dengaku). Although the origins of dengaku are obscure, the form appears to have developed from rice-planting rituals. Gradually, however, spectators came to watch dengaku as an entertainment rather than participate in it as a ceremony. The eleventh-century Eiga monogatari (A Tale of Flowering Fortunes), which chronicles Japanese aristocratic life during the Heian period (794-1192), provides an account of contemporary dengaku performances in which musical troupes accompanied the workers as they planted rice.[5] Sarugaku evolved from acrobatic performances, magic shows and juggling, which had been introduced from China by the eighth century. Spectators from all classes came to view such street performances, which in the Heian period also incorporated puppet-shows and comical plays that often satirized officials and priests.[6] In the diary of Fujiwara Munetada (1032-1114), entitled the Chūyuki, the author relates that warriors, doctors, priests and even courtesans came to see the performances.[7]

The popularity of such performances in the Heian capital (modern-day Kyoto) meant that dengaku gradually took on some of the sophistication of the city. Furthermore, since dengaku was heavily influenced by sarugaku, it is often difficult to determine what differentiated the two during the late Heian and early Kamakura periods. Edo period copies of the twelfth-century Nenjū gyōji emaki (Picture Scrolls of Annual Rites and Ceremonies) illustrate a dengaku performance in the precincts of an unidentified Shinto shrine (fig. 1). Within the grounds of the shrine, demarcated by a low wall and a torii gate, sits an unruly audience of people from all stations in life. The orchestra of drum players is situated at the lower left, and two actors engaged in knife juggling can be seen at the centre.

During the early fourteenth century, dengaku and sarugaku came to be strongly associated with the military aristocracy. Hōjō Takatoki (1303-1333), the last of the military leaders who had assumed control of the Kamakura shogunate, was famed for his excessive patronage of dengaku, and his fervour for the performances was often blamed for his loss of political authority.[8] However, it was the patronage by Ashikaga Yoshimitsu (1358-1408) — a powerful member of the succeeding line of military rulers and a famed aesthete — of the sarugaku performers Kan'ami (1333-1384) and Zeami (1363-1443) that had the greatest influence on the development of Nō as a theatre of the elite and that solidified its close relationship with the military.

The Ashikaga shogunate moved the centre of political authority from the provincial town of Kamakura back to the seat of the imperial family in Kyoto, thus increasing awareness of the cultural pursuits of the court. Yoshimitsu, not wishing to be overshadowed by the sophistication of the hereditary aristocracy, became a grand patron of the arts. During the Kitayama era (1392-1408), named after the site of his splendid residential compound in northwestern Kyoto (of which only the Golden Pavilion remains today), Yoshimitsu was at the peak of his power. His collection of costly ceramics, brocades and paintings was lavishly displayed at this

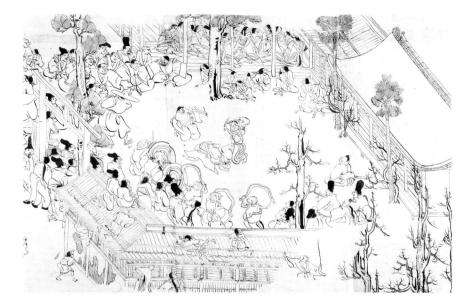

Fig. 1. *Nenjū gyōji emaki* (Picture Scrolls of Annual Rites and Ceremonies). Japan, Edo period, 17th century, copy of a 13th-century handscroll, ink on paper. Tanaka Collection, Tokyo.

[9] P. G. O'Neill in his book, *Early Nō Drama: Its Background, Character, and Development 1300-1450* (London: Lund Humphries, 1958) discusses the use of the terminology. "The word Nō as it is now used is an abbreviation of Sarugaku Nō and signifies a performance of Nō plays, songs, and dances by Sarugaku players. In the Kamakura... and Muromachi periods, performances of Nō were given in several different types of entertainment and it was usual, therefore, to distingush them by describing them as Ennen Nō, Dengaku Nō, etc. But, during the Muromachi period, the Nō performed by Sarugaku groups achieved such overwhelming superiority and popularity that its rival forms gradually disappeared and it became less and less necessary to specify Nō performances as those of Sarugaku."

[10] For a detailed study of Zeami's theories on the relationship between actor and audience consult Jacob Raz, "The Actor and his Audience: Zeami's Views on the Audience of the Nō", *Monumenta Nipponica*, vol. XXXI, no. 3 (Autumn, 1976), pp. 251-274.

[11] Ryusaku Tsunoda, William Theodore de Bary, *et al.*, eds., *Sources of Japanese Tradition*, vol. 1 (New York: Columbia University Press, 1958), p. 278.

[12] *Ibid.*, p. 283.

domain; and it was into this world that Zeami and his father Kan'ami were introduced after Yoshimitsu had become enthralled with the young actor upon watching him, in 1374, in a *sarugaku* performance at the Imakumano Shrine in Kyoto.

Kan'ami was a celebrated *sarugaku* performer and led his own troupe. The appeal of his performances derived from his ability to integrate refined *dengaku* practices with those of *sarugaku*, his adoption of a technique of dancing to narration known as *kusemai*, and the vitality of his style, developed while acting before large audiences in shrines and temples throughout Japan. Zeami, however, was brought up in the court of the military aristocracy from the time of his first encounter with the shogun, and it was to the tastes of this class that he directed his practice of *sarugaku*, later to become known as *sarugaku* Nō, or simply Nō.[9] Zeami had a highly theoretical approach to the Nō theatre and authored numerous treatises on the training of actors, the proper movements in a performance and the relationship between the actor and his audience.[10] He wrote repeatedly in these treatises about the necessity of satisfying the tastes of the aristocracy.

One of the most important ideals of Zeami's Nō was the attainment of *yūgen*. The indigenous Japanese aesthetic concept of *yūgen* is difficult to define. The term has been characterized by some as "the word used to describe the profound, remote and mysterious, those things which cannot easily be grasped or expressed in words".[11] In discussing *yūgen*, Zeami himself wrote "the *yūgen* of discourse lies in a grace of language and a complete mastery of the speech of the nobility and gentry, so that even the most casual utterance will be graceful".[12] The symbolism and understatement advocated by Zeami in his treatises — a response to the aesthetic world of the nobility — contrast starkly with the contemporary Nō performances of another playwright-actor, Miyamasu (active late 14th-early 15th centuries). Unlike Zeami, Miyamasu continued to perform for the common people, and the language he used was the colloquial speech of his audience. Furthermore, his plays were often dramatic spectacles designed

to capture the imagination of his uneducated spectators.[13] It was the Nō of Zeami, however, as perpetuated by his Kanze school and patronized by the military elite, that determined much of the subsequent development of this dramatic form.

During the sixteenth century, Nō attained an even higher degree of support from the military aristocracy. Following the fall of the Ashikaga shogunate and the rise of feuding warlords, the Kanze and other troupes turned to the local lords for patronage. Two of the most powerful clans vying for military supremacy at the time, the Mōri family in Chōshū (modern-day Yamaguchi Prefecture) and the Maeda family in Kaga (modern-day Ishikawa Prefecture), were particularly enthusiastic supporters. Toyotomi Hideyoshi (1536-1598), a general who was largely instrumental in unifying Japan, was also one of the most avid patrons and performers of Nō. During his ascendancy, Nō came to be particularly associated with events of extreme political significance. In 1593, while awaiting the commencement of the invasion of Korea, Hideyoshi memorized over ten Nō roles. Later that year, during a three-day celebration of the long-awaited birth of a son and heir, he performed in numerous plays at the Imperial Palace. Participating with Hideyoshi in at least one of those plays was his general, Tokugawa Ieyasu (1542-1616).

An event of even greater political significance is documented in a screen in the Kōbe City Museum of Namban Art (fig. 2). The painting shows a Nō performance commemorating the official visit of the Emperor Go-Yōzei in 1588 to Hideyoshi's palace, Jurakutei.[14] This visit, for which Hideyoshi made preparations for many months, conferred a particular legitimacy to his military authority. In the right section of the screen, an actor accompanied by an orchestra performs on a temporary stage. Seated behind curtains inside the building is the emperor with his retinue of court women, and on the veranda Hideyoshi holding a fan, can be seen surrounded by his retainers.

Upon Hideyoshi's death in 1598 and the defeat of the Toyotomi clan by the Tokugawa, Ieyasu established his government in Edo (modern-day Tokyo), which was to remain the seat of military power for almost two hundred and fifty years. In order to promote peace in the previously wartorn country and to guarantee the effective administration of fiefdoms dominated by rival military families, the Tokugawa initiated a system of alternate attendance in Edo and promulgated legislation that strictly controlled social relationships. Strongly influenced by Confucian ideals, the Tokugawa divided society into four classes: the military, the farmers, the artisans and the merchants. Sumptuary legislation was also enacted to ensure that each class would remain in its station and that the military elite would retain the visible symbols of wealth and power that were considered their prerogative. One of these symbols was the Nō drama.

The Chinese had for centuries believed that the moral integrity of the emperor and his correct performance of certain rituals reinforced his legitimacy.[15] The Tokugawa too established their own rituals to strengthen the position of the shogun as the head of a Confucian-based government. Nō became one of the most important of such rituals and functioned as an official ceremony of the regime. As early as 1607, even before the

[13] Laurence Kominz, "Nō as Popular Theater", *Monumenta Nipponica*, vol. XXXIII, no. 4 (Winter, 1978), p. 444.

[14] Hiroshi Ozawa states that the screen probably documents the visit by Go-Yōzei in 1588, but it could also depict the visit in 1592. *Fuzokuga: matsuri, kabuki*, vol. 13 of *Nihon byōbu-e shūsei* (Tokyo: Kodansha, 1978), p. 101.

[15] For a detailed account of these rituals see Howard J. Wechsler, *Offerings of Jade and Silk: Ritual and Symbol in the Legitimization of the T'ang Dynasty* (New Haven: Yale University Press, 1985).

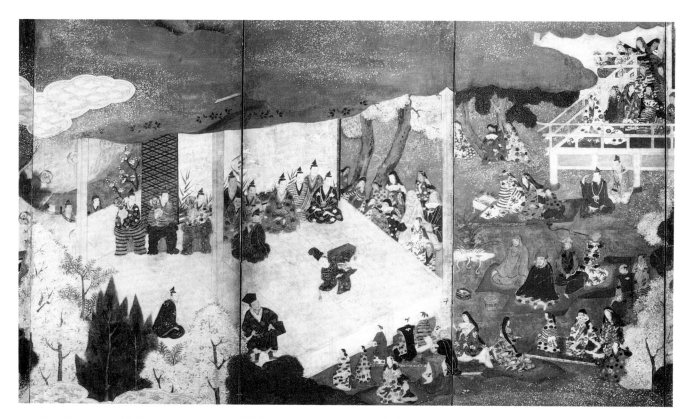

Fig. 2. *Viewing the Nō Theatre*. Japan, Edo period, 17th century, eight-panel screen, ink, colour and gold on paper. Kōbe City Museum of Namban Art.

Tokugawa had solidified their control over the country, they instituted a yearly performance of Nō that took place on the second, third and fourth days of the New Year and that the daimyo were required to attend.[16] Donald Keene points out in his excellent introduction to the Nō theatre, that "the gravity and stately movements of Nō" made the dramatic form ideal for expressing "the decorum imposed by the Confucian code".[17]

The enactment of the drama according to prescribed patterns was in consonance with Chinese ideas about the performance of rituals of state. The legitimacy of the Chinese emperor depended on the correctness of his movements, for they were thought to affect the order of the cosmos. Likewise, Nō actors who failed to act correctly were often subjected to severe punishment, even forced to commit ritual suicide, for it was believed that faults in the performances could lead to national calamities.[18] Due to the increasing institutionalization of the drama, Nō performances followed a set order and were rarely modified. As already mentioned, the use of the drama as a court ritual meant that Nō was always acted before a select audience that rarely, if ever, included commoners. As a result, Nō was no longer subject to the prevailing tastes of an open audience; and since Nō had become a private ceremony, dramatic appeal and colloquial dialogue were no longer of any concern.

## THE HISTORICAL DEVELOPMENT OF NŌ COSTUMES
Most theatrical costumes reflect the period in which they were made and used. Even costumes for supposed historical dramas make references to the period portrayed only in a generalized way, using symbols that are widely

[16] Hyobu Nishimura, *Mori ke denrai ishō*, vol. 3 of *Nihon dentō ishō* (Tokyo: Kodansha International, 1968), p. 5.

[17] Donald Keene, *Nō: The Classical Theatre of Japan* (Tokyo: Kodansha International, 1966), p. 46.

[18] *Ibid.*, p. 48.

understood as representing previous eras. Stella Mary Newton, in her book on Renaissance theatre costume, has termed these symbols a type of "visual language shared by the designer and the audience".[19] The development of Nō costumes, however, followed a different pattern. In the early history of the drama, Nō costumes were closely tied to the fashions of the day, but after the Nō theatre assumed ceremonial importance in the mid-seventeenth century, costumes followed set forms. These set types not only conveyed elements that symbolized the past, but in fact were themselves emblems of the past and of the aristocratic heritage that was to be remembered and revered by the audience.

Very little is known about the earliest *sarugaku* and *dengaku* costumes. It is possible to determine, however, that from the late Heian period the costumes used by *sarugaku* players had a close relationship to the garments worn by the audience. For example, in the twelfth-century diary called the *Chūyuki*, an account is given of the spectators removing their clothes and throwing them to their favourite actors in lieu of an entrance fee.[20] The actors then wore them in later performances. This custom of stripping off garments and giving them to noted actors was also followed in *dengaku* performances and is documented in the *Taiheiki*:

Zealously [Hōjō Takatoki] gave over a dancer to each of his great captains, that they might embellish their costumes, so it was said, "This is the Lord Such and Such's dancer", and "That is Lord Thus and So's dancer"; and the lords bestowed gold and silver and precious stones upon them, and fine garments of damask and brocade. When those dancers danced at a feast, [Takatoki] and all his kinsmen took off their robes and trousers and tossed them out, none willing to be outdone. Most like to a mountain were the garments that they piled up together, nor can any man say how many thousands and tens of thousands they spent.[21]

The developed Nō theatre also continued this custom. A document from 1463 relates that during a period of three days, over two hundred and thirty-seven garments were donated to the actors.[22] Eventually this custom became even more refined, with the audience removing their garments and donating them in unison according to type of robe.[23] Perhaps due to the fact that this practice was indulged in by members of the upper classes, Nō costumes are generally referred to as Nō *shōzoku* rather than Nō *ishō*. In Japanese, *shōzoku* is the term often used to refer to the clothing of the military and the aristocracy, whereas *ishō* is primarily used to describe the clothing of commoners and costumes for the Kabuki theatre.

Zeami, owing to his deep concern for his aristocratic patrons, urged that Nō costumes be selected with the audience in mind. In one of his treatises on the Nō theatre, the *Fushikaden*, he writes that it is essential to select the right type of garment in order to depict a court lady:

When it comes to impersonating high-ranking women of the court, such as ladies-in-waiting, for example, since the actor cannot easily view their actual deportment, he must make serious, detailed inquiries concerning such matters. As for items of clothing such as *kinu* and the *hakama*, these too cannot merely be chosen on the basis of the actor's personal preference. The actor must make a proper investigation concerning what is correct. When it comes to impersonating an ordinary woman, however, the actor will be familiar with the appropriate details, and so the task will not be difficult.[24]

[19] Stella Mary Newton, *Renaissance Theatre Costume and the Sense of the Historic Past* (London: Rapp and Whiting, 1975), p. 21.

[20] Cited in Raz, *Audience and Actors*, p. 48.

[21] Craig McCullough, p. 131 (see note 8).

[22] Ken Kirihata, "The Characteristics of Noh Costumes", in *The Reproduction of Noh Costumes* (Kyoto: Yamaguchi Noh Costume Research Center, 1984), p. 7.

[23] *Ibid.*

[24] J. Thomas Rimer and Masakazu Yamazaki, trans., *On the Art of the Nō Drama: The Major Treatises of Zeami* (Princeton: Princeton University Press, 1984), p. 11.

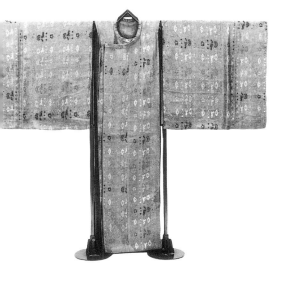
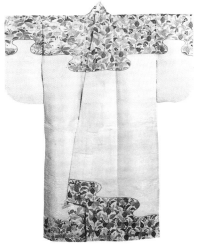

Fig. 3. *Kariginu* with decoration of animals and flowers. Japan, Momoyama period, 16th century. Kasuga Shrine, Gifu Prefecture.

Fig. 4. *Kosode* in *kata-suso* style with decoration of spring grasses, paulownia and vine scrolls. Japan, Momoyama period, 16th century. Ura Shrine, Kyoto.

Fig. 5. *Nuihaku* in *kata-suso* style with decoration of flowering plants. Japan, Momoyama period, 16th century. Once hereditary property of the Komparu family, formerly in the Teirakusha Collection. Tokyo National Museum.

[25] Shigeki Kawagami, "Nō no densho ni miru shōzoku", *Nō kyōgen shōzoku* (Tokyo: Tokyo National Museum, 1987).

[26] "On the other hand, when it comes to imitating labourers and rustics, their commonplace actions should not be copied too realistically... They should be imitated in detail insofar as they have traditionally been found congenial as poetic subjects." *Fushikaden* in Rimer, p. 10.

[27] Tetsuro Kitamura, *Nō shōzoku*, no. 46 of *Nihon no bijutsu* (Tokyo: Shibundō, 1970), p. 22.

From this statement Shigeki Kawagami has concluded that Zeami did not create costumes to be worn by actors in roles of women of high class, but used garments that court women actually wore.[25] In contrast, however, Zeami also believed that when characters from humbler stations in life were included in the Nō theatre, they should be portrayed as "poetic subjects".[26] In accordance with his aristocratic approach to the theatre, Zeami urged that even a play's rustic characters be costumed in silk robes — apparel that would clearly not have been available to actual members of the lower classes.

With the death of Ashikaga Yoshimochi (1385-1428), Zeami fell out of favour as an actor. His nephew, On'ami (1398-1467), became the respected actor of the shogun's successors and eventually assumed control of the Kanze school. During On'ami's lifetime Nō costumes become even more sumptuous, with the theatre's patrons bestowing on actors robes of damask and brocade imported from China. A contemporary temple record states that On'ami himself was presented with an elegant damask robe. Such robes could be conferred only by a superior and could not be worn without permission.[27] The richness of such fabrics, which were used until the mid-sixteenth century, is confirmed by the small group of robes preserved at the Kasuga Shrine in Gifu Prefecture. The *kariginu* (fig. 3), for example, which takes its form from the informal garb of courtiers, is woven in brocade with intricate patterns of animals and flowers.

Treatises written during the latter half of the Muromachi period by the playwright Komparu Zempo (about 1474-about 1520) further document the establishment of certain robe types as most appropriate for the theatre. In his writings, Komparu includes references to such costumes as the *kamishimo* — a set consisting of a short jacket with pleated pants adapted from contemporary samurai clothing — and the *chōken* — a wide-sleeved jacket originally worn by aristocrats. Through the Momoyama period, however, the appearance of the robes seems not to have differed greatly from those worn by the audience. A comparison of a well-known

sixteenth-century *kosode* — a common type of garment worn by women — belonging to the Ura Shrine in Kyoto (fig. 4), and a contemporary *nuihaku* — a type of robe ornamented with embroidery and metallic foil that had come to be worn in the Nō theatre by actors in female roles — formerly belonging to the Komparu family and now in the Tokyo National Museum (fig. 5), reveals startling similarities. The Nō robe shares the form of the *kosode*, which has a wide body and narrow sleeves, and is also composed of similar materials, including silk with unglossed warps and glossed wefts (*nerinuki*), embroidery with soft flossed silk, and metallic foil applied between the designs. The decoration of the narrow zones of the shoulder and hem is a standard Momoyama practice found on both Nō robes and *kosode*.

Scholars of the Nō theatre tend to focus on the dramatic innovations of Zeami, and scholars of Nō robes tend to focus on textiles from the sixteenth century. Nevertheless, a study of the theatre and its costumes during the Edo period can elucidate the relationship between the costumes and political legitimacy. With the proclamation of Nō as the ceremonial rite of the state by the Tokugawa shogunate, Nō robes became increasingly separated from the fashions of the day. Government supervision of performances meant that Nō troupes were discouraged from making innovations in their acting or their costumes. The authority of the theatre as a ritual resided in its correctness according to previously established tradition. Thus, throughout the Edo period, although their dimensions grew larger, Nō robes continued to resemble the clothing of members of the court and the military aristocracy of the sixteenth and early seventeenth centuries. Popular fashion in the mid-seventeenth century, on the other hand, was marked by the development of new techniques and the emergence of new decorative motifs, and as a consequence the garments produced during this period became increasingly distinct from theatrical garb.

Any refinements that did take place in Nō costumes were primarily technical, the result of the more intricate weaving methods developed at the Nishijin looms in Kyoto. One of the Nō robes in the exhibition provides an excellent example of the craftsmanship of these Kyoto weavers (cat. 162, figs. 6, 7). The garment is an eighteenth-century *atsuita-karaori* — a type of robe executed in brocade woven with long, floating supplementary pattern wefts and worn by actors in the roles of young men or determined women — with a decoration of chrysanthemums, paulownia and "flaming drums". Before the brocade for the robe was woven, the warp threads were rung-dyed in purple and pale blue so that when they were woven with the wefts they formed blocks of separate colours that slightly meld together. Bands of mist in red thread and gold-covered paper, with supplementary pattern wefts, form an intricate ground pattern. In addition, longer floating supplementary pattern wefts have been used for the assertive "flaming drums" and the graceful flowers, thus creating the illusion of another layer of surface patterns. Futhermore, the floating pattern wefts are secured by the warps in zigzags of lightning. Despite the number of patterns, the design is balanced and readily comprehensible.

Sumptuary legislation imposed by the Tokugawa government prohibited the use of exceedingly costly materials for the clothing of most mem-

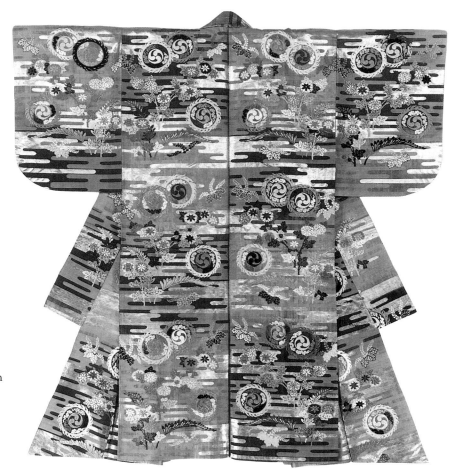

Fig. 6. *Atsuita-karaori* with decoration of chrysanthemums, paulownia and "flaming drums" on bands of mist. Japan, Edo period, 18th century. Tokugawa Art Museum, Nagoya.

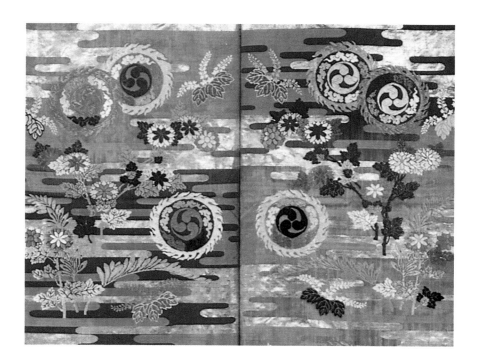

Fig. 7. Detail of fig. 6.

bers of society and for the costumes of other forms of theatre. Kabuki actors, for example, were forbidden to wear brocaded robes. As a result, the officially sanctioned luxuriousness of Nō robes was even more noticeable. Through the preservation of the forms of costumes originating in the aristocratic past, the replication of motifs throughout the Edo period, and the utilization of textiles limited to the upper classes, by the mid-seventeenth century Nō robes had become quite distinct from contemporary garments. The subtle nuances of particular robe types were not easily grasped by those outside the narrow world of the military class and the hereditary aristocracy, who were not conversant with the complexities of the theatre itself. Thus, the robes became analogous to a private language. Yet these robes clearly reinforced the distinctions between the rulers and the ruled and thereby functioned as a powerful statement of the authority of the Tokugawa government.

The author would like to express her deepest appreciation to Smith College for the award of a Mendenhall fellowship, during the tenure of which this essay was written. She would also like to thank Iwao Nagasaki of the Tokyo National Museum for his continued encouragement and insightful comments, Michio Yonekura of the Tokyo National Research Institute for Cultural Properties and Kadokawa Shoten for their help in securing photographs, and Jonathan Vogel of Amherst College for his clarification of philosophical terminology.

BIBLIOGRAPHY

Elison, George and Bardwell L. Smith, eds. *Warlords, Artists, and Commoners*. Honolulu: The University Press of Hawaii, 1981.

Ishimura, Hayao, Nobuhiko Maruyama and Tomoyuki Yamanobe. *Robes of Elegance: Japanese Kimonos of the 16-20th Centuries*. Raleigh: North Carolina Museum of Art, 1988.

Japan Society. *The Tokugawa Collection: Nō Robes and Masks*. New York: Japan Society, 1977.

Keene, Donald. *Nō: The Classical Theatre of Japan*. Tokyo: Kodansha International, 1966.

Kitamura, Tetsuro. *Nō shōzoku*. No. 46 of *Nihon no bijutsu*. Tokyo: Shibundō, 1970.

Nara Prefectural Museum. *Yūgen nō sekai e*. Nara: Nara Prefectural Museum, 1985.

O'Neill, P. G. *Early Nō Drama: Its Background, Character and Development 1300-1450*. London: Lund Humphries, 1958.

Raz, Jacob. *Audience and Actors: A Study of their Interaction in the Japanese Traditional Theatre*. Leiden: E. J. Brill, 1983.

Shimizu, Yoshiaki, ed. *Japan: The Shaping of Daimyo Culture 1185-1868*. Washington: National Gallery of Art, 1988.

Stinchecum, Amanda Mayer, Monica Bethe and Margot Paul. *Kosode: 16-19th Century Textiles from the Nomura Collection*. New York: Japan Society and Kodansha International, 1984.

Tokyo National Museum. *Nō kyōgen shōzoku*. Tokyo: Tokyo National Museum, 1987.

Yamanobe, Tomoyuki, ed. *Nō shōzoku*. 2 fasc. Tokyo: Tokyo chunichi shimbun, 1963.

# The Tea Ceremony: Art and Etiquette for the Tokugawa Era

BY
RICHARD L. WILSON

I N Japan, the tea ceremony is called *cha-no-yu*. Denoting "hot water for tea", the term also conveys the essence of a tradition: hosts and guests gather, build a fire, boil water and make tea. *Cha-no-yu* acquired its spirit in an age of war. It was conceived as a moment of repose between life and death. Having little use for worldly goods, practitioners chose to honour dew-laden flowers. Their successors, custodians of a new national peace, endeavoured to capture the dew.

On the thirteenth day of the second month, 1623, second-generation Tokugawa shogun Hidetada (1579-1632) paid an official visit to the Edo (Tokyo) residence of his younger brother Yoshinao (1600-1650), lord of Owari domain. That event, meticulously recorded in the clan archives, was calculated to display the power and cultural prowess of both host and guest. Yoshinao greeted his older brother outside the garden adjoining a small tea hut, or *suki-ya* (fig. 1). The leaders then repaired to the hut to enjoy a light repast, which was followed by a presentation of tea to the shogun from Yoshinao's own hand. The record tells us that the shogun himself arranged the flowers for the alcove and rebuilt the fire in the hearth. From the *suki-ya* the party moved to the slightly larger, brighter room called *kusari no ma* (fig. 2); there they were joined by a number of retainers, with whom they shared tea and inspected a selection of fine tea utensils that could not be fitted into the *suki-ya* presentation. After a change into formal apparel, Hidetada was shown into the large reception chamber, or *shoin* (fig. 3), where loyalties were affirmed through exchanges of fine arms and armour and through official toasts. In contrast to the modestly appointed *suki-ya* and *kusari no ma*, the *shoin* was luxuriously decorated and furnished with Chinese antiquities displayed in permanent architectural fixtures. The *shoin* ceremonies were followed by further gift giving and performances of Nō and Kyōgen, drama forms that had been favoured by the military from the medieval era. The reception concluded as it started, in the humble *suki-ya* with an intimate presentation of tea.

At the time of Hidetada's visit, twenty years had passed since his father Tokugawa Ieyasu (1542-1616) had assumed the mantle of shogun in official acknowledgement of his nationwide hegemony. Having survived

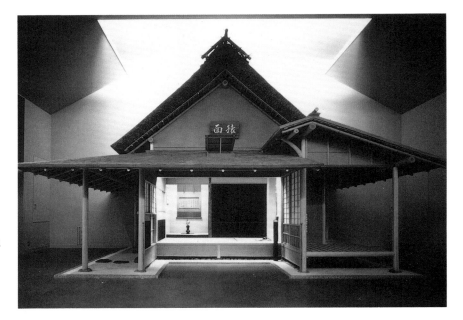

Fig. 1. Re-creation of *suki-ya*-style tea room, based on "Sarumen" (Monkey-face) tea room in Nagoya Castle. Tokugawa Art Museum, Nagoya.

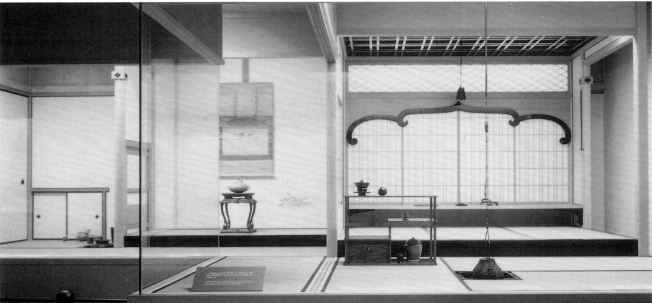

Fig. 2. Re-creation of *kusari no ma* (Chain room, so-called because of the suspended kettle) based on rooms in the Ninomaru, Nagoya Castle. Tokugawa Art Museum, Nagoya.

decades of national unrest, Ieyasu understood the need to maintain order not only in the civil population but within the ranks of the military. He insisted that the samurai be skilled in both martial and scholarly arts, and strove to formulate a code of etiquette suitable for a warrior government. The most attractive model was that of the Ashikaga shoguns of the Muromachi period (1338-1573). Its own disorders notwithstanding, the Ashikaga period represented the most recent era of shogunal supremacy prior to the disruption and excess of the sixteenth century; furthermore, it was under Ashikaga rule that an all-embracing code for official hospitality had first been developed.

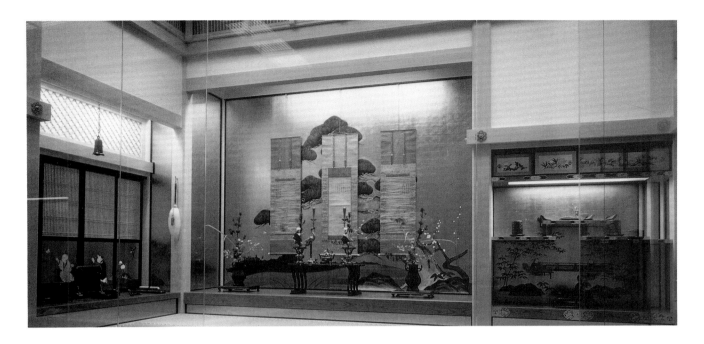

Fig. 3. Re-creation of formal audience chamber, or *shoin*, based on the Ninomaru *shoin* in Nagoya Castle. Tokugawa Art Museum, Nagoya.

For all their conservatism, it would be a grave error to assume that the early Tokugawa hegemons merely sought to reinstate medieval etiquette. The element that separated Tokugawa hospitality from earlier styles was the emphasis on *cha-no-yu*. Tea had probably been enjoyed ceremonially since the thirteenth century, when Zen monks introduced the Chinese custom of drinking whisked powdered tea. It was not long afterwards that the members of the nobility began to indulge in contests called *tō-cha*, in which participants vied to identify the origins and names of different teas. A more restrained enjoyment of tea was inculcated in the salon of the Ashikaga shogun Yoshimasa (1435-1490). After preparation in adjacent quarters, tea would be presented to guests in the newly developed *shoin*, a room which was equipped with fixtures for display of highly admired Chinese *objets d'art*. It is also said that an occasional advisor of Yoshimasa, Murata Jukō (1422-1502), served him tea in a nine-foot square hut devoid of luxury and distraction.[1] Inspired by Jukō, wealthy merchants in Sakai and Kyoto moved tea in the direction of spiritual exercise rather than mere pastime. Their leader was Takeno Jōō (1502-1555), who skilfully blended his early interests in medieval poetry and Zen Buddhism into a new way of tea, one that was practised in the diminutive thatched hut (*sōan*) rather than in *shoin* rooms, and which experimented with ordinary folkwares in place of the fine Chinese vessels. Under the direction of Jōō's student Sen no Rikyū (1522-1591), the new way evolved into the austere style known to posterity as *wabi*. Rikyū further modified the setting and utensils: he reduced the tea room to minimal size and began to design wares exclusively for the *wabi* tea aesthetic. The great warlord-unifiers Oda Nobunaga (1534-1582) and Toyotomi Hideyoshi (1536-1598) were attracted to the tea ceremony, and this not only increased its fashionableness but established tea as the means through which to ingratiate oneself with the pow-

[1] Jukō's interest in the smaller tea room and his relationship with Yoshimasa are attested to in the 1589 tea record *Yamanoue Sōji ki*. See Sōshitsu Sen, ed., *Chadō koten zenshū* (Collection of Tea Ceremony Classics) 6 (Kyoto, 1958), pp. 51-52. The *Yamanoue Sōji ki* is not a contemporary document and in the absence of other supporting material these aspects of Jukō's career are sometimes questioned.

erful. By the time of the 1623 Hidetada reception, tea was not merely one of the art forms that constituted official hospitality: the framing of formal visits with *suki-ya* tea presentations demonstrates that the tea ceremony had become *the* form for state etiquette. So dynamic was the synthesis of tea and official life in the early Tokugawa era that *daimyō cha-no-yu* — the tea of the feudal lords — wrested creative leadership away from the merchant tea tradition inaugurated by Jōō and Rikyū. The kind of programme and setting employed in the Hidetada visit nevertheless reflects an interest in the entire tea tradition. The *shoin* reception, while not including tea service, was held in chambers furnished in a manner similar to the late fifteenth-century Ashikaga rooms where seminal developments in the ceremony took place; tea in the *suki-ya* evoked the mood of the *wabi* tea practitioners Jōō and Rikyū; the *kusari no ma*, as we shall see, demonstrated the style of Hidetada's own teacher, Furuta Oribe.

The art of the tea master might be likened to that of the interior decorator, with one very important difference: there is not a single object that remains static for the entire course of a tea ceremony. The utensil selection process, called *tori-awase* (literally "take and adjust"), is multidimensional. First, there is the situation, which requires thinking of the guest, season and specific occasion being celebrated. Then there is the formal aspect — the orchestration of the colours, textures, shapes and materials of the utensils with the larger solids and voids of the architecture. Concealed from the uninformed viewer but of paramount importance to the knowing guest is the history of the utensils: their origins, ownership and manner of inheritance. In the hands of a creative tea master there is no limit to the messages, overt and subtle, that can be transmitted through *tori-awase*. And what messages did Yoshinao and his advisors have for a guest as eminent as the shogun? The utensils used in the *suki-ya* during Hidetada's 1623 visit are tabulated below (pp. 68-69).[2] Of special note is that all of the objects, save the tea caddy, are still preserved in the Tokugawa Museum; two of them are displayed in this exhibition (cats. 108, 114).

When read horizontally, the table describes the evolution of the general utensil type and the details of that particular object; when read vertically, it reveals the larger values intended in the selection by host Yoshinao. Appropriate to the unadorned and intimate confines of the *suki-ya*, the objects represent the heyday of *wabi* tea. The priest's writing, Korean tea bowl, bamboo tea scoop and Namban-style water jar all typify the mid- to late-sixteenth-century move away from costly and ostentatious Chinese objects. Colours are subdued and nearly monochromatic; finishes are rough, and shapes are simple. The ownership history of the vessels also directly involves the great *wabi* masters Jōō and Rikyū. Perhaps even more important is the military pedigree, which involves Ashikaga Yoshimasa and Toyotomi Hideyoshi; nearly all of the objects passed through the hands of Tokugawa Ieyasu. Hosokawa Yūsai (1534-1610), former owner of the scroll, was a highly respected warrior-scholar who advised Ieyasu on Ashikaga etiquette forms in the early years of the seventeenth century.[3] Ishikawa Ujikatsu, upon being defeated by Ieyasu in 1600 at the Battle of

[2] The utensil inventory is transcribed from the original *Genna onari no ki* (Record of Official Receptions for the Genna Era, 1615-1624) in Toyozō Satō, "Shōgun-ke 'Onari' ni tsuite (7)" (Official Reception for the Shogunal Families - Part 7), *Kinko sōsho* 8 (1981), p. 609.

[3] Toyozō Satō , "Shōgun-ke 'Onari' ni tsuite (8)", *Kinko sōsho* 13 (1986), pp. 321-322.

Sekigahara, traded the "Kine-no-ore" flower vase for his life. The *suki-ya* was thus a display of family treasures and an affirmation of the Tokugawa as successors to the late-sixteenth-century power struggle. At the level of state ritual, *tori-awase* obviously had to serve claims to political and cultural legitimacy.

Between about 1615 and 1675, the co-ordination of formal events and tea instruction for the shogun were the responsibility of daimyo employed as official tea advisors. The first appointee to this post was Furuta Oribe (1544-1615). For those versed in tea ceremony lore, the inclusion of Oribe-owned objects in the 1623 Hidetada reception may strike a discordant note. After all, the Tokugawa had ordered Oribe's death only eight years earlier, and many of the utensils used in the *suki-ya* had been confiscated from his collection. Oribe rose from obscure origins to marry the younger sister of Nakagawa clan leader Kiyohide in 1569; after the death of Kiyohide at the Battle of Shizugatake in 1583, Oribe became guardian of the young successor, Hidemasa. By 1585, Oribe was master of his own domain at Nishioka in Yamashiro (Kyoto) with an entitlement of 35,000 *koku*.[4] There is no certain evidence of his involvement with tea until that same year, when he is mentioned as hosting merchant teaists Sumiyoshi Sōmu (1534-1603) and Tsuda Sōgyū (?-1591).[5] Although he is widely acknowledged as one of the top students of Sen no Rikyū, there are very few references to Oribe in tea-related records until the end of the century. That obscurity may be attributed to Ishida Mitsunari (1560-1600), a warlord influential with the Toyotomi clan in the 1590s who was hostile to the Rikyū circle.[6] On the twenty-second day of the third month, 1599, however, the diary of a Kōfukuji priest, entitled *Tamon-in nikki*, announced the "arrival of celebrated tea master Oribe from Fushimi".[7]

It was probably after the Tokugawa victory (and Toyotomi/Ishida defeat) at Sekigahara in 1600 that Oribe moved towards consolidating his style — one characterized by spaciousness, vigour and idiosyncracy. Oribe had studied tea under Rikyū; but while the elder man was a merchant who developed his tea in the turbulent 1570s and 1580s, Oribe in his heyday was a samurai allied to a regime that had instilled the entire nation with a longed-for sense of peace and economic stability. It was also a regime that insisted on military decorum, and Oribe addressed that issue in his approach to tea. For guests of high rank, there had to be room for retainers and proper demarcations of status, and Oribe modified the *sōan*-style tea hut accordingly.[8] Understanding the increased importance of refreshment in the peacetime tea ceremony, Oribe either himself designed or encouraged others to create new lines of food vessels at rural ceramics centres nationwide. As for the style of these wares, the *Sōjinboku*, a three-volume guide to the tea ceremony first printed in 1626, relates Oribe's fascination with the "recently made warped tea bowls from Seto";[9] the use of the term "warped" suggests the freely shaped ceramics fired at the Motoyashiki kiln in Mino from about 1600 and now known as Oribe ware (fig. 9). Other evidence of Oribe's interest in deformation is a 1601 mention in the tea diary *Matsuya kaiki* of Oribe's use of the bulging, inverted

[4] Land holdings were assessed according to the number of *koku* (about five bushels) of rice that they produced.

[5] Recorded in the *Tsuda Sōgyū chanoyu nikki*, thirteenth day, second month, 1588. See Sen, ed., *Chadō koten zenshū* 7 (Kyoto, 1959), p. 408.

[6] Tatsusaburō Hayashiya, *Zuroku chadō shi* (An Illustrated History of the Tea Ceremony) 2 (Tokyo, 1962), p. 33.

[7] *Ibid.*

[8] For an English-language study on Oribe's influence on architecture, see Shōsei Nakamura, "Furuta Oribe and Ennan", *Chanoyu Quarterly* 17 (1977), pp. 9-19.

[9] Sen, ed., *Chadō koten zenshū* 3 (1960), pp. 234-235.

Fig. 4. Incense case with design of Hotei, China, 15th-16th century, carved lacquer. Tokugawa Art Museum, Nagoya.

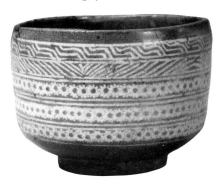

Fig. 5. Tea bowl, called "Mishima Oke", Korea, 16th century, glazed stoneware. Tokugawa Art Museum, Nagoya.

## UTENSILS USED IN *SUKI-YA* TEA CEREMO[NY]

| UTENSIL | ORIGINAL FUNCTION | TEA CEREMONY FUNCTION |
|---|---|---|
| Incense case, with design of Hotei (Chinese monk Pudai) Carved lacquer | Incense case China 15th-16th c. | Holds incense that will be added to hearth fire |
| Hanging scroll, calligraphy by priest Xutang Zhiyu (Japanese: Kidō Chigu, 1185-1269) Ink on paper | Religious exhortation China 13th c. | Initial alcove decoration, sets spiritual tone for ceremony |
| Tea caddy, "Shigi Takatsuki" Glazed ceramic | Medicine or spice jar China 12th-13th c. | Holds tea for formal, thick tea presentation |
| Flower vase, "Kine-no-ore" (Break in the pestle) Bronze | Altar vase China 12th-13th c. | Contains flowers, which are arranged in alcove in second half of ceremony |
| Tea bowl, "Mishima Oke" Glazed ceramic | Utilitarian bowl Korea 16th c. | Usually used for formal, thick tea service |
| Tea scoop, "Namida" (Tears) by Sen no Rikyū Bamboo | Tea scoop Japan 16th c. | Used to scoop powdered tea into tea bowl |
| Water jar, *Namban* style "Imo-gashira" (Potato Head) Unglazed | Storage jar China or Southeast Asia 16th c. | Contains fresh water to replenish kettle and rinse tea bowl |
| Kettle, "Kaji" (Rudder) Iron | Kettle Japan 15th c. | Used to boil water for tea |

| DEBUT OF UTENSIL TYPE IN TEA CEREMONY | OWNERSHIP | ILLUSTRATIONS |
|---|---|---|
| Used in formal displays from 15th c.; in tea ceremony use thereafter | Ashikaga Yoshimasa Oda Uraku (1547-1621) Furuta Oribe Tokugawa Yoshinao | Fig. 4 |
| Calligraphy first recorded in tea room about 1535; this scroll recorded at Hideyoshi's Jūraku mansion in 1587 | Hosokawa Yūsai Tokugawa family | Cat. 108 |
| Used continuously in tea drinking from 13th c. | Hongan-ji Temple, Kyoto Toyotomi Hideyoshi Tokugawa family | Similar to cat. 102 |
| Used in formal displays from 15th c.; in tea ceremony use thereafter | Toyotomi Hideyoshi Ishikawa Ujikatsu Tokugawa Ieyasu Tokugawa Yoshinao | Cat. 114 |
| Korean tea bowls used from second quarter of 16th c. | Sen no Rikyū Sen Dōan (1546-1607) Tokugawa Ieyasu Tokugawa Yoshinao | Fig. 5 |
| Bamboo from mid-16th c.; metal and ivory scoops earlier | Sen no Rikyū Furuta Oribe Tokugawa Ieyasu | Fig. 6 |
| Namban type from second quarter of 16th c. | Takeno Jōō Tokugawa Ieyasu Tokugawa Yoshinao | Fig. 7 |
| Iron kettles for tea in continuous use since 14th c. | Furuta Oribe Tokugawa Ieyasu Tokugawa Yoshinao | Fig. 8 |

Fig. 6. Tea scoop, called "Namida" (Tears), Japan, 16th century, bamboo. Tokugawa Art Museum, Nagoya.

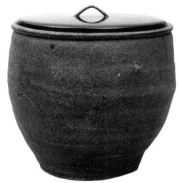

Fig. 7. Water jar, called "Imogashira" (Potato Head), China or Southeast Asia, 16th century, unglazed stoneware. Tokugawa Art Museum, Nagoya.

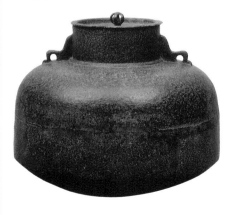

Fig. 8. Kettle, called "Kaji" (Rudder), Japan, 15th century, iron. Tokugawa Art Museum, Nagoya.

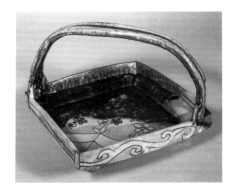

Fig. 9. Oribe ware handled dish, Japan, Momoyama period, late 16th-early 17th century, glazed stoneware. Freer Gallery of Art, Washington (Acc. no. 67.21).

"hagmouth" style kettle.[10] Oribe was also mindful of the exotic imagery introduced by European priests and traders from the late sixteenth century.[11]

Instrumental in Oribe's ascent was the patronage of the Tokugawa. Oribe fought on the Tokugawa side in 1600 at the decisive battle at Sekigahara, and as a consequence his fief was enlarged by 7,000 *koku*. The *Keichō kenbunroku anshi* (Draft Record of Observations for the Keichō Era) mentions the first known visit of second-generation Tokugawa scion Hidetada to an Oribe tea ceremony on the fifth day of the fourth month, 1605.[12] Ten days later, Hidetada was appointed shogun. The Keichō record also states that in 1610, Oribe was elevated to the status of official tea master to the shogun. According to *Sumpuki* (Sumpu record), the diary of Gotō Mitsu Sugu (1571-1625), in 1612 Oribe was uncontestedly the top tea master in the realm.[13] Within two years, however, he was out of favour. During the late 1614 campaign against the Toyotomi at Osaka, Oribe was grazed by a stray bullet. According to legend, he was hit while cutting bamboo for tea scoops, prompting Ieyasu to remark that Oribe "was the kind of man who would die from a fish bone stuck in his throat".[14] In 1615, Oribe was implicated in anti-Tokugawa plotting and was forced to die by his own hand. After Oribe's death the Tokugawa family confiscated all of his property, including his tea utensils; as we have seen, a number of them were displayed by Yoshinao at the 1623 gathering. How would guest Hidetada look upon the seized treasures of his dead teacher? Before answering this question, it must first be noted that none of the utensils were in the assertive personal style of Oribe; indeed, it appears that there are few Oribe wares in the Tokugawa collection at all.[15] Oribe's influence on Tokugawa *cha-no-yu* is manifested much more subtly, and for evidence let us examine the vessel inventory from the *kusari no ma*, the second tea room that Hidetada entered on his 1623 visit:

Arranged in the desk alcove (*shoin-doko*):
    Writing box, brush and brush holder formerly owned by Oribe;
    Poems by Fujiwara no Teika (cat. 107);
    Summoning bell (*kanshō*) and mallet (*shimoku*) (cat. 151).
[Suspended from the ceiling:]
    Kettle with eight view (*hakkei*) pattern and hook.
On the portable shelf (*fukuro-dana*):
    *Tenmoku* tea bowl (cat. 117);
    Bulge-bottom (*o-shiri fukura*) tea caddy;
    Tea scoop called "Mushikui" (Worm-eaten) by Sen no Rikyū;
    Celadon water jar;
    Kettle lid rest (*futaoki*) in the *hoya* style.[16]

The larger, brighter space of the *kusari no ma* and the comparative lightness of the utensils convey the diverting atmosphere associated with Oribe; moreover, research by Toyozō Satō of the Tokugawa Art Museum, reveals that an almost identical assemblage was used by Oribe in a tea cere-

[10] *Chadō koten zenshū* 9 (1957), p. 203.

[11] Oribe's interest in foreign subjects may stem from a relationship with Christian warlord Takayama Ukon (1552-1615), who in 1573 became lord of Takatsuki Castle (near Osaka) and thus a neighbour of Oribe. There is also a theory that Ukon and Oribe were blood relatives. See Hayashiya, *Zuroku chadō shi 2*, p. 33.

[12] Hayashiya, p. 36.

[13] *Ibid.*, p. 37.

[14] A. L. Sadler, *Chanoyu: The Japanese Tea Ceremony* (Rutland, Vt., 1968), p. 138.

[15] The bulk of the sixteenth- and seventeenth-century Japanese ceramics in the Tokugawa collections are not family heirlooms but a twentieth-century gift from the Okaya family of Nagoya merchants.

[16] Satō, "Shōgun-ke 'Onari' ni tsuite (7)", p. 606.

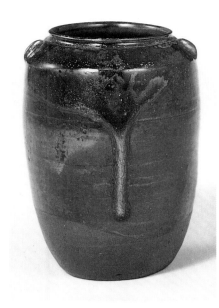

Fig. 10. Takatori ware tea caddy, called "Yokodake", Japan, Edo period, early 17th century, glazed stoneware. MOA Museum of Art, Atami. Takatori is known as one of the seven Japanese kilns that produced wares in the taste of Enshū.

mony given in a *kusari no ma* on the first day of the second month, 1604.[17] It is thus safe to conclude that the 1623 arrangement was based on an Oribe concept, and that in his service with the Tokugawa, Oribe concentrated on room designs and utensil selections befitting shogunal etiquette and respectability. The flamboyance we now associate with the Oribe style was manifested principally at his salon in Fushimi, the garrison town that developed after Hideyoshi built a castle there in 1594.

One of the guests at Oribe's 1604 *kusari no ma* gathering was Kobori Enshū (1579-1647), who had just succeeded his father as the master of a 10,000 *koku* fief in Ōmi (Shiga Prefecture). The *Genryū chawa* (Talks on Orthodox Tea), written in about 1716 by tea master Yabunouchi Chikushin (1678-1745), offered the opinion that "Oribe was a flowerless fruit, but Enshū was a fruitless flower";[18] that is, Oribe's work possessed inner spirit but lacked finesse, whereas Enshū had finesse but no essence. Enshū's finesse derived from schooling in Japanese classical poetry and calligraphy, and study of Zen Buddhism under the Daitokuji priest Shunoku Shōon (1529-1611). As a warrior-bureaucrat, he was supervisor of construction at numerous temples, imperial residences and castles; his well-known tea room Mittan in the Kyoto temple at Daitokuji shows a refined *shoin* style.[19] As a tea master, Enshū was particularly well known for his connoisseurship. He not only classified extant Chinese and Japanese tea utensils, but spurred production of new teawares at Japanese kilns (fig. 10). It is with Enshū that the practice of naming the objects and inscribing their wooden boxes began; this activity was informed by his scholarship and classicism. Enshū was designated official tea master for third-generation Tokugawa shogun Iemitsu (1604-1651) around 1637. In that capacity Enshū added greater subtlety to the Ashikaga-derived schemes of decoration for reception rooms, but the all-encompassing official hospitality of the Hidetada era was not to be repeated. By the time of Iemitsu, there was little need to evoke the aura of legitimacy. The reception programme was abbreviated, and amusements such as hawking and swimming were fitted into the routine.[20]

In such circumstances, tea at the state level could only move in the direction of technical codification, as it did under Enshū's official successor, Katagiri Sekishū (1605-1673). In 1627, Sekishū inherited the 13,000 *koku* family fief in Ibaragi (now part of Osaka), and by 1633 he was in Tokugawa employ as construction supervisor for the Chion-in, the Tokugawa ecclesiastical centre in Kyoto. Sekishū had a productive career as official tea master for the fourth Tokugawa shogun, Ietsuna (1641-1680), whom he served from 1665. Sekishū penned the *Ryū-e gyobutsu*, a manual of connoisseurship for the shogun, and also wrote the *Sekishū sanbyakujō* (Three Hundred Precepts of Sekishū), which provides detailed instruction for every imaginable aspect of the tea ceremony. For example, in Part III, article number 72 (preparing for a ceremony), we read:

When accompanying the nobility you must carry new, unused tissue and silk wiping cloth. One must naturally carry a folding fan, and when presenting something to a noble it is not permissible to hand it over directly, but rather place it on

---

[17] *Ibid.*

[18] *Chadō koten zenshū* 3, p. 403.

[19] For further information, see Shōsei Nakamura, "Kobori Enshū and Mittan", *Chanoyu Quarterly* 14 (1976), pp. 7-19.

[20] Satō, "Shōgun-ke 'Onari' ni tsuite (7)", pp. 623-624.

your opened fan. When entering the tea room refrain from putting your short sword on the sword rack (where the noble would hang his) and instead lay down a piece of paper and stand your sword on that. Refrain from resting your shoes against the tea hut wall (as the noble would do) and instead lay them flat in a separate place. It is not permissible to sit in the waiting arbour along with a noble; if he urges you to join him you must sit crosslegged on the bench without letting your legs dangle in front of him.[21]

With this kind of manual available, it was no longer necessary to have daimyo tea instructors for the shogun; Sekishū was in fact the last such appointee. At the Tokugawa headquarters in Edo Castle, the tea ceremony became a staff function. *Chadō gashira*, or in-house tea ceremony supervisors, first appear in the *Tokugawa jikki* (Tokugawa Chronicles) in 1616; by the mid-seventeenth century, they were being granted the status of *wakadoshiyori*, the third highest rank in the bureaucracy.[22] They oversaw the tea rooms, gardens and work by related craftsmen, and maintained staffs of *cha-bōzu*, or "tea pages", attired as monks. One important official function was the annual procession of newly filled tea jars — the *o-chatsubo dōchū* — from the tea-growing district of Uji, near Kyoto, to Edo Castle. During this spectacle, which was codified in 1632, the jars were sent along the Tōkaidō highway accompanied by a retinue of up to three hundred people. Villagers along the road were pressed into service, and the ignominy of having to bow to the jars is now part of national lore.

The tea ceremony at the shogunal level may seem to have been suffocating in its formality, but within that formality there was the gift of enduring form. In searching for an all-encompassing style of hospitality, the military aristocrats revived old traditions such as the *shoin* reception and reinforced more recent ones such as *wabi* tea. In sanctioning the tea ceremony as the language of official reception, the rulers ignited a nationwide surge of interest. As the numbers of tea practitioners increased, so did the domestic manufacture of tea utensils. In the field of ceramics, regional warlords vied with each other to create industries that would turn out not only distinctive teawares but ordinary merchandise to increase their domain's income. The proliferation of devotees and objects encouraged connoisseurship; masters like Enshū broadened the scope of art appreciation to embrace not only the treasured Chinese objects, but also the Japanese pieces that had hitherto been regarded as mere utensils. In their fondness for documentation, teamaster-connoisseurs would also prove to be important contributors to Japanese art historical scholarship as a whole. If Jōō and Rikyū brought the tea ceremony to its spiritual zenith, it was the Tokugawa teaists who introduced it to the realm of the tangible.

But for all its contributions to material culture and scholarly activity, did not the Tokugawa tea ceremony decline into a mere secularized tea drinking? That the tea ceremony under the Tokugawa had changed since the age of Jōō and Rikyū is beyond doubt. Rikyū's unworldly *wabi* tea, fundamentally Buddhist in outlook, reflects the uncertain and turbulent era of civil wars. The Tokugawa, who brought those wars to an end, espoused Confucian principles of harmony and decorum. At the level of practice those ideals were naturally mediated by human desire and the exigencies of

[21] *Chadō koten zenshū* 11 (1961), p. 340. The existence of as many as six variant editions of the *Sekishū sanbyakujō* complicates an attribution to a single author, but there is little doubt as to the text's origin in the Sekishū school as an instrument of codification and authority.

[22] Hayashiya, *Zuroku chadō shi 2*, pp. 51-52.

the times. Rikyū and his fellow merchant teamen profited from their access to the highest circles of military power; the Tokugawa teaists were not unmindful of how the ceremony might serve as an instrument of regulation and control. Contradictions notwithstanding, it is the military model that has endured — despite the fall of the shogunate over a century ago. The most influential tea organizations in Japan today are the Sen schools managed by family descendants of Rikyū, but their teachings are far more akin to the punctilio of Sekishū than to the introspective way of their own ancestor. New schools and new methods may succeed, but will never entirely supersede the Tokugawa legacy in *cha-no-yu*.

The author would like to thank Toyozō Satō of the Tokugawa Art Museum, Nagoya, and Sōshin Ogasawara of the Sōshin Foundation, Houston, for their kind assistance.

BIBLIOGRAPHY

Castille, Rand. *The Way of Tea*. New York and Tokyo: Weatherhill, 1971.

Fujioka, Ryōichi. *Tea Ceremony Utensils* (Arts of Japan Series, vol. 3). New York and Tokyo: Weatherhill-Shibundō, 1973.

————. *Shino and Oribe Ceramics* (Japanese Arts Library, vol. 1). Tokyo, New York and San Francisco: Kodansha International, 1977.

Hayashiya, Tatsusaburō. *Zuroku chadō shi* (Illustrated History of the Tea Ceremony), vol. 2. Kyoto: Tankōsha, 1962.

————. *Cha no bijutsu* (The Art of the Tea Ceremony) (Nihon no bijutsu series, vol. 15). Tokyo: Shibundō, 1969.

Japan House Gallery. *Chanoyu: Japanese Tea Ceremony*. New York: Japan House Gallery, 1979.

Kuwata, Tadachika. *Chadō jiten* (Dictionary of the Tea Ceremony). Tokyo: Tokyodō Shuppan, 1967.

Murayama, Takeshi. *Oribe* (Famous Ceramics of Japan, vol. 8). New York, Tokyo and San Francisco: Kodansha International, 1982.

Nakamura, Shōsei. "Kobori Enshū and Mittan". *Chanoyu Quarterly* 14 (1976), pp. 7-19.

————. "Furuta Oribe and Ennan". *Chanoyu Quarterly* 17 (1977), pp. 9-19.

Sadler, A. L. *Chanoyu: The Japanese Tea Ceremony*. Rutland, Vt.: Charles E. Tuttle, 1968.

Satō, Toyozō. "Shōgun-ke 'Onari' ni tsuite" (Official Reception for the Shogunal Families). *Kinko sōsho* 6, 7, 8, 13 (1979-1987).

Sen, Sōshitsu, ed. *Chadō koten zenshū* (Collection of Tea Ceremony Classics). 12 volumes. Kyoto: Tankōsha, 1957-1962.

————. *Chanoyu bijutsu zenshū* (Collection of Tea Ceremony Art). 15 volumes. Kyoto: Tankōsha, 1970-1971.

Tanaka, Sen'ō. *The Tea Ceremony*. Tokyo, New York and San Francisco: Kodansha International, 1973.

Tokugawa Art Museum. *The Shogun Age Exhibition*. Nagoya: Tokugawa Art Museum, 1983.

————. *Meihin zuroku* (Masterpieces of the Collection). Nagoya: Tokugawa Art Museum, 1987.

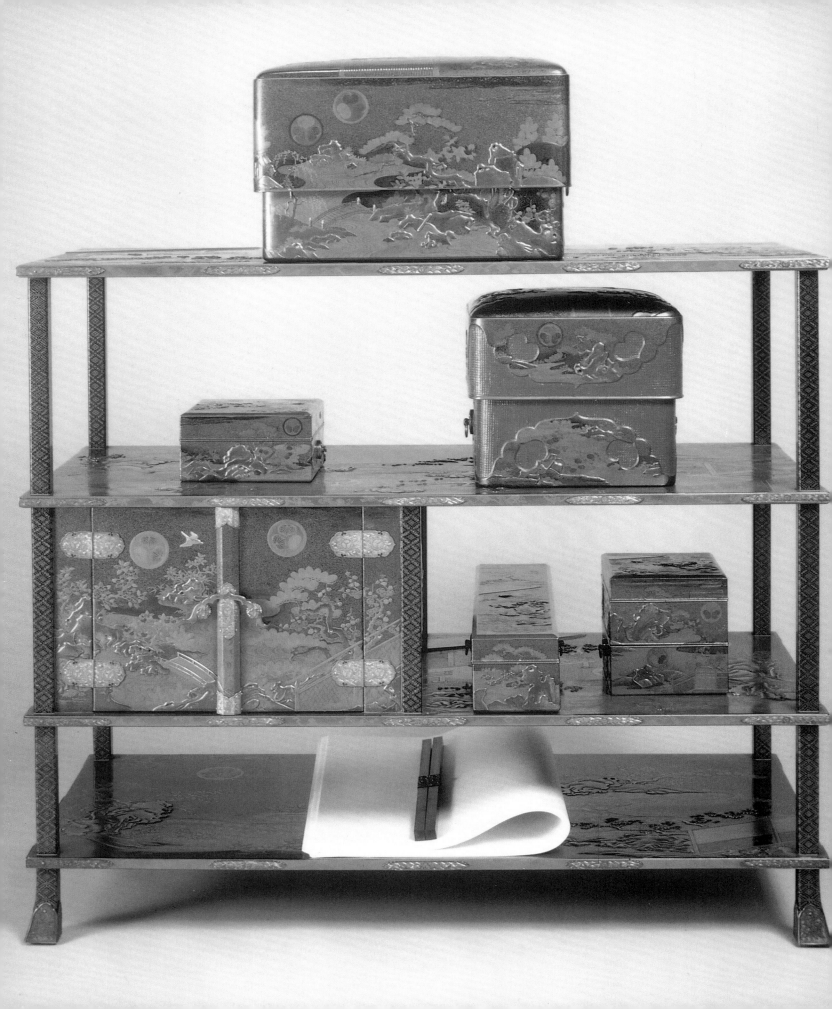

# Splendour and Supremacy: Lacquer for the Tokugawa

BY
ANN YONEMURA

AMONG all the traditional Japanese crafts, lacquer has maintained a uniquely privileged status. The lustre and opulence of *maki-e* — lacquerware decorated with gold and silver — suffused the surroundings of Japanese nobles and daimyo with radiant elegance. Versatile, durable and incomparably beautiful, lacquer was a universal feature of the surroundings of the Japanese elite and of the institutions such as Buddhist temples and Shinto shrines that enjoyed their patronage. The aesthetics of lacquerware, with its graceful shapes, polished surfaces, vivid colours and refined design, were a definitive expression of Japanese taste and artistic sensibility.

During the Edo period (1603-1868), the ownership, display and use of luxurious property became a political concern for the Tokugawa shoguns and a specific subject addressed by their laws and edicts. Motivated by a desire to underscore political authority with a clearly hierarchical system for the ownership and display of wealth, the Tokugawa shogunate promulgated laws that strictly regulated the ownership and use of property on the basis of rank. Lacquerware decorated in gold and silver, a conspicuous manifestation of wealth and power, was frequently cited in Tokugawa sumptuary edicts. An edict of the early eighteenth century, for example, encourages frugality by restricting even the wives of daimyo to using plain black lacquerware decorated with the family crest in gold.[1]

Within their own domains, however, the Tokugawa shoguns and their close relatives enjoyed the most costly and opulent lacquer objects. The brilliance of lacquer illuminated nearly every aspect of the public and private lives of the Tokugawa. Their sumptuous lacquerware, decorated in gold, silver and other precious materials, ranged from items for personal use such as boxes for inkstone and writing equipment (*suzuri-bako*, cat. 201), and mirror stands (cat. 190) to processional vehicles such as palanquins (cat. 208). Lacquer also embellished the armour (cats. 16-19), sword mountings, saddles and stirrups (cats. 83-86) used by the warrior in battle and, during the long Tokugawa peace, for ceremonies and processions. Grand architectural monuments such as Tōshōgū, the mortuary shrine for Tokugawa Ieyasu (1542-1616), were emblazoned with extravagant decoration in lacquer, gilt metal and coloured paint.

From earlier military rulers such as the Ashikaga shoguns, the Tokugawa inherited a taste for fine Chinese as well as Japanese lacquer

Fig. 1. Kōami Nagashige (1599-1651), ensemble from the Hatsune lacquer dowry, Edo period, 1639, lacquer, gold, silver and coral on wood. Tokugawa Art Museum, Nagoya.

[1] George Sansom, *A History of Japan, 1615-1868* (Stanford, California: Stanford University Press, 1963), pp. 160-161.

objects. Chinese lacquers, ceramics and bronzes were collected and handed down as treasures to be displayed in the *shoin*-style reception rooms of the palatial residences of the Tokugawa. Following the precedents set under the cultural leadership of the Ashikaga shoguns during the Muromachi period (1338-1573), other daimyo families had also developed collections of Chinese antiquities by the beginning of the Edo period.

Works of art that were documented as having belonged to the celebrated Ashikaga shogunal collection held the highest status, but all fine Chinese objects were appreciated and valued. Scroll trays (cat. 137), writing brushes, seal cases (cat. 147), incense boxes (cats. 127, 128), teabowl stands (cats. 133, 134) and trays (cats. 149, 150) of Chinese lacquer decorated by carving, inlaying of mother-of-pearl, or engraving were displayed in the shelves or the writing alcove of the *shoin*-style reception room, or used for serving tea. For tea, antique objects from China were often combined with objects made by Japanese craftsmen.

The prestige and aesthetic distinction of the art collections of the Ashikaga shoguns influenced the preferences of the Tokugawa shoguns for specific styles of Japanese lacquerware and encouraged their patronage of master craftsmen who were descendants of the lacquer artists who had served the Ashikaga. Japanese *maki-e* lacquers commissioned by the Ashikaga shoguns were highly valued, both for their history of association with the shogunal collections and for their intrinsic quality and beauty. The lacquer objects made for Ashikaga Yoshimasa (1435-1490, r. 1449-1474), whose refined taste dominated the cultural world of the late fifteenth century, were especially admired.[2]

Among the works of art commissioned by the Tokugawa shoguns were copies of the famous Higashiyama lacquers, named for Ashikaga Yoshimasa's residence in eastern Kyoto. In his diary, *Mume ga e suzuri-bako nikki* (Diary of the Making of a Writing Box with a Plum-branch Design),[3] lacquerer Kōami Iyo (1661-1723) records the details of his commission in 1718 by the shogun Tokugawa Yoshimune (1684-1751) to make a copy of a *suzuri-bako*, or box for inkstone and writing equipment, that had formerly belonged to Ashikaga Yoshimasa. Yoshimasa's writing box had been made by Kōami Iyo's ancestor, Michikiyo. As the diary relates, even for a direct descendant of a lacquerer of the Higashiyama era, the re-creation of a lacquer box to match the exceptional quality of that period proved to be more costly in terms of material and labour than he had anticipated. Work on the box was expected to require ninety days of labour by several skilled craftsmen, but an additional twenty days was requested and granted.

Kōami Iyo's detailed diary provides specific information concerning the time, materials and painstaking labour required by commissions for lacquerwork of the utmost quality. Commissions by important patrons often carried deadlines determined more by the needs of the patron than by the requirements of the craftsmen, who were obliged to allow adequate time for the lacquer to set properly between each procedure. Patrons also retained the prerogative to suggest, approve or modify the designs of major projects. The Tokugawa shoguns maintained an office where the master artisan would report to government officials during the course of a com-

[2] See Beatrix von Ragué, *A History of Japanese Lacquerwork* (Toronto and Buffalo: University of Toronto Press, 1976), pp. 112-121, and in particular p. 113, pl. 92, for an illustration of a Kasugayama writing box that is documented as having belonged to Ashikaga Yoshimasa.

[3] For English translation and description, see Andrew J. Pekarik, *Japanese Lacquer 1600-1900: Selections from the Charles A. Greenfield Collection* (New York: The Metropolitan Museum of Art, 1980), appendix 1, pp. 121-123. The text of the diary in Japanese is published as Kōami Iyo, "Mume ga e suzuribako nikki" [Diary of the Making of a Writing Box with a Plum branch Design] (1718); "Tada isshin" [Single-minded Concentration] (1720).

missioned project. Work in progress was submitted regularly for inspection and approval by the official in charge. These government representatives might also co-ordinate collaborative projects where, for example, a painter who held an official appointment in the service of the shogun might be required to provide designs to be executed by a lacquerer. The ultimate result of this system for overseeing paintings, lacquerware and other art projects was to ensure a superior and remarkably consistent standard of technical quality in the official arts commissioned by the Tokugawa, while favouring conservative rather than innovative approaches to subject matter and design.[4]

The creation of a lacquer dowry for the wedding of the daughter of a shogun or daimyo was one of the most prestigious and demanding commissions that could be received by a master lacquerer. The lacquer dowry consisted of numerous pieces of furniture, such as portable shelves, mirror stands (cats. 187, 188, 190), kimono racks (cat. 191), basins (cats. 197, 198) and storage containers for clothing, personal possessions, cosmetics, mirrors and combs. Writing boxes, desks and reading stands for literary pursuits were also included, together with equipment for amusements such as the shell-matching game (cats. 183-186) and incense identification contests. The lacquer dowry comprised, in fact, all the objects needed by the bride for her personal use in her new home, plus a splendid palanquin to carry her from her childhood residence to her husband's domain.

Of these lacquer objects, the palanquin (cat. 208) and the large portable chests — used to transport the bride and her property during the wedding procession — were the only ones not of a predominantly intimate nature. Processions were an important and regular feature of Japanese life during the Edo period, being an essential part both of weddings joining families of high social rank and of the *sankin-kōtai* system, which required daimyo to spend alternate years resident in Edo.

As important public symbols of power and status, processions and marriages — together with related questions concerning numbers of attendants, numbers of palanquins and selection of those to be carried — were addressed by Tokugawa laws such as the *Buke sho-hatto* (Rules for the Military Houses, cat. 14) and later sumptuary edicts. The typical palanquin for a high-ranking woman of the daimyo class during the Edo period echoes, on a smaller scale, the principal details of the architecture of palatial residences such as Nijō Castle in Kyoto, built for Tokugawa Ieyasu: the buildings and the palanquins alike are adorned with gilt-metal fittings, gold, silver, and black lacquer decoration, while the interior chambers of both, seen only by the owners or invited guests, are resplendent with colourful paintings on gold-leaf paper that entirely cover the walls and ceiling.

The remainder of the lacquer dowry consisted of objects for private use, known as *oku-dōgu*. Because the lacquer dowry was one of the most important expressions of the social status and wealth of the bride's family, no expense was spared in commissioning the finest lacquerwork within their means. Often, indeed, this demonstration of wealth was the lacquer dowry's primary function, for in many cases the objects were hardly used, but were preserved in the family storehouse and cherished as part of the family estate.

[4] For a discussion of the workshops of painters of the Kanō school, who served the Tokugawa shoguns, see Yoshiaki Shimizu, "Workshop Management of the Early Kanō Painters, ca. A.D. 1530-1600", *Archives of Asian Art*, vol. 34 (1981), pp. 20-45.

To ensure the very finest quality in the lacquer dowry, the wealthy and powerful Tokugawa shoguns and their close relatives engaged the greatest lacquer masters. The outstanding lacquer dowry completed in 1639 for the marriage of Chiyohime (or Reizei-in), the eldest daughter of of the third Tokugawa shogun, Iemitsu (1604-1651), to Mitsutomo (1625-1700), the second lord of the Owari Tokugawa family, was supervised by master lacquerer Kōami Nagashige (1599-1651). Descended from lacquerers who had served the Ashikaga shoguns and successive military rulers such as Toyotomi Hideyoshi, Nagashige was the heir to a legacy of knowledge of his craft and of important commissions for the military elite. The elegant decoration of the Kōdai-ji, the mortuary temple built for Hideyoshi and completed in 1605, had been executed by lacquerers of the Kōami family.

Chiyohime's lacquer dowry of more than fifty pieces of furniture and accessories was completed in less than three years. The dowry is known as "Hatsune" (First Warbler), the title of the twenty-third chapter of the *Tale of Genji*, the classical literary masterpiece of the Heian period (794-1192). Written by court lady Murasaki Shikibu around the year 1000 A.D., the *Tale of Genji* describes the romances of Prince Genji in the rarified world of the Heian court aristocracy.

The selection of a theme from the *Tale of Genji* for the decorative programme of the Hatsune dowry may seem to have been motivated mainly by a nostalgia for an earlier era and a desire to repeat the historical pattern of shoguns and daimyo identifying with and assuming many of the customs of the Heian aristocracy. However, in light of the political events preceding the marriage of Chiyohime, including the abdication of Emperor Go Mizunoo in 1629, the courtly theme of the lacquer dowry for the daughter of the immensely wealthy shogun must have had the effect of casting an ironic glow over the eclipse and impoverishment of the Kyoto nobility.

Whatever the motivations for Iemitsu's selection of the Hatsune chapter of the *Tale of Genji* for his daughter's wedding furniture, the theme is repeated frequently in lacquers made for the Tokugawa and other daimyo patrons throughout the Edo period. Furthermore, chapter twenty-four of the same work — entitled "Kochō" (Butterflies) — is the theme of other lacquer furniture once owned by Chiyohime.

The Hatsune dowry, which has been kept among the possessions of the Owari Tokugawa family now in the Tokugawa Art Museum, represents the outstanding achievement of Kōami Nagashige and his workshop under the patronage of shogun Iemitsu (fig. 1). Like Iemitsu's major architectural project, the Tōshōgū Shrine at Nikkō, dedicated to his grandfather, Tokugawa Ieyasu, the Hatsune dowry for his daughter is an expression of the supreme confidence and extravagant wealth of Iemitsu as a ruler and a patron of the arts. The individual pieces of the Hatsune dowry are encrusted with precious gold, silver and coral. Like jewellery in other cultures, the lacquer dowry of Japan was an embodiment of affluence.

Two pieces in this exhibition — a seventeenth-century stationery box and writing table (cats. 204, 205) — are comparable in style and quality to the objects in the Hatsune dowry. Decorated with gold and silver *maki-e* and inlays of calligraphic characters and beads in cast silver and

gold, these objects represent the outstanding quality of lacquers made for high-ranking members of the Tokugawa family in the early Edo period. Another object on display — an elaborate lacquer box for *shikishi* (cat. 207), the decorated squares of paper used for calligraphy — reflects the high status of the art of writing with a brush, which was practised by both men and women in daimyo households.

In comparison with the varied decorative themes of lacquer objects made for other patrons, the lacquers made for the Tokugawa family tend to repeat a limited canon of themes and to perpetuate an elaborate but orthodox decorative style. The increasing innovation and novelty of design that characterizes lacquer objects made for patrons of the burgeoning merchant class was not encouraged in officially commissioned work.

Other daimyo families, apart from the Tokugawa, also sought to commission lacquers from outstanding craftsmen. Among the lacquerers who worked for daimyo patrons during the Edo period, the Igarashi family shared with the Kōami the distinction of having served the Ashikaga shoguns. Although attribution of surviving lacquer objects to specific Igarashi lacquerers is difficult, Igarashi Dōho (d. 1678) is associated with several outstanding works of the early Edo period.[5] Dōho, after beginning his career in Kyoto, moved in the mid-seventeenth century to Kanazawa, the seat of government of Kaga Province, in western Japan. There, he established a lacquer workshop under the patronage of the daimyo of Kaga, Maeda Toshitsune. This outstanding artist's move from Kyoto resulted in the establishment, for the Kaga daimyo, of lacquer workshops that continued to produce lacquerware of distinctive design and technique, and of quality comparable to the shogun's lacquers.

The rise of the merchant class, who were theoretically at the bottom of the Tokugawa hierarchy of warrior, farmer, artisan and merchant, created a new category of patrons for lacquerers. Despite sumptuary edicts issued by the shogunate to restrict ownership of luxurious goods, the merchants began to use their accumulated wealth to indulge a taste for such possessions.

Strict enforcement of the sumptuary edicts was difficult and burdensome to the shogunate, who could not send inspectors into every household. Frugality in public and extravagance in private became a typical pattern for the wealthy but not officially privileged merchants. Numerous families of lacquerers with less venerable heritages than those who enjoyed the patronage of the shoguns and the daimyo flourished in the thriving city of Edo as their patrons collected lacquerware of varied designs in accordance with fashion and individual taste.

During the Edo period, then, lacquer occupied an exalted position in the hierarchy of the arts. The Japanese lacquers decorated in gold and silver and the rare antique Chinese lacquers that were part of the collections of the shoguns and the daimyo were manifest symbols of wealth and power. The lacquer objects owned and commissioned by the Tokugawa and other important daimyo illustrate to perfection the grandeur of their surroundings, surroundings that were the tangible expression of how these people defined themselves in a social order where their position was supreme.

[5] See von Ragué, p. 196, pl. 162, for an illustration of a writing box with an autumn field decoration by Igarashi Dōho (private collection, Japan).

BIBLIOGRAPHY

Shimizu, Yoshiaki. "Workshop Management of the Early Kanō Painters, ca. A.D. 1530-1600", *Archives of Asian Art*, vol. 34 (1981), pp. 20-45.

Tokugawa, Yoshinobu, *et al.*, *The Shogun Age Exhibition from the Tokugawa Art Museum, Japan.* Tokyo: The Shogun Age Executive Committee, 1983.

von Ragué, Beatrix. *A History of Japanese Lacquerwork.* Translated by Annie R. de Wasserman. Toronto and Buffalo: University of Toronto Press, 1976.

Yonemura, Ann. "Art and Authority: A Tokugawa Palanquin", *Asian Art*, vol. II, no. 1 (January, 1989).

# THE TOKUGAWA

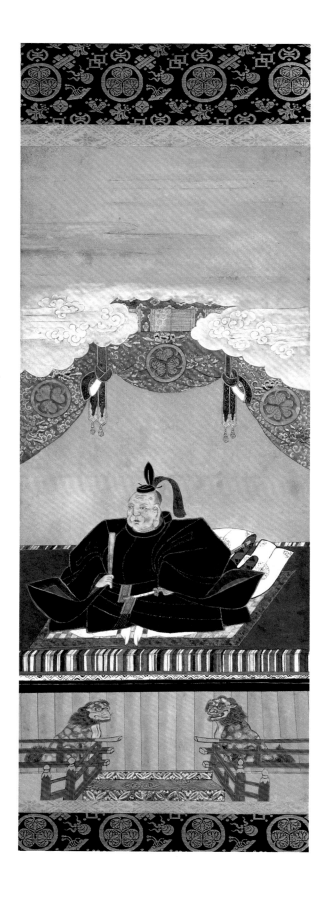

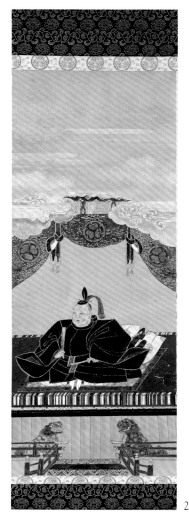

2

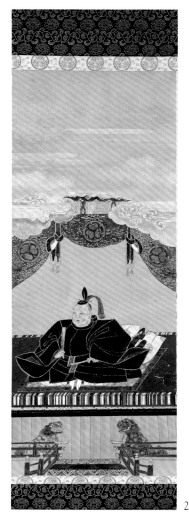

## PORTRAIT OF TOKUGAWA IEYASU

Kanō Tan'yū (1602-1674)
Hanging scroll, ink, colours, gold pigment and
gold and silver leaf on paper
89.7 x 38.8 cm
Edo period, 17th century

In 1603 Tokugawa Ieyasu was appointed *Seii-taishōgun* (Barbarian-subduing Generalissimo), abbreviated "shogun", a title given to the chief holder of political power in the military administration of the country. Originally, this post had been a temporary imperial commission conferred on a general charged with subjugating offending "barbarians" (which, at the time, meant the indigenous people of eastern Japan). From the Kamakura period (1192-1336) onward, however, when the military class seized the reins of government, the post of

shogun came to embody supreme authority in all affairs of state — political and economic, as well as military.

Ieyasu was born in troubled times, when the country was torn by wars among rival regional lords defending their local authority. By virtue of his personal qualities and by force, he attained the office of shogun after a succession of victories in a fierce struggle for power. Sixty-two years old when he took over as shogun, Ieyasu died of illness thirteen years later at the age of seventy-five. Even after his death, peace and stability continued for two and a half centuries under the Tokugawa administration. A harmonious culture flourished throughout the Edo period (1603-1868), which derives its name from the seat of the Tokugawa regime in Edo (present-day Tokyo).

Ieyasu was honoured posthumously as the founder of the Edo period and of the Tokugawa shogunate; his person and his exploits were even raised to the level of a religious cult.

The style of this portrait is based on an icon-like style of Shinto painting. Represented in old age, Ieyasu is depicted as a deity. Portraits of him of this type are said to have been painted by Kanō Tan'yū, the foremost among the artists officially attached to the Tokugawa shogunate.

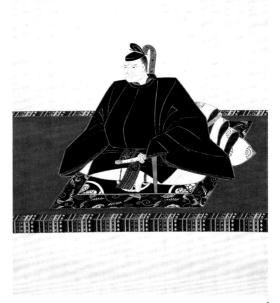

3

4

## 2

### *PORTRAIT OF TOKUGAWA IEYASU*

Sakurai Seikō
Hanging scroll, ink, colours, gold pigment and gold and silver leaf on paper
99.4 x 39.1 cm
Copy from the 12th year of the Shōwa era (1937)

## 3

### *PORTRAIT OF TOKUGAWA YOSHINAO*

Sakurai Seikō
Hanging scroll, ink, colours and gold on paper
139.4 x 48.2 cm
Copy from the 12th year of the Shōwa era (1937)

## 4

### *PORTRAIT OF TOKUGAWA YOSHINAO*

Sakurai Seikō
Hanging scroll, ink, colours and gold on paper
142.4 x 70.3 cm
Copy from the 12th year of the Shōwa era (1937)

Tokugawa Yoshinao, the ninth son of Tokugawa Ieyasu, was born in the fifth year of the Keichō era (1600), when

Ieyasu was fifty-seven. The three sons born to Ieyasu during the latter years of his life played an important role in the consolidation of the shogunate. Yoshinao and his younger brothers Yorinabu and Yorifusa founded, respectively, the Owari, Kii and Mito domains, and were commonly known as the *Go-sanke*, or the "Three Honourable Families". From his father, Yoshinao inherited above all a taste for learning. In addition to writing a great many works on history, military strategy and Shintoism, he excelled in painting and calligraphy.

Number 3 is a copy made in the twelfth year of the Shōwa era (1937), after an original portrait of Yoshinao that belonged to the Shōjō-ji temple, which sits atop Mount Tokuju, in the district of Naka-Ku, Nagoya. The temple, founded by Yoshinao's son Mitsutomo, direct

second-generation descendant of the Owari Tokugawa, was destroyed during the Second World War. Number 4, also executed in 1937, is an enlarged copy of the original portrait of Yoshinao.

5

## PORTRAIT OF SŌŌ-IN

Sakurai Seikō
Hanging scroll, ink and colours on silk
80.6 x 34.1 cm
Copy from the 11th year of the Shōwa era
(1936)

Okame-no-kata, the mother of Toku-
gawa Yoshinao, first lord of Owari,
was one of Tokugawa Ieyasu's concubines.
After Ieyasu's death, she withdrew from
public life and took the name Sōō-In.
She died on the sixteenth day of the
ninth month of the nineteenth year of
the Kanēi era (1642), at the age of sixty-
seven. A temple was dedicated to her in
Nagoya.

The present work shows Sōō-In sitting
in an upright posture on a tatami mat.
She is wearing a flowing green robe (uchi-
kake) over a red kosode and is holding a
rosary in her right hand. The freshness of
the face suggests that Sōō-In was still
young when the portrait was painted. The
original Edo period portrait is at the
Seiryō-in temple in Fukakusa, Kyoto.

6

## GENEALOGY OF THE
## TOKUGAWA FAMILY

Brocade-bound folding book, ink on gold leaf
and paper
33.1 x 1,711 cm
Edo period, 17th century

This document outlining the genealogy
of the Tokugawa family dates from
the reign of Emperor Seiwa (858 to 876).
It includes the children and a number of
the granchildren of Tokugawa Ieyasu,
who compiled it. The cover is bound in a
brocade designed especially for the book.
The paper used in the document is sprin-
kled with gold and silver powder and dec-
orated with plant and floral motifs exe-
cuted in gold powder mixed with diluted
glue. All these elements contribute to the
document's opulent appearance.

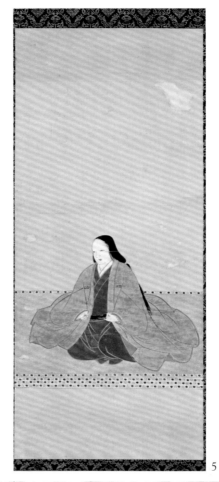

5

6

84

7

## SUMPU ONWAKEMONO-CHŌ
Record of the property bequeathed to
Tokugawa Yoshinao from Tokugawa Ieyasu

Three books, ink on paper
28.3 x 21.8 cm each
Edo period, 1616-1618

These books form a catalogue of the
property that Tokugawa Yoshinao,
the first lord of Owari, inherited from his
father, Ieyasu, the first Tokugawa shogun.
In 1605, only two years after he had
received the title of shogun from the
emperor, Ieyasu turned over that position
to his son Hidetada and retired to
Sumpu Castle in Suruga (today the
Shizuoka Prefecture). Ieyasu died there on
the seventeenth day of the fourth month
of the second year of the Genna era
(1616) at the age of seventy-five. Follow-
ing his death the property that remained
in the castle was divided among four of
his surviving five sons: Hidetada, the sec-
ond shogun; Yorinobu, the first lord of
Kii; Yorifusa, the first lord of Mito; and
Yoshinao, his ninth son. From the elev-
enth month of 1616 to the same month
in 1618, members of the Owari Tokugawa
family journeyed several times from their
castle in Nagoya to Sumpu Castle to
receive their inheritance. This three-
volume estate list was drawn up at that
time; the entire catalogue of Ieyasu's
bequest comprised eleven volumes. Along
with gold and silver, the inheritance of
the Owari Tokugawa included such
diverse items as swords and other weap-
ons, suits of armour, tea ceremony uten-
sils, Nō drama properties, clothing, furni-
ture, art objects such as paintings and
calligraphies, and precious imported tex-
tiles and medicines. Yet more impressive
than the range of luxury goods usually
associated with bequests is the magnitude
of the inheritance. Entries such as 600
white *kosode* garments, 1,800 kilograms of
raw cotton (500 *kan*) and 1,000,000 gold
*koban* coins figure among the listings, viv-
idly illustrating Ieyasu's vast wealth and
providing tangible evidence of the politi-
cal and military power of the first shogun.

Many of the art objects recorded in this
inventory survive today, and a number of
them have been included in the present
exhibition.

8

8

## FINAL INSTRUCTIONS OF
## TOKUGAWA YOSHINAO
## ADDRESSED TO MITSUTOMO

One of two handscrolls, ink on paper
36.3 x 151.7 cm
Edo period, dated 12th day, 2nd month, 3rd
year of the Keian era (1650)

Tokugawa Yoshinao, the first lord of
Owari, died at his Edo residence in
1650 at the age of fifty-one. He wrote two
separate wills — one addressed to his
eldest son and successor Mitsutomo, the
other to the seven principal vassals of the
Owari domain — both of which were
deeply coloured by Confucian ethics. The

will addressed to Mitsutomo can be sum-
marized as follows:
• First and foremost, be loyal to both the
ruling shogun, Iemitsu, and the memory
of his predecessor, Hidetada;
• Do not forget the way of the warrior, its
martial discipline and ethical values, as
exemplified by the life of *Gongen-sama*;
• Be totally honest and upright and exer-
cise proper discretion at all times;
• The principal duty of the head of a clan
is to see into the hearts of his retainers
and see through any evil intentions or
deeds.

9

9

 FINAL INSTRUCTIONS OF TOKUGAWA
YOSHINAO TO THE PRINCIPAL
VASSALS OF THE OWARI DOMAIN

Mounted handscroll, ink on paper
36.3 x 124.9 cm
Edo period, 1650

The will left by Yoshinao for his princi-
pal vassals may be summarized as
follows:
• Watch over my successor [Yoshinao's
eldest son];

• Give him counsel, that he may find his
way back again should he wander from
the true path;
• Lords and subjects must all serve the
shogun's family faithfully and with
devotion;
• Strengthen the armed forces, since they
are necessary, but take care not to
encourage a spirit of rebellion against the
shogunate;
• Isolate and severely punish corrupt ele-
ments of the court;

• See that none of the mementoes I
bequeath is excluded from the
apportionment.
   It is believed that the black ink seal
affixed below the signature on this docu-
ment was reserved for Yoshinao's personal
use, unlike that found on official docu-
ments concerning his subjects and on
paintings and calligraphies. This seal also
served when books were withdrawn from
his library.

 MAP OF THE LAND CONTROLLED BY
THE OWARI TOKUGAWA FAMILY

Hanging scroll, ink and colours on paper
171.5 x 122.5 cm
Edo period, 1698

This is a map of the land possessed by the Owari Tokugawa, which included all of Owari province and a part of Mino province. The lord of Owari had total control over the administration, adjudication and taxation of this territory.

The *gun* (counties or major administrative sub-divisions of the provinces) are distinguished by colour with the names of the villages and major roads recorded in black ink. Agriculture was the basis of the economy during the Edo period, with rice being the main crop. Rice was so important to the diet and economy of Edo society that the output of a piece of land, even if it was used to produce other crops, was expressed in terms of rice. The information in this map is based on a cadastral survey taken in 1698. According to that survey, there were over 1,800 villages within this domain and an annual yield of over 645,000 *koku* of rice (or about 110,000 kilolitres) in that year. The number of villages within an area was a particularly important figure since the village was the basic unit by which the output of an entire province was measured. Due to such factors as 250 years of unbroken peace, advances in agricultural technology and the development of new farmland, agricultural output in the Edo period increased significantly. During the Edo period, the administration of frequent and accurate cadastral surveys to evaluate the production level of each village was one of the most important duties of feudal lords.

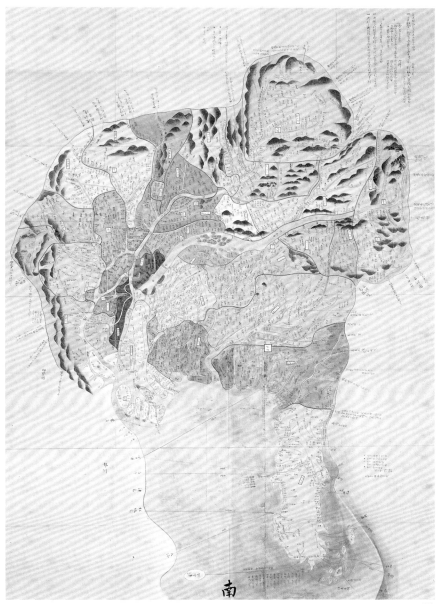

10

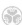

11

 MAP OF NAGOYA CASTLE AND ITS
SURROUNDING TOWN

Hanging scroll, ink and colours on paper
89.3 x 103 cm
Edo period, 19th century

This diagram of Nagoya Castle and the surrounding city depicts the home of the Owari Tokugawa clan, which ranked second only to the shogun himself. The castle and its supporting town were planned and built under the supervision of the first shogun, Ieyasu, from 1610 to 1612.

The two most important considerations in the planning for castle towns of the Edo period were the psychological element, for the majestic presence of the castle exerted a powerful influence over the general populace, and the practical factor of defensive capability in times of unrest. These considerations were manifested in the scale of the castle enclosure, the placement of the residences of the samurai, connections provided by the moats for overland and water transport, location of the temples and the special arrangements of roads and pathways. Another significant consideration was the promotion of the town's economic prosperity through the concentration of commercial and industrial activities in the town precincts. The city of Nagoya was planned and constructed with the aim of fulfilling the above requirements, and it was the second largest castle town in Japan, outranked only by the shogunal capital of Edo.

In this map, samurai residences, temples and the merchants' sector are distinguished by different colours, enabling the viewer to perceive readily the characteristics of the separate sectors.

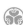

## 12

 DEED TO OWARI PROVINCE
(presented to Tokugawa Yoshinao, first lord of
Owari, by Tokugawa Hidetada, the second
Tokugawa shogun)

Handscroll, ink on paper
45.1 x 61.6 cm
Edo period, dated 25th day, 8th month, 13th
year of the Keichō era (1608)

This document was sent by Tokugawa
Hidetada, the second shogun, to
Tokugawa Yoshinao, the first lord of
Owari, and instructs Yoshinao to take
control of Owari province, which was
officially granted to him at that time.

For the Owari Tokugawa family, this
document was of the utmost importance,
since it provided the very basis for the
existence of the Owari fief. This letter is
dated the twenty-fifth day of the eighth
month of the thirteenth year of the
Keichō era (1608) and corresponds to the
period when the social structure of the
shogunate was in the process of consolida-
tion. Beneath the date appears the writ-
ten seal of Shogun Hidetada in black ink.
Whenever the shogun sent a document of
this nature to a member of the imperial
family or to a daimyo with an income
exceeding one hundred thousand *koku*, he
wrote his own seal as seen here. If the
same kind of document was issued to
lesser daimyo, temples or shrines, or the
nobility, he merely affixed a red stamped
seal, which was a simpler manner of
placing one's signature than using brush
and ink.

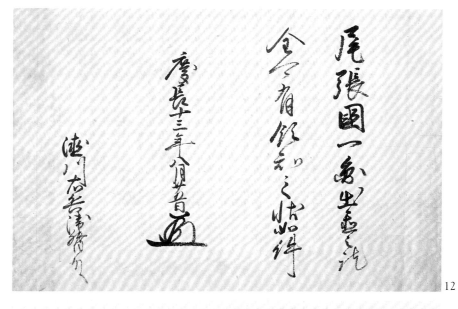

12

## 13

ESTATE DEED

Unmounted sheet, ink on paper
41.4 x 55.5 cm
Edo period, dated 14th day, 9th month, 4th
year of the Shōhō era (1647)

This document is the deed for the
granting of land from the lord of
Owari to one of his retainers. The person
issuing the deed was Yoshinao, the first
lord of Owari. The recipient was an
Owari retainer of middle rank named
Ueda Gohei.

This deed awards to Ueda taxation
rights to approximately two hundred *koku*
(1 *koku* = about 180 litres) of the rice
produced by the two villages of Tamba
and Hachisuka in Owari province. The
tax rates levied on this two hundred *koku*

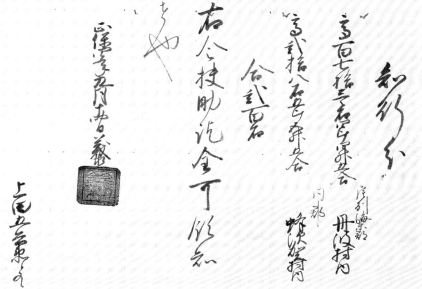

13

were not necessarily the same every year,
but usually about forty to fifty percent. In
a year when the tax rate rose to sixty per-
cent, Ueda received an income of 2,160
litres of rice, with the remaining 1,440
litres becoming the share of the farmers
who produced the crop. The portion of
rice that Ueda received annually and did
not use to feed his family and dependents
would be sold and converted into money
for his own use.

This document not only has the func-
tion of being a clear statement of the
yearly stipend of a retainer, but also fixes
the status of the recipient within the hier-

archy of the fief and regulates the military
obligations that he would be expected to
bear in times of warfare. As a result, it
serves to establish the basis for the very
existence of the Ueda family within the
feudal hierarchy.

In the Owari domain, there were some
1,200 to 1,300 families that were pro-
vided with deeds of this kind in the
course of the Edo period. Such documents
were issued in the event of the accession
of a new lord or a change in the succes-
sion in the household of the recipient, as
well as when the recipient rose or fell in
status.

## 14

### BUKE SHO-HATTO (RULES FOR THE MILITARY HOUSES)

Unmounted sheet, ink on paper
45.8 x 315 cm
Edo period, dated 25th day, 9th month, 6th year of the Ansei era (1859)

The *Buke sho-hatto* is a set of approximately fifteen fundamental laws promulgated by the shogun for the regulation of the conduct of the daimyo and the perpetuation of Tokugawa suzerainty. They were first issued by Tokugawa Ieyasu in 1615, the year of the fall of Osaka Castle, a fall which ended all organized resistance to Tokugawa rule and was the final step in the unification of the country. Afterwards, all the succeeding fourteen shoguns, at the time of their succession, would summon the daimyo throughout the land to gather at the official residence, Edo Castle, where the regulations would be read publicly and the daimyo would pledge absolute submission and obedience to the new military ruler. This edition of the *Buke sho-hatto* was one of the last ever issued. Dated on the twenty-fifth day of the ninth month of the sixth year of Ansei (1859), it was presented at that time to the Owari Tokugawa family by the fourteenth shogun, Tokugawa Iemochi (r. 1858-1866).

Among its provisions, which varied somewhat from edition to edition, the

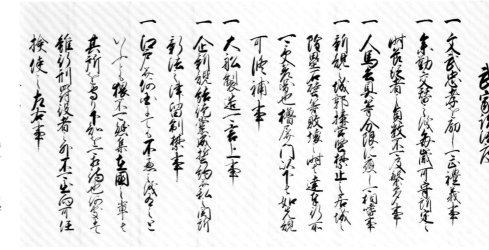

14

*Buke sho-hatto* exhorted the daimyo to excel in both the martial and literary arts. There were prohibitions on all new castle construction, and castle renovation was also restricted. Daimyo were forbidden to form leagues, and all marriages between their families required official sanction. The rules governing the *sankin-kōtai* system, in which daimyo were required to spend alternate years at their Edo residences, were made explicit. A daimyo who breached any of these rules would face severe punishment and the dissolution of his family.

Besides the *Buke sho-hatto*, which was aimed at the daimyo, the shogun drew up another set of laws for those retainers under his direct control and yet another for the benefit of the emperor and the nobility. This latter group of rules, known as the *Kinchū kuge sho-hatto* (Rules for the Palace and Court), was also first published in 1615. The fact that these three sets of ordinances were strictly observed by the groups for which they were intended gives some indication of the extent of the shogun's authority.

## 15

### THE PROCESSION OF A DAIMYO TO EDO

Odagiri Shunkō (1810-1880)
Handscroll, ink and colours on paper
28.9 x 2,588.2 cm
Edo period, 19th century

The feudal lords, or daimyo, of the Edo period were required to maintain two households, one in their native domain and another in the capital city of Edo. Under a shogunal decree they were obliged to spend alternate years at their Edo residences (*sankin-kōtai*). Moreover, when a daimyo returned to his provincial lands he was compelled to leave behind his wife and children as virtual hostages of the shogunate. This system was instituted in order to ensure that daimyo of fiefs far from the capital would be unlikely to instigate a rebellion against the shogun.

Thus throughout the Edo period there were approximately 260 to 270 daimyo every year who made the round-trip

journey between their own provincial domains and the capital. The makeup of a processional retinue was strictly regulated by sumptuary laws so as to be commensurate with a daimyo's standing and the size of his fief. Its basic character was that of a military parade, including in its ranks the various detachments of lancers, musketeers and archers, in addition to units for transporting stores of food and sundry provisions and furnishings to meet the necessities of daily life. Eager to make a display of their might, the daimyo organized colourful processions of considerable pomp and splendour. Comprised at the very least of one hundred men, they are often reported to have numbered several thousand.

Residents along the route swept the highway at the daimyo procession's approach and prostrated themselves at the roadside, waiting until it had passed. These were occasions for the rural population not only to witness the power of the daimyo, but also to experience indirectly

the authority of the shogun, the master of these regional lords who were constantly coming and going in processions over the highways. The daimyo were constrained to accept each year the tremendous drain on their purses caused by this frequent travel. Clearly, the custom was one of the measures by which the shogun was able to exercise his control over powerful provincial lords.

With the growing number of travellers bound for or returning from Edo created by these processions, the highways and facilities at post towns were expanded and consolidated. These travellers also promoted the dissemination of Edo culture throughout the provinces.

This handscroll depicts the Owari Tokugawa family procession headed toward Edo from Nagoya, the clan seat. Tradition attributes the work to Odagiri Shunkō, a middle-ranking retainer known also as a painter.

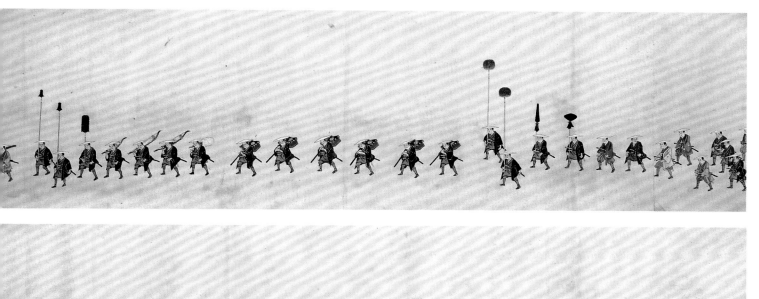

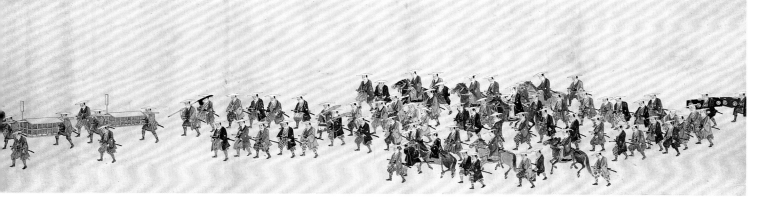

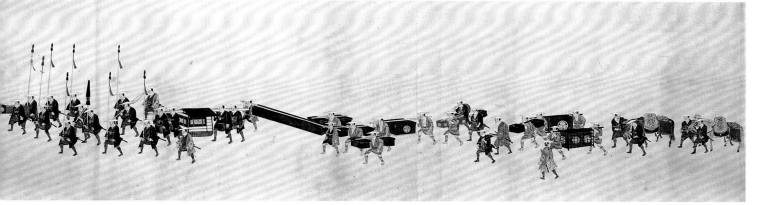

15

 ARMS AND ARMOUR

## 16

### SUIT OF ARMOUR IN Ō-YOROI STYLE

Black-lacquered iron plates with black silk
lacing
165 cm (height with stand)
Edo period, 18th century

This suit of armour is made in the
ō-yoroi style, which is the most
formal type of armour for high-ranking
samurai. Used for actual combat purposes
from the middle of the Heian period
through the late Muromachi period
(10th-15th cent.), ō-yoroi were used for
ceremonial purposes in later periods. This
set of decorative armour was produced to
be worn on ceremonial occasions by
Matsudaira Katsunaga, who was the sixth
son of Munekatsu, eighth lord of Owari.

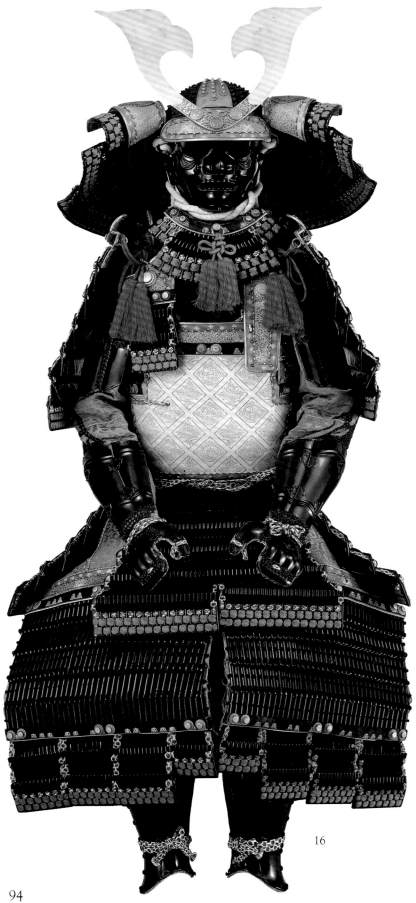

16

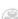

# SUIT OF ARMOUR IN *GUSOKU* STYLE

Silver-lacquered iron plates with white silk
lacing
170.5 cm (height with stand)
Edo period, 17th century

This suit of armour is in the *gusoku* or, more properly, *tōsei-gusoku* (modern equipment) style. Of the different types of Japanese defensive armour, the *gusoku* style is the most recent, having been developed during the Momoyama period (16th cent.). Drawing from experience derived over a period of prolonged warfare, *gusoku* is characterized by lightness and flexibility, in addition to affording strong protection.

This armour was made to be worn by Tokugawa Yoshinao, first lord of Owari. Of the many suits of armour owned by Yoshinao, this one is said to have been his favourite.

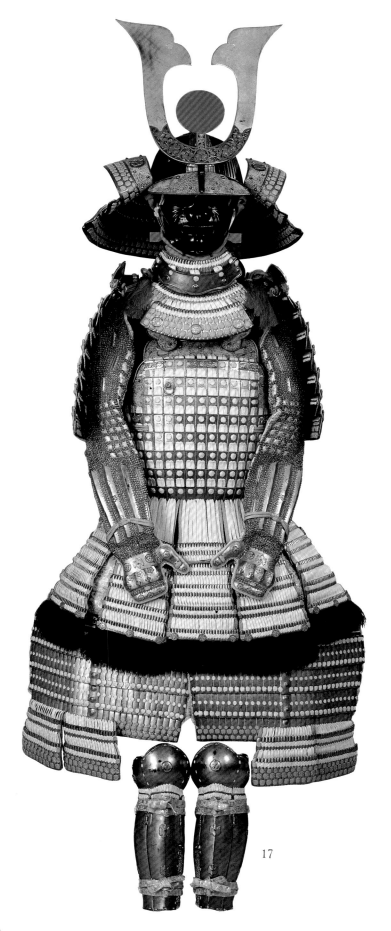

17

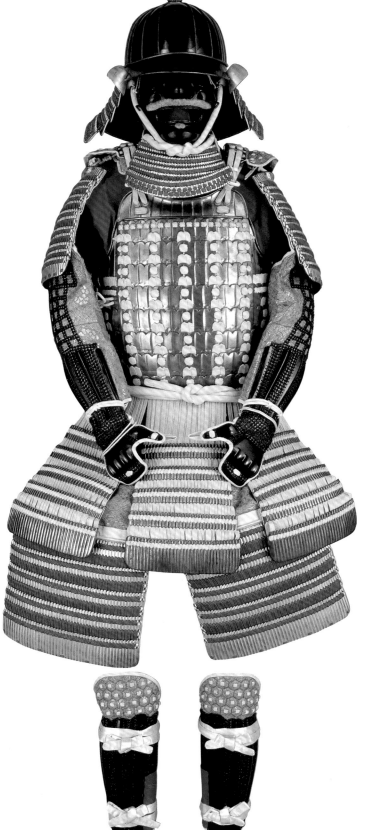

18

SUIT OF ARMOUR IN *GUSOKU* STYLE

Silver-foiled leather plates with white silk
lacing
155 cm (height with stand)
Edo period, 18th century

Made in the *tōsei-gusoku* style, this
suit of armour consists of a cuirass,
designed to protect the trunk of the
wearer, composed of small leather plates
covered with silver foil and tied together
with white silk lacing. Over the years,
silver usually oxidizes and blackens, but
the excellent state of preservation of this
suit of armour is evidenced by the attrac-
tive silver colour it retains. Segments of
the white silk lacing have been restored.
The overall white and silver colour scheme
is sumptuous, and portions have been
accented with gold instead of silver leaf.

This suit of armour was worn by
Michimasa, nineteenth among the chil-
dren of Tsunanari, third lord of Owari.

18

## 19

### SUIT OF ARMOUR IN *GUSOKU* STYLE

Black-lacquered leather plates with white silk
lacing
155 cm (height with stand)
Edo period, 19th century

This suit of armour is also in the
*tōsei-gusoku* style, which was popular
during the Edo period. The principal
components of Japanese armour were
made of small lacquered iron or
leather plates tied together with coloured
silk lacing. During the tranquil Edo
period, the function of armour became
largely ceremonial, and many sets were
made using small joined leather plates,
like the present example, rather than the
heavier, stronger iron plates.

The leather plates of this suit of armour
have been coated with black lacquer and
joined with white silk lacing. In addition
to this white lacing, vermilion and multi-
coloured plaited lacing has been used for
the borders. Lacing of this type could only
be used by samurai of high rank.

This suit of armour was worn by
Tokugawa Yoshinori, sixteenth lord of
Owari.

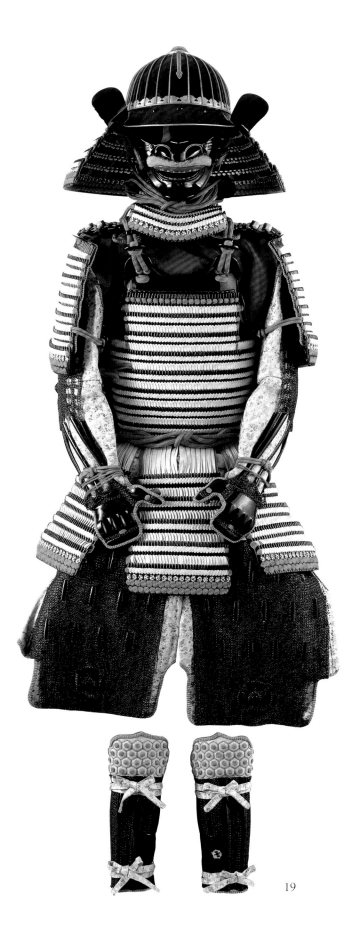

19

## 20

 BATTLE DRUM

Wood and leather
37.9 cm (diameter)
Edo period, 17th century

Battle drums (*jin-daiko*) were used on the battlefield to give the signal to attack or retreat. Such drums were extremely useful: once a code had been agreed upon, it was possible to communicate the generals' orders to all battalions, even at night.

The frame of this drum is covered with black lacquer, and the skins at both ends are decorated with three comma-shaped motifs forming a spiral, also in black lacquer.

This drum was used by Tokugawa Yoshinao, first lord of the Owari domain.

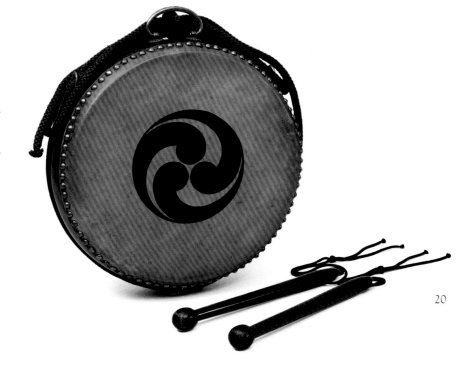

20

## 21

 MILITARY LEADER'S FAN

Wickerwork with *tame-nuri* (cinnabar) and black lacquer
64.5 × 32.1 cm
Edo period, 17th century

## 22

 BATON WITH TUFT OF YAK'S HAIR

Black-lacquered rod
36.4 cm (rod), 60.2 cm (tuft)
Edo period, 17th century

## 23

 MILITARY LEADER'S FOLDING FAN

Wood, paper, designs in gold and silver pigment
36.2 × 57.2 cm
Edo period, 17th century

Combat during the medieval period in Japan was largely hand-to-hand. From around the end of the Muromachi period, however, combat strategies altered in favour of military formations using spear and firearm battalions. For this reason, many different types of instrument to be used by the commander to direct the movement of his troops were ingeniously devised. Signal calls with gongs, drums and conches were used effectively to command a large body of troops. There were also instruments, however, resembling a baton of command, that were used as symbols to indicate the rank of the supreme commander of the army.

Number 21 is a rounded, flat fan, while number 23 is a folding fan with a Wheel of the Law pattern. Number 22 consists of a rod with a tuft of white yak's hair attached at one end. Since the yak is indigenous to high altitude areas in Tibet and northern India, its hair was, of course, imported. The Japanese people of the time believed it to be the fur of a white bear. Since the bear had a widespread reputation for ferocity, this fur was highly prized as decoration for armour and weaponry.

Number 21 was used by Tokugawa Tsunanari, third lord of Owari, while numbers 22 and 23 were used by Yoshinao, first lord of Owari.

21

22

23

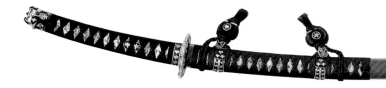

24

24

## TACHI MOUNTING

Aventurine lacquer ground with thread-wrapped scabbard and leopardskin sheath
104.2 cm (length), 53 cm (scabbard)
Edo period, 18th century

This type of mounting was produced for the *tachi*, a long curved sword whose blade exceeded sixty centimetres in length and was worn slung from the left side of the sash with the cutting edge facing downward. The thread-wrapped *tachi* mounting, or *itomaki-no-tachi*, was a type of *tachi* mounting that had been widely used since the late Kamakura period and derived its name from the fact that not only the hilt but also the upper part of the scabbard was wrapped with silk braid. Originally worn in actual combat, the wrapping was provided to facilitate the drawing of the blade. The present mounting is shown here as a *shirizaya-no-tachi*, in which a removable fur sheath was provided for the scabbard to protect it from the weather. The type of fur used was determined by the rank of the wearer, and deer, wild boar or bear skins were commonly used for this purpose. This example, however, is presently provided with a sheath made of imported leopardskin, reserved for samurai of especially high rank.

The metal fittings for this mounting are made of an alloy of copper and gold called *shakudō*, with detailed gold and silver inlay on a *nanako* (literally "fishroe") ground, exhibiting granulation produced using a round-headed chisel. The high quality of all of the components of this mounting is in keeping with the exalted rank of the lords of Owari.

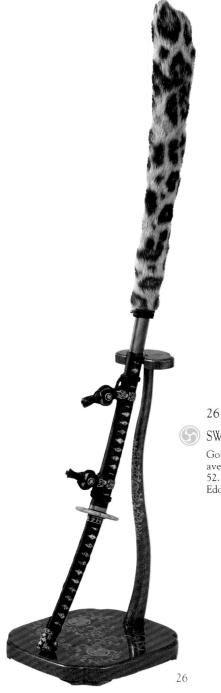

26

## SWORD STAND FOR TACHI

Gold and silver *maki-e* designs on an aventurine lacquer ground
52.2 x 27.5 x 24 cm
Edo period, 19th century

26

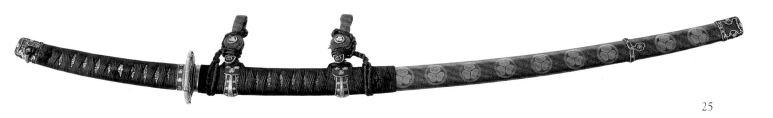

## 25

### TACHI MOUNTING

Thread-wrapped scabbard, *maki-e* designs on an
aventurine lacquer ground
100 cm
Edo period, 18th century

*Tachi* mountings meant to be worn sus-
pended from the sash with a cord so
that the cutting edge faced downward
were popular from the Heian through
Muromachi periods. Toward the end of
the Muromachi period, however, it
became preferred practice to thrust the
sword into the sash with the cutting edge
upward to facilitate drawing and striking.
During the Edo period, *tachi* fell largely
into disuse among the majority of samu-
rai, and this type of mounting was rele-
gated to formal use by the shogun, daimyo
and court nobility.

This mounting, decorated with *aoi*
crests, belongs to the *itomaki-no-tachi* type
(see cat. 24) and was produced to serve
as the mounting for a blade engraved with
a chrysanthemum crest, named "Kiku
Gosaku". Part of the scabbard and the hilt
of this mounting are wrapped with blue
silk cord. In 1713, Tokugawa Gorōta,
fifth lord of Owari, dedicated this mount-
ing to the mausoleum of the previous
lord, his father Yoshimichi.

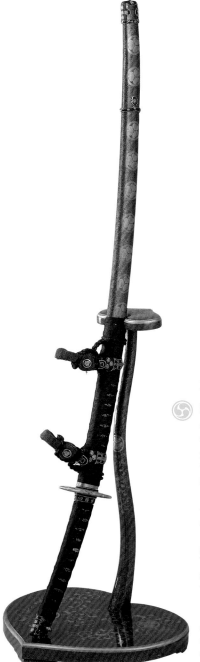

27

### 27

### SWORD STAND FOR *TACHI*

Gold and silver *maki-e* designs on an
aventurine lacquer ground
51.7 × 26.8 × 30 cm
Edo period, 19th century

There are two types of stand for *tachi*:
on one, the sword is placed horizon-
tally, and on the other, it is placed verti-
cally. The two pieces presented here
(cats. 26, 27) are examples of the vertical
stand. The base of number 26 is square.
The aventurine lacquer has been
sprinkled with gold and silver, and deco-
rated with arabesques and mallow leaf
(*aoi*) designs. The base of number 27
is heart-shaped. Made according to the
same process as the first stand, it too is
covered with arabesques and mallow leaf
designs, as well as pine motifs.

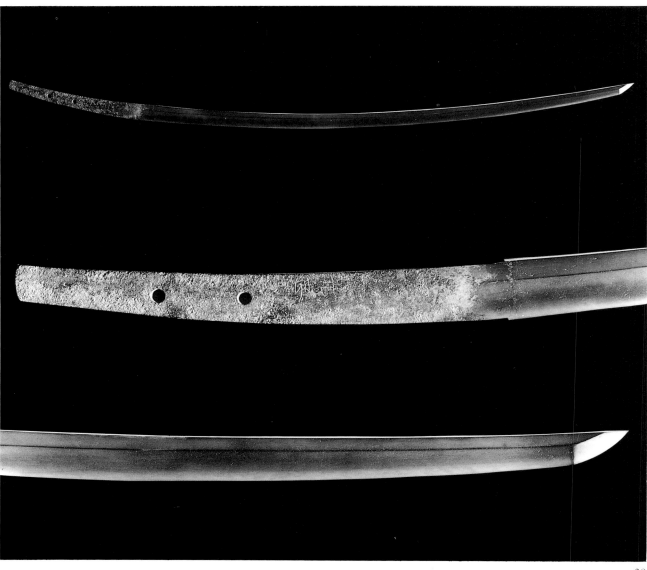

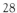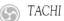 *TACHI*

Inscription: *Mitsutada*
Steel
107.2 cm
Kamakura period, 13th century

Swords were made in several regions of Japan, but the principal workshops were in the provinces of Yamashiro, Bizen and Sagami (today the Kyoto, Ōkayama and Kanazawa prefectures, respectively). The province of Bizen, where there were a number of ironsmiths' guilds — notably the Osafune, the Hatakeda and the Ichimonji — was the country's most important sword-producing region, and

during the Muromachi period much of its output was exported to China.

Japanese swords possess a number of special characteristics related to shape, general appearance, the marks left on the blade during shaping (*hamon*) and execution, and these characteristics vary according to the school, region and period of the individual sword's fabrication.

The present sword bears the inscription of Mitsutada, who was both the founder and the finest craftsman of the best school in the province of Bizen, the Osafune. The sword has been owned by the

Tokugawa family since the third month of the sixteenth year of the Keichō era (1611), when it was given by Toyotomi Hideyori to Tokugawa Yoshinao, first lord of Owari.

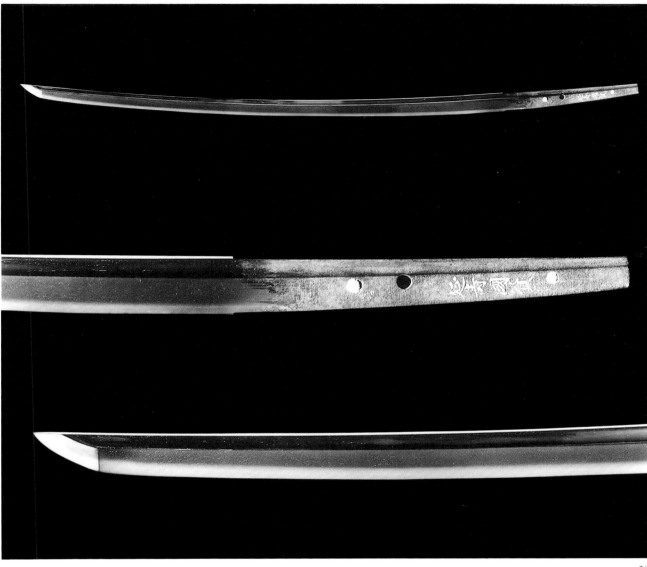

## TACHI

Inscription: *Enju Kunisuke*, inlaid in gold; seal
(*kaō*): *Hon'a*
Steel
91.2 cm
Kamakura period, 14th century

As a result of this sword's inlaid inscription, Hon'ami Mitsutada — a thirteenth-generation member of the Hon'ami family, specialists in Japanese sword identification — was able to establish that the piece was made by Kunisuke, of the Enju school, in the province of Higo (today the Kumamoto Prefecture). The research report that accompanies the sword indicates that Hon'ami Mitsutada undertook his identification on the third day of the sixth month of the fourth year of the Kyōhō era (1719).

The Enju school was founded in the second half of the Kamakura period and lasted until the rise of the North and South dynasties (*Nan-boku chō jidai*) in the fourteenth century. Among the swordsmiths of this school, Kunisuke owes his reputation as a master to his particular way of forging his blades.

This sword was given by the eighth Tokugawa shogun, Yoshimune, to a seventh-generation descendant of the Owari Tokugawa, Yoshiharu, on the occasion of the latter's appointment in the sixteenth year of the Kyōhō era (1731) as *Sakon-e-gon no chū-jō*, a high-level post in the imperial palace guard.

## 30

### KATANA

Attributed to Masamune
Steel
92.1 cm
Kamakura period, 14th century

The report that accompanies this sword tells us that on the third day of the twelfth month of the third year of the Shōtoku era (1713), Hon'ami Mitsutada, a thirteenth-generation member of the Hon'ami family, identified it as being the work of Masamune.

Masamune was the most famous of all Japanese swordsmiths. Today, indeed, the name of Masamune is synonymous with "Japanese sword" (*nihon-tō*). This master-craftsman was born in Kamakura, in the province of Sagami. After learning all the traditional techniques of sword fabrication and assimilating the styles of other schools — notably those of the Bizen region — Masamune created his own style. Masamune's approach had an enormous influence on Japanese sword making and resulted in the founding of a group of craftsmen known as the "Ten Wise Men of Masamune".

In the twelfth month of the third year of the Shōtoku era (1713), Ietsugu, the seventh Tokugawa shogun, presented this sword as a gift to Tokugawa Tsugutomo, sixth lord of Owari, on the occasion of the latter's accession to the position of lord and the bestowal on him by the imperial court of a noble title fitting to his rank.

## 31

### KATANA

Inscription: *Kanemoto*
Steel
88.9 cm
Muromachi period, 16th century

It is known that several generations of master-craftsmen from the province of Mino (today the Gifu Prefecture) took the name of "Kanemoto" during the Muromachi period.

At that time, Mino was the most important sword-producing region in Japan. It boasted a number of schools (notably the Seki and the Shizu) that produced many highly renowned swordsmiths. This particular sword was created by Kanemoto (second generation), the most famous of the Mino swordsmiths, who was better known by the pseudonym of "Seki no mago-roku".

In the eighth month of the third year of the Enpō era (1675), this sword was bequeathed to Tsunanari, third-generation member of the Owari Tokugawa, by Matsudaira Yasunaga, fourth son of Tokugawa Mitsutomo, second lord of Owari.

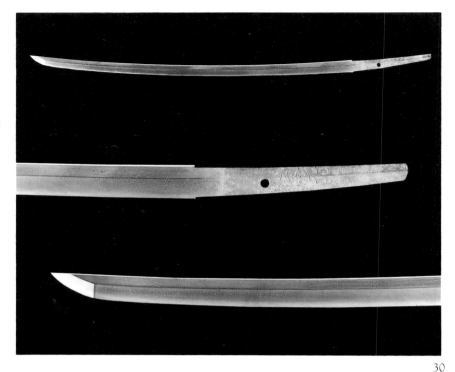

30

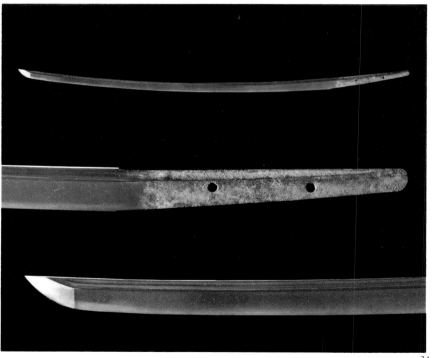

31

## 32

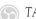

### WAKIZASHI

Inscription: *Sukezane*
Steel
44.3 cm
Kamakura period, 13th century

Originally, Sukezane was a member of the Ichimonji school, in the province of Bizen, but he later moved to Kamakura, in the province of Sagami, and became a master-craftsman of great renown. His style is typical of the early Kamakura period. Sukezane settled in Kamakura in the third year of the Bunei era (1266), on the orders of the imperial prince Koreyasu, seventh shogun of the Kamakura government. We know that Sukezane was accompanied on his move by several colleagues from the Ichimonji school and that his new workshop in Kamakura became extremely prosperous.

This information is to be found under the heading "Unknown Provenance and History" in the inventory of the swords in the shogunal collection drawn up in the second year of the Enkyō era (1745).

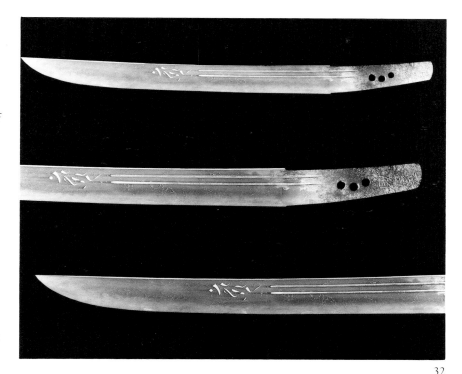

32

## 33

### TANTŌ

Inscription: *Yoshimitsu*
Steel
30.3 cm
Kamakura period, 14th century

Yoshimitsu (whose real name was Tōshirō) was a swordsmith of the Awataguchi school, in the province of Yamashiro. His fame, like that of Masamune, dates back to the Muromachi period. Works by Yoshimitsu, Masamune and Gō-yoshihiro, who came to be known as the "Three Great Ones", were highly prized and treated as precious objects during the Edo period. As most of the swords created by Yoshimitsu that have come down to us are *tantō* (dagger), it seems likely that he concentrated on the production of this type of blade in preference to the *tachi*, of which we have only a few by him.

The cutting edges (*mi-haba*) of the sword blades fabricated by Yoshimitsu are much broader those of ordinary *tantō*. It is probably for this reason that Yoshimitsu's blades are referred to as *hōchō* (kitchen knife).

The many objects that were part of the legacy of Ieyasu, the first Tokugawa shogun, to his son Yoshinao, first lord of Owari, are listed in the seventh volume of the inventory of Ieyasu's bequest, entitled

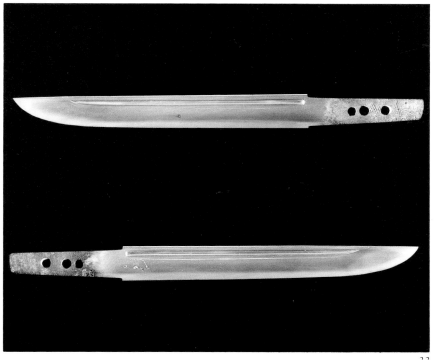

33

*Sumpu Onwakemono-chō.* From a description in this inventory, it has been possible to establish that the present *tantō* was given to Ieyasu by Ōtani Yoshitsugu.

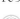

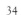

## TACHI MOUNTING, NAMED "HYŌGO-GUSARI"

Copper, with gold and silver inlaid designs
100 cm
Edo period, 18th century

The *tachi* is a long sword worn slung from the left-hand side of the belt, with the cutting edge of the blade facing the ground. From the Heian period on, this way of wearing a long sword was considered ideal for a mounted warrior. During the Edo period, however, another shorter sword was developed that was worn thrust into the belt with the cutting edge facing upwards.

## DAISHŌ (cat. 35-42)

It was both the right and the privilege of the samurai of the Edo period to wear a pair of swords thrust into the sash. The pair, consisting of a *katana* and a *wakizashi*, was called a *daishō* (literally, "large and small") and was the symbol of the samurai.

The daimyo attached a great deal of importance to the decoration of their sword accessories (metal fittings, lacquered scabbards) and commissioned them from the finest craftsmen. Sword accessories were actually collected as works of art and treasured as heirlooms. The richly decorated, beautifully crafted sword fittings that have come down to us from the Edo period represent the continuation of this tradition.

### 35
#### KATANA MOUNTING
Black-lacquered scabbard, *shakudō* fittings
98.2 cm
Edo period, 17th century

### 36
#### WAKIZASHI MOUNTING
Black-lacquered scabbard, *shakudō* fittings
66.7 cm
Edo period, 17th century

Both the scabbards of this pair of swords (*daishō*) are covered in a type of black lacquer called *rō-iro* (mirror lacquer), notable for its transparency and the

Although cords were usually made of leather laces or plaited material, the cord of this particular *tachi* mounting is a silver chain — hence its name, *Hyōgo-gusari* (Hyōgo chain). Generally speaking, the scabbards of Japanese swords are made of lacquered wood, but this one is made principally of copper, ornamented with inlaid designs in gold and silver. The carved designs that decorate the scabbard include mallow leaf, pine branch and crane motifs.

It appears that during the Heian

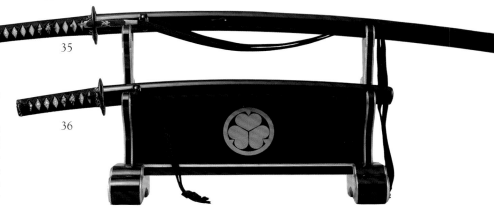

period, the use of this type of sword mounting was reserved for high-ranking warriors in the service of members of the nobility. It is recorded that this sword was made at the time of Tokugawa Munechika, a ninth-generation descendant of the Owari Tokugawa. It is a replica of a sword that was among the treasures donated to Atsuta Jingū, one of the oldest Shinto temples in the Owari domain.

brilliance of its shine. The two sword mountings, which are enhanced by handsome metal fittings, were the property of an important daimyo — the lord of the Owari domain — who wore them during official ceremonies. These scabbards, which are famous, were made by a craftsman of the Gotō family.

The two sword-guards (*tsuba*) are decorated with autumn plant motifs. According to Gotō Kōbi, a fifteenth-generation descendant of the Gotō family who lived towards the end of the Edo period, these *tsuba* were created by Kenjō, a seventh-generation Gotō who died in the third year of the Kanbun era (1663).

The *katana* fittings — the *menuki*, the *kozuka* and the *kōgai*, which form a set called the *mi-tokoro-mono* — are decorated with two lions made of pure gold.

The fittings were attributed by Gotō Kōbi to Yujō, an ancestor of the Gotō family who died in the ninth year of the Eishō era (1517).

The *wakizashi* fittings — the *menuki* and the *kozuka*, forming the *ni-tokoro-mono* — are also decorated with pure gold lions. According to Gotō Kōbi, these accessories were created by Tokujō, a fifth-generation descendant of the Gotō family who died in the eighth year of the Kanei era (1631).

There exists an inventory indicating that these swords were used towards the end of the Edo period by Mochinaga, fifteenth-generation descendant of the Owari Tokugawa, and by Yoshikatsu, who served as both fourteenth and seventeenth lord of the Owari domain.

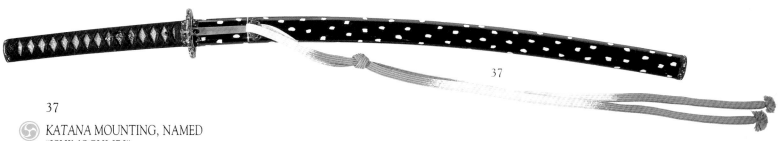

37

37

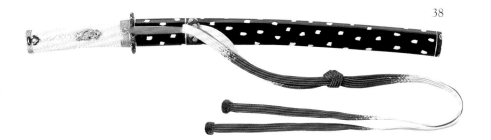

38

## 37

### *KATANA* MOUNTING, NAMED "ISHIMOCHI-IRI"

Black-lacquered scabbard inlaid with fish bone, *shakudō* fittings
95.5 cm
Edo period, 19th century

## 38

### *WAKIZASHI* MOUNTING, NAMED "ISHIMOCHI-IRI"

Black-lacquered scabbard inlaid with fish bone, *shakudō* fittings
55 cm
Edo period, 19th century

This pair of swords (*daishō*), one long (*katana*) and the other short (*wakizashi*), was made specially for the use of Tokugawa Yoshikatsu, fourteenth lord of Owari. Both scabbards are inlaid with pieces of fish bone, called "Ishimochi". The head of the *ishimochi*, a salt-water fish of the sciaenid family, contains a protuberant bone called an otolith. The inlaid white spots on the scabbards stand out brilliantly against the black lacquer ground.

The *menuki* of the *katana* represents a tiger and is probably the work of the master smith Gotō Mitsunori. The handle of the *ko-gatana* and the *kōgai* are both made of pure gold. The *kōgai* is divided in two lengthwise and somewhat resembles a pair of chopsticks. The *menuki* of the *wakizashi* represents a dragon. The *menuki*, hilt and *kōgai* of the short sword are also made of gold. The motifs ornamenting the remaining fittings, such as the sword-guard, represent autumn plants or chrysanthemums and are identical on both swords. The *wakizashi* was made in the third month of the first year of the Ansei era (1854), and the *katana*, in the sixth month of the fourth year of the Ansei era (1857).

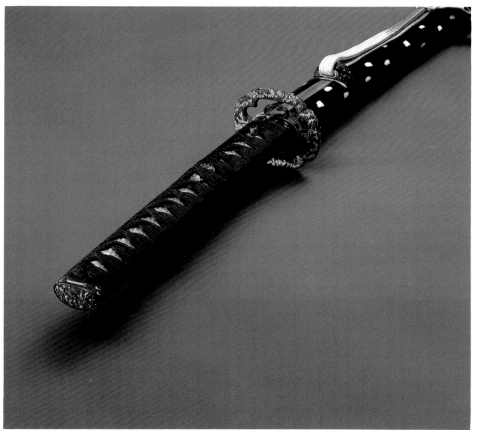

37 (detail)

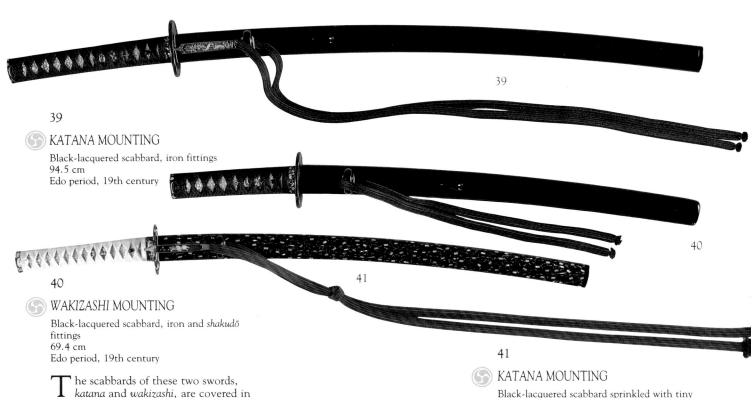

39

## KATANA MOUNTING

Black-lacquered scabbard, iron fittings
94.5 cm
Edo period, 19th century

40

## WAKIZASHI MOUNTING

Black-lacquered scabbard, iron and *shakudō*
fittings
69.4 cm
Edo period, 19th century

41

## KATANA MOUNTING

Black-lacquered scabbard sprinkled with tiny
pieces of mother-of-pearl and gold leaf, *shakudō*
fittings
76.1 cm
Edo period, 19th century

42

## WAKIZASHI MOUNTING

Black-lacquered scabbard sprinkled with tiny
pieces of mother-of-pearl and gold leaf, *shakudō*
fittings
50.6 cm
Edo period, 19th century

The scabbards of these two swords, *katana* and *wakizashi*, are covered in shiny black lacquer (*rō-iro*). The two iron sword-guards are decorated with an open-work flower motif and bear the engraved signature "Yamasaka Kichibei". The style of works by Yamasaka Kichibei, a master-craftsman who specialized in the fabrication of sword-guards, is typical of the Owari province during the Muromachi period. The name of Yamasaka Kichibei was used by at least three successive generations. The particular style of the signature on the two swords presented here suggests that they may be by the second-generation Yamaska Kichibei. In contrast to the more delicate sword-guards made of *shakudō*, iron sword-guards were valued for the intrinsic qualities of the metal itself, including its colour and strength.

The three *katana* accessories (the *menuki*, the *kozuka* and the *kōgai*) are decorated with a pure gold "Kurikara" dragon. These pieces have been attributed since the early Edo period to Gotō Jōshin, a third-generation descendant of the Gotō family who died in the fifth year of the Eiroku era (1562). According to a Buddhist legend recounted in certain Sanskrit texts, the "Kurikara" dragon — who here swallows the blade around which he is curled — is the incarnation of the god Vidyàràja. The dragon design appears on the sword as the result of a desire to place the weapon's owner under the protection of this divinity.

The *menuki* of the *wakizashi* is also decorated with a "Kurikara" dragon in pure gold and is probably, like the *katana*

accessories, the work of Gotō Jōshin. The *kozuka* of the *wakizashi*, which is in *shakudō*, is decorated with a tiger motif in gold and silver inlay and bears the signature of Yoshioka Inaba-no-suke.

In the Orient, the dragon was the traditional symbol of the monarch and exalted personages and was frequently paired with the tiger to represent simultaneously strength and power.

According to contemporary documents, this particular pair of swords was used towards the end of the Edo period by Tokugawa Yoshikatsu, who served as both the fourteenth and the seventeenth lord of Owari.

Although the scale of the swords that form this *daishō* pair (*katana* and *wakizashi*) is not large, the decorative lacquer covering of the scabbards is very striking. The ground of the decoration consists of a layer of transparent black lacquer called *rō-iro* (mirror lacquer) onto which have been sprinkled tiny pieces of red and blue mother-of-pearl and little rectangles of gold leaf. The decoration has been finished by the application of another layer of transparent lacquer that has been polished, giving the scabbards a brilliant shine. The light blue cord that is bound around the hilts of the two swords is in a perfect state of preservation.

The metal fittings are in *shakudō* ornamented with delicate designs in gold

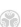

plate. The two sword-guards are decorated with an openwork grass motif and are partially gold plated. The *kozuka* and the *kōgai* were made by Gotō Kōbi, a fifteenth-generation descendant of the Gotō family, and are decorated with designs representing a horse and young pines. The remaining *katana* fittings, including the *menuki* and the *kashira* (pommel) are also decorated with plant and horse designs. The *menuki* and the *kozuka* of the *wakizashi*, which are decorated with motifs representing hares among autumn grasses, bear the inscription "Ishiguro Koreyoshi". These motifs may also be seen on the *kashira* and the *fuchi* (a metal hilt fitting at the level of the sword-guard), which bear the inscription "Ōoka Masatsugu".

It is said that this pair of swords was presented to the lord of Owari in 1826 by his vassal Naruse Kichizaemon. It also apparently belonged to Tokugawa Yoshikatsu's sixth son, Yasuchiyo, who was born in 1864 and died in 1869. This elegant but delicate pair of swords was indeed an ideal set for the young son of an important daimyo.

43

### 43

### SWORD STAND FOR *KATANA*

Gold *maki-e* designs on a black lacquer ground
33 × 18.6 × 49 cm
Edo period, 19th century

### 44

### SWORD STAND FOR *KATANA*

Gold *maki-e* designs on a black lacquer ground
28 × 17.6 × 50.9 cm
Edo period, 19th century

### 45

### SWORD STAND FOR *KATANA*

Gold *maki-e* designs on a black lacquer ground
29 × 17.5 × 54.5 cm
Edo period, 19th century

44

45

46

### 46

### SWORD STAND FOR *KATANA*

Gold *maki-e* designs on a black lacquer ground
29.7 × 17.3 × 54.8 cm
Edo period, 19th century

Whenever a member of the samurai class went out in public, he wore a pair of swords called a *daishō*, composed of a long sword (*katana*) and a short sword (*wakizashi*), thrust through his waistband. Indoors, he wore only the smaller *wakizashi*. The only times when the *wakizashi* was not worn were while sleeping, when bathing and when entering a tearoom. Yet even at these times the sword was kept in a specific spot nearby.

In order for this symbol of the warrior to be handled and displayed with the proper respect, the sword was always placed on a stand like those in numbers 43 through 46 whenever it was removed from the warrior's side. The centre of number 46 is decorated with a large *aoi* or mallow leaf design in gold on a lacquer ground. Numbers 43, 44 and 45 are ornamented with smaller, scattered *aoi* motifs, also in gold.

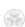

## 47

PAIR OF *TSUBA* FOR *DAISHŌ*

Inscription: *Inshū-jū-Ichijū* (Ichijū, residing in Inaba province)
Iron, carved in relief with gold inlay
7.7 × 7.3 cm
7.2 × 6.9 cm
Edo period, 17th century

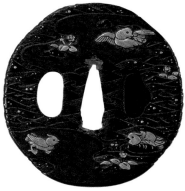

47

## 48

TSUBA

Designs in gold inlay on a *shakudō* ground
7.2 × 6.8 cm
Edo period, 17th century

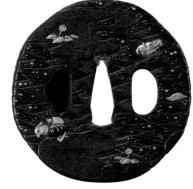

O n both faces of this sword-guard,
which is decorated with a motif of
mandarin ducks (*oshidori*), the sandy
beach is represented by the granular finish
(*nanako*) of the ground, the waves are
rendered by delicately carved lines, and
the water lily, sea-spray and mandarin
duck designs are of inlaid gold.

Although this sword-guard bears no
inscription, it is traditionally attributed to
Gotō Eijō, a fifth-generation descendant
of the Gotō family.

48

## 49

TSUBA

Attributed to Gotō Sokujō (died 1631)
Copper, *iro-e* designs
7.2 × 7 cm
Edo period, 17th century

T he outer surface of this copper sword-
guard, which is square with rounded
corners, is decorated with a motif of
grapes, while the inner surface is orna-
mented with wave designs executed in
relief.

On the metal plate (*seppa-dai*) that sur-
rounds the guard's central opening can be
seen the inscription "Made by Sokujō",
accompanied by the seal (*kaō*) of
Mitsuaki. It was this inscription that led
Gotō Mitsuaki, a sixteenth-generation
descendant of the Gotō family, to attrib-
ute this work to Gotō Sokujō, an eighth-
generation descendant of the same family.
Sokujō died in the eighth year of the
Kanei era (1631), at the age of thirty-two.

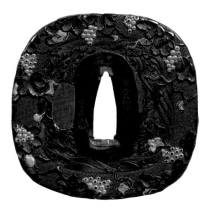

49

## 50

🌀 TSUBA

Gold *iro-e* designs on a *shakudō* ground
6.4 × 5.8 cm
Edo period, 17th century

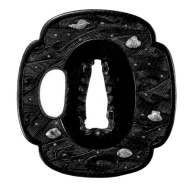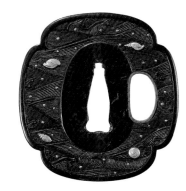

50

This sword-guard presents a basically square shape, with four lobes serving as the sides of the square. Both faces of the guard are decorated with sea-shell motifs on a wave-filled ground. The shells are highlighted with very thin gold leaf, and the whole is sprinkled with gold dust representing droplets of water. The design is probably intended to evoke a beach on which empty sea shells are thrown and tossed about by the waves. The contrast between the dark ground and the gold of the shells and water droplets is extremely striking.

This piece may be attributed to Gotō Renjō (d. 1708), a seventh-generation descendant of the Gotō family.

## 51

🌀 RIMMED TSUBA

Gold and silver *iro-e* designs on a *shakudō* ground
7.7 cm (diameter)
Edo period, 17th century

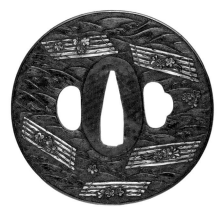

## 52

🌀 TSUBA

Gold and silver *iro-e* designs on a granular (*nanako*) *shakudō* ground
7.1 × 6.7 cm
Edo period, 18th century

51

The main purpose of the *tsuba* or sword-guard was to protect the hand and to maintain the overall balance of the sword. During the Edo period, however, the decorative characteristics of the *tsuba* took precedence over its practical qualities, and detailed carving techniques, variegated designs and alloy techniques developed markedly.

The pair of iron-ground *tsuba* in number 47 bears a design of an aged plum tree sending forth new branches and blossoms, executed in relief carving and gold inlay. This design not only signifies the spring in the Orient but also symbolizes the breath of new life, for the plum is the first among the withered winter trees to send forth blossoms each year.

Numbers 51 and 52 display finely executed carving and gold and silver inlay on a blue-black *shakudō* ground. Number 51 bears a design of rafts floating on the surface of a river scattered with cherry blossoms. The elements of the changing seasons form an integral part of the Japanese artistic consciousness. Cherry blossoms are the objects of special appreciation, for these evanescent flowers bloom in such great profusion that an entire mountainside will adopt a pink hue, but they are soon scattered by the unpredictable spring weather. Their singular beauty and evanescent quality appealed greatly to the aesthetic sense of the Japanese. The design motif that appears on this *tsuba* was originally conceived as cherry blossom petals scattered on the river surface like a string of floating rafts. Later the idea of floating rafts was transformed into the concrete depiction of rafts incorporated into the design.

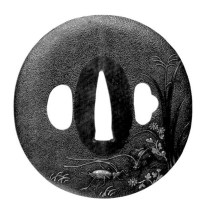

52

Number 52 bears a design of insects singing among the autumn grasses. This motif developed from the Japanese attachment to the sound of insects in the autumn night, heard only briefly before the onset of winter and tinged with a sense of loneliness.

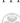

## 53

### SET OF SWORD FITTINGS

Attributed to Gotō Yūjō
Gold *iro-e* designs on a granular (*nanako*)
*shakudō* ground
*Kozuka*: 9 × 1.5 cm
*Kōgai*: 21.2 × 1.3 cm
*Menuki*: 2.4 cm
Muromachi period, 15th century

53

54

55

The Gotō were highly renowned as a family of master-craftsmen who specialized in the fabrication of sword fittings. From the time of Ashikaga Yoshimasa on, they served all the shoguns of the Muromachi period. Their descendants worked for a number of powerful military leaders, including Oda Nobunaga and Toyotomi Hideyoshi, and for the Tokugawa family up until the Meiji era. For close to four centuries, the Gotō family was completely identified in Japan with the highest quality sword fittings. Their fame was such, in fact, that they were referred to simply as "the toolers". The founder of the family, Yūjō, was particularly famous for his dragon and lion motifs.

This set of three sword fittings is attributed to Yūjō in a report drawn up in the eighth year of the Bunka era (1811) by Gotō Kōbi, a fifteenth-generation descendant of the family. On the *kozuka* and the *kōgai* can be seen Yūjō's crest, accompanied by the *kaō* representing the signature of Kōbi.

## 54

### SET OF SWORD FITTINGS

Attributed to Gotō Sōjō
Gold *iro-e* designs on a granular (*nanako*)
*shakudō* ground
*Kozuka*: 9.6 × 1.4 cm
*Kōgai*: 21 × 1.2 cm
*Menuki*: 4 cm
Muromachi period, 16th century

## 55

### SET OF SWORD FITTINGS

Attributed to Gotō Jōshin (died 1562)
Gold and silver *iro-e* designs on a *shakudō*
ground
*Kozuka*: 9.7 × 1.3 cm
*Kōgai*: 21 × 1.3 cm
*Menuki*: 3.6 cm
Momoyama period, 16th century

These fittings are decorated with vine and gourd motifs in relief. The gourd is in gold, while the stem, leaves and shoots of the vine are all in silver. The decorations have been fixed to the ground by the *iro-e* technique, which involves a fusion of the different metals.

In a research report submitted in the eighth year of the Bunsei era (1825) by Gotō Kōbi, a fifteenth-generation descendant of the Gotō family, this set of sword fittings is attributed to Gotō Jōshin, a third-generation descendant of the same family who died in the fifth year of the Eiroku era (1562) at the age of fifty-one.

Jōshin and his successor Kōjō, a fourth-generation descendant, invented and developed a new method of fusing metals, using wax. This technique made possible the creation of much more delicate designs than those resulting from the traditional technique known as *fukuro-gise* and was the source of a significant burgeoning of sword fitting production.

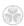

## 56

### SET OF SWORD FITTINGS

Attributed to Gotō Kōjō
*Iro-e* designs on a granular (*nanako*) *shakudō*
ground
*Kozuka*: 9.7 × 1.9 cm
*Kōgai*: 21.2 × 1.2 cm
*Menuki*: 3.6 cm
Edo period, 17th century

## 57

### SET OF SWORD FITTINGS

Attributed to Gotō Tokujō (died 1631)
*Iro-e* designs on a granular (*nanako*) *shakudō*
ground, partially gilded
*Kozuka*: 9.7 × 1.9 cm
*Kōgai*: 21.2 × 1.2 cm
*Menuki*: 2.5 cm
Edo period, early 17th century

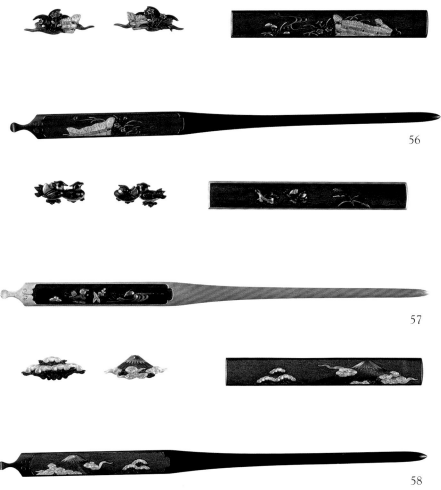

56

57

58

Three types of sword fittings, the *kozuka*, *kōgai* and *menuki*, form a set called *mi-tokoro-mono*. As a rule, the entire set is executed by a single artisan and bears the same motif. A *kozuka* is the handle of a small knife whose blade measures about twelve centimetres in length. A *kōgai* is shaped like a paper knife and does not have a tempered blade; it was originally used as an implement to arrange the hair. These two fittings were inserted into two openings provided in the sword-guard to fasten them flush against the scabbard, one on each side. Since the swords of a *daishō* pair were always thrust into the sash with the cutting edge upward, the *kōgai* was placed on the outside of the sheath away from the wearer, and the *kozuka* on the inside. *Menuki* are decorations affixed on both sides of the hilt. One or two pegs pass through the hilt to secure the blade, and their heads became increasingly decorative. In time, the functional pegs and the ornamental heads were separated, thus resulting in the *menuki*.

These three types of sword fittings were largely decorative. During the Edo period, mountings fully equipped with *mi-tokoro-mono* were worn by samurai of high rank. Furthermore, correctly fitted mountings used by the shogun, daimyo and *hatamoto* (literally, "bannermen", lesser vassals directly responsible to the shogun) customarily included *mi-tokoro-mono* produced by the Gotō family of metalworkers.

Successive generations of Gotō metalworkers, exclusive producers of sword accessories, had served the families

of both the Ashikaga and Tokugawa shoguns. None of these three sets of sword fittings is inscribed by the artisan himself, but all display the distinctive Gotō style using blue-black *shakudō* with a granular *nanako* finish, and Edo period descendants of the Gotō family have identified the metalsmith responsible for each set.

Both numbers 54 and 56 bear designs of autumn wildflowers, a motif that has long been cherished by the Japanese and is often used in the applied arts. The design of paired mandarin ducks appearing in number 57 is interpreted as symbolizing conjugal happiness. Also, the attractive plumage of the male has made the mandarin duck a popular subject in both painting and the applied arts.

## 58

### SET OF SWORD FITTINGS

Inlaid gold and silver designs on a *shakudō*
ground
*Kozuka*: 9.7 × 1.5 cm
*Kōgai*: 21.1 × 1.2 cm
*Menuki*: 3.2 cm
Edo period, 18th century

Mount Fuji is the highest mountain in Japan, and owing to its remarkably regular form it has always been one of the favourite motifs of Japanese painters and decorative artists.

This set of sword fittings has been ornamented with a Mount Fuji whose eternal snows are depicted by inlays of silver. The pines, clouds and other motifs in the foreground are highlighted with inlaid gold. The set is probably the work of a member of the Gotō family, but no definite attribution has been made.

59

## SPEARHEAD

Inscription: *Kanetaka*
Steel
60.6 cm
Muromachi period, 16th century

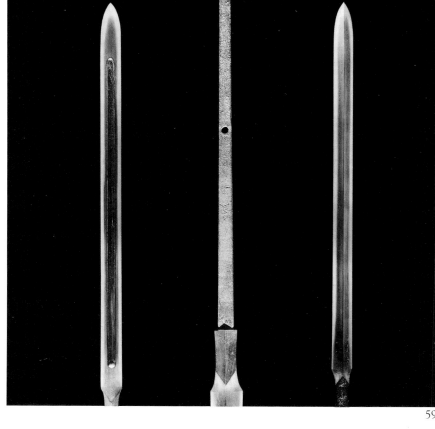

59

T his spearhead, whose cross-section is of a flattened, triangular shape, stretches to the substantial length of two *shaku* — about sixty centimetres. From historical listings of Japanese craftsmen, we know that there were two ironsmiths who bore the name of Kanetaka and that they both lived in the province of Mino. One of them lived in Naoe at the beginning of the Bunna era (about 1352), and the other is mentioned as living during the Eishō era (about 1505). Since this spearhead became part of the collection of the Katagiri family, it has been attributed to "Kanetaka from Naoi in the province of Mino". ("Naoi" is simply a misspelling of Naoe.) And as the piece was attributed to the Kanetaka who lived in Naoe, it was consequently dated to the Bunna era. However, careful examination of the spearhead indicates that it was executed during the Eishō era and is thus probably the work of the Kanetaka who lived around 1505.

It is recorded that this spear was part of the famous set known as the "Seven Spears of Sengadake" used by Katagiri Sukesa Katsumoto during the Battle of Sengadake in the eleventh year of the Tenshō era (1583), a battle at which Toyotomi Hideyoshi defeated Shibata Katsuie and became the ruler of Japan.

The Katagiri family donated this spearhead to the Tokugawa Art Museum on the seventeenth day of the sixth month of the ninth year of the Shōwa era (1934).

60

## SPEARHEAD

Steel
40.1 × 10.1 cm
Muromachi period, 16th century

60

T here are three main types of Japanese spear, classified according to spearhead shape: the straight spear, with no cross-bar; the side sickle spear, with a single side blade; and the cross-shaped spear, with a full cross-bar. The shape of the side blades on the sickle and cross-shaped spearheads can vary widely. There are also several types of cross-section blade shape, ranging from the triangular- or diamond-shaped to a form similar to a sword blade.

The cross-shaped spearhead seen here is smaller than most of its type. The ends of the two side blades curve slightly upwards, and the main blade is diamond-shaped. Although the piece bears no inscription, the shape and the forging technique employed suggest an attribution to a craftsman of the Kinbō school, in the province of Yamato, and a date towards the end of the Muromachi period.

In the inventory of the Tokugawa family collection drawn up in the fifth year of the Meiji era (1872), it is stated that this spear was kept, along with other heirlooms, in a box that was dated on the outside "the fourth month of the third year of the Genroku era" (1690).

## 61

### ⚛ SPEAR

Inscription: *Mino no Kami, Fujiwara no Masatsune* (Fujiwara no Masatsune, Governor of Mino)
Steel, wood coated with black lacquer and inlaid with mother-of-pearl
384 cm (total length), 15.3 cm (steel tip)
Edo period, 17th-18th century

During the turbulent decades of civil war that preceded the long peace of the Edo period the spear was, after firearms, the most effective offensive weapon and was, in fact, the most useful weapon in hand-to-hand combat. In battle, recognition was given to the warrior who first crossed spears with the enemy, and he was designated "Ichiban-yari" (first spear), the highest battlefield honour a foot soldier could receive.

The spear is said to have been first used in the Muromachi period (14th cent.), and by the sixteenth and seventeenth centuries it proved to be an extremely valuable weapon when used in concert by large groups of foot soldiers. In general,

spears were heavily damaged in the course of battle, so that while numerous swords survive from the Heian and Kamakura periods, examples of spears from these periods are rare.

The shaft of this spear is decorated with *raden*, in which broken fragments of iridescent shell are inlaid on a black lacquer ground. The shell used here is that of an abalone. The artisan who produced the blade for this spear was a smith named Masatsune, who worked exclusively for the lord of Owari. Since the fifteenth century, Masatsune's family had been swordsmiths belonging to the Seki school of Mino province (today the Gifu Prefecture), but with the establishment of the Owari fief in the early seventeenth century, they moved to the castle town of Nagoya and continued for successive generations to produce weaponry in the service of the Owari Tokugawa.

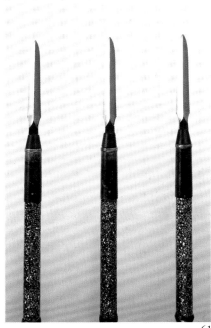

61

## 62

### ⚛ BOW

Wood and bamboo wrapped with lacquered rattan, 222.7 cm
Edo period, 18th century

## 63

### ⚛ QUIVER WITH FIVE ARROWS

Wild boar hide, ivory fittings
41.8 cm
Edo period, 17th century

The bow was used as a combat weapon in Japan from ancient times, and through the Kamakura period mounted archery was a requisite skill for all high-ranking warriors. From the end of the Muromachi period, however, large units of foot soldiers bearing firearms and spears were found to be superior to mounted archers, who were relegated to secondary importance. In spite of this, archery was not completely forgotten, and the once powerful weapon of the ancient warrior remained part of the martial training of high-ranking samurai even in the Edo period.

Number 62 is a bow made of both wood for tension and bamboo for flexibility. This composite core was wrapped with several layers of rattan, which imparted additional strength. The most unusual feature of Japanese bows is that the grip is below centre, in contrast to most other bows, which employ centre grips.

The quiver (cat. 63) is decorated with an ivory fitting in the shape of a dragonfly. The dragonfly, or *tonbo* in Japanese, was also called *kachi-mushi*, literally "victorious insect". Hence, the dragonfly motif was a very frequent ornament on weapons. The decorative use of wild boar hide, seen here, was relatively rare during the Edo period.

Both the bow and the quiver were owned by Tokugawa Munechika, ninth lord of Owari.

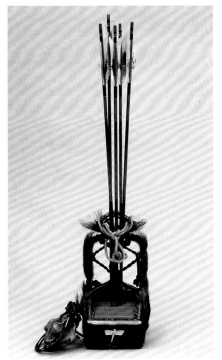

62

63

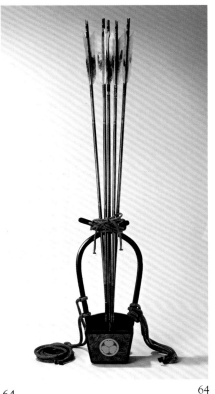

64

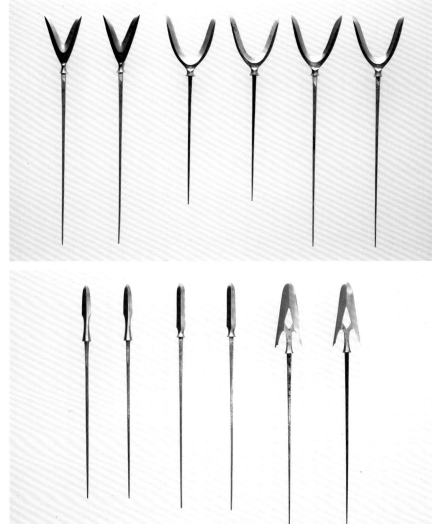

64

 QUIVER WITH FIVE ARROWS

Designs in gold paint on a lacquer ground
38.3 cm
Edo period, 17th century

The *aoi* design (crest of the Tokugawa family) decorating this quiver is painted in gold on lacquer. The quiver was probably owned by Tokugawa Yoshinao, first lord of Owari.

65

 ARROWHEADS

Steel
24.6 to 28.6 cm (length), 1.2 to 6 cm (width)
Edo period, 18th century

65

The bow and arrow was used as a combat and hunting weapon in Japan from ancient times. The arrowheads, while sometimes made of bronze or stone, were generally of iron. The introduction of firearms into Japan rendered the bow and arrow obsolete as a weapon of war. Nevertheless, archery was still considered a noble pursuit and was one of the martial arts included as part of the education and training of members of the warrior class (*bushi*) during the Edo period.

Arrowhead shape varied according to the date of manufacture, and there were

many different forms. Two examples each of six types of arrowhead are presented here, all twelve being said to have belonged to Tokugawa Munekatsu, eighth lord of Owari.

Towards the upper left may be seen two arrowheads whose tips divide into a V shape: these are called *saba-o* (mackerel tail). The two types whose tips form a U shape are called *kari-mata* (forked). Those with cylindrically-based tips are called *marune* (round tipped). The straight arrowheads whose tips look almost like sword blades are called *teikaku*

(right-angle). Finally, at the lower right may be seen two arrowheads whose inverted V-shaped tips have a diamond-shaped hole: these are called *hara-kuri* or *chō-kuri* (disemboweler).

The inscription "Takamichi" is carved on the two round tipped arrows, and the name "Masatsune" appears on the ten others. The names of both these iron-smiths, who lived in the Nagoya region of Owari, were passed on from generation to generation. It seems likely that the arrow-heads presented here were specially commissioned by the lord of Owari.

# FIREARMS

(cats. 66-74)

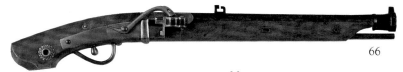

66

According to the 1607 document known as the *Teppō-ki* (Record of Firearms), in 1543 a Portuguese ship drifted onto the shores of Tanegashima, a small island south of Kyūshū, and introduced firearms to Japan. Until that time, the only projectile weapons used by the Japanese were bows and arrows, and catapults. Once firearms came into use, they revolutionized military strategy and castle-building methods. Firearm production and gunpowder mixing techniques spread rapidly throughout Japan, and before long many of the principal cities were manufacturing firearms. Domestic production was favoured both by the large demand for powerful weaponry from rival warlords during this period of incessant strife and by the expertise of Japanese smiths, who were already masters of metalworking and casting techniques as a result of their experience in producing sword blades, sword accessories and armour.

Matchlocks are a form of musket in which the shot and gunpowder are inserted, then fired by lighting a fuse. The barrel is not rifled as in modern firearms. The effective range of the matchlock was usually about two hundred metres, and it is said that even a well-trained soldier could fire no more than four shots per minute.

66

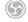 MATCHLOCK

Iron barrel, oak stock
48.5 cm
Edo period, 18th century

Number 66 is a short-barrelled matchlock with a very narrow bore. It fires bullets weighing two *mon-me*, or seven and a half grams.

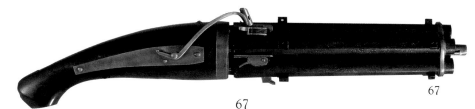

67

67

FIVE-BARRELLED MATCHLOCK

Iron barrels, oak stock
57.6 cm
Edo period, 17th-18th century

The five barrels of this gun, arranged in the shape of a star, are designed to rotate, thus allowing the consecutive firing of five bullets. The piece is extremely rare, if not unique. According to contemporary records, the gun was made especially for the lord of Owari. Like number 70, it is possibly the work of Shibatsuji.

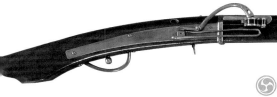

68                                                              68

MATCHLOCK

Inscription: *Shibatsuji Riemon Sukenobu*, seal (*kaō*)
Iron barrel, oak stock
119.7 cm
Edo period, 17th century

The barrel of this matchlock is decorated with *aoi* crests inlaid with silver, symbols of the Tokugawa family. The weapon, which is designed to fire leadshot weighing 13.125 grams, was specially commissioned by the Owari Tokugawa. The smith named in the inscription on the barrel was a resident of Sakai, near Osaka, but little is known of his career. During the sixteenth century, Sakai was a free commercial city — somewhat like medieval Venice — and a major centre of firearm production. The port of Sakai was also an important point of entry for saltpetre (a raw material for gunpowder), until it began to be produced domestically in the seventeenth century.

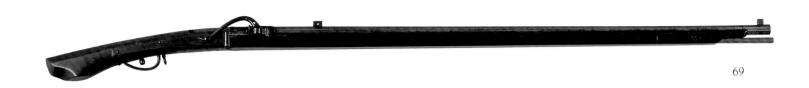

69

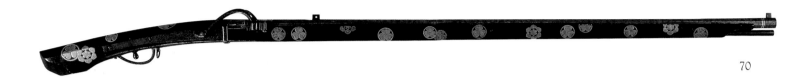

70

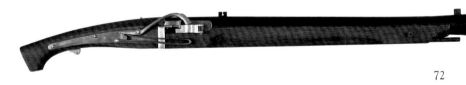

71

72

## 69

### ⟐ MATCHLOCK

Inscription: *Kunitomo Tōzaemon Shigetō*
Iron barrel, oak stock
134.2 cm
Edo period, 18th century

The upper part of the barrel of this weapon, near the breech, is inlaid in gold with *aoi* crests. The metal fittings are in *shakudō*, an alloy of copper and gold. The workmanship of the piece as a whole is quite remarkable.

Very little is known about Kunitomo Shigetō apart from the fact that he was active as a gunsmith from the end of the seventeenth to the middle of the eighteenth century.

## 70

### ⟐ MATCHLOCK

Inscription: *Namban Taihō Tetsu Kasane-bari* (Made from an imported cannon); seal (*kaō*): *Shibatsuji*; dated: 11th month of the 8th year of the Kanbun era
Iron barrel, oak stock
134.2 cm
Edo period, 1668

The inscription engraved on the barrel of this matchlock indicates that it was made from an imported cannon that had been dismantled. Japanese ironsmiths traditionally manufactured arms and armour from ferruginous sands, rather than iron ore. As soon as Japan began importing iron, towards the middle of the

sixteenth century, it became highly prized for use in the fabrication of weapons.

The barrel of the gun is covered with J-shaped arabesques, inlaid in silver. There are also zigzag motifs resembling lightning, *aoi* designs and motifs in the shape of an *obi* (kimono sash), all in gold inlay. The serpentine (*hinawa-basami*), pan and other *shakudō* fittings are all decorated with exquisitely carved arabesques and *aoi* motifs. The fine craftsmanship and luxurious finish reflect the exalted status of the lords of Owari.

The oak stock of the gun is covered with black lacquer and ornamented with painted *aoi* motifs of varying sizes. The motif appears in three forms: as the customary trifoliate crest, as a veined outline of the mallow leaf and as a rather unusual six-leafed motif. The name "Yoshizawa" is inscribed in ink on the inner surface of the butt. Little is known about the makers of this weapon, but it is thought to have been fabricated in Sakai, a city famous for gun making.

## ☷ CANNON IN THE SHAPE OF A DRAGON

Bronze
77.1 cm
Momoyama period, 16th century

Cannon were imported into Japan from Portugal and Spain during the sixteenth century. It is said that at that time cannon were employed in Japanese warfare principally to frighten the adversary with the thundering noise and smoke they produced. A certain number of cannon were manufactured in Japan, but they were never used as widely as handguns.

This bronze cannon is of striking design, with a dragon-shaped head whose gaping mouth corresponds to the muzzle of the weapon. The upturned tail and fins resemble those of a fish: indeed, the aim seems to have been to represent a *shachi*, an imaginary marine animal. The base is carved out of oak and bears a wave pattern in relief; a brass strap riveted in place stabilizes the barrel. This unusual cannon is believed to have belonged to Tokugawa Ieyasu.

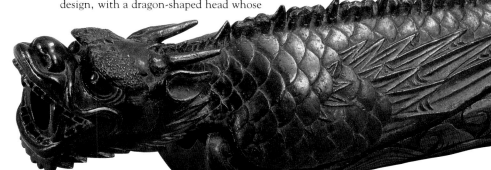

74

## 71

## ☷ MATCHLOCK

Inscription: *Kunitomo Katsuzaemon Shigetō/ Shibatsuji Denzaemon Kiyosada*
Iron barrel, oak stock
107.6 cm
Edo period, 1733

In this piece, the upper part of the barrel near the breech is decorated with an *aoi* crest in gold inlay. From the inscription engraved on the barrel we learn both the date of the weapon's manufacture and the fact that it was the result of a collaboration between two craftsmen. One of those responsible — Kunitomo Shigetō — also created number 69.

## 72

## ☷ MATCHLOCK

Inscription: *Kunitomo Ujimasa*
Iron barrel, oak stock
103.9 cm
Edo period, 18th century

The cross-section of the barrel of this weapon is circular. The Chinese character *chi* (earth) is inlaid in gold on the upper part of the barrel, near the breech. The stock is made of oak and the metal fittings are in brass.

## 73

## ☷ CANNON

Inscription: *Tsujiya Heie Yukitane*
Brass
49.4 cm
Edo period, 18th century

This cannon is made of brass covered with bright red lacquer. On either side of the cannon, towards the middle, can be seen lion's head ornaments with rings attached. The signature "Oda Shinsuke" is inscribed in ink on the oak base. The base is such that the cannon rests flat on the ground. This small-scale cannon is discharged by the lighting of a mechanism situated on top, rather than by a trigger.

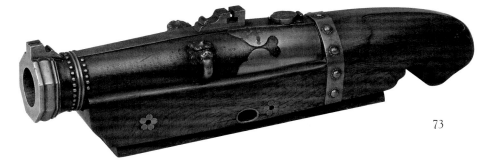

73

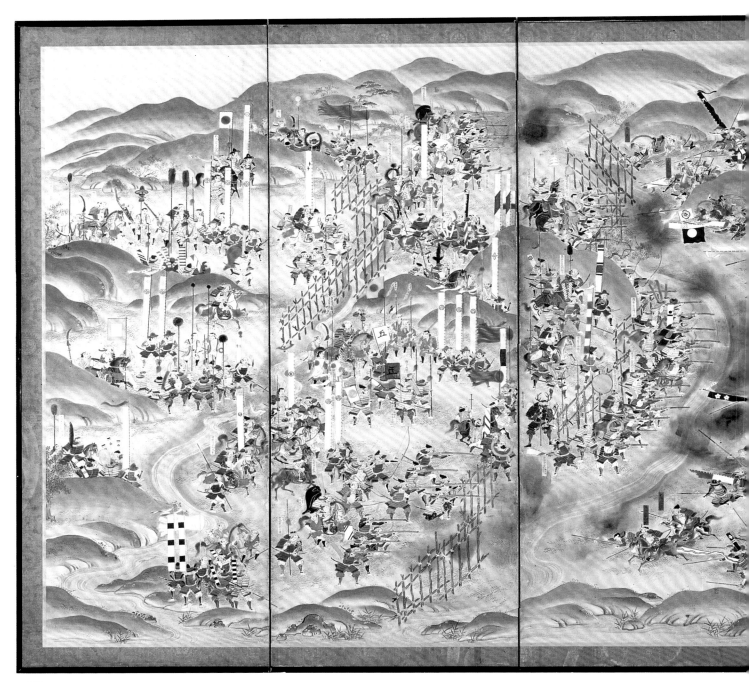

75

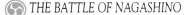 THE BATTLE OF NAGASHINO

Six-fold screen, ink and colours on paper
157.9 × 366 cm
Edo period, 17th century

Paintings of famous battle scenes,
executed on folding screens, were
commissioned by the victors and their
descendants to memorialize triumphs in
warfare. These screens, which when
folded were capable of being easily moved
about, were utilized as interior partitions.
Battle scenes were counted among the
most appropriate subjects for decorating

the large-scale surface afforded by this
format. The production of screens of this
type seems to have begun in the early
seventeenth century. Subsequently, many
paintings were copied from these early
works. In this portrayal of an actual
battle, the artist presents us with a single
picture depicting a multitude of incidents
that were actually separated in time.
There is a degree of idealization in the
rendering and a selectively exaggerated or
abbreviated handling of the details. What

we see was not intended to be a rigidly
accurate account of historical fact.

This screen painting depicts the con-
frontation that took place at Nagashino
(today in the Aichi Prefecture) in 1575,
on the twenty-first day of the fifth month.
To the left, the allied armies of Oda
Nobunaga and Tokugawa Ieyasu have
taken up their positions. Squads of mus-
keteers are shown firing their matchlock
weapons in volleys, protected by a series
of wooden palisades erected along the

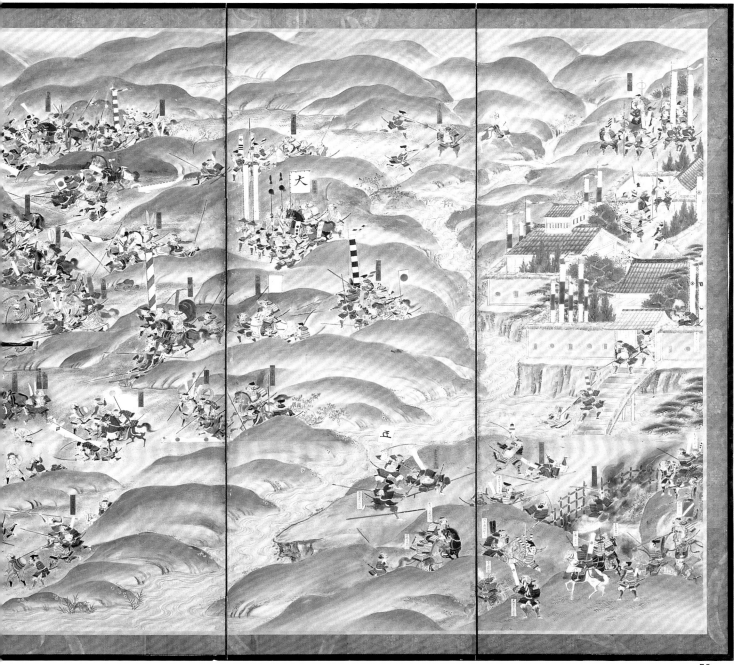

banks of the river. In the opposite field, to the right, is arrayed the cavalry of the Takeda clan (Katsuyori), whose army was reputed to be invincible.

During this battle, the allied Oda-Tokugawa forces sent into action a newly organized company of three thousand musket-bearing foot soldiers, the determining factor in their eventual overwhelming victory. The Battle of Nagashino was a pivotal event in Japanese history: it proved the military superiority of firearms — only recently introduced to Japan from Europe — over the traditional cavalry charge.

Following the battle, the downfall of the Takeda clan was imminent. The Oda and Tokugawa clans, however, were one step closer to domination of the whole country. It is estimated that the military forces that met at Nagashino consisted of seventeen to eighteen thousand men under the allied Oda-Tokugawa banners, against six thousand rallied under the Takeda colours. In the centre of the painting, the artist has illustrated the very moment at which a line of crouching musketeers discharge their guns; each soldier still has his left eye shut after taking aim, and black smoke rises from the muzzles. The number of soldiers depicted is far from realistic, and yet the artist has succeeded in capturing vividly the sense of an actual battle. This screen is one of a pair; the other is entitled *The Battle of Nagakute* (cat. 76).

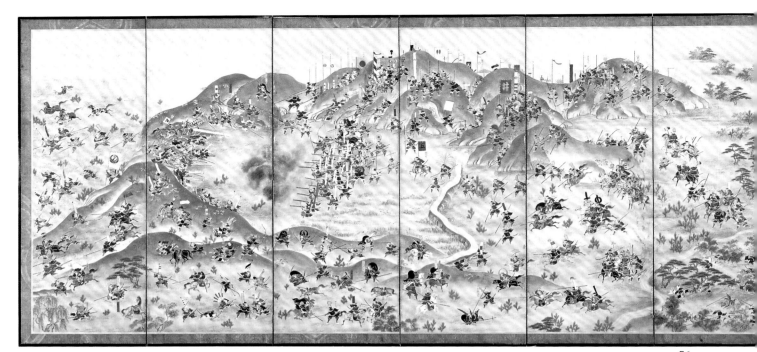

76
76

### THE BATTLE OF NAGAKUTE

Six-fold screen, ink and colours on paper
157.9 × 366 cm
Edo period, 17th century

This screen painting illustrates the battle that was fought in 1584, on the ninth day of the fourth month, at Nagakute (today a suburb of Nagoya). The battle was an important episode in a struggle waged continuously over a nine-month period, from the third to the eleventh month of that year. Centred in the province of Owari, the conflict pitted the forces of Tokugawa Ieyasu against the army of Toyotomi Hideyoshi.

The number of men fighting on the Tokugawa side is estimated at six thousand eight hundred, while the supporters serving under the command of Hideyoshi's two generals were about seventeen thousand strong. In spite of being vastly outnumbered, Ieyasu was tactically superior, and he struck a devastating blow, taking the lives of both the Toyotomi generals. Nonetheless, nine months' warfare did not result in a decisive victory for either side, and a stalemate was reached. In the following year, the two men made peace. At this time, Hideyoshi wielded the greatest power in Japan, and he eventually succeeded in completing the unification of the entire country under his sole domination. Through his victory at Nagakute, however, Tokugawa Ieyasu had secured his reputation as far as Hideyoshi was concerned; thereafter, he co-operated in the latter's campaign towards unification.

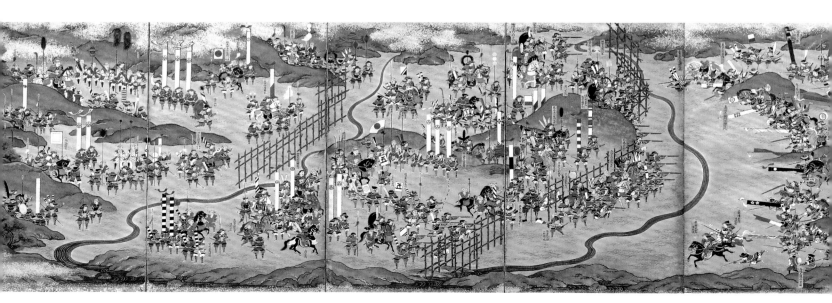

The Battle of Nagakute took place nine years after the one at Nagashino, depicted in this work's companion screen (cat. 75). Both of these battles played a vital role in the course of the establishment of Tokugawa supremacy, and it is natural that these victories should have been commemorated. Thought to be the work of the same artist, these two screens have been handed down for generations in the Owari branch of the Tokugawa family.

## 77

 *THE BATTLE OF NAGASHINO*

Eight-fold screen, ink and colours on paper
76.6 × 380 cm
Edo period, 17th century

The subject of this screen painting is, like number 75, the Battle of Nagashino. The two screens correspond closely in subject and composition, although the present work consists of eight panels rather than six and is not as tall.

One feature displayed here that is common in painted screens depicting battle scenes is the presence of oblong strips of paper on which are inscribed the names of the principal characters. Certain of these strips also bear a sentence that describes the actions of a particular figure. It is thought that this screen was painted about a century after the battle occurred, dating it to the same period as number 75. In executing the work, the artist probably consulted a great deal of documentary literature and took account of orally transmitted reports before arriving

at the final pictorial form we see here. Like the previous pair of battle screens (cats. 75, 76), this piece has been handed down from generation to generation of the Owari Tokugawa family, a treasured memorial to the victory won by their ancestors. This type of pictorial record was intended to evoke in descendants and future retainers the exultation of triumph.

## 78

 *THE BATTLE OF SEKIGAHARA*

Two pairs of two-fold screens, ink and colours on paper
72.4 × 55.4 cm (each screen)
Edo period, 19th century

The Battle of Sekigahara, which took place on the fifteenth day of the ninth month of the Keichō era (1600) at Sekigahara, in the province of Mino, is the most famous battle in Japanese history. It is known as *Tenka wake-me no kassen*, meaning "the battle that determined the future of the country". Following the death of Toyotomi Hideyoshi, who had almost succeeded in unifying Japan, the armies of Tokugawa Ieyasu and Ishida Mitsunari, a former vassal of Hideyoshi, clashed head on. The two sides were virtually identical in strength, for the country was divided nearly equally between the two camps, but the army of the Toyotomi clan was eventually defeated and Tokugawa Ieyasu claimed power. Three years after the battle, in 1603, Ieyasu became shogun and the official ruler of all Japan. Before long Ieyasu was succeeded as shogun by his son Hidetada who, during the first year of the Genna era (1615), managed to quell the few remaining forces of the Toyotomi clan still in Osaka.

Because the Battle of Sekigahara was so decisive in the establishment of the Tokugawa shogunate, it is the theme of a great many paintings.

In the thirteenth year of the Shōwa era (1932), the Tokugawa Art Museum acquired four paintings that had once belonged to the Tayasu-Tokugawa family, a branch that had split from the family of the shogun during the eighteenth century to form a new line. After their acquisition, the paintings were transformed into two pairs of two-fold screens, with each pair showing the encampment of one of the clans and surrounding skirmishes.

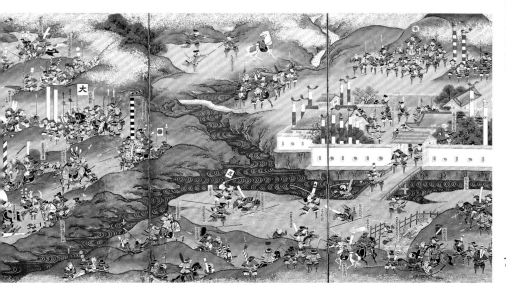

77

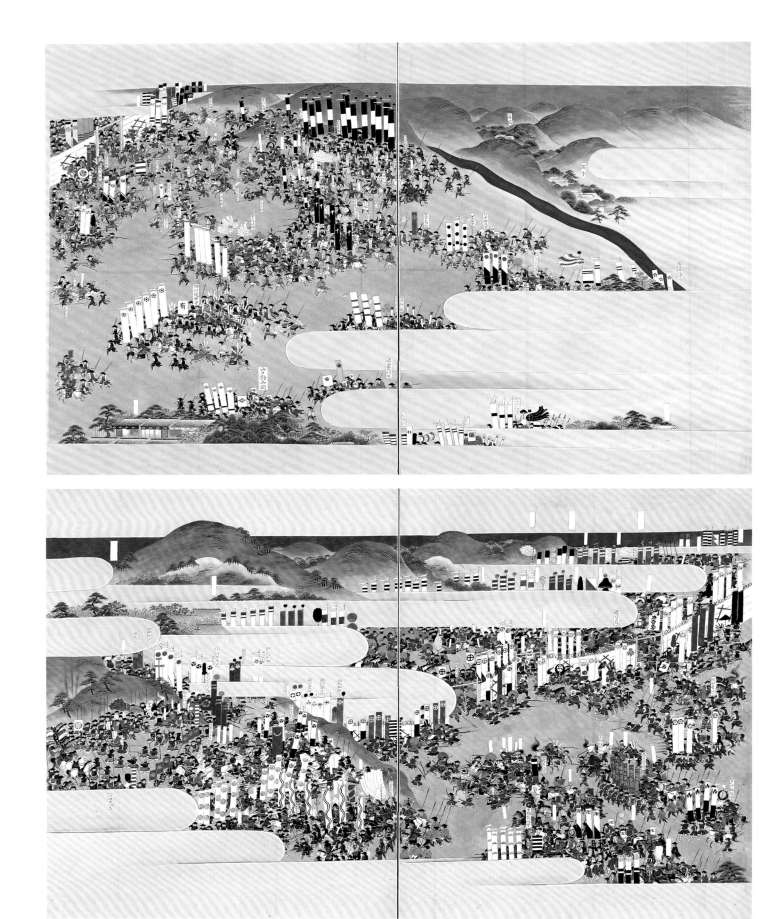

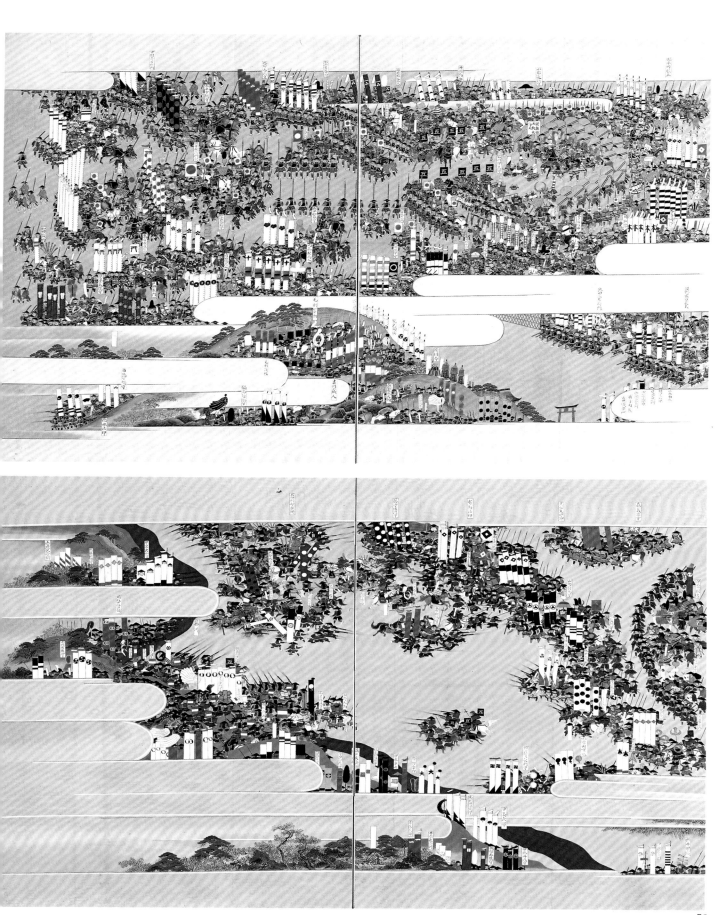

## 79-80

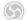 *HAWKS*

Kamiya Haruzane (1824-1862)
Pair of eight-fold screens, colours on paper
91.5 × 37.4 cm (each painting)
Edo period, 19th century

The birds depicted on these screens were used for hawking (*takagari*), a kind of hunting in which domesticated hawks and peregrines were set loose to catch cranes, wild geese and other wild fowl. The custom started in the fourteenth and fifteenth centuries and rapidly became a favourite sport of the military class. While pursued as a recreational activity, however, hawking also served as a form of military exercise. Riding about the countryside hardened warriors physically, while also permitting inspection of both the territory and the populace of the fief.

The collection and raising of fine hawks constituted a status symbol among the warrior class. The samurai saw the brave and daring nature of these birds as an expression of their own ideals, and hawks became a favoured theme in painting from about the fourteenth or fifteenth century on.

Tokugawa Ieyasu's enthusiasm for hawking is said to have been unequalled, and nearly all the successive shoguns of the Edo period shared his keen interest. A system providing the kind of organization necessary to hawking was even established, overseen by samurai who specialized in the training of hawks.

Kamiya Haruzane, who painted this screen, was a late Edo period artist of the Kanō school officially attached to the Owari fief. It appears likely that Haruzane copied these hawks from an earlier painting, rather than from life.

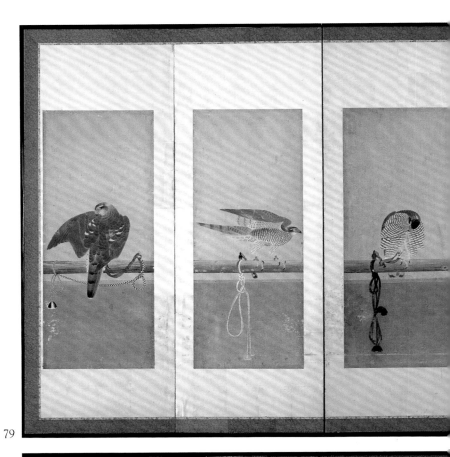

79

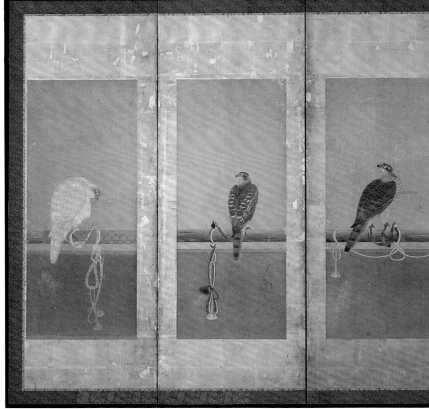

80

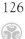

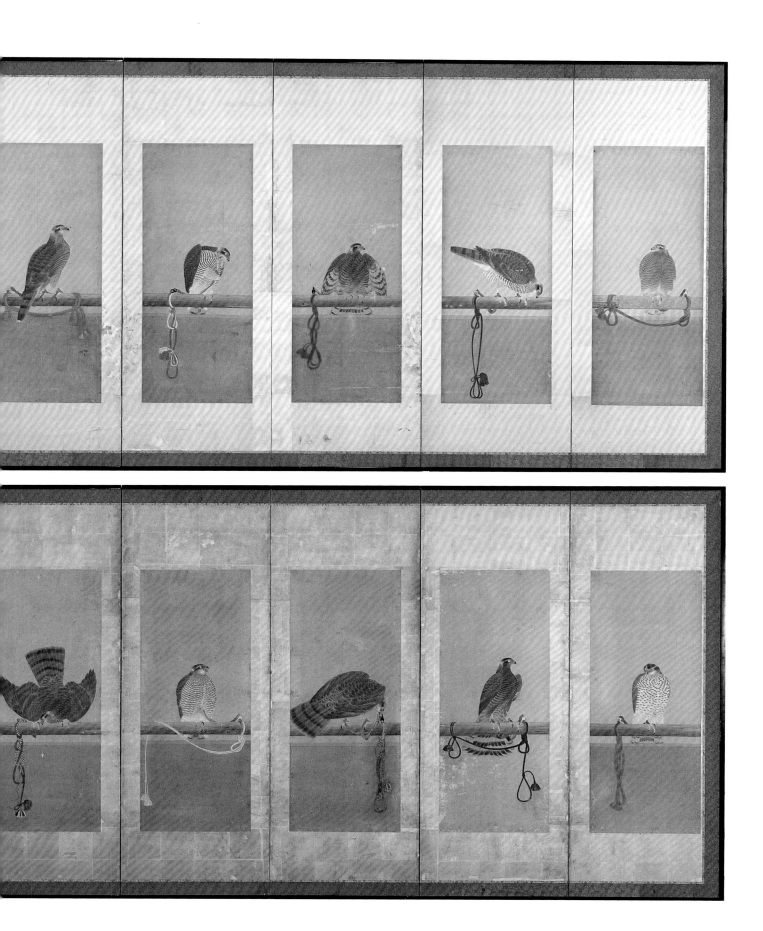

## 81-82

### HORSE RACING

Pair of six-fold screens, ink, colours and gold
leaf on paper
148.5 × 339.4 cm (each screen)
Edo period, 17th century

On a magnificent gold leaf ground decorated with gold clouds and bands
of mist, and sprinkled with gold powder,
are painted scenes of an equestrian
competition.

On the left side, a river lined with
cherry trees in blossom symbolizes spring;
on the right, another river, lined with
red-leafed maples, symbolizes autumn.
Although the work is entitled *Horse
Racing*, it depicts rather dressage and
equitation events taking place in a riding
area enclosed within a bamboo fence.
Gathered outside the fence are men and
women of all ages and ranks, such as a
Buddhist priest wearing a stole, and a
group of ladies of noble bearing observing
the horsemen from beneath a shelter.

One of the most representative of Japanese paintings on the theme of horse
racing is entitled *The Horse Race at Kamo*.
Towards the end of the Keichō era, this
horse race was included among the rituals
observed at the Shinto temple Kami-gamo
jinja. The race was part of a popular propitiatory cult aimed at ensuring a good
harvest. In *The Horse Race at Kamo*, a
Shinto temple situated on the banks of
the Mitarashi River was chosen as the setting in order to emphasize the religious
nature of the ritual: the temple's first and
second *torii* (archways) can be seen.

Unlike *The Horse Race at Kamo*, the
present painting displays no religious elements — it simply represents an equestrian competition. The tendency to minimize religious content in favour of
recreational aspects evident in this work
became increasingly noticeable during the
Edo period.

This painting bears neither a signature
nor a seal, but it is believed to be the
work of a painter from the Kanō school.

The pair of screens was presented by
the Owari Tokugawa to their official purveyors, the Okaya family, who donated it
to the Tokugawa Art Museum in the fortieth year of the Shōwa era (1965).

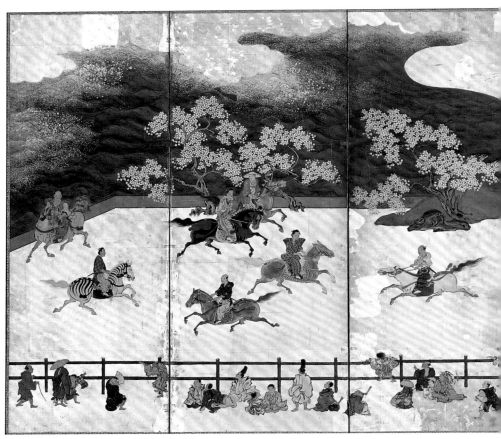

81

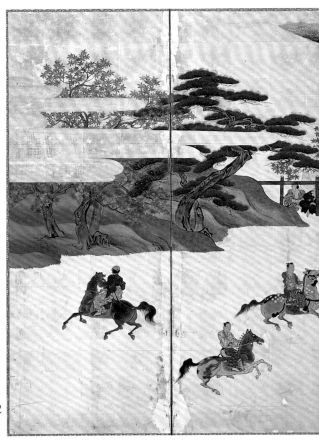

82

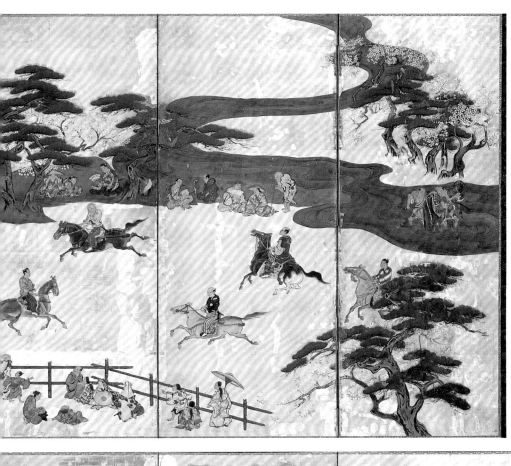

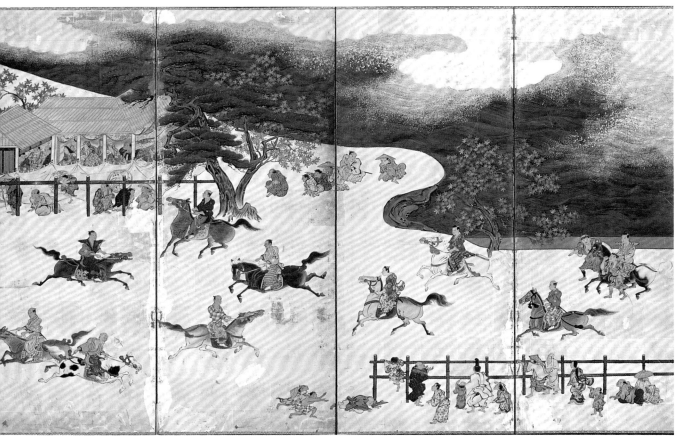

## 83

◉ SADDLE AND STIRRUPS

Gold *maki-e* and inlaid mother-of-pearl designs
on a cinnabar and black lacquer ground
Saddle: 63.5 × 42 × 41 cm
Stirrups: 30.8 × 13.3 × 27.2 cm
Edo period, 18th century

This set of horse trappings includes a
saddle, a pair of stirrups and their fit-
tings. A soft, thick pad made of cloth or
tanned deer hide was spread on the back
of the horse to cushion the weight and
sharp edges of the hard wooden saddle.
While riding horses was a privilege
granted only to warriors of upper and mid-
dle rank in the Edo period, it was also an
obligatory part of their military training.
These samurai vied with each other in
outfitting their horses with lavish, elabo-
rately worked equipment.

The design of this saddle features the
trifoliate *aoi* crest of the Tokugawa family
executed in gold *maki-e* prominently
placed in the centre of the front rim of
the pommel. Extending across both the
pommel and the cantle of the saddle are
the leafy branches of a maple tree,
depicted primarily in gold *maki-e* with a
scattering of leaves inlaid in iridescent
blue shell (*raden*). The ground is com-
pletely covered with a cinnabar lacquer
that has been deliberately worn away
in spots to reveal the undercoat of black
lacquer. The stirrups are lacquered
using the same decorative techniques,
but the design has been reduced to
a single demonic mask on the front
of each stirrup.

An inscription inked on the underside
of the saddle indicates that it was made in
the eleventh month of 1590 by Yoshihisa.
In the Edo period, old saddles were
prized and were often decorated anew
with *maki-e* lacquer (see also cat. 84).

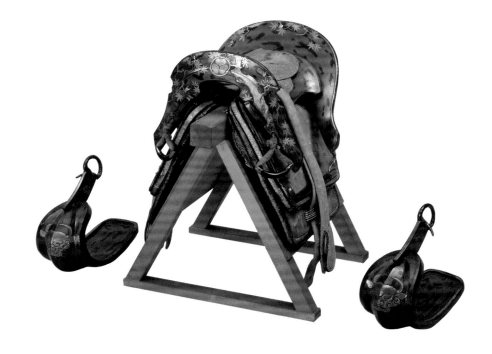

83

## 84

◉ SADDLE AND STIRRUPS

*Maki-e* designs on an aventurine lacquer ground
Saddle: 41 × 27 × 39 cm
Stirrups: 30 × 13 × 26 cm
Edo period, 19th century

In the Edo period only samurai of middle
or high rank were permitted to possess
their own riding horses. Of these the war-
riors of the highest status such as the
shogun, daimyo and *hatamoto* used riding
equipment ornamented in a manner

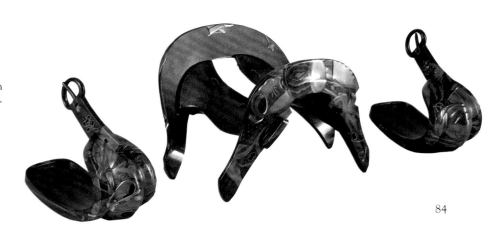

84

appropriate to their social position.

Japanese saddles were usually made of
hardwood such as oak or maple and were
decorated with lacquer. Stirrups were
made primarily of steel. The decoration of
this saddle and stirrup set is executed in
high relief, or *taka-maki-e*, and depicts
various kinds of military hardware such as
swords, bows and arrows, firearms, flags,

whips and fans. According to the carved
inscription on the underside of the saddle,
the wooden body was fashioned in the
fifth month of 1507. Redecorated in the
nineteenth century, this set was presented
as a gift to Tokugawa Yoshikatsu, the
fourteenth lord of Owari, by Emperor
Kōmei (r. 1847-1866) shortly before the
fall of the Tokugawa regime.

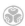

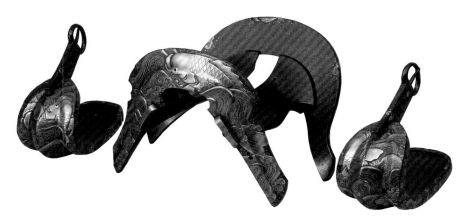

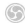 SADDLE AND STIRRUPS

Gold *maki-e* designs on an aventurine lacquer
ground
Saddle: 29.9 × 38.4 × 40.8 cm
Stirrups: 26 × 29.6 × 12.3 cm
Edo period, 19th century

Both the stirrups and the saddle of this
set feature painted gold decorations
on an aventurine lacquer ground. The
decorative motif is a carp borne by waves.
The saddle bears an inscription indicating
that it was made in the third year of the
Shōhō era (1646) and a signature in the
form of a seal (*kaō*). These details provide
evidence that the craftsman was
Sadashige, an eighth-generation member
of the Ise family, saddlers of the Inaba
domain. The lacquerwork dates from the
early Edo period; the gold decorations,
however, appear to be somewhat later.

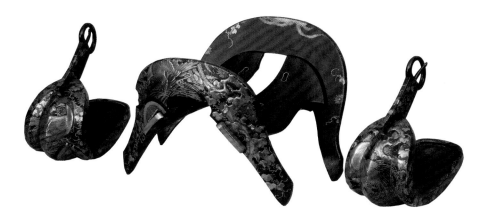

86

86

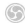 SADDLE AND STIRRUPS

Gold *maki-e* designs on an aventurine lacquer
ground
Saddle: 31.2 × 37.8 × 41.2 cm
Stirrups: 27.7 × 29 × 12.5 cm
Edo period, 19th century

The saddle of this set of horse trap-
pings is in wood, and the stirrups are
made of iron. The saddle is covered with
aventurine lacquer and decorated with
gold pine branch and ivy motifs. On the
front of the saddle can be seen a rooster-
like bird perched on a drum. This image
is clearly inspired by the ancient Chinese
legend that tells of a king who had a drum

installed outside his palace on which
unhappy subjects could manifest their dis-
satisfaction with his rule. The country,
however, entered upon a long period of
peace and harmony, and no one went to
beat the drum. Overgrown with moss, it
became an ideal and tranquil perch for
the bird who came to settle on it.

On the rear of the saddle can be seen
the seal (*kaō*) representing the artist's sig-
nature, and a date — the second month

of the eighteenth year of the Bunmei era
(1486). For many years this work was
attributed to Ise-no-kami Sadamune, a
member of the famous Ise family of master
saddle-makers. This attribution is now
thought, however, to be unfounded. The
shape of the saddle and the particular
technique of *maki-e* used are more in
keeping with a date towards the end of
the Edo period.

# THE TEA CEREMONY

# THE CHIYOHIME DOWRY

(cat. 87-96)

The Tokugawa Art Museum possesses a collection of several dozen gold objects inherited from the family's ancestors. Recent research into this collection has determined that eleven objects used during the tea ceremony, ten incense utensils and six pieces of furniture were originally part of the dowry of Reizei-in Chiyohime, the wife of Tokugawa Mitsutomo, second lord of Owari.

Chiyohime, daughter of the third Tokugawa shogun, Iemitsu, was born in the fourteenth year of the Kanei era (1637). She was wed to Mitsutomo when she was only two and a half years old. This somewhat precocious union was designed to consolidate the shogunate, for after the shogun himself, the lord of Owari was the most powerful daimyo in Japan.

Many of the objects from Chiyohime's large dowry have disappeared. According to an inventory drawn up in the nineteenth century, in the category of gold and silver objects alone, the dowry contained close to a thousand pieces. Besides the gold items mentioned above, the collection of the Tokugawa Art Museum includes a group of gold-decorated (maki-e) lacquered objects and a selection of painted fabrics. All the pieces from the dowry were intended as works of art, and the materials and decorative techniques employed are of the very finest.

The dish (cat. 87) and sake cup (cat. 88) were part of the table service. The teapot (cat. 89) and tea bowl (cat. 90) were used to prepare and serve medicinal infusions. The brazier (cat. 91) and the kettle (cat. 92) were for use during the tea ceremony (cha-no-yu). The other tea ceremony utensils that have come down to us from this set include tea bowls, a daizu (shelf used to hold the various utensils), a natsume (a thimble-shaped tea caddy) and an ordinary tea caddy. The incense burner (cat. 94) and its accessories (cats. 93, 95, 96) were used to pro-duce the aroma of the fragrant woods. All these objects were intended for use by Chiyohime or her husband, or during the reception of distinguished guests.

The teapot, brazier and kettle (cats. 89, 91, 92) are made from thick sheets of gold. The dish, sake cup, incense tray and incense container (cats. 87, 88, 93, 95) are made from thin sheets of gold, bent and welded together. The incense utensil holder (cat. 96) appears to have been moulded. The support material of the sake cup, tea bowl and tray (cats. 88, 90, 93) is wood. Against the hexagonal trellis-decorated (shokkō) ground of all these pieces may be seen aoi crests, together with arabesques and zigzag motifs carved in relief or very delicately engraved.

87

 DISH

Gold
3.6 cm (height), 19.8 cm (diameter)
Edo period, 17th century

88

 SAKE CUP

Gold
3.5 cm (height), 11.1 cm (diameter)
Edo period, 17th century

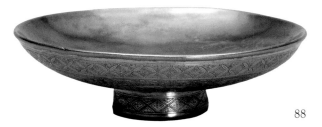

88

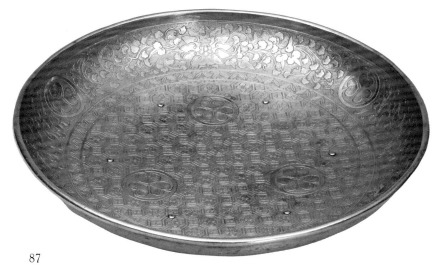

87

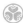

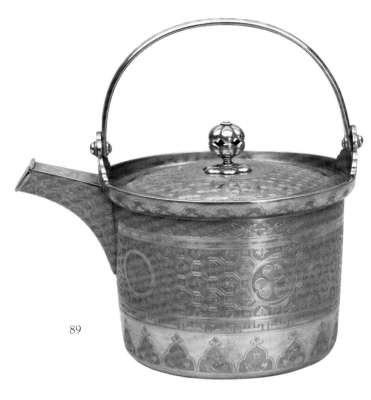

89

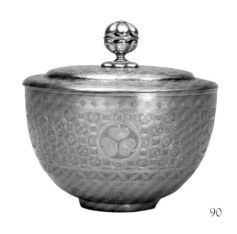

90

## 89

🍀 TEAPOT

Gold
17.3 cm (height), 11.5 cm (diameter)
Edo period, 17th century

## 90

🍀 TEA BOWL

Gold
6.8 cm (height), 6.8 cm (diameter)
Edo period, 17th century

## 91

🍀 BRAZIER

Gold
24.6 cm (height), 34.5 cm (diameter)
Edo period, 17th century

## 92

🍀 KETTLE

Gold
18.6 cm (height), 23 cm (diameter)
Edo period, 17th century

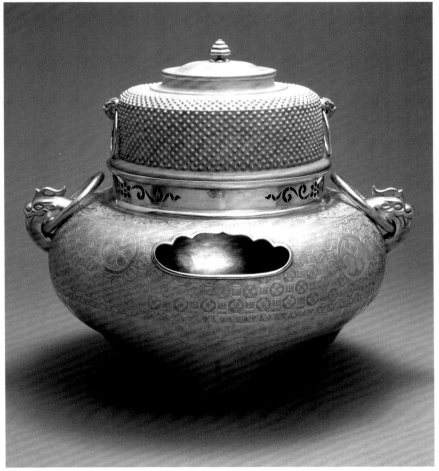

91-92

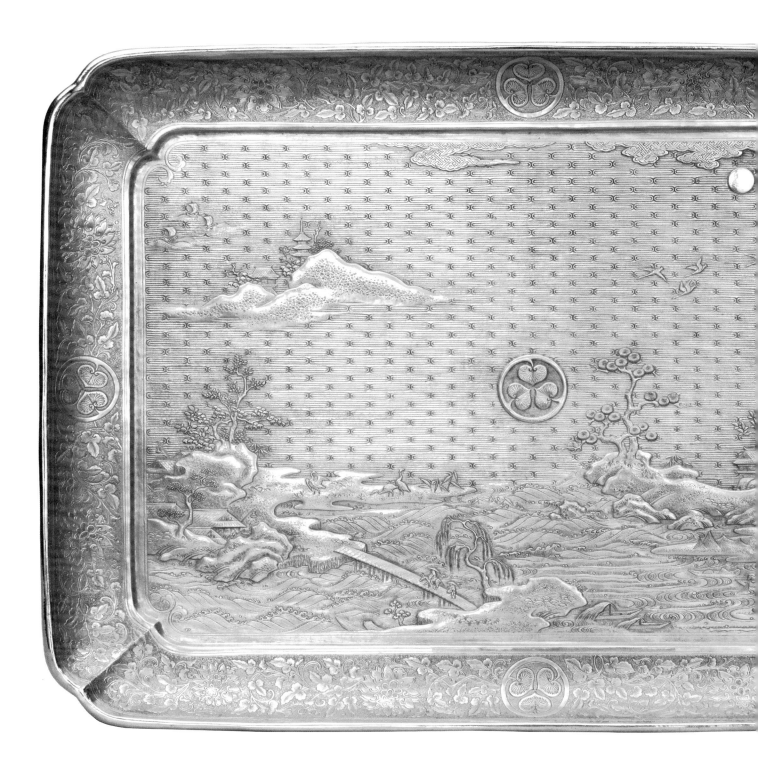

### 93

🏵 INCENSE TRAY

Gold
3.9 × 26.8 × 36.9 cm
Edo period, 17th century

### 94

🏵 INCENSE BURNER

Gold
9.1 cm (height), 7.3 cm (diameter)
Edo period, 17th century

### 95

🏵 INCENSE CONTAINER

Gold
7.1 cm (height), 4.8 cm (diameter)
Edo period, 17th century

### 96

🏵 INCENSE UTENSILS AND HOLDER

Gold
12.4 cm (height), 5.5 cm (diameter of base)
Utensils: spatula, *kōsuji*, silver tweezers,
chopsticks
Edo period, 17th century

96

95

93

94

## 97

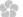 LETTER FROM EMPEROR GO-KŌGEN

Ink on paper
30.8 × 45.6 cm
North and South dynasties, 14th century

Letters written in the hand of a Japanese emperor are known as *shinkan*. Among the *shinkan* written by successive emperors, those dating from the middle of the Kamakura period until the period of the North and South dynasties are noted for the refinement of their calligraphy. These letters are called *shinkan-sama*, *sama* being an honorific suffix in Japanese.

Like his father before him, Emperor Go-Kōgen (1338-1374) wrote a very beautiful hand and excelled in the composition of *waka* poetry.

The subject of the letter presented here is musical notation. As it bears neither a date nor the name of the person to whom it was addressed, it is not known exactly when it was written.

97

## 98

 POEM FROM THE ANTHOLOGY *KOKIN WAKASHŪ*

Calligrapher: Emperor Fushimi (1265-1317)
Ink on paper
30.7 × 47.6 cm
Kamakura period, late 13th-early 14th century

This poem was part of the *Kokin wakashū* (Ancient and Modern Poems), which was the first poetic anthology to be compiled by order of the emperor. The poem is written in the style of calligraphy known as *chirashi-gaki*, in which the characters are widely spaced out across paper decorated with pieces of gold and silver varying in size from small flakes to particles of dust.

The calligrapher of this poem is said to be the emperor Fushimi, considered to be among the finest of all the poet-calligrapher emperors in the history of Japan. Fushimi admired and drew inspiration from the work of a number of the great masters of Japanese calligraphy, including Ono-no-Tōfū and Fujihara Yukinari. The versatility of Fushimi's style — which could range from the refined and intricate to the firm and broad — won him many admirers during his own lifetime.

98

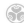

## 99

*DANCING HOTEI*

Tokugawa Mitsutomo (1625-1700)
Hanging scroll, ink on paper
32.7 × 55.8 cm
Edo period, 17th century

Paintings of this subject are often entitled "Dancing Hotei"; for it seems that when Hotei (Budai in Chinese, meaning "Cloth Bag"), a Chinese Chan monk of the Tang dynasty (618-907), shouldered his staff and sack as he wandered about, he looked almost as if he were dancing.

Using only ink, the artist has skilfully captured Hotei's "dancing" form by varying the ink tones from light to dark and by modulating the width of his brushstrokes. The effect is striking, both in Hotei's splendid expression and in the overall composition.

The artist, Tokugawa Mitsutomo, drew his inspiration for his painting from a portrait of the same subject by the Song period Chan painter Liang Kai. Liang's *Dancing Hotei* was one of the articles that belonged to Tokugawa Ieyasu, and after his death it was preserved in the treasury of the Owari branch of the Tokugawa family. When Tokugawa Mitsutomo died in 1700, Liang's painting was among those of his former possessions presented to the fifth shogun, Tokugawa Tsunayoshi. The painting by Liang Kai, to which Mitsutomo was apparently particularly attached, is now in the collection of the Kōsetsu Museum in Kōbe.

As well as being a fine painter, Mitsutomo, the second lord of Owari, excelled in calligraphy and the martial arts.

99

## 100

CALLIGRAPHY

Tokugawa Munechika (1733-1799)
Hanging scroll, ink on *kaishi* paper
35.3 × 50 cm
Edo period, 18th century

This verse was composed and written by Tokugawa Munechika, the ninth lord of Owari. Reputed to have been a kind and generous man, as well as a diligent scholar, Munechika was a wise ruler who contributed towards a revival in the fortunes of the Owari Tokugawa family and its domain. This example of his calligraphy reflects long hours of practice and is executed in a competent hand. It lacks, however, a certain inspiration. The subject of the poem is a cuckoo (*hototogisu*) on a summer day.

100

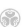

101

### FLOWER VASE, NAMED "KABURA"

Pale grey stoneware, celadon glaze
25 × 13.9 cm
Chinese, Southern Song, 12th-13th century

This flower vase offers a fine example of the beautiful glaze known as "celadon". The body of the vase is shaped like a turnip (*kabura*), hence its name.

The shape of the piece is inspired by the ancient Chinese *zun*, which was a wine container used exclusively during ritual celebrations. Original *zun* vases were made of bronze, but the form was later duplicated in ceramic. The Japanese flower vase known as *usu-bata* possesses a similar shape.

101

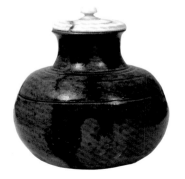

102

## 102

### TEA CADDY, NAMED "KARA-MARUTSUBO"

Stoneware
6.4 cm (height), 7 cm (diameter)
Chinese, Southern Song, 12th-13th century

This Chinese stoneware tea caddy served as a container for the powdered tea used in the tea ceremony, but was originally made for use as a spice jar. The literal meaning of *Kara-marutsubo* is "Chinese round-bodied jar".

The Japanese were quick to perceive the profound beauty of such simple, ordinary ceramic objects, which soon came to be treasured as the most important of tea ceremony utensils. This type of stoneware tea caddy is used only at the most distinguished tea gatherings.

104

## 104

### WATER JAR

Seto ware
14.5 cm (height), 7.3 cm (diameter)
Edo period, 17th century

The *mizusashi*, or fresh-water jar, serves as a container for the clean water used in the tea ceremony. In the ceremony, there are both elaborate, ornate utensils and those which are characterized by their simple, unassuming quality. The former were used primarily for formal gatherings in the reception rooms of official residences, while the latter were used in simple thatched tea huts. These unassuming utensils were not considered coarse or vulgar; they were seen rather as the expression of a new aesthetic sensibility that had developed in reaction to a surfeit of richness and extravagance.

This particular water jar is in the shape of a cylinder that flares slightly towards the top. The opening of the jar is called *hito-e guchi*, a reference to the rather sharply cut edge. The piece is covered with a glaze of the type traditionally manufactured in the Seto region, and the only decoration is a bold vertical line executed with a spatula.

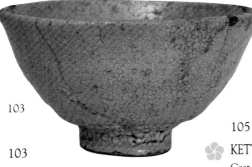

103

## 103

### TEA BOWL, NAMED "ISO-SHIMIZU"

Stoneware with bluish glaze
8.7 cm (height), 14.5 cm (diameter)
Korean, Yi dynasty, 16th century

Tea bowls imported from Korea are known generally in Japan as *Kōrai-chawan*. A particular variety of Korean bowl, called *ido-chawan*, is thought to have been manufactured in the south of the Kyongju region during the first half of the Yi dynasty (15th-16th cent.); from the Momoyama period on, *ido-chawan* were considered by the Japanese to be the finest of all Korean bowls. They are categorized according to size, shape and colour: *ō-ido* (large), *ao-ido* (blue) and *ko-ido* (small).

The present bowl, named "Iso-shimizu", belongs to the *ō-ido* group and is covered with a thick layer of bluish glaze. The irregularity of the bowl's form and the subtle colouring of its glaze together evoke a kind of inner melancholy that is entirely in tune with the calm and intimate nature of the *wabi* tea ceremony.

## 105

### KETTLE

Cast iron
13.4 cm (height), 25.5 cm (diameter)
Edo period, 17th century

This cast iron kettle was used to boil water during the tea ceremony. Within the context of the tea ceremony, kettles — like the other utensils used — served both as practical items and as objects of aesthetic appreciation. Shape, texture and decoration were all important elements in judging a kettle's beauty. This particular kettle is notable for its stable, balanced form and its distinctively rough surface.

It was customary, when serving tea to a guest of some importance, to use a kettle whose lid was held by strings. On the present piece, these were fastened to the rings on either side of the kettle's mouth. The copper lid is in the shape of an old-fashioned mirror.

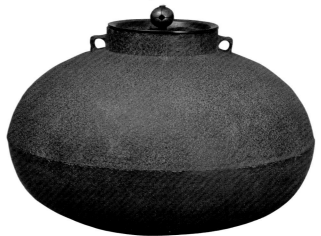

105

## 106

### CALLIGRAPHY

Ichizan Ichinei (1247-1317)
Hanging scroll, ink on paper
103.5 × 34.7 cm
Kamakura period, 14th century

Ichizan Ichinei, who was born in the
Chinese province of Tai Zhou, arrived
in Japan in 1299. The shogunal regent at
that time, Hōjō Sadatoki, suspected
Ichizan of being a Chinese spy in the pay
of the Yuan family and had him impris-
oned in the Shūzen-ji temple, in the
region of Izu. Ichizan was eventually
cleared, however, and rose to take on an
important post at the Kenjō-ji temple, in
Kamakura. Later, having gained the full
confidence of Emperor Go-Uda, he was
named by imperial decree to the top posi-
tion at the Nanzen-ji temple, in Kyoto.

This single-line calligraphy, which is
thought to have been originally one of a
pair, quotes a passage from the Buddhist
text *Kongō Hannya Haramitsuta Kyō* that
reads as follows: "When the mind is clear,
free from all concerns, then, in this state
of complete emptiness, will the truth
appear". The serene quality of the piece is
typical of Ichizan's work.

## 107

### OGURA-SHIKISHI, POEM

Calligrapher: Fujiwara no Teika (1162-1241)
Ink on *shikishi* paper
18.5 × 15.3 cm
Kamakura period, 13th century

The name *Ogura-shikishi* derives from
the coloured paper (*shikishi*) used on
the *shōji*, or sliding doors, at Fujiwara no
Teika's chalet on Mount Ogura, in the
Saga region. Teika was a famous poet of
the early Kamakura period, much admired
by poets of later generations for his clas-
sical learning as well as his poetry. From
the end of the Muromachi period, as the
tea ceremony gained in popularity,
Teika's poems did much to introduce
enthusiasts to the spiritual aspects of the
ritual. Calligraphies by Teika, particularly
those executed on *Ogura-shikishi*, were
more and more highly prized as ornaments
with which to decorate the tea room.
During the Momoyama period, eminent
members of the warrior class and tea mas-

106

ters competed for possession of these
*Ogura-shikishi*, and throughout the Edo
period works by Teika counted among the
most prestigious of gifts. Teika's style of
calligraphy was actually so admired that it
was given a name of its own — *Teika-ryū*
(Teika style).

107

The thirty-one syllable *waka* poem that
appears on this *shikishi* sheet was written
by the mid-tenth-century poet Mibu no
Tadami. The message contained in the
poem may be summarized thus: "My heart
is filled with an unspoken love. Oh secret
love, divined by none".

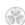

## 108

### CALLIGRAPHY

Xutang Zhiyu (1185-1269)
Hanging scroll, ink on paper
30.6 × 62.7 cm
Chinese, Southern Song, 1254

Xutang Zhiyu (in Japanese, Kidō Chigu or Sokkō) was a renowned Chan monk of the Southern Song period. He entered the priesthood at the age of fifteen and rose to be the abbott of the great monastery on Mount A-yu-wang. He was regarded as one of the master calligraphers of his time.

A number of Japanese Zen monks of the period journeyed to China to study under distinguished monks. This example of Xutang's calligraphy was a gift to a Japanese monk named Tokui who had gone to China to study.

Because the tea ceremony sought its spiritual foundations in Zen teachings, the writings of Zen monks, known as *bokuseki* (ink traces), were particularly prized and often mounted as hanging scrolls to adorn the tea room. Calligraphies by Xutang are the most highly prized *bokuseki*, not only for their inherent aesthetic qualities, but also because this artist is perceived as the spiritual forefather of a considerable segment of the Japanese Zen community.

This work was a gift from Tokugawa Tsunanari, the third lord of Owari, to his heir and successor, Yoshimichi. Yoshimichi, in turn, presented it to the sixth Tokugawa shogun, Ienobu (r. 1709-1712). It was returned to Yoshimichi after Ienobu's death in 1712.

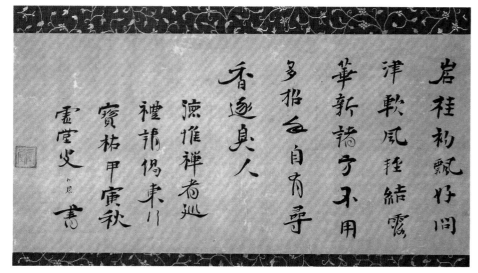

108

109

## 109

### CALLIGRAPHY

Seigan Sōi (1588-1661)
Hanging scroll, ink on paper
34.8 × 67.9 cm
Edo period, 17th century

The work presented here is a calligraphy written on a *kake-mono* (hanging scroll) that accompanied a tea caddy named "Ojima" belonging to the Owari Tokugawa. The scroll bears the name of the tea caddy, written in large letters in a firm but flowing hand. A poem about the caddy can be seen on the left, together with the signature of the calligrapher, Seigan Sōi.

Seigan Sōi was the one hundred and seventieth person to assume control of the Daitoku-ji temple, in Kyoto. Later, on the orders of the third Tokugawa shogun, Iemitsu, to whom he acted as Zen master, Sōi was put in charge of the Tōkai-ji temple, in Edo.

Sōi was renowned as a painter as well as a calligrapher. His powerful and unique calligraphic style was inspired by such Southern Song masters as Chō Sokushi and Kyodō Chigu.

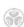

110

 AUTUMN MOON OVER DONGTING
LAKE

Attributed to Mu Qi (d. between 1264-1274)
Hanging scroll, ink on paper
29.4 × 93.1 cm
Chinese, Southern Song, 13th century

The region in the Hunan Province of China where the confluence of the Xiao and Xiang Rivers flows into Dongting Lake is celebrated for the picturesque beauty of its landscape. Delighting in this scenery, Chinese painters adopted eight themes based on the landscape of the area as favourite subjects for their compositions. These eight classical themes are named collectively the "Eight Views of the Xiao and Xiang Rivers". The present painting illustrates one of them.

The painting is suffused with a softness that it is almost impossible to imagine as having been executed with a brush. Rep-resented impressionistically, the lake can barely be seen through the evening mist.

Although many points in his biography remain obscure, Mu Qi, the artist to whom this painting is traditionally attributed, is thought to have been a Chan monk from Sichuan Province who lived towards the end of the Southern Song. Following this period, his paintings were not highly regarded in China. In Japan, however, where they were respected as an inspirational source for monochrome ink paintings (*suiboku-ga*), they were of great significance.

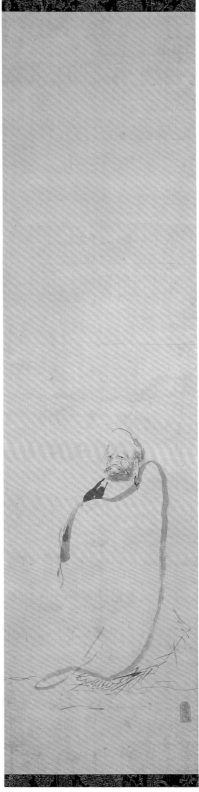

112

## 111

*SPRING LANDSCAPE WITH HERONS*

Hanging scroll, ink and colours on silk
37 × 37.3 cm
Chinese, Yuan-Ming dynasty, 14th-15th
century

This spring landscape shows a river winding peacefully between sandy shores, against a backdrop of distant mountains. Several species of bird, including the heron, browse along the riverbank, under tall willows or among the abundant flowers and reeds.

This type of small-scale landscape, called *shōkei-ga*, was extremely popular in China among the nobility and members of the imperial family during the late Northern Song period. Chō Dainen was an artist particularly famous for his small landscapes, and the fine detail of the present work is reminiscent of his style. However, the painting lacks something of the precision and force characteristic of Chō Dainen's work, and it seems probable that it was executed by a later artist.

## 112

*BODHIDHARMA CROSSING THE YANGZI ON A REED*

Miyamoto Musashi (1582/4-1645)
Hanging scroll, ink on paper
112.4 × 28.2 cm
Edo period, 17th century

The Indian monk Bodhidharma (Bodaidaruma in Japanese, shortened to Daruma) was the sixth-century founder of the Chan sect of Buddhism, known in Japan as Zen Buddhism. The theme of this painting derives from the traditional account of Bodhidharma's audience with Emperor Wudi (502-550), sovereign of the Chinese state of Liang. The interview was unsuccessful, as the emperor failed to be awakened to the truth of the doctrine. Afterwards, Bodhidharma left the state of Liang, crossing the Yangzi River on a single reed.

Miyamoto Musashi (better known as a painter by the name of Niten), who served the daimyo Hosokawa in Kyūshū in the latter years of his life, is celebrated in Japanese history as a master swordsman. Although he painted only for personal cultivation and amusement, his works display an accomplished economy

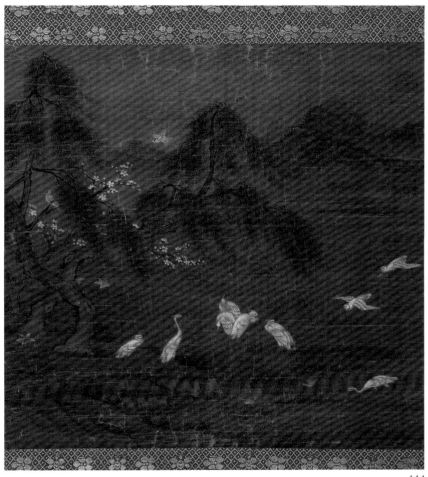

111

of brush work that is suggestive of the style of Liang Kai (active early 13th cent.) a Chinese Chan painter of the Southern Song. Bodhidharma seems to have been a favourite subject for Musashi, who specialized in depictions of birds and figure painting, and whose deep penetration into the spirit of Zen Buddhism stood him in good stead in mastering "the Way" in swordsmanship. To Musashi, "knowing the Way in various arts" meant, above all, realizing their essence in the practice of swordsmanship. For him, swordsmanship, Zen and painting were essentially one and the same art.

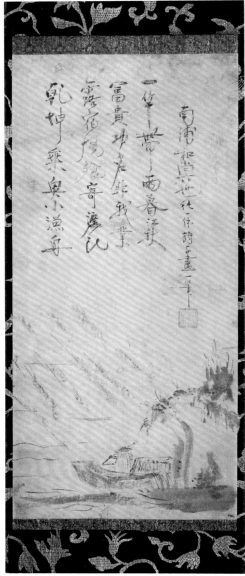

114

113

 *FISHING BOAT IN THE RAIN*

Inscription: *Ikkyū Sōjun*
Hanging scroll, ink on paper
58.6 × 27.3 cm
Muromachi period, 15th century

Ikkyū Sōjun (1394-1481) employed several pseudonyms. Apart from bearing the name "Ikkyū", the artist who created this work was also known as "Kyō-un shi" and "Kokkei".

In the upper part of the painting may be seen a Chinese quatrain, with seven characters to each line, that is related to the work's theme. The poem is followed by an inscription indicating that both it and the painting are the work of Ikkyū Sōjun, the sixth person after the master

Nanpo to have assumed control of the Kenchō-ji temple. Ikkyū's seal, in red, accompanies the inscription.

There exist many ink landscapes, or *suiboku-ga*, attributed to Ikkyū. The similarity of the seal seen here to those that appear on authenticated works by this artist, together with the characteristically calm style of drawing and calligraphy, provide conclusive evidence that this work, too, is by him.

In the painting, rain falls diagonally from left to right. Steep rocks descend

from the upper right, ending in the central foreground of the composition where we see a small fishing boat. In the boat a solitary fisherman is rowing, his back bent. It seems clear — and the poem confirms this — that the image of the humble fisherman, absorbed in his simple task with no thought for wealth or glory, has been used to symbolize the artist's state of mind. Both the lightness of the ink and the broad, quick strokes admirably convey the essence of this evocative work.

115

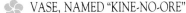
**TEA-LEAF JAR, NAMED "KINKA"**

Ceramic with yellowish glaze
41.5 cm (height)
Chinese, Yuan-early Ming dynasty, 13th-15th
century

This piece was made in southern China and is representative of a type of jar imported in large quantities to Japan from the early fourteenth century. These jars were used for storing leaf tea and came to be viewed as objects of rare value. By the sixteenth century, they were appreciated as objects of art and were employed both in simple, thatched tea huts and in the reception rooms of daimyo.

Chinese tea-leaf jars came to be seen as important elements in the ritual surrounding the tea ceremony. Every year the family of the Tokugawa shogun dispatched a procession to the tea-growing district of Kyoto. The men would carry these jars and have them filled with fresh leaf tea for use by the Tokugawa family. During the journey to and from Kyoto, these processions were assigned a status equal to that of the retinue of a mid-ranking daimyo.

Named "Kinka" or "Golden Flower", this tea-leaf jar was passed from hand to hand among powerful warlords in the sixteenth century, and subsequently came into the possession of the first Tokugawa shogun, Ieyasu.

115

114

**VASE, NAMED "KINE-NO-ORE"**

Bronze
25.8 cm (height), 10.5 cm (diameter)
Chinese, Southern Song, 12th-13th century

This Chinese bronze vase, dating from the Southern Song, is one of the most famous tea ceremony flower vases in Japan, and its value is commensurate with its fame. It is said that the vase was named "Kine-no-ore" because its shape resembles that of a pestle broken in half. In the tea ceremony, undecorated vases are preferred to highly ornate ones, and are in fact valued for their very simplicity. This vase has no decoration other than the two animal masks placed symmetrically on either side of the upper part of the neck.

In the long and eventful history of this prized vase, there is one particularly notable episode: in 1600, having been beaten in battle by Tokugawa Ieyasu, general Ishikawa Ujikatsu escaped execution by presenting this vase to his adversary.

116

**TEA BOWL, NAMED "HOSHI KENSAN"**

*Tenmoku*, with oil-spot glaze and
silver-bound rim
7.1 cm (height), 12.1 cm (diameter)
Chinese, Southern Song, 12th-13th century

This tea bowl, whose edge is rimmed in silver, is traditionally called "Hoshi kensan" among the members of the Owari Tokugawa family. The general name for this type of bowl is *yu-teki* (oil spot), and it belongs to the category known as *tenmoku chawan*, which are bowls manufactured in the *chien* kilns (Kenyō in Japanese) of China. Both the inner and outer surfaces of the bowl are covered with what appear to be countless spots of oil, which in many places seem to run down to form drips (*nogi-me*). These lines and spots give rise to a silvery shine that is quite striking.

116

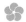

### 117

### TEA BOWL

White *tenmoku*, with gold-bound rim
6.4 cm (height), 12.1 cm (diameter)
Muromachi period, 15th-16th century

With the adoption of the practice of drinking powdered tea, *kensan tenmoku* tea bowls (see cat. 132) began to be imported into Japan in large quantities. Soon, attempts were being made by Japanese potters to imitate Chinese *tenmoku* bowls. Their attempts proved successful, and during the fifteenth century large quantities of these bowls were produced at kilns in the Seto region. Later, the same potters began to make *tenmoku* bowls with ash glazes, in addition to the usual iron glazes. The shape and colour of this white *tenmoku* tea bowl, which has an ash glaze, deeply impressed tea ceremony devotees, and it came to be greatly admired as a rare and treasured object.

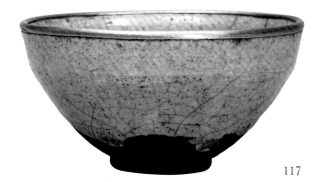

117

### 118

### TEA BOWL, NAMED "WAKAMIZU"
Attributed to Raku Ryōnyū (1756-1834)

Raku ware with black glaze
8.6 cm (height) , 11.5 cm (diameter)
Edo period, 17th century

*Raku-yaki* is a Japanese method of manufacturing pottery whose emergence coincided with the rise in popularity of the tea ceremony. The founder of the Raku family, Chōjiro, is reputed to have given the final form to this type of bowl himself, under the guidance of Sen no Rikyū.

The squarish bowl presented here (of the form known as *masu*) is attributed to Ryōnyū, an eighth-generation descendant of the Raku family. The combined effect of the brilliance of the shiny black glaze and the slight irregularity of form typical of *Raku-yaki* render the bowl the perfect expression of the essence of the *wabi* aesthetic, which stresses the instrinsic beauty of the useful.

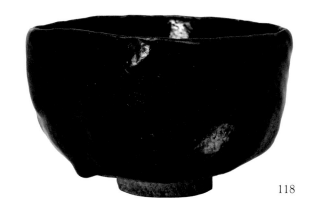

118

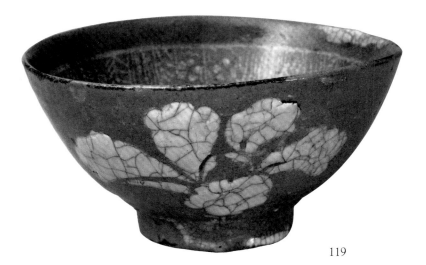

119

 TEA BOWL, NAMED "MISHIMA GAIKA"

Stoneware with inlaid design, celadon glaze
8.2 cm (height), 16.7 cm (diameter)
Korean, Yi dynasty, 16th-17th century

This bowl was manufactured in Korea. The modern Korean name for this type of ware can be translated "ceramic made from sand and covered with blue powder". The Japanese name for such pieces is "Mishima", and for this there are two explanations: the first, and more usual, is that the design on the bowls resembles the calendar of the Shinto temple Mishima jinja; the second is that the Korean island of Kyobuntō, once an important point of exportation for pottery of this type, used to be called Mishima.

Both the inner and outer surfaces of this beautiful bowl are decorated with large-petalled peonies, and the whole is covered with a green celadon glaze. Among the Mishima tea bowls that have come down to us, the present example is the only one of its type.

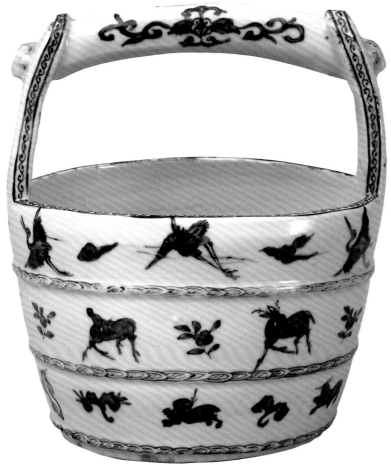

120

120

 BUCKET-SHAPED WATER JAR

Porcelain, with underglaze blue designs
26.4 cm (height), 22 cm (diameter)
Chinese, Ming dynasty, 16th-17th century

Because porcelain was shipped from the port of Ning-po, in the Chinese province of Zhejiang, this type of ware was generally known as *Ning-po some-tsuke* (painted porcelain from Ning-po). This particular piece is an example of *ko-some-tsuke* (porcelain with blue designs, made towards the end of the Ming dynasty). The jar is designed to resemble a wooden bucket, a model very popular with tea ceremony enthusiasts.

The body of the jar is divided horizontally into three sections, decorated respectively with cloud, crane and deer motifs.

When Fushimiya Jin-e-mon, who was assigned the task of augmenting the famous collection of works belonging to Matsudaira Fumai, was asked to examine this jar in the sixth year of the Bunka era (1809), he gave his opinion that it was an example of *mushi-kui* — a term apparently once used for *ko-some-tsuke*.

Tokugawa Naritaka, the twelfth lord of Owari, was an enthusiastic practitioner of the tea ceremony, and he had a copy of this water jar made in Seto ware.

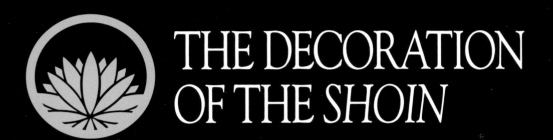

# THE DECORATION OF THE SHOIN

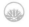

## BODHIDHARMA, ZHENG HUANGNIU AND YU SHANZHU

Wuzhun Shifan (1179-1249)
Three hanging scrolls (triptych), ink on paper
Central scroll: 89.1 × 32 cm
Side scrolls: 84.1 × 30 cm
Chinese, Southern Song, 13th century

During the fourteenth and fifteenth centuries, the aesthetic interest of Zen monks and members of the cultivated ruling class in Japan turned enthusiastically toward China, resulting in the importation of large quantities of Chinese articles. Of these, ink paintings of the Song and Yuan periods were the most highly valued and they came to be regarded in Japan as treasures. It was an age in which Zen (Chan in Chinese) Buddhism enjoyed great prestige, and Zen-related themes in works produced by Zen monks were highly prized.

The three paintings of this triptych were executed by the Song period Chan prelate, Wuzhun Shifan. In the upper portion of each painting are Wuzhun's signature and a poem referring to the motif below.

Each of the paintings is a portrait of a Chan Buddhist monk. Bodhidharma was an Indian monk renowned as the sixth-century founder of the Chan school of Chinese Buddhism. A single reed is shown at his feet, an allusion to the legend that he travelled to China from India riding on a reed.

In either the left or right lower corner of each painting is the same square relief seal that reads "Dōyū". The presence of this *kanzō-in* (connoisseur or collector's seal) indicates that these paintings were once part of the collection of the third Ashikaga shogun of the Muromachi period, Ashikaga Yoshimitsu (r. 1368-1394). From the fifteenth century until the present day, paintings bearing this seal have been regarded in Japan as outstanding works of art and prized accordingly.

121

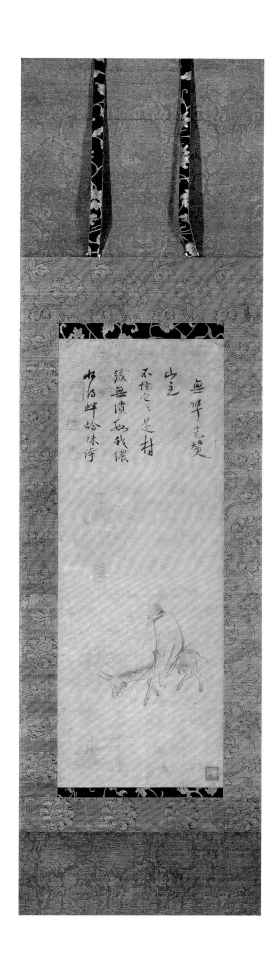

## 122

### SHŌKI, THE DEMON-QUELLER, AND DRAGONS IN BILLOWING WAVES

Kanō Tsunenobu (1636-1713)
Three hanging scrolls (triptych), ink and light colours on paper
113 × 51.2 cm (each scroll)
Edo period, 17-18th century

Shōki (Zhong Kuei in Chinese) is a Chinese deity who routs demons and malevolent spirits and drives away pestilence and plague, which accounts for his representation here as a terrifying and truculent Chinese warrior. According to one legend, the Tang emperor Xuanzong (r. 712-756, also called Ming Huang) had a dream while suffering from a fever in which he saw Shōki subduing and destroying demons. When he awakened, the fever had left him. Thereupon, goes the legend, the emperor ordered the court painter Wu Daozi to draw the figure of Shōki as he had appeared in his dream. Traditionally, this painting is said to have been the "original" portrait of Shōki. Wu Daozi is famous as the initiator of the traditional art of monochrome ink painting.

In Japan, Shōki was represented not only as a god who stamps out epidemics and pestilence, but also as a symbol of military power. This triptych was executed by Kanō Tsunenobu, an official painter in the employ of the Tokugawa shogun and a leading artist of the late seventeenth and early eighteenth centuries.

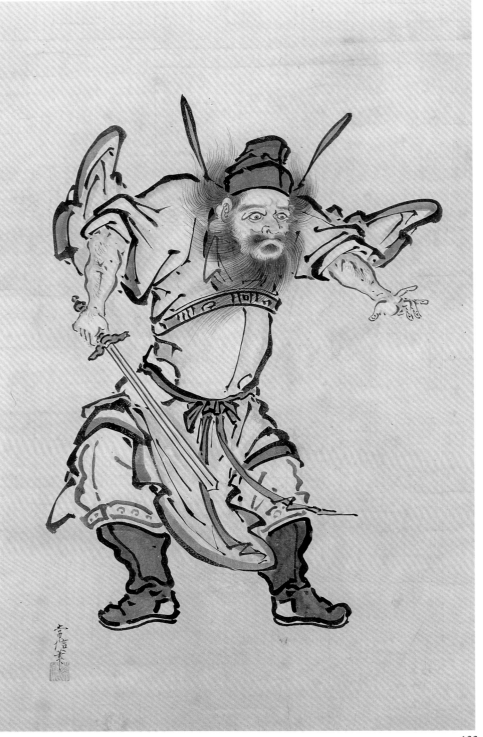

122

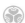

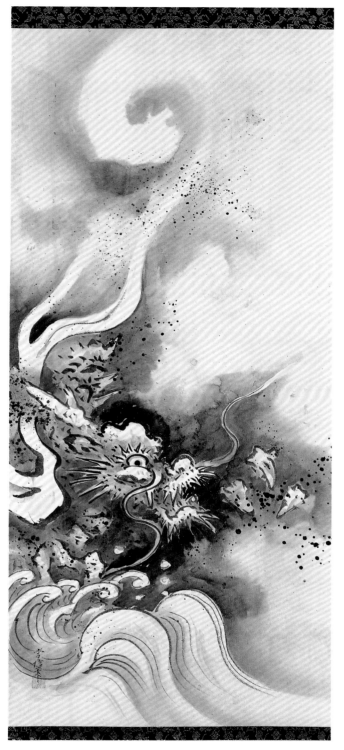

## JURŌJIN, THE GOD OF LONGEVITY, WITH BIRDS AND FLOWERS

Kanō Tan'yū (1602-1674)
Three hanging scrolls (triptych), ink and light
colours on silk
121.6 × 50.6 cm (each scroll)
Edo period, 1672

A legendary Chinese character said to have lived during the Song period (960-1279), Jurōjin (Shou Laoren in Chinese) is revered in Japan as one of the *Shichi-fukujin*, or "Seven Gods of Happiness and Good Fortune". His appearance in paintings as a symbol of long life goes back many centuries, and he is often employed to convey congratulations. He is usually represented as a white-haired and bearded old man seated under a great pine tree, holding a tall staff and accompanied by a deer — all symbols of the blessing of longevity.

The artist of this triptych, Kanō Tan'yū, was one of the foremost artists of the Edo period. From his position as the leading official painter (*goyō-eshi*) to the Tokugawa shogunate, he dominated the field of painting during his lifetime.

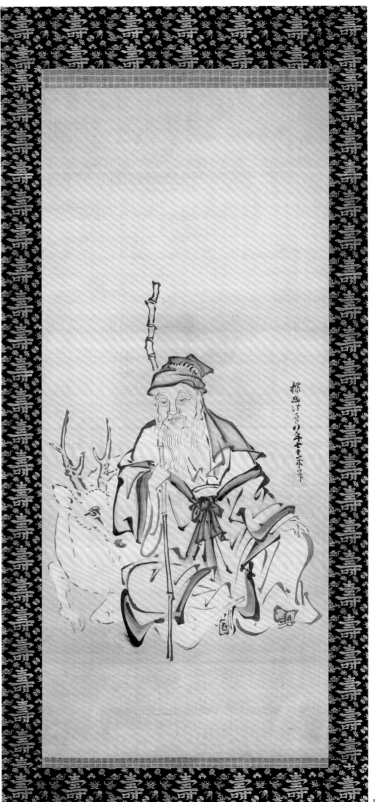

123

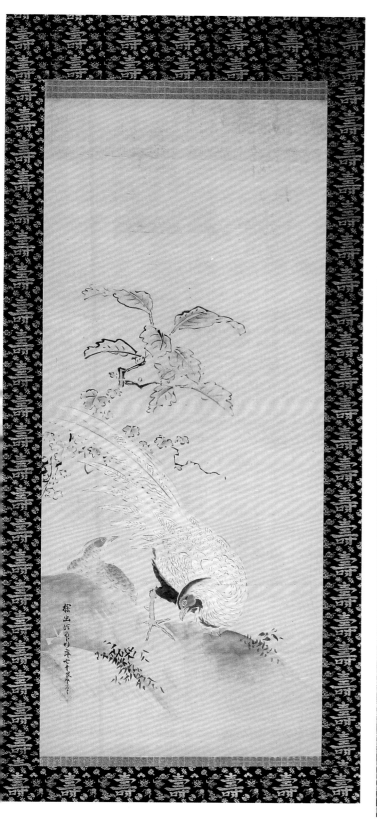
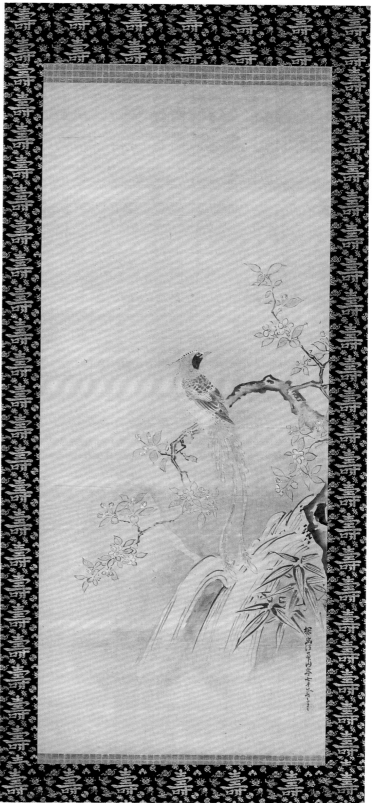

157

## 124

### THE BODHISATTVA KANNON, GODDESS OF MERCY

Three hanging scrolls (triptych), ink on silk
Central scroll: 104.5 × 51.5 cm
Side scrolls: 103.8 × 50.4 cm
Chinese, Yuan period, 14th century

The *oshi-ita*, or *tokonoma* alcove, is invariably decorated with three or five *kake-mono*, or hanging scrolls. The central scroll always illustrates a theme related to the object of devotion, whether Buddhist, Confucian or Taoist, while the side screens, which form pairs, usually depict flowers, birds or animals.

During the Muromachi period, when this style of decoration developed, it was quite common for the central and side paintings to be by different artists, and this is the case with the triptych presented here. The central scroll depicts the Bodhisattva Kannon, goddess of mercy, dressed in white and seated on a rock beside a river. On the opposite bank, Zenzai Dōji, a Bodhisattva embodying the pursuit of the Buddhist vocation, prays. The two side scrolls represent plum tree and bamboo motifs. Since the Edo period, these three paintings have been attributed to Kaō Sōzen, a Japanese monk who died in 1345. However, a careful examination of the works leads to the conclusion that the artist was probably Chinese, rather than Japanese. Furthermore, the style of the central painting, which is unlike that of the other two, suggests that the work dates from an earlier period.

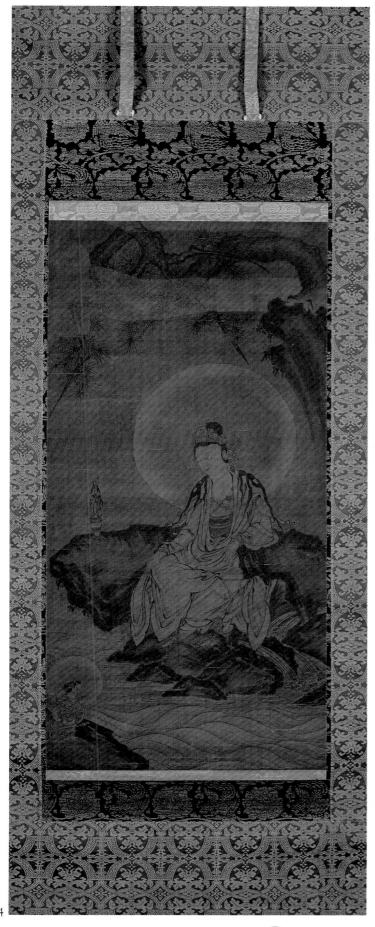

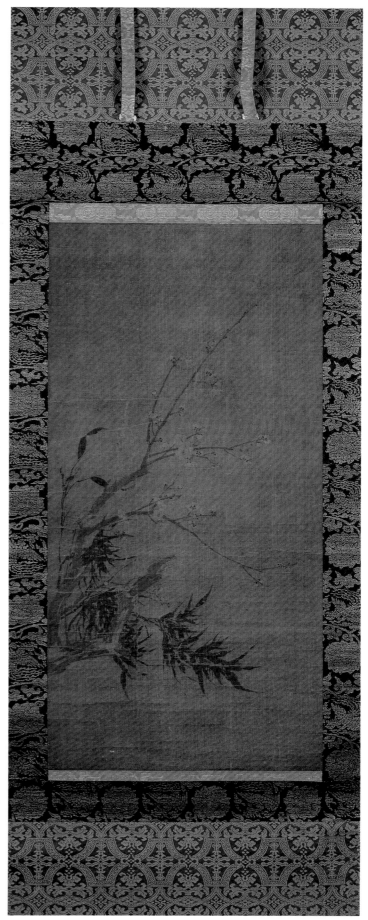

## 125

✿ PAIR OF *HU*-SHAPED VASES

Bronze
33.9 cm (height), 19.5 cm (diameter)
Chinese, Ming dynasty, 15th century

The origin of the shapes of Chinese and Japanese flower vessels can frequently be found in ancient Chinese ritual bronzes of the Shang and Zhou dynasties (about 1776-221 B.C.). The two vases presented here are in the shape of a bronze wine jar called a *hu*, a type that was widely produced during the late Eastern Zhou dynasty (about 650-221 B.C.). The vases are decorated with a *tao-tie* mask, a stylized rendering of the countenance of a mythological monster that was one of the principal motifs on ancient Chinese bronze vessels.

Flowers were arranged in these two vessels to form a symmetrical composition.

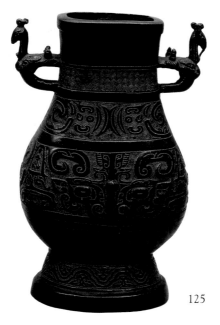

125

## 126

✿ SET OF INCENSE UTENSILS

Copper
Chopsticks: 20.1 cm
Spatula: 17.1 cm
Stand: 9.5 cm (height), 3.9 cm (diameter)
Edo period, 18th century

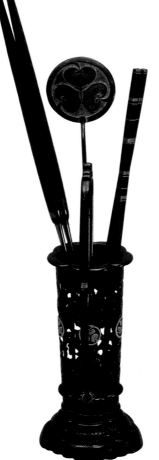

126

These utensils were placed before the hanging scrolls, numbering either three or five, that hung in the *tokonoma* alcove in the formal reception room of the residences of the shogun and daimyo. Flowers, incense and candles are the three traditional offerings placed before Buddhist altars, and the adoption of this religious model served to impart dignity to the paintings displayed in the *tokonoma*.

Numerous rules governed the choice of flowers to be arranged in these vases, for the status and character of the master of the residence was expressed in the flowers' shape and composition. The Japanese art of flower arrangement (*ikebana*) has its origins in this tradition.

The incense used in the incense burners was stored in containers such as those seen in numbers 127 through 129. All are circular with flush-fitting lids and are executed in high-relief carved lacquer, the specific names for which were derived from the colour of the lacquer used. Numbers 128 and 129 are called *tsuishu* (literally, "piled-up cinnabar"); number 127 is an example of *kōka-ryokuyō* (red flowers, green leaves), red and green being the two colours used to differentiate the blossom from the foliage. Carved lacquer developed in China during the Song and Yuan periods, and objects made by these techniques were extremely popular in Japan among tea ceremony practitioners.

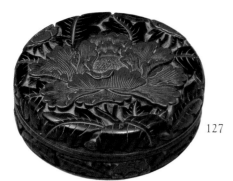

127

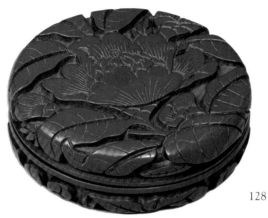

128

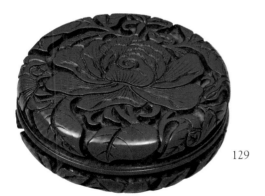

129

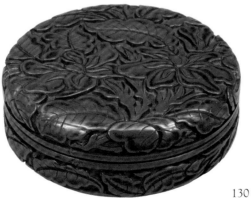

130

**127**

### INCENSE CONTAINER

Carved cinnabar and green lacquer
3.4 cm (height), 8.3 cm (diameter)
Chinese, Ming dynasty, 16th century

**128**

### INCENSE CONTAINER

Carved cinnabar lacquer
3.9 cm (height), 11.2 cm (diameter)
Chinese, Ming dynasty, 15th-16th century

**129**

### INCENSE CONTAINER

Carved cinnabar lacquer
3.9 cm (height), 9.8 cm (diameter)
Chinese, Ming dynasty, 15th-16th century

**130**

### INCENSE CONTAINER

Carved red lacquer
3.9 cm (height), 10.6 cm (diameter)
China, Ming dynasty, 16th century

The Japanese custom of burning aromatic woods (*kōboku*) or incense goes back many centuries. Chips of aromatic wood were used either by themselves or mixed with substances of plant or animal origin, such as *jin-kō* (Japanese daphne), *ja-kō* (musk) and *chōji-kō* (clove tree).

This incense container, designed to contain aromatic wood chips, has been decorated using the traditional Chinese technique of *chōshitsu*, which involves the application of a very thick coat of lacquer that is afterwards carved. The outside of the box is ornamented with gardenia motifs (*kuchi-nashi*) in relief, and the inside is covered with black lacquer.

 TEA CADDY, NAMED "HON'AMI"

Seto ware
12.5 cm (height), 4.3 cm (diameter)
Muromachi period, 15th-16th century

This ceramic tea caddy, or *cha-ire*, serves as a container for the powdered tea used in the tea ceremony. It has an ivory lid and is classified as a *kata-tsuki*, or square-shouldered caddy. The tea caddy was long considered to be among the most important of the utensils used during the tea ceremony. It was even believed that certain exceptional pieces were as valuable as an entire province.

The name of this tea caddy originates with the Hon'ami family, who were known as influential sword connoisseurs. Hon'ami Kōetsu (1558-1637), who lived during the late Momoyama and early Edo periods — a time when the tea ceremony was flourishing — was famous not only as the most cultivated individual of his day, but also as an avid devotee of the tea ceremony.

131

## TEA BOWL

*Kensan tenmoku* with hare's-fur effect
6.6 cm (height), 12.1 cm (diameter)
Chinese, Southern Song, 12th-13th century

132

The practice of drinking powdered green tea whisked in boiling water became prevalent in China during the Song period. Jian ware tea bowls (called *kensan* in Japan) came to be considered the most suitable for drinking tea in this manner. The term *kensan* is the Japanese reading of the Chinese characters meaning "small, shallow bowl from Jian", and it is used to refer to ware produced at the Jian kilns in the Chinese province of Fujian.

When the custom of drinking tea was introduced into Japan, *kensan* bowls began to be imported in large quantities. Certain of these imported bowls, considered to be superior in quality, were set aside and came to be viewed not simply as ordinary tea bowls, but as treasured objects. The selection of these bowls was made on the basis of their form and the quality of the glaze, with particular preference being given to a mottled glaze effect. Categorized generally as *tenmoku* in Japan, these lustrous black-glazed stone-ware bowls take their name from the Tian-mu mountains in the Zhejiang province of China, traditionally the place where the first bowl of this type to enter Japan — taken there by a Buddhist monk during the Kamakura period — originated.

### 133

## STAND FOR *TENMOKU* TEA BOWL

Carved red lacquer
7.9 cm (height), 17.6 cm (diameter)
Chinese, Ming dynasty, 16th century

### 134

## STAND FOR *TENMOKU* TEA BOWL

Carved red lacquer
7.9 cm (height), 16.7 cm (diameter)
Chinese, Ming dynasty, 16th century

Stands for *tenmoku*-style tea bowls, the most common of which are called *kensan*, are known as *tenmoku-dai*. The two stands presented here are decorated with similar motifs and were both made using the traditional Chinese technique of *chōshitsu*.

According to this technique, a wood base is covered with a thick layer of lac-quer — red, green, yellow or black — that is then carved with designs featuring the stems, leaves and petals of various flowers, most commonly chrysanthemums, peonies or peach blossoms. The interior surfaces of pieces of this type are usually covered with black lacquer.

The *chōshitsu* technique was developed in China during the Song period and enjoyed considerable popularity from the Yuan to the Ming dynasties. Many very fine pieces from this time have come down to us.

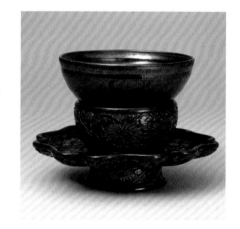

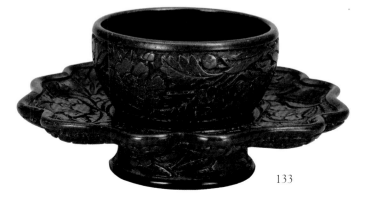

133

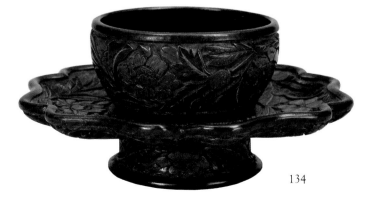

134

## 135

 INCENSE BURNER IN THE SHAPE OF A DUCK

Bronze
24.5 × 20.3 cm
Chinese, Ming dynasty, 14th-15th century

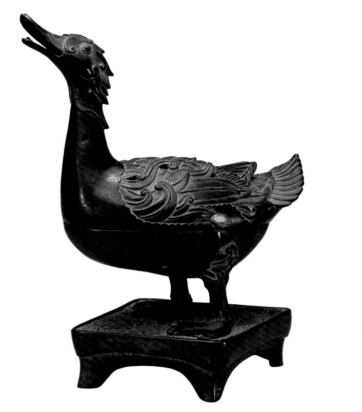

135

Large numbers of Chinese animal-shaped incense burners were imported into Japan during the Muromachi period. These were indispensable as ornamentation for the reception rooms of a daimyo's residence. The incense burners were not merely for display, however: the incense emanating from them was intended to give the rooms a more sumptuous and dignified atmosphere.

This incense burner is in the form of a duck and is placed on a stand decorated with a pattern of swirling waves. The body of the duck serves as the burning chamber, and the smoke and fragrance emanate from the bill. This example ranks among the finest of the incense burners of this type imported into Japan.

136

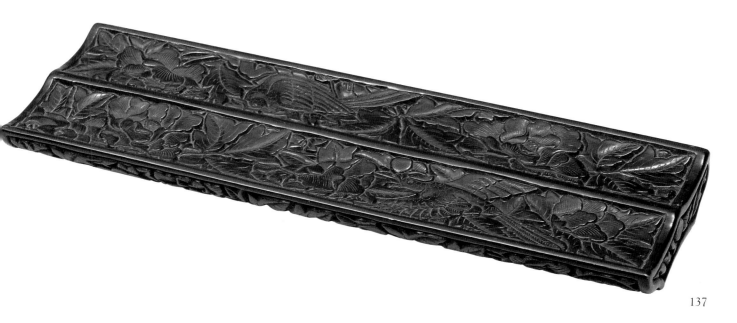

## 137

 HANDSCROLL TRAY

Black lacquer over carved wood
3.6 × 39.4 × 11.6 cm
Chinese, Ming dynasty, 16th-17th century

A *jiku-dai* is a handscroll tray, used to hold rolled up paintings or calligraphies and placed on a shelf or in the *shoin-doko*. This particular tray, whose entire surface is covered with peony and bird motifs, has been designed to accommodate either one or two scrolls, depending on which side faces upward.

In an imitation of the *chōshitsu* carved lacquer technique, the tray has been created by first carving the wood and then covering it with black lacquer.

Although *jiku-dai* are mentioned in a number of chronicles, including the *Go-shoku-sho* (Document on Decorative Objects), actual examples are very rare.

## 136

 BOWL

Celadon with embossed designs
9.5 cm (height), 32.4 cm (diameter)
Chinese, Ming dynasty, 14th-15th century

This three-footed celadon bowl was produced at the Longquan kilns in China. The outer surface is decorated with the "Eight Divinatory Diagrams" (*Ba Gua*), representing the natural and cosmic forces whose interaction is said to have formed and sustained the universe. A peony motif is embossed on the unglazed portion of the inner surface, and the feet are in the shape of heads of mythical animals.

In Japan, the grass known as *sekishō* (sweet rush) was thought to help eliminate the oily smoke of candles and was placed in bowls such as this one, which were then integrated into the decor of reception rooms.

## 138

 PAPER KNIFE

Gold *maki-e* designs on a plain wood ground
19.2 cm
Edo period, 18th century

A paper knife was an essential instrument kept on the desk in a study. The mounting of this knife is of a type that was popular in Japan about one thousand three hundred years ago, during the Nara period. The sheath and handle are made of rosewood decorated with a design of hare's-foot ferns that has been applied in gold using the *kiji-maki-e* technique.

## 139

 INK STICK

Ink, embossed design
1 × 3.8 × 12.1 cm
Edo period, 18th century

Ink was made by first burning vegetable oils or pine resin. This process yielded a high grade of soot that was then mixed thoroughly with glue and aromatic substances. This mixture was put into a mould, which was often decorated with one of a variety of designs or Chinese characters. Chinese ink sticks were not merely utilitarian objects whose sole function was the production of liquid ink: they were appreciated and collected as objects of aesthetic value. As a result, ink stick makers devoted much time and attention to the creation of designs and the carving of moulds.

The ink stick presented here was made in China and reshaped in Japan, where the *aoi* crest of the Tokugawa family was added as a decoration.

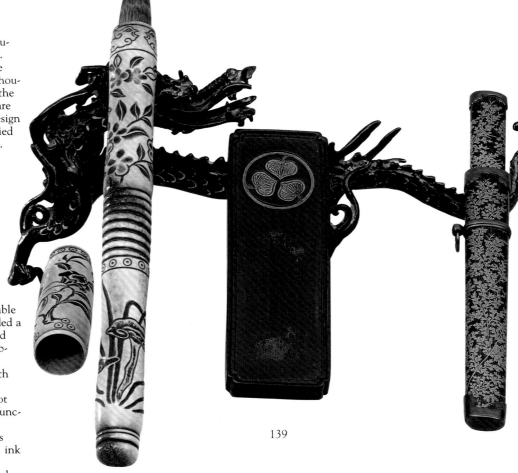

139

140

138

## 140

 DECORATIVE WRITING BRUSH

Horn, with designs in gold leaf
19.2 cm (brush), 8.7 cm (cap)
Chinese, Ming dynasty, 16th-17th century

It was in China, during the Ming dynasty, that the various articles associated with calligraphy first began to be appreciated as objects of aesthetic contemplation. At this period, indeed, magnificent and extremely valuable brushes

were created whose function was exclusively aesthetic.

Diverse decorative techniques were used in the creation of brushes: *haku-e* (painted gold or silver designs on a lacquer ground); *raden* (mother-of-pearl inlay); *chōshitsu* (carving in a thick layer of lacquer), which included *tsuishu* (red lacquer), *tsuikoku* (black lacquer) and *kōka-ryokuyō* (red flower and green leaf designs); carving on bamboo or ivory; and

porcelain decorated with red or blue designs.

This particular brush, made of horn, is adorned with camellia and japonica (*reishi*) motifs. The cap bears a rather unusual pomegranate design. In Japan, this type of ornamental brush was placed in the *shoin-doko* as part of the reception room decor.

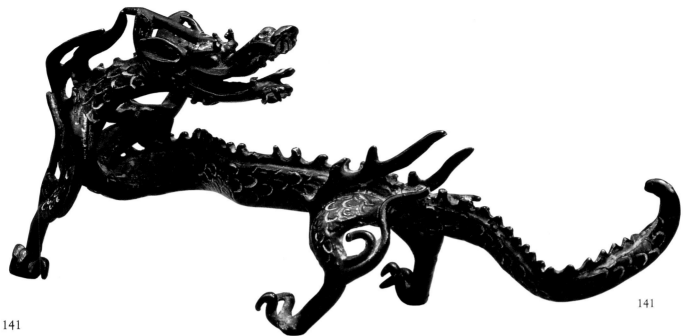

141

## 141

 BRUSH STAND IN THE SHAPE OF A DRAGON

Bronze
6 × 21.8 × 8.9 cm
Chinese, Ming dynasty, 16th century

This bronze object, modelled in the shape of a dragon turning back its head, serves as a brush stand. Such stands are usually made of metal, stone or ceramic, and take the form of either an animal or a series of mountains. Dragon-shaped brush stands were used by people of rank, for in China the dragon was honoured as the most sacred of mythical animals.

## 143

WATER DROPPER IN THE SHAPE OF A COMPOSITE ANIMAL

Bronze
16.3 × 7.6 × 7.3 cm
Chinese, Ming dynasty, 16th century

Water droppers were used to hold the water needed to produce liquid ink from an ink stick. Bronze Chinese water droppers from the Ming dynasty were frequently modelled in the shape of birds or animals. In Japan, water droppers like the one seen here have long been known as "water buffalo". The actual shape of this water dropper, however, reflects that of the zoomorphic *zun*, an ancient Chinese ritual bronze vessel.

## 142

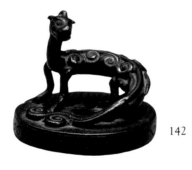

142

PAPERWEIGHT IN THE SHAPE OF A DRAGON

Bronze
4.4 cm (height), 4.8 cm (diameter)
Chinese, Ming dynasty, 16th century

Paperweights produced in China were made in a variety of materials, including bronze, iron, ceramic and stone. This bronze paperweight is in the form of a dragon, coiled to echo the shape of the round base.

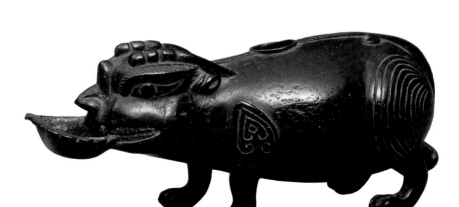

143

## 144

 INKSTONE

Carved shale
21.4 × 12 × 8.4 cm
Chinese, Song, 13th century

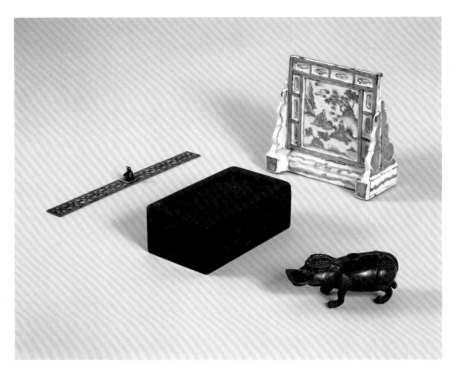

The inkstone (*suzuri*) is used for making and storing liquid ink. After a small amount of water has been poured into the depression in the stone, the ink stick is rubbed along the stone's abrasive surface and mixed with the water. The inkstone is the most important of the stationery tools found in the study and, of the "four treasures" used in writing (paper, ink, brush and inkstone), is the most valued because of its permanence.

Inkstones are made of a variety of hard materials such as porcelain, metal, tile and stone. The most common material, however, is shale, especially the *she* and *duan* stones from the Chinese provinces of Anhui and Guangdong. The quality of these stones is determined by the texture and pattern of the stratification of the rock from which they were cut. Chinese poems extolling the qualities of superior inkstones are carved in intaglio along the upper rim of this *suzuri*, and a scene depicting eight horses browsing beneath trees is carved in relief along the sides of the stone.

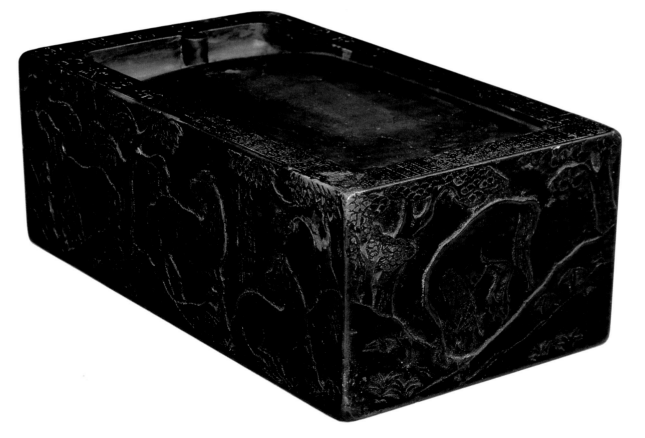

144

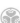

## 145

INKSTONE SCREEN

Porcelain, with blue underglaze designs
9.8 × 22.2 × 22.5 cm
Chinese, Ming dynasty, 17th century

This screen was designed to be placed along the upper edge of an inkstone to prevent dust or other extraneous matter from dirtying the ink. Various materials including metal, wood, lacquer and ceramic were used in the production of Chinese inkstone screens, and many different decorative techniques were employed in their ornamentation. This particular screen is made of porcelain and features an underglaze blue design of two scholars reciting verses outdoors by the light of the full moon.

145

## 146

146

PAPERWEIGHT

Cloisonné designs on brass
3.3 × 35.9 × 3.1 cm
Chinese, Ming dynasty, 15th century

This implement was used both as a ruler and as a paperweight. A paperweight was an essential tool when writing with a brush. Besides holding the paper still while writing was in progress, the weight also kept the paper flat and secure while it dried.

The cloisonné technique (*shippō*) has been used to decorate this piece. This method of ornamentation involves the filling of numerous cavities carved on a metal plate (usually gold, silver, copper or brass) with polychrome enamel glazes that can be either transparent or opaque. The object is then fired at a high temperature. This paperweight was imported from China, where the technique had been known since the Han period (2nd cent. B.C.-2nd cent. A.D.). Cloisonné achieved its highest level of development in China during the reign of Jing-tai (1450-1457), of the Ming dynasty, and this object was made according to the techniques perfected at that time. The knob is in the form of a little boy.

## 147

### TIERED SEAL BOX

Carved red lacquer
16.5 × 14.2 × 14.2 cm
Edo period, 19th century

Seal boxes were designed to serve not only as containers for precious seals, but also as decorative elements of the *shoin-doko* and, as a consequence, were created using the very finest of lacquer techniques, such as *raden* and *chōshitsu*. Seal boxes were usually divided into three or four tiers, in which were stored the seals themselves, red or black sealing wax, glue and other related articles.

This four-tiered seal box with indented corners was created using the *tsuishu* technique. The outer surface of the lid is decorated with a carved design featuring a horseman beneath trees. The sides of the box are ornamented with peony, chrysanthemum and orchid motifs.

147

## 148

### WATER DROPPER

Bronze, traces of gilt
8.7 × 14.9 × 13.9 cm
Chinese, Ming dynasty, 14th-15th century

Now used as a water dropper, this vessel derives its shape from a Buddhist water vessel of the *fusatsu* (*bu-sa* in Chinese, *posadha* in Sanskrit) type, used in the Buddhist assemblies that were held every two weeks for the reading and explanation of the precepts. Although the present vessel has a handle, which is not a feature of *fusatsu* water containers, the tall foot, the rounded body circumscribed by a single band and the distinctive shape of the spout, which has a stylized lotus at its base, are all characteristic of Buddhist objects of this type. Bronze *fusatsu*-style vessels were widely produced in Japan during the Kamakura period, approximately the time at which this early Ming Chinese vessel was made.

As a water dropper, the container served to hold the water required when grinding the ink stick into liquid ink. It was also used as a vase to hold a single spray of flowers when formally decorating the alcove of a reception room.

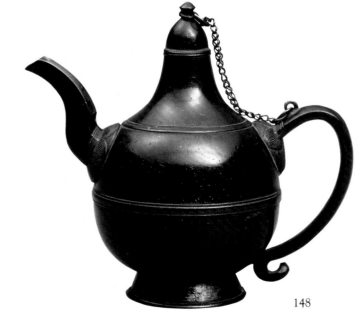

148

Made of cast bronze, this vessel was originally gilded, but very little gilt remains today. The piece is austere to the point of severity, the only decorative motif present being the lotus at the base of the spout and handle.

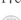

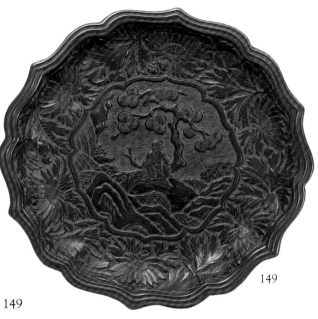

149

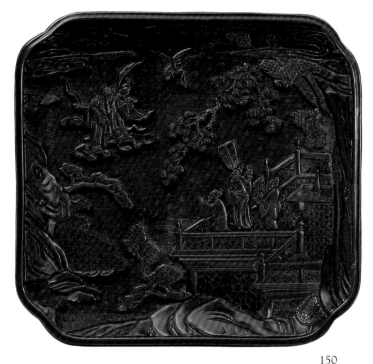

150

## 149

### TRAY

Carved red lacquer
2.1 × 18.6 × 19.7 cm
Chinese, Ming dynasty, 16th century

## 150

### TRAY

Carved red lacquer
3 × 20.1 × 20.1 cm
Chinese, Ming dynasty, 16th century

Both these small trays were manufactured using the *tsuishu* technique (carving in a thick layer of red lacquer). It was customary, in the traditional ornamentation of the *shoin*, for a jar of water to be placed on a tray of this type.

The centre of the upper surface of number 149, which is in the shape of a flower, is decorated with a design featuring a man contemplating a waterfall while seated under a pine tree. Along the border are carved chrysanthemum and foliage motifs, and the under surface bears carved vine motifs.

Number 150 is a square tray with rounded, slightly indented corners. The decoration is inspired by a legend that tells of Sei Ō-bo, the fairy who bestows immortality, being borne by clouds. The under surface is ornamented on two sides with motifs of flying horses.

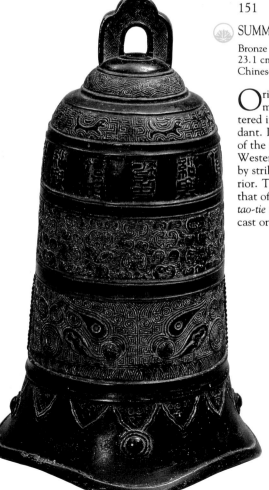

151

## 151

### SUMMONING BELL

Bronze
23.1 cm (height), 13.1 cm (diameter)
Chinese, Ming dynasty, 15th century

Originally these bells were used by the master of the house when sequestered in his study, to summon an attendant. Later, however, they served as part of the decor of a formal study. Unlike Western bells, Chinese bells are sounded by striking a wooden mallet on the exterior. The shape of this bell is inspired by that of ancient Chinese ritual bells, and *tao-tie* masks and Chinese characters are cast on its surface.

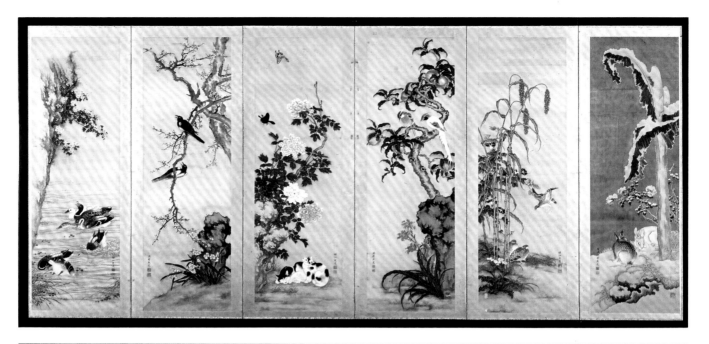

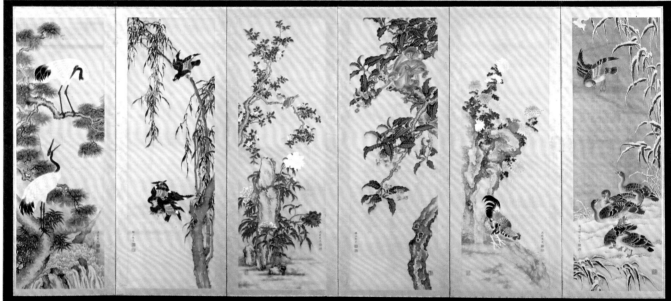

152

152

 *BIRDS AND FLOWERS*

Kumashiro Yūhi (1693-1772)
Pair of six-fold screens, ink and colours on silk
162.6 × 50.5 cm (each painting)
Edo period, 1754

When the Chinese painter Shen Quan visited Japan in 1731, he took with him a precise and graphic style for representing the world of flowering plants, birds and animals. This style was adopted by many Japanese artists and within a short time was practised widely throughout the country.

Yūhi, the creator of this work, was a pupil of Nanpin. He was born into a Nagasaki family that held the hereditary position of *tō-tsūji* (Chinese-Japanese interpreter) and became the head of this civil department.

Paintings by members of the "Nagasaki school" are notable for their vivid, fresh colouring — hitherto unseen in Japanese painting — and their new approach to composition. These two characteristics are apparent in the painting shown here.

Yūhi's abundant use of primary colours and purple, and his handling of compositional elements within the picture plane are both typical of the Nanpin-derived style.

Although mounted as folding screens, the paintings do not form a single, continuous composition: each of the panels is an independent picture. Screens of this type are known as *oshie-bari byōbu* (pasted-picture folding screen).

## PINE TREES BY THE SEA

Maruyama Ōkyo (1733-1795)
Pair of six-fold screens, ink and gold leaf on paper
158.3 × 358.4 cm (each screen)
Edo period, 1788

Maruyama Ōkyo was born in Kyoto in the eighteenth year of the Kyōhō era (1733). Originally bearing the name of "Mondo", he was also known by the nickname of "Chūsen" and sometimes used the two pseudonyms of "Settei" and "Senrei"; these he abandoned in favour of "Ōkyo" in about the third year of the Meiwa era (1766).

The work is executed over a heavy layer of gold leaf. One of the screens depicts a peaceful beach, where the surface of the water is barely rippled and not a breath of wind disturbs the trees. The other screen shows waves crashing against a craggy rock and pine trees tossing violently in the wind. Clearly, the artist's aim was to highlight the contrast between immobility and movement. This extremely graceful painting, which owes much of its expressive quality to the striking use of black ink against a gold ground, is typical of Ōkyo's style, a style influenced severally by the Kanō school, by a partic-

ular form of Western realism and by the decorative expressionism of *Yamato-e*.

The date inscribed on the work in Chinese characters indicates that it was completed in the early summer of the eighth year of the Tenmei era (1788), when Ōkyo was fifty-five years old. Ōkyo's signature and the seals "Ōkyo-no-in" and "Chūsen" are also written in Chinese characters. In addition, the artist's family name of "Minamoto" appears on the right-hand screen.

*Gift of the Okaya family*

153

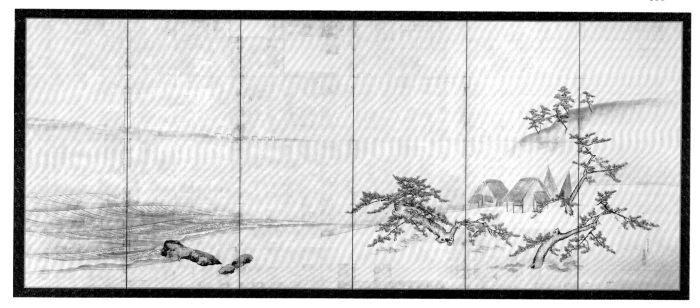

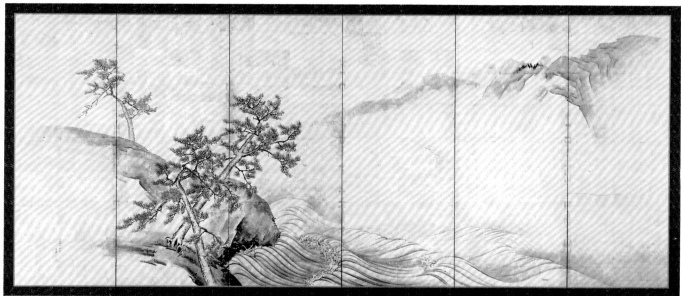

## 154

### ITSUKUSHIMA AND MATSUSHIMA

Tosa Mitsuoki (1617-1691)
Pair of six-fold screens, ink, colours, gold
pigment and gold leaf on paper
122.1 × 366.6 cm (each screen)
Edo period, 17th century

Japan's three most famous landscape views are the island of Itsukushima, in Hiroshima Prefecture, the bay of Matsushima, in Miyagi Prefecture, and the Ama no Hashidate peninsula, in Kyoto Prefecture. Traditionally, these three scenic sites are grouped under the label *Nihon Sankei* (the "Three Landscapes of Japan").

In the centre of the right screen is the main building of the Itsukushima Shrine, while on the left are depicted the scattered islands that dot Matsushima Bay. Both scenes are viewed from a high vantage point over the sea. The artist has incorporated into these landscapes colourful genre elements, amply populating each picture with visitors enjoying the sites.

The attribution to Tosa Mitsuoki is substantiated by the presence of his signature and seal in the outer lower corners of both screens. These screens represent one of Mitsuoki's largest compositions.

A focus for the painting form known as *Yamato-e* (traditionally Japanese, as distinguished from Chinese-style painting), the Tosa school was established at about the beginning of the fifteenth century. Its painters were officially patronized by the imperial court and also served the household of the Ashikaga shogunate. Tosa Mitsuoki, the son of Tosa Mitsunori (1583-1638), was responsible for reviving the Tosa school, which had been languishing since the latter half of the sixteenth century, and also served as director of the Official Bureau of Painting at the court (*edokoro azukari*). His works are executed with an exquisite delicacy and attention to detail learned from academic Chinese painting.

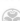

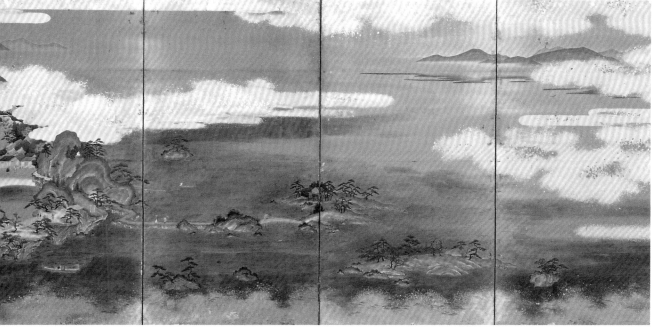

154

## 155

### SCENES OF RICE CULTIVATION

Kanō Tan'yū (1602-1674)
Pair of six-fold screens, ink and light colours on
paper
147.2 × 355.6 cm (each screen)
Edo period, 17th century

This pair of screens, painted in the Chinese style, depicts the sequence of rice cultivation through the seasons, from planting to harvesting. Like many illustrations of sericulture and silk-weaving, this agricultural theme, which was imported from China, originally had a certain admonitory function. Since its early representation in the sixteenth century, on the sliding-door panels (*fusuma*) of the Daisen-in of the Daitoku-ji temple in Kyoto, it was a favourite subject of Kanō school artists.

Son of Takanobu (1571-1618) and grandson of Eitoku (1543-1590), the artist of these screens, Kanō Tan'yū, was presented with his father to Tokugawa Ieyasu, in 1612. Later, he was appointed an official painter to the shogunate (*goyō-eshi*) and was granted a residence in the capital. Thus the status of the Edo branch of the Kanō school was firmly established. From then on, until the end of the Tokugawa regime in 1868, the Kanō family maintained its dominant position at the centre of the various groups of painters.

Tan'yū's signature and the accompanying inscription, "*sai hitsu*", are evidence that this pair of screens was executed when the painter was between the ages of thirty-four and fifty-nine, the period of his full maturity as an artist.

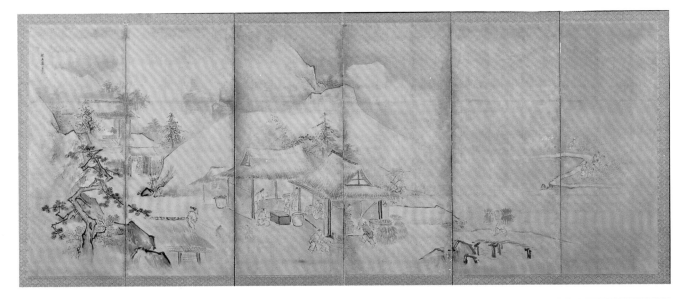

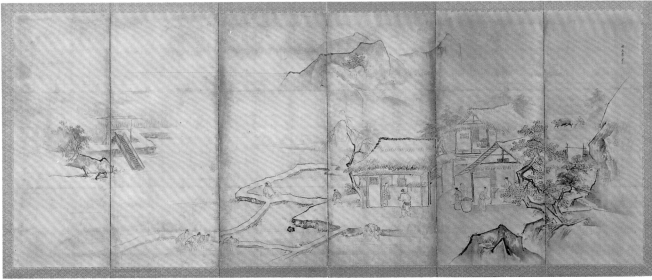

155

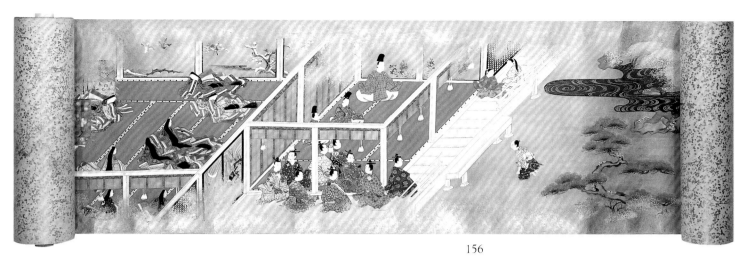

156

## 156

### BUNSHŌ ZŌSHI

Handscroll (one of three), ink, colours, gold pigment and gold leaf on paper
32 × 1,553.8 cm
Edo period, 19th century

An *otogi-zōshi*, or folktale, written sometime around the fifteenth century, the *Bunshō zōshi* (Story of Bunshō) is a popular tale whose classical "rags-to-riches" theme concerns the acquisition of wealth and high status. The story's hero is Bunshō, a servant of the humblest order to the high Shinto priest of the grand shrine Kashima Myōjin. Intent on discovering Bunshō's true nature, the priest dismisses him from his position. Bunshō becomes a successful salt-maker and prays regularly at the Kashima Myōjin Shrine. He is also blessed with two beautiful daughters, who are courted by suitors from far and wide. Eventually, the elder sister is wed to the son of an imperial advisor, and the younger is summoned to the court to become a lady-in-waiting. The narrative further recounts that Bunshō, too, is raised to nobility. Owing to the story's theme, many illustrated scrolls of the *Bunshō zōshi* were produced as articles for young women's trousseaus. The present scroll served this purpose when, in 1836, it accompanied Sachihime, the daughter of Konoe Motasaki, at the time of her marriage to Tokugawa Nariharu, the eleventh lord of Owari.

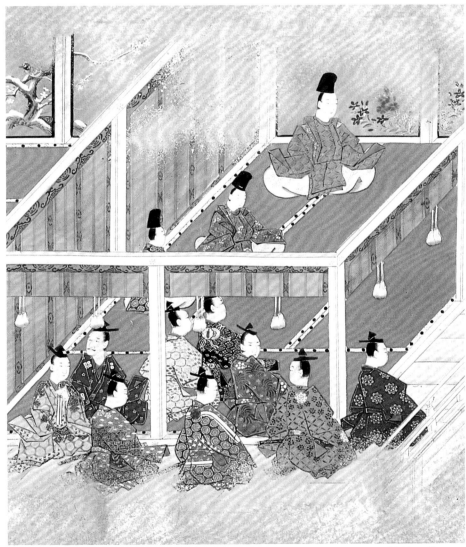

156 (detail)

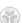

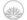
*UNEME KABUKI*

Two handscrolls, ink, colours, gold and silver
leaf on paper
36.7 × 790 cm (each scroll)
Edo period, 17th century

Notable for its extremely gay, flamboyant style of dress, the *Kabuki odori* (*Kabuki* dance) was created towards the beginning of the seventeenth century by a woman named Izumo no Okuni. *Kabuki* quickly leapt into vogue as a new form of public entertainment, spawning a wide variety of new types of theatrical performance. Uneme, the main performer depicted in this set of scrolls, was one of Okuni's successors. The work illustrates performances staged by her in the Shijō quarter of Kyoto. The texts of five varieties of song also appear, followed by illustrations of their accompanying dances. Lastly, there is a eulogy to *Kabuki* and a final scene of Uneme dancing, dressed as a man. The subject of the pictures is not limited to the dance, however. Spectators, vendors, members of the audience and even Portuguese and Dutch

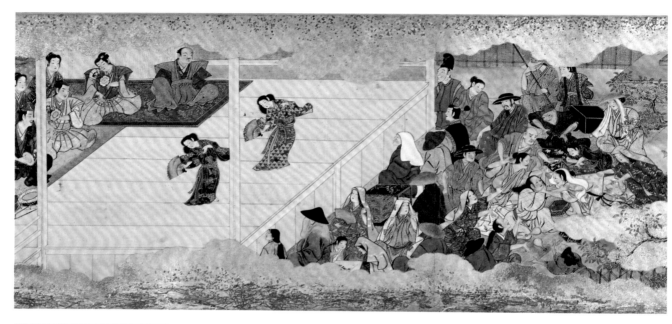

157

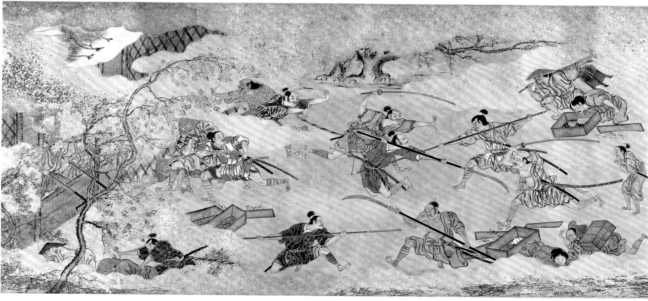

158

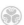

visitors are also depicted, rendering these scrolls of great historical interest.

The detailed clarity of the drawing and the richly applied colours, together with the texts sprinkled with dust and flakes of gold and silver, make this a truly magnificent work. The artist has not been identified, but the painting exhibits stylistic features that are reminiscent of the work of Iwasa Matabei (1578-1650).

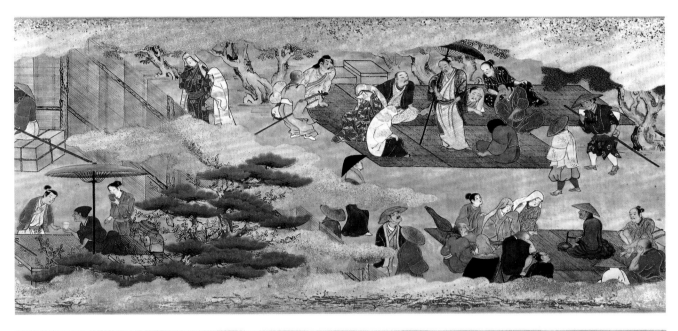

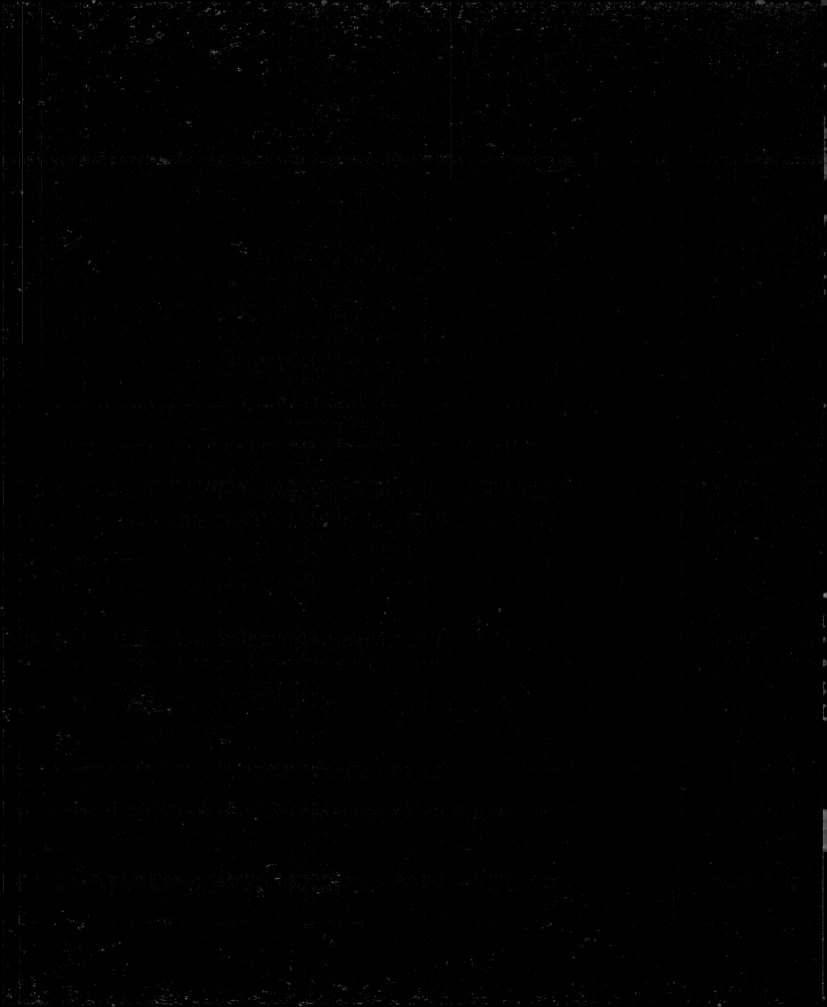

 NŌ COSTUMES

### KARAORI

Outer robe with brocaded designs on a red
twill-weave ground
150 × 145.4 cm
Edo period, 18th century

The term *karaori* is not only the name
of one type of Nō costume, but also
describes a kind of fabric. Because of the
high degree of skill required in its
weaving, this fabric was chosen to create
the most gorgeous and elaborate of the
Nō costumes.

In *karaori* brocade a design is produced
on a three-harness twill ground by float-
ing a number of coloured weft threads
that are then fastened down with gold or
silver foiled threads, forming beautiful
patterns on the surface of the fabric. The
designs are of such intricacy and delicacy
they appear to be embroidered. This
sumptuous cloth was originally of Chinese
manufacture, but from the beginning of
the sixteenth century it was woven in
Japan using techniques learned from the
Chinese.

During the period when Nō was
becoming established, in the fourteenth
century, *karaori* was a treasured cloth
whose use was strictly limited to the upper
classes. The fact that it came to be used
later for Nō costumes is a measure of the
prestige enjoyed by this theatrical form.

As a Nō costume, the *karaori* has
almost always been used as an outer robe
for women's roles. Exceptions are made,
however, and it may be used for the role
of a child or young boy, or serve as an
inner robe for the role of a young man of
status. The colour red is incorporated into
the design of robes used for young wom-
en's roles, but never appears in the cos-
tumes of women of middle or advanced
age.

The *karaori* presented here is a particu-
larly splendid example. Multi-coloured
designs of chrysanthemums and butterflies
have been wrought into a logwood-dyed
dark red ground, across which float bands
of silver mist. Striking, against the sub-
dued red ground, the flower and butterfly
motifs — especially those rendered in
various tones of yellow and blue — pos-
sess that particular brilliance associated
with plant dyes. The brightness of the
colours, which offsets to some extent the
august quality of this Nō costume, was
characteristic of the period.

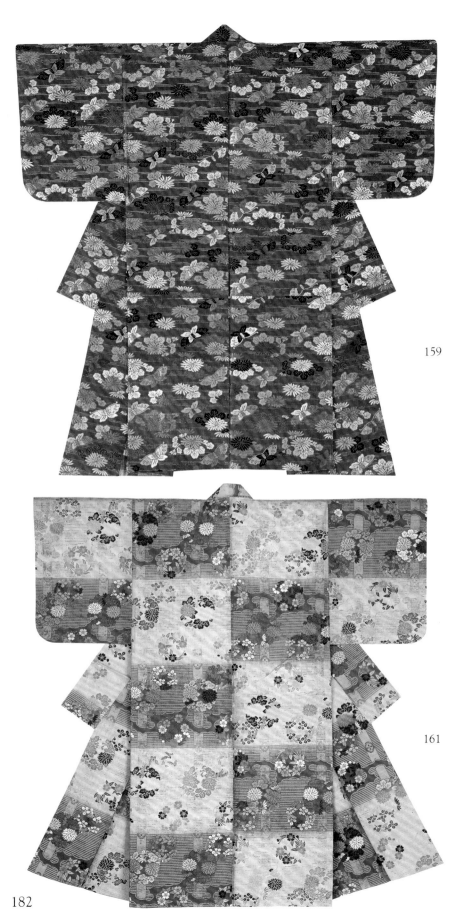

159

161

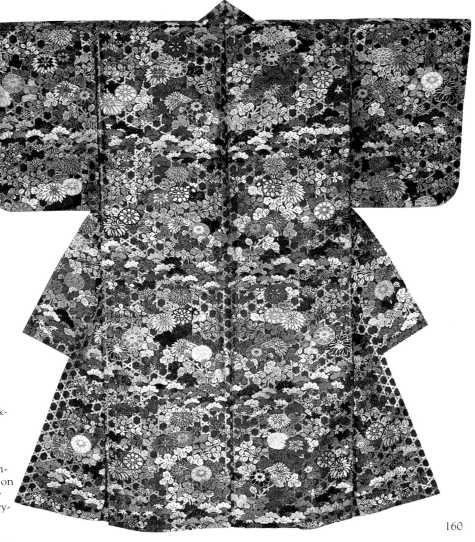

160

 KARAORI

Outer robe with brocaded designs on a black-red twill-weave ground
151.5 × 142.4 cm
Edo period, 18th century

In the *karaori* seen here, a woven bamboo basket motif is brocaded in gold on a black-red ground. The robe is further embellished with a design of pines, chrysanthemums and bush clover blossoms worked in threads of a dozen or so colours. The pine motif that starts the design sequence cuts the pattern into horizontal blocks, but these are attenuated by the richness of the colours used, and the overall effect is one of sumptuousness.

161

KARAORI

Outer robe with brocaded designs on a red and white rung-dyed twill-weave ground
151.5 × 142.4 cm
Edo period, 18th century

The red of this *karaori* is enhanced by an overall design of reed screens worked in silver thread. Over a secondary pattern of clouds are woven gorgeous medallions of flowers of the four seasons.

160

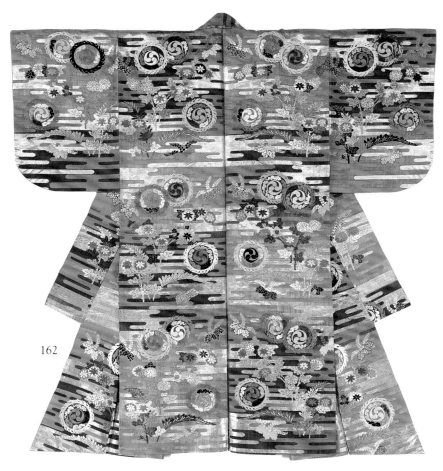

162

⬡ *ATSUITA-KARAORI*

Outer robe, *atsuita* and *karaori* brocades on a
purple and pale blue silk twill-weave ground
153.5 × 150 cm
Edo period, 18th century

An *atsuita-karaori* is made of a heavy
*atsuita* brocade decorated with a
*karaori*-type woven relief design. An
*atsuita-karaori* can serve either as an
*atsuita* (see cat. 164) or a *karaori* (see
cat. 159).

Shelf-shaped bands of mist rendered in
gold and silver threads, floating across
blocks of purple and light blue, form the
ground pattern in this garment. The mag-
nificence of the robe is largely due to the
choice and arrangement of the overlying
motifs, which succeed in being effective
without destroying the beauty of the
ground design.

The principal motif is the "flaming
drum", with its decoration of triple
comma-shapes surrounded by clouds and
ringed by flames. The design evokes the
pattern on the head of the giant drum
used in performances of ancient imperial
court music, or *gagaku*. In contrast to
these flaming medallions, the serene mist
of the ground pattern seems almost static.
The contrast has been softened by sprays
of chrysanthemums, realistically rendered.
The paulownia blossoms suggest hovering
butterflies, while the drums seem to hang
like additional blossoms on the chrysan-
themum stems. The deep purple rungs
strike a unifying note of dignity.

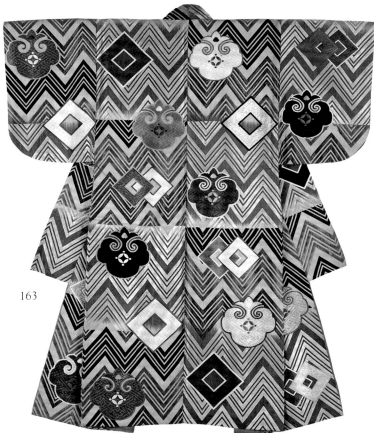

163

⬡ *ATSUITA-KARAORI*

Outer robe, *atsuita* and *karaori* brocades on a
yellow and light green rung-dyed twill-weave
silk ground
148.5 × 133.3 cm
Edo period, 17th century

This robe's delicate bands of ground
colour, which blend softly away at
the edges, are scarcely discernible beneath
the bold zigzag stripes woven in the weft.
The stripes flash in six vivid shades: deep
blue, blue, brown, brilliant red, yellow
and white. The pictorial motifs are
worked in eight colours of glossed *karaori*
threads. Their long, shining floats are
tacked down by weft threads in geomet-
rical (*saya-gata*) and "lightning" key-fret
patterns that are evocative of classical

*yūsoku* figured silks. This attention to almost imperceptible detail even on boldly patterned garments is typical of Nō costumes. The exceptional quality of this piece allows us to date it to the late seventeenth century.

The gong motif has its source in the cloud-shaped metal gong used to announce the times of meals or meditation periods in Zen Buddhist monasteries. The gong often appears as a crest motif. The metal nail puller (*manriki*) motif probably owes its frequent use as a crest to the literal meaning of its name, "myriad powers". As designs on Nō costumes, these two images seem to have a primarily decorative rather than a symbolic significance.

## 164

### ATSUITA

Outer robe with brocaded designs on a red twill-weave ground
154.5 × 136.4 cm
Edo period, 18th century

When worn as an inner robe, the Nō costume called the *atsuita* is used for male roles — from young boys to old men — and for the roles of *oni* (ogres) and *tengu* (red-faced goblins with long noses). The *atsuita* also serves as an outer robe for old women of humble origin.

In the *atsuita* presented here, a four-blossom rhombus design in white, yellow and gold has been woven in floated-weft relief over the entire surface of the red ground. The four-blossom rhombus is a traditional aristocratic design in use since the Heian period. It appears most frequently on the *jūni-hitoe*, a formal costume consisting of numerous layers of unlined robes worn by high-ranking women of the imperial court.

## 165

### ATSUITA

Outer robe with brocaded designs on a dark blue twill-weave ground
148.5 × 139.4 cm
Edo period, 18th century

On the dark blue ground an overall hexagonal tortoise-shell pattern has been woven into a straw-coloured, three-harness twill. Over this a *karaori*-style floated design of dragon medallions has been magnificently wrought in red, blue, white, yellow and light green threads.

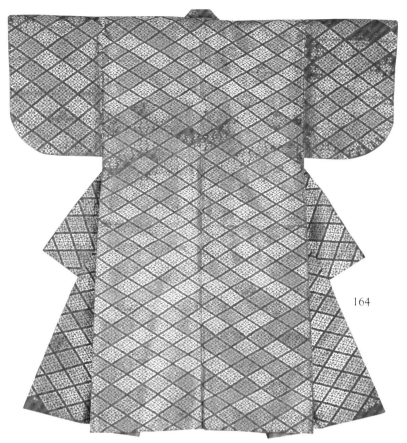

164

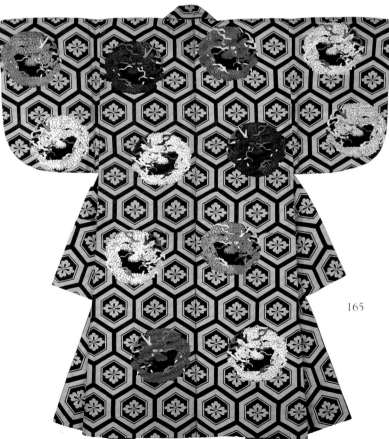

165

185

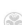

166

167

166

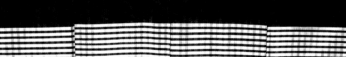

ATSUITA-KARAORI

Outer robe, *atsuita* and *karaori* brocades on a
red twill-weave silk ground
157.5 × 143.5 cm
Edo period, 18th century

On a deep red ground, a "thunder-
bolt" lattice pattern in bright green
frames the jewel-like motifs known as
"nine stars" (*kuyō-boshi*). The "nine stars"
motif, with Saturn at the centre, repre-
sents the nine planets of Indian astrology.
The motif was introduced into Japan as
an element of esoteric Buddhism, accord-
ing to which it represents the mandala of
the Buddhist guardians and bodhisattvas
that surround Dainichi. It was also used as
a family crest.

In contrast to this abstract but
nonetheless flower-like form, the over-
sized, double-blossom chrysanthemums
look almost crest-like in their stylization.

The fine texture of the *atsuita* twill used
for the chrysanthemums contributes to
the delicacy of this fabric, which, while it
lacks the assertiveness of rung-dyed or
plaid *atsuita*, possesses its own bright
elegance.

167

NOSHIME

Inner robe of plain-weave silk
136.4 × 133.3 cm
Edo period, 18th century

The Nō costume called the *noshime* is
used for the roles of warriors of low
rank, monks and men of the people. On
rare occasions it might be used to costume
the character of a middle-aged woman of
humble birth. It is always worn as an
inner robe. The various types of *noshime*
are the *muji* (plain), *shima* (striped) and
*dan* (broad-banded).

This costume is divided from shoulder
to hemline into nine broad rungs, created
by sewing together two identical back
panels that include the sleeves, so that
the pattern runs continuously across the
costume.

The overall unity of the design belies
the painstaking manner in which it was
executed, which involved complex multi-
ple dyeing of both warp and weft threads.
The alternation of plain panels with plaid
helps to unify the colour effect.

The shoulder line is defined by a band
of plain blue. The same blue continues in
the warp as stripes alternating with white,

crossed by a weft of broad blue and white stripes. The red of the third panel reappears as a series of almost invisibly thin, light red warp stripes in the fourth, which is also crossed by groups of pencil-thin white stripes. The plain green, and green and white plaid bands echo the blue pair, but the next panel, which is red, varies by alternating red with light blue warp stripes and overlaying them with blue weft stripes. The garment finishes with a wide band of solid green.

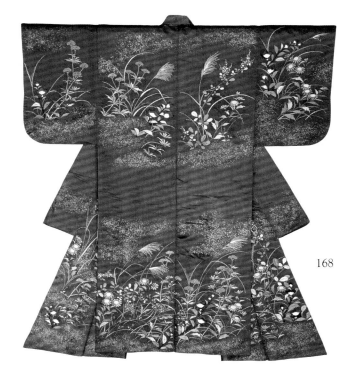

168

168

 *NUIHAKU*

Inner robe with embroidered and gold foil designs on a red silk ground
148.2 × 136.2 cm
Edo period, 19th century

*Nuihaku* is the term used for a Nō costume on which embroidery and gold or silver foil have been employed to work rich and stunning designs. The *nuihaku* is used chiefly for female roles: if worn by actors playing men, its use is limited to the roles of an emperor, an upper-rank member of the nobility or a youth.

In the robe seen here, a design of autumn grasses has been embroidered in a painterly style on the rich, deep red of the ground fabric. The space surrounding the grasses has been sprinkled with gold foil powder. In the choice and treatment of its decorative motifs, this garment resembles a *kosode* (see cats. 192-195) more than a Nō costume.

The design on this *nuihaku* has been conceived so as not to encroach on the waist area, which is usually covered by a sash. This custom of leaving the central area of a garment undecorated began in the middle of the Edo period with the introduction of a new, broader style of *obi*, or sash, that was tied in a large knot.

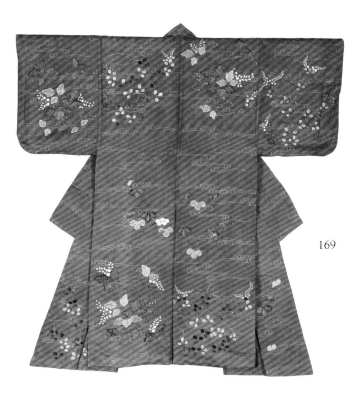

169

169

 *NUIHAKU*

Inner robe with embroidered and silver foil designs on a red silk ground
150 × 145.4 cm
Edo period, 19th century

Upon a red ground of six-harness twill with a pattern of heaped rhombuses, a design of swirling water is worked out in silver foiling and is in turn overlaid with embroidered motifs of bush clover, arrowroot and ivy. The patterns are discontinued in the waist area, which would normally be covered by a sash.

The decoration of this *nuihaku* is similar to that commonly appearing on the *kosode* robes that were worn in everyday life.

## 170

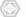 *SURIHAKU*

Inner robe with gold foil designs on a white ground
160.6 × 135.2 cm
Edo period, 18th century

Like the *nuihaku*, the *surihaku* is worn as an inner robe. The garment seen here is decorated with gold foil printed directly onto the fabric, without embroidery.

The design motifs used on Nō costumes are rarely symbolic or related to a particular role. Here, however, the overlapping scale-like design is intended to evoke the fiery temperament of a demon. Costumes bearing this type of motif, usually in red or white, were used principally for the Nō plays entitled *Aoi-no-ue*, *Dōjō-ji* and *Momiji-gari*.

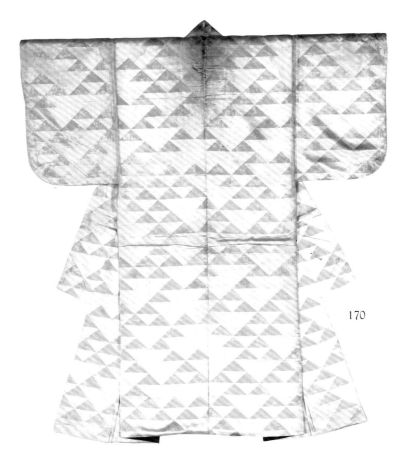

170

## 171

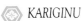 *KARIGINU*

Outer jacket with gold brocaded designs on a white satin ground
157.6 × 197 cm
Edo period, 18th century

This type of Nō costume is used for roles of male deities or noblemen. Originally, the *kariginu* (literally, "hunting silk") was a hunting garment worn by members of the aristocracy.

The satin ground is covered with a large Chinese flower motif in gold brocade, girded by a *tatewaki* floral arabesque border. The design is based on traditional aristocratic motifs.

171

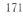

## 172

### KARIGINU

Outer jacket with gold brocade designs, on a
deep blue twill-weave silk ground
167.5 × 205 cm
Edo period, 18th century

The lion and peony motif is a common
one, but its appearance on this robe
in medallion format is noteworthy. While
both flower and beast are quite realisti-
cally rendered, the swirl of the peony
branch creates a circular frame that seems
to confine the lion's dynamic energy.
This motif is a fine example of the devel-
opment of Edo period *kinran* brocades
away from Chinese geometrical designs
and towards increasingly pictorial and
asymmetrical patterns.

## 173

### CHŌKEN

Outer jacket with brocaded designs on a blue-
gray gauze-weave ground
109 × 197 cm
Edo period, 18th century

With its large sleeves and wide front
panels, the *chōken* is characteristic
of Nō costumes. The sleeves are attached
at the shoulders, sewn down fifteen centi-
metres on the front and the back, but not
stitched at the underarms at all. The
*chōken* is worn for both men's and wom-
en's roles. In the case of men, it is used to
emphasize the refined elegance of a court-
ier, while for women it is employed when
a character is called upon to demonstrate
her grace and charm in a dance.

This particular *chōken* is decorated with
fan and arrowroot motifs, enhanced by a
secondary design of butterflies.

## 174

### CHŌKEN

Outer jacket with gold brocaded designs on a
purple ground
98.4 × 160.8 cm
Edo period, 18th century

Chōken are usually made either of a
fabric called *rokin*, a kind of silk
gauze highlighted with gold or coloured
threads, or of *kinsha*, a light voile-like
material, also highlighted with gold, that
can be either plain or brocaded.

This jacket is of gold-highlighted
purple *rokin*. The main decorative motif
features convolvulus flowers, and the
secondary Chinese pinks.

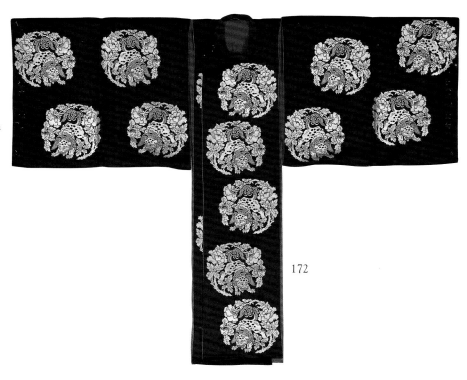

172

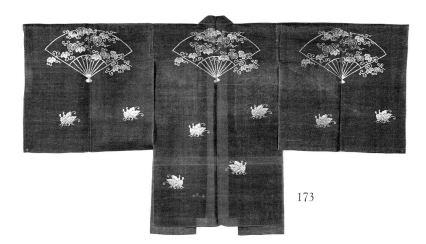

173

174

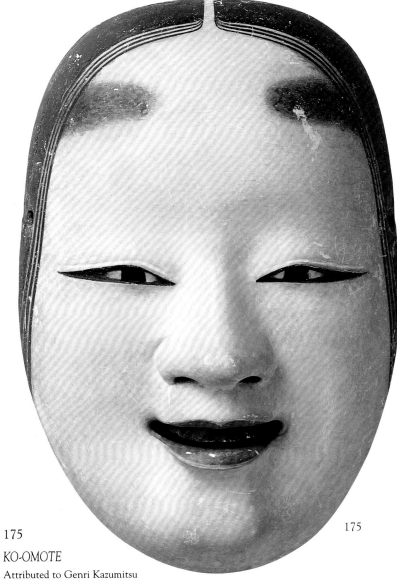

175

## 176

 *FUKAI*

Nō mask, painted cypress
20.9 × 13.6 cm
Edo period, 18th century

This is the mask of an ageing woman. The narrow, deep-set eyes and the sagging cheeks both serve as indications of the character's advancing years. The penetrating, resigned expression reveals the deep and sincere compassion of someone who has experienced the sorrow and pain that life can bring.

The *Fukai* mask is used principally to symbolize the grief of a mother who has lost her child. It sometimes represents a reasonably young face, sometimes an older one.

## 177

 *ZŌ*

Inscription: *Kodama Omi*
Nō mask, painted cypress
21.2 × 13.5 cm
Edo period, 18th century

The narrow eyes and open mouth of the Zō mask, which shows only the trace of a smile, give it a chilling beauty. Its dignity and reserve set the Zō apart from other young women's masks and mark it for roles of angels and goddesses. Some schools call it the mask "under the heavenly crown" (*Tengan shita*). It is used in women's plays that evoke the feeling of refined elegance called *yūgen* and feature the slow, dignified *jo-no-mai* dance. The lustre of the mask and the grace of the dance are superbly matched.

This particular mask, called *Naki-zō* or "crying Zō", creates an impression of sublime majesty when worn by the heavenly maiden who has lost her feather robe in *Hagoromo*, or by the goddess Tatsuta no Myōjin in *Tatsuta*.

The presence of a burnt-on seal reading "Kodama Omi" indicates that the mask was made by the founder of the Kodama school, Kodama Omi Mitsumasa. The mask did not enter the Tokugawa collection until 1881, when it was purchased from Hosokawa Morihisa, who had probably inherited it as an heirloom.

The name Zō comes from the mask's creator, the prominent *dengaku* dancer and mask carver Zōami Hisatsugu, who was a contemporary of Zeami.

## 175

 *KO-OMOTE*

Attributed to Genri Kazumitsu
Nō mask, painted cypress
18.2 × 13.9 cm
Edo period, 18th century

The name "Ko-omote" ("Little Face") evokes and romantically idealizes the attraction and naiveté of youthful beauty. The great charm of this mask almost exceeds the conventions of the *Ko-omote* form. The cheeks, very full and shiny, bring the expression close to that of another young woman's mask called *Mambi*. The ample features of this *Ko-omote* mask recall the Chinese proverb that compares a young beauty to a full-blown peony. As the number of different types of mask increased, their details became increasingly specific. One of the easiest ways of distinguishing between the various women's masks is through the distinctive patterns formed by the loose strands of hair. This painted hair style, with its three strands parted in the middle and not overlapping, is found only on *Ko-omote*.

This mask is reputed to be the work of Genri Kazumitsu, a second-generation carver of the Deme family. On the back of the mask is the signature of Okura Tsuneyoshi, a Kyōgen player who probably owned the mask at one time.

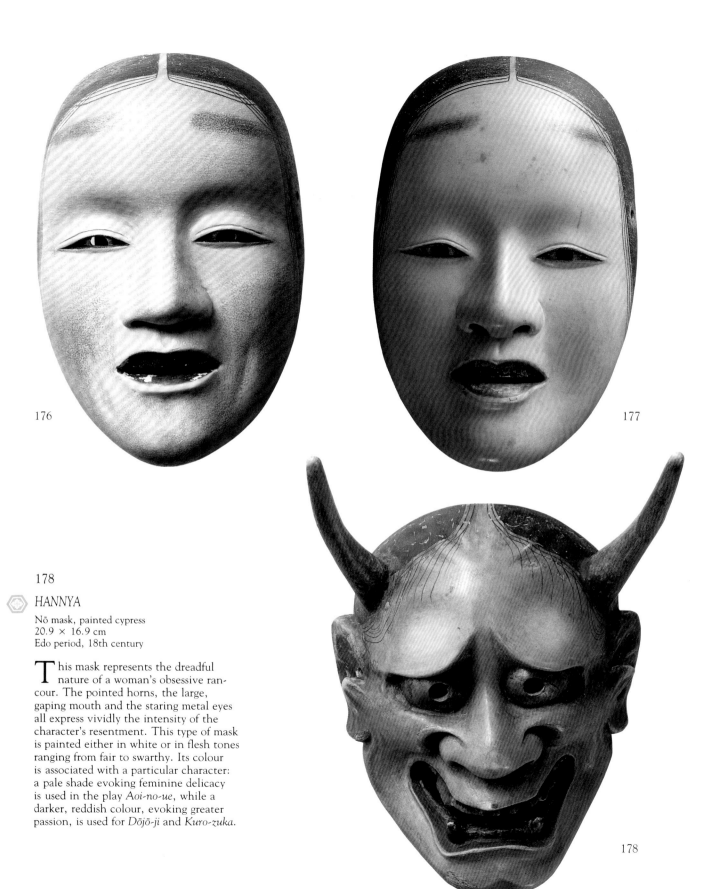

176

177

178

### HANNYA

Nō mask, painted cypress
20.9 × 16.9 cm
Edo period, 18th century

This mask represents the dreadful nature of a woman's obsessive rancour. The pointed horns, the large, gaping mouth and the staring metal eyes all express vividly the intensity of the character's resentment. This type of mask is painted either in white or in flesh tones ranging from fair to swarthy. Its colour is associated with a particular character: a pale shade evoking feminine delicacy is used in the play *Aoi-no-ue*, while a darker, reddish colour, evoking greater passion, is used for *Dōjō-ji* and *Kuro-zuka*.

178

## 179

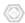 SAGAMI-NO-JŌ

Nō mask, painted cypress
20.3 × 15.9 cm
Edo period, 18th century

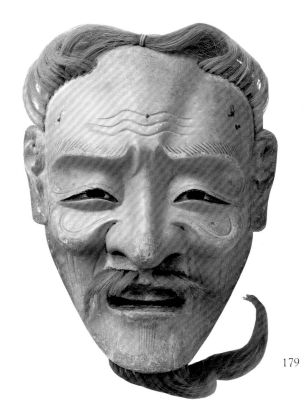

179

All the Nō masks whose names end in *jō* represent old men. This particular mask features tufts of real dressed hair on the head. The face is rather thin, with prominent cheekbones.

The various other types of old men's masks are the *Kōji-jō*, the *Sankō-jō*, the *Asakura-jō*, the *Marai-jō* and the *Mai-jō*. The differences between the masks serve to identify the characters being played by the wearers.

In the case of a mask personifying an old man of some distinction, real hair is used on the chin to represent the beard, the moustache is painted on and only the upper teeth are represented. When the character being portrayed is humbler, however, both the beard and the moustache are made from real hair and the upper and lower teeth are depicted.

In this *Sagami-no-jō* mask, all the facial hair is made of real hair, but only the upper teeth are visible. We may therefore assume the old man portrayed to be of middling respectability.

## 180

KANTAN-OTOKO

Inscription. *Yū*
Nō mask, painted cypress
20 × 14 cm
Edo period, 17th century

The back of this mask bears the stamp "Yū" — the first character of its maker's name. The craftsman was almost certainly Yūkan Mitsuyasu, a second-generation member of the Deme family, from the Ōno region. Yūkan died in the first year of the Jōō era (1652).

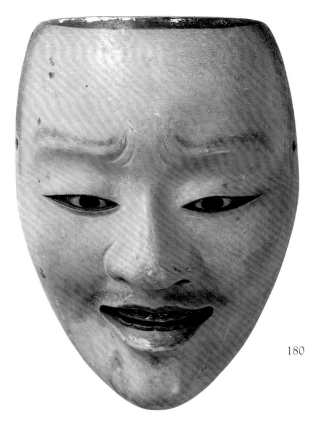

180

## 181

### KOBESHIMI

Nō mask, painted cypress
20 × 16.5 cm
Edo period, 17th-18th century

Lips pressed tight, the *Kobeshimi* mask frowns and glares fixedly ahead. The flaring nostrils, tense cheeks and powerful chin all emphasize the devilish power attributed to Emma, the overlord of hell. The word *beshimu* suggests a firmly set mouth, and a clenched jaw is characteristic of all *Beshimi* masks. The wrinkled brow, the metallic eyes and the ears all express ferocity. Along the top of the mask, a black line marks the edge of the formal *kanmuri* cap the character wears.

Despite its terrifying appearance, the *Kobeshimi* mask usually symbolizes a benevolent deity. When the mask is worn for the role of Emma, in *Ukai*, the lord of hell delivers the cormorant fisher from infernal torment. In *Shōki*, the mask is worn by Chong Kuei, who becomes a protective deity after posthumous recognition by Emperor Xuan Zong. In *Himuro* (The Cavern of Ice), the *Kobeshimi* mask represents the god Himuro no Kami, who provides the emperor with ice in midsummer.

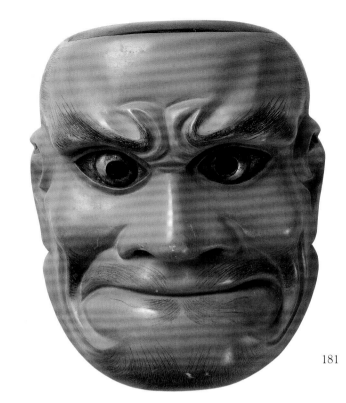

181

## 182

### WAKA-OTOKO

Inscription: *tenka ichi Yūkan*
Nō mask, painted cypress
19.7 × 15 cm
Edo period, 17th century

The *Waka-otoko* mask, like the *Chūjo* and the *Ima-waka*, represents a highborn, well-educated youth. His clear-cut features evoke the firm resolve of a knight errant rather than the sleekness of an aristocrat. The mask has a flatness similar to that of the *Kantan-otoko*. The gallant, decided mouth and the rendering of the sidelocks are particularly notable.

An inscription burnt on the back of the mask includes the seal "*tenka ichi*", followed by the name "Yūkan". Yūkan Mitsuyasu, son of the famous mask carver Zekan, was a second-generation member of the Deme family who died in the first year of the Jōō era (1652).

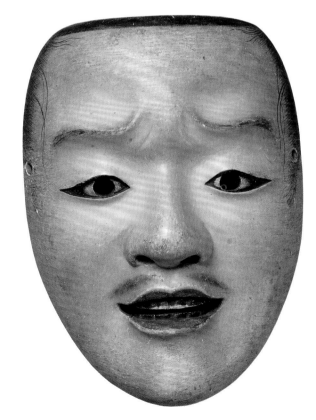

182

# SPLENDOUR AND REFINEMENT

## 183

⊛ *KAI-OKE*

Pair of shell boxes, gold and silver *maki-e*
designs on an aventurine lacquer ground
28.7 × 22.2 × 22.2 cm
Muromachi period, 16th century

## 184

⊛ *KAI-OKE*

Pair of shell boxes, gold and silver *maki-e*
designs on an aventurine lacquer ground
48 × 39 × 39 cm
Edo period, 18th century

## 185

⊛ *KAI-OKE*

Pair of shell boxes, gold and silver *maki-e*
designs on a black lacquer ground
41.4 × 34.6 × 34.6 cm
Edo period, 19th century

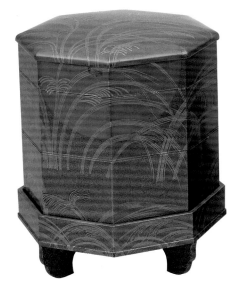
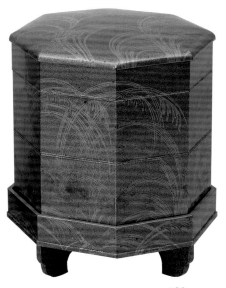

183

These paired octagonal containers, called *kai-oke* ("shell buckets"), were for storing the shells used in the game of *kai-awase* (shell-matching). Two identical sets of one hundred and eighty shells were required for the game, each with a different miniature painting on its smooth interior. Clam shells that fitted easily into the palm of the hand were preferred. The paintings were inspired by works in well-known poetry anthologies such as the *Kokin wakashū*, or a popular work of classical literature like the *Tale of Genji* (*Genji monogatari*). One set of shells, called the *jigai*, was placed face down in front of the players, while the shells from the other set, the *dashigai* (literally, "played shells"), were shown one at a time so that the painting could be seen. The players then tried to find the matching shell from the *jigai* by turning the shells over. The player who discovered a shell's mate would be awarded the pair, and the player with the best memory — and consequently the most shells at the end of the game — would be declared the winner. This game was particularly popular at the New Year.

Each of these *kai-oke* has a flush-fitting (*inrō-buta*) lid and a four- or eight-legged octagonal stand. One of the boxes held the *dashigai*, the other the *jigai*. Because of the double-ridged lines that circle them, the containers appear to be stacks of three different-sized boxes, but each one is actually a single unit. Both the form of the boxes and the rules of the game had become set by the end of the Muromachi period (16th cent.). Since each shell could only be matched with a single one

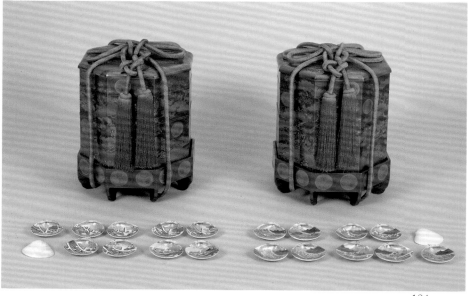

184

among all the other shells, *kai-oke* became a symbol of feminine morality and, as a result, an especially valued part of a wedding trousseau.

All the shell boxes shown here are decorated with *maki-e* lacquer. The design of number 183 is a popular autumn scene, probably inspired by the "Musashi no kuni" section of the *Tale of Ise* (*Ise monogatari*). This set of *kai-oke* is the earliest of the three illustrated here (cats. 183-185) and is an excellent example of the

high technical and artistic quality of lacquerware produced in the Muromachi period. The pair is traditionally said to have been used by Okame-no-kata (Sōō-In, see cat. 5), the mother of Tokugawa Yoshinao, first lord of Owari, and one of the wives of Ieyasu, the first Tokugawa shogun.

Number 184 was used by Jūhime (Seisō-in), the wife of Tokugawa Haruyuki, son of Tokugawa Munechika, ninth lord of Owari.

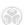

185

## 186

🏵 *KAI-OKE*

Pair of shell boxes, gold and silver *maki-e* designs on a black lacquer ground, brocade lid
53.6 × 40 × 40 cm
Edo period, 18th century

These *kai-oke* are larger than the others shown (cats. 183-185). The entire surface of each is covered with a transparent black lacquer known as *rō-iro* (mirror lacquer), against which are gold mallow leaf (*aoi*) designs and octagonal *shokkō*-style arabesques. The brocade lid is decorated with mallow leaf motifs.

Like number 184, this piece was part of the dowry of Jūhime (Sei-sō-in), lawful wife of Tokugawa Haruyuki, son of Tokugawa Munechika, ninth lord of Owari. Jūhime was the daughter of Munenobu, seventh-generation descendant of the Kii Tokugawa. She was married on the eleventh day of the fourth month of the ninth year of the Anei era (1780).

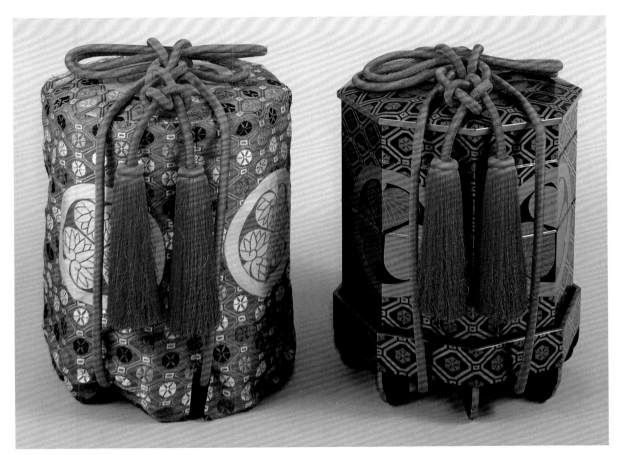

186

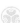

### DRESSING TABLE AND ACCESSORIES

Gold and silver *maki-e* designs on an
aventurine lacquer ground
27.4 × 27.4 × 65.6 cm
Edo period, 18th century

188

### DRESSING TABLE AND ACCESSORIES

Gold and silver *maki-e* designs on an
aventurine lacquer ground
27.6 × 27.6 × 64.9 cm
Edo period, 18th century

By the beginning of the Edo period
(17th cent.), the *kyōdai* (literally,
"mirror stand") or dressing table, like the
one illustrated here, was the centrepiece
of a high-born lady's toilet equipment.
A slender support holds a round mirror
above a square box with two drawers in
which were stored a variety of cosmetics
and accessories. *Kyōdai* of this type made

their appearance at the end of the
Muromachi period (16th cent.) and
became the standard form for dressing
tables during the Edo period.

Both of these *kyōdai* are lavishly
decorated with gold and silver dust
applied by means of the *maki-e* technique.
Similar in design and technique, the two
objects have been attributed to the same
lacquer workshop. The design on both
stands features pine and orange tree
motifs, both symbols of longevity,
enhanced with scattered *aoi* crests,
emblems of the Tokugawa family. Pine
and orange tree designs appeared
frequently on objects included in the
traditional dowry of a new bride.

Many of the articles stored in the
dressing table had their own separate
cases, decorated with the same motifs that
adorned the table itself. Among these
smaller accessories were boxes for mirrors,
combs, eyebrow brushes, brushes for
cleaning combs, tiered oil containers, a
small basin for the water used in preparing
the cosmetics and small boxes of white
face powder and rouge. Number 187 still
retains many of its original contents.
Apart from the mirror and its case, the
water basin, the tiered oil container and
the rouge box, however, all the items
originally stored in number 188 have
unfortunately been lost.

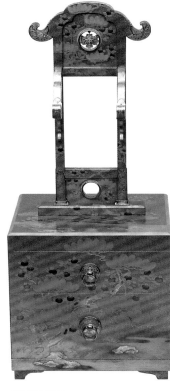

188

189

## COMB CABINET AND ACCESSORIES

Gold *maki-e* designs on an aventurine lacquer ground
25 × 34.4 × 35.6 cm
Edo period, 18th century

A *kushidai* (comb cabinet) held the objects used in dressing a woman's hair. This comb cabinet has four drawers of different sizes beneath a rectangular tray where the various toilet articles were placed when in use.

The cabinet contains two kinds of comb, one with relatively few teeth (*tokigushi*) and two fine-toothed combs (*sukigushi*); a brush with black bristles used for cleaning the combs; a spatula used for preparing cosmetics; two long-stemmed eyebrow brushes; oil containers; a small basin for water used in preparing the cosmetics; boxes for powder and rouge; a razor box; and a box for tooth blackener.

The design and techniques used for this *kushidai* are the same as those employed for the basins numbered 197 and 198, and the box numbered 196. There are several objects of this type in the collection of the Tokugawa Art Museum, and it is thought that they were made as part of a set of toilet articles for a bride's wedding trousseau.

In addition to *kushidai*, two other containers were used for storing the cosmetic articles needed when arranging one's hair: the *kushi-bako* (comb box) and the *tabi-kushi-bako* (travel comb box).

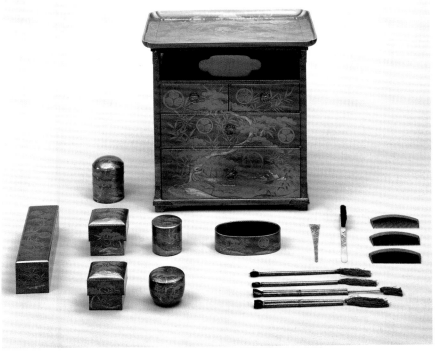

189

 MIRROR STAND

Gold *maki-e* and inlaid designs on an
aventurine lacquer ground
70.1 × 30.6 cm
Edo period, 19th century

Glass mirrors have been used in Europe for centuries and had already arrived in America before being introduced into Japan, in the mid-nineteenth century. Mirrors used during the Edo period and earlier were made of bronze, nickel or iron; the surface of the metal was coated with a mixture of mercury and tin and then highly polished to a lustrous finish. The back of these metal mirrors bore designs that were often of considerable artistic value.

Mirrors with handles did not appear until the end of the Muromachi period (16th cent.). *E-kagami*, as these mirrors were called, were enormously popular and widely used during the Edo period. The stand shown here is designed to hold such a mirror. Like the dressing tables in numbers 187 and 188, a stand of this type freed both hands for arranging the hair or applying cosmetics. This collapsible stand, which is placed directly on the floor, is similar to those mentioned in documents of the Heian period, when mirror stands are thought to have first appeared.

The gold aventurine lacquer ground of this particular stand is decorated with plum blossom and ivy motifs that form an arabesque. The design is enhanced with randomly scattered *aoi* crests, and all the decorations are executed in gold *maki-e* and inlay. The same motifs are repeated on the large, trifoliate *aoi* on which the mirror is placed: this openwork crest is

covered with a thin sheet of gold on which the plum and ivy arabesques have been finely carved. The lavish decoration applied to this simple piece of household furniture illustrates the level of technical excellence achieved by both lacquer and metal craftsmen of the late Edo period. The box, which has a large *aoi* crest in *maki-e* in the centre of its lid, originally held two mirrors — a large and a small — both of which are now lost.

190

191

 GARMENT RACK

Gold *maki-e* designs on a black lacquer ground
165.5 × 188.5 cm
Edo period, 19th century

This rack was used to hold garments such as the *kosode*. The garment could be hung either by passing the upper horizontal bar through the sleeves or by being folded over the bar.

This garment rack is decorated with pine, bamboo, plum tree and arabesque motifs in gold, against a black lacquer ground. A gold-painted X-shaped emblem can also be seen. This is the crest of the

Niwa family, who were daimyo of the Nihonmatsu domain, in the Mutsu region. The annual revenue of this fief was over one hundred thousand *koku*. Kanehime (born 1831), wife of Tokugawa Yoshikatsu, twice lord of the Owari domain — after having been fourteenth lord, he took the title again to become the seventeenth — and Masa-hime (born 1838), wife of Mochinaga, fifteenth lord

of Owari, were respectively the third and fifth daughters of Niwa Nagatomi. It is thought that this garment rack belonged to one of the sisters, although it is not known which. (See ill. cat. 192.)

## 192

### WATAIRE-KOSODE

Cotton-padded inner robe, embroidered designs
on a white figured satin ground
177.3 × 122.4 cm
Edo period, 19th century

The kimono is the national costume of
Japan. When the sleeve opening of
the garment is narrow, it is called a
*kosode*. The *kosode* first appeared in the
fifteenth century, but it was not until the
seventeenth and eighteenth centuries that
it gained wide popularity. It was usually
worn belted with an *obi* (sash), but long-
trained *kosode* like the ones presented
here (cats. 192, 193) were slipped on as
outer robes, with the back part left to trail
behind.

A pattern of flowers and butterflies
woven into the white figured satin ground
of number 192 is further embellished with
an embroidered design of wisteria, drum
and iris motifs. Figured satin (*rinzu*) is a
particular type of fabric in which glossed
threads are used in the weaving so that a
shiny finish is produced.

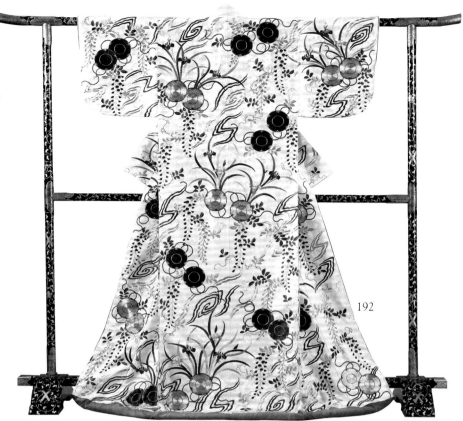

192

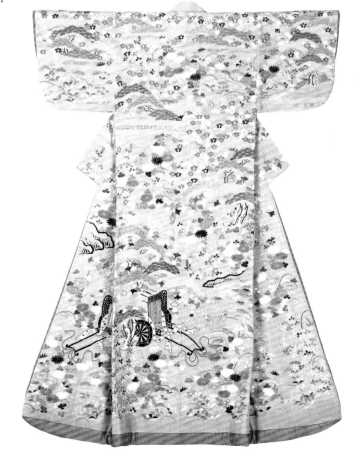

191

## 193

### WATAIRE-KOSODE

Cotton-padded inner robe, dyed and
embroidered designs on a pale blue silk crepe
ground
175.7 × 121.2 cm
Edo period, 19th century

In this robe, a design of classical palace
scenes and flowering trees and grasses of
the four seasons has been dyed on a pale
blue silk crepe ground and accented with
embroidery of gold and coloured silk
threads. This *goshodoki* motif was
particularly popular among women
serving at the imperial palace in Kyoto
during the eighteenth and nineteenth
centuries. The designs incorporated into
this type of pattern may include palace
buildings and pavilions, flowering trees
and grasses of the four seasons, flowing
water, fans, baskets and ox-drawn carts.
*Chirimen* (silk crepe) is a fabric in which a
strong twisted raw silk weft thread is used
in the weaving. When the woven cloth is
placed in warm water, the threads shrink,
creating fine creases in the fabric.

193

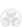

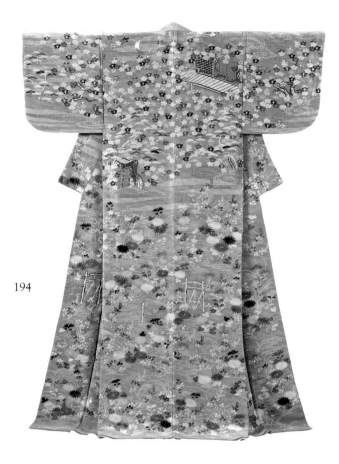

194

195

 194

*WATAIRE-KOSODE*

Cotton-padded inner robe, embroidered designs
on a silk crepe ground
173.6 × 121.2 cm
Edo period, 19th century

The upper part of this robe is
embellished with a design depicting
the moon, the imperial palace and an
ox cart, on a ground covered with pine
and cherry blossom motifs. The lower
section features embroidered decorations
representing autumn plants, a hedge and
a swing gate surrounded by trees.

The scene adorning the upper part
of the robe may possibly illustrate the
"Banquet Among the Flowers" ("Ka-en")
described in the *Tale of Genji* (*Genji
monogatari*). The iconographical source
of the lower section is not known.

This robe, which was worn by members
of the *bushi* or samurai class, is made of
silk dyed using the *yūzen* technique and
embellished with embroidery. The under
garment, of which the inside and outside
are identical, is attached to the inside of
the outer robe of silk crepe (*chirimen*).

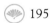 195

*WATAIRE-KOSODE*

Cotton-padded inner robe, embroidered designs
on a silk crepe ground
174.2 × 121.2 cm
Edo period, 19th century

Like the two preceding garments (cats.
193, 194), this robe is decorated with
traditional scenes of the imperial palace.
It is made of silk dyed using the *yūzen*
technique and embellished with
embroidered motifs.

The decorative themes, which feature
stream and fan motifs, are depicted
against a ground covered with cherry
blossom, chrysanthemums, pine branches,
red maple leaves and bamboo.

## 196

### BOX CONTAINING ACCESSORIES FOR BLACKENING TEETH

Gold and silver *maki-e* designs on an
aventurine lacquer ground
40.6 × 11.1 × 11.2 cm
Edo period, 18th century

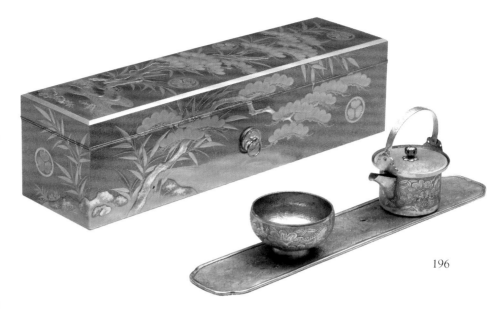

196

A *watashikane-bako* is a box for storing
the various utensils used in
blackening teeth, including the long,
narrow brass plate called a *watashikane*
(literally, "stretched across metal") that
was placed across the rim of the basin, or
*mimi-darai* (see cat. 198). Other articles
include the spouted ewer and small bowl,
which were used when boiling the
colouring stain, and the brush used for
applying the stain to the teeth.

A dark liquid made from oxidized iron
was placed in the ewer, which was set on
the plate above the *mimi-darai*. To ensure
that the stain adhered to the teeth, a
powder (*fushiko*) was added to the liquid,
which was then applied by brush. The
*mimi-darai* was used for rinsing the mouth
during this procedure. The various
implements contained in the *watashikane-bako* were normally used with a *mimi-darai*, so these two items were usually
decorated with the same designs.

In addition to the *watashikane-bako*,
there is a box called the *kane-bako* that
was also used for holding the various
tooth-staining tools. Shorter and wider
than the *watashikane-bako*, this box may
have either one or two tiers.

## 197

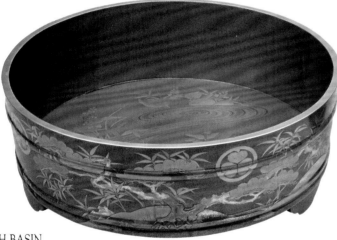

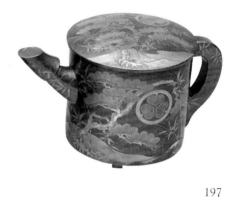

197

### EWER AND WASH BASIN

Gold and silver *maki-e* and gold leaf designs on
an aventurine lacquer ground
Ewer: 22.7 cm (height), 19.8 cm (diameter)
Wash basin: 19.7 cm (height), 52.1 cm
(diameter)
Edo period, 18th century

A s its name suggests, this kind of
basin — called a *te-arai* (literally,
"hand wash") or *ōte-arai* ("ō" meaning
"large") — was used for washing one's
hands.

The ewer (*yutsugi* or *yutō*) was used in
tandem with the wash basin. It held the
hot water to be poured into the basin.

The surfaces of both vessels are com-
pletely covered with a rich aventurine
lacquer ground and a design of pine trees,
bamboo and various flowering aquatic
grasses growing among the rocks of a
swiftly moving stream, with scattered *aoi*
crests in gold and silver *maki-e* accented
with cut gold leaf. The interior of the
ewer and the inner rim of the wash basin
are decorated only with aventurine
lacquer. These objects are excellent
examples of the type of articles included
in the lavish wedding trousseau that
accompanied a Tokugawa bride of the
mid-Edo period (18th cent.).

## 198

### WATER BASIN AND STAND

Gold and silver *maki-e* designs on an
aventurine lacquer ground
28.1 cm (total height), 26.7 cm (diameter)
Edo period, 18th century

The *mimi-darai* (literally, "ear tub") is
a small basin named for its two short,
ear-shaped handles. The *mimi-darai* is
slightly smaller than another basin, the
*tsuno-darai* (cat.199), called thus because
of the long horn-like shape of its four
handles.

Mimi-darai were used primarily for
rinsing the mouth when blackening the
teeth, a custom that was practised among
aristocratic Japanese women from ancient
times. From the latter half of the Heian
period, male members of the nobility also
blackened their teeth, and during the Edo
period, all married women blackened
their teeth, regardless of social standing.

The design on this basin and stand is
the same as that seen on numbers 189,
196 and 197: a riverside landscape
featuring rocks, bamboo and pine, dotted
with the *aoi* crest of the Tokugawa family.

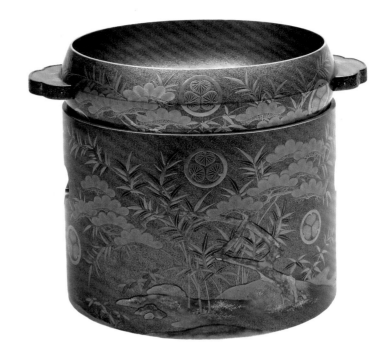

198

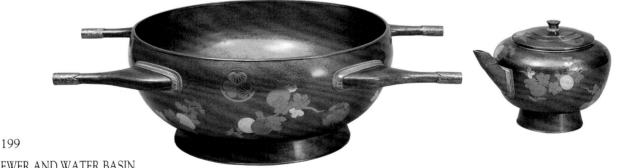

199

199

### EWER AND WATER BASIN

Gold *maki-e* designs on a lacquer ground
Basin: 19.7 × 42.1 cm
Ewer: 15.7 × 14.2 cm
Edo period, 19th century

The *tsuno-darai* is a water basin used
during a woman's toilet and the
application of her make-up. The basin's
four handles allow it to be easily carried
by two people. The ewer, or *hazō*, holds
the water that is poured into the basin.
These two pieces, which are examples of

objects used every day by noble families
from the Heian period on, were part of
the trousseau of *Sachihime (Shungyō-in)*,
who married Nariharu, eleventh lord of
Owari, in the seventh year of the Tenpō
era (1837).

Only about eighty pieces from the

household furnishings that constituted
Shungyō-in's trousseau have come down
to us. They are all decorated with
chrysanthemums and broken branches,
painted in gold on a lacquer ground. The
surviving objects include three sets of
shelves — a *zushi-dana* (closed shelf with

small double doors), a *kuro-dana* (black shelf) and a *sho-dana* (bookshelf) — a *kai-oke* (shell box), a *koshi* (palanquin for ladies) and a long-handled umbrella. In addition, there are over a hundred miniature objects (*hina-dōgu*) used principally during the Girls' Festival. Shungyō-in was a member of the Konoe family, who lead the five families of the *Sesshō-kanpaku* (Regent-Council to the Empire) and whose crest was a peony. The group of objects that belonged to her, passed on from generation to generation, is the best example we have of a daimyo bride's trousseau from the Edo period.

The decoration of the objects demonstrates a variety of techniques including the application of a lacquer ground, decorative motifs of *hira-maki-e* (gold paint on a flat lacquer ground), *taka-maki-e* (gold paint on a high-relief lacquer ground), *kiri-gan-e* (sprinkled gold or silver dust) and *kana-gai* (collage of cut gold or silver leaf). All the metal fittings are pure silver.

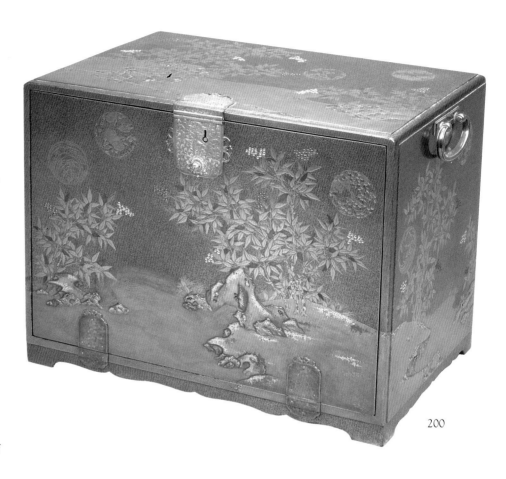

200

 STORAGE CABINET FOR BOOKS

Gold and silver *maki-e* designs and cut gold leaf on an aventurine lacquer ground
26.6 × 40 × 31.2 cm
Edo period, 17th-18th century

On the five exterior surfaces of this book cabinet are landscapes of nandina growing along the rocky banks of a stream. Interspersed between these berry-laden bushes are roundels of peonies, chrysanthemums and Chinese bellflowers. The entire design is executed in gold and silver *maki-e* against a gold aventurine lacquer ground accented with small, cut squares of gold and silver leaf.

This cabinet was made to contain a fifty-four volume edition of the most celebrated work of Japanese literature, the *Tale of Genji* (*Genji monogatari*). The volumes were divided among six drawers (two rows of three drawers each), and the names of the various chapters were written on the outside of their respective drawers.

The *Tale of Genji* was written by Murasaki Shikibu (about 978-about 1016), a lady of the court who has been called the world's first female novelist.

The work explores the lives and fates of the courtiers of the period with a sensitivity and perception unequalled in early Japanese literature. The hero of the work is the imperial prince Hikaru Genji.

The *Tale of Genji* was extremely popular among the court nobility from the moment of its appearance, and in succeeding years it became the standard of excellence to which all novels aspired. Reading the work was part of the education of members of the upper ranks of society, and copies by aristocratic master calligraphers were highly prized additions to wedding trousseaus. The edition contained in this cabinet was the work of the noble calligrapher Konoe Motosuke, who died in the fourth year of the Shōtoku era (1714).

It is recorded that this edition of the *Tale of Genji* was copied in the fifth year of the Enpō era (1677).

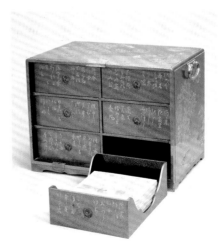

## 201

INKSTONE CASE

Gold and silver *maki-e* and inlaid designs on a
cinnabar lacquer ground
23.2 × 22 × 4.3 cm
Edo period, 18th-19th century

Until the nineteenth century,
when pens were imported in large
quantities to Japan from Europe, the
Japanese wrote with brushes. Even today,
diplomatic documents are signed with a
brush.

A *suzuri-bako* is a small case for storing
instruments used when writing with a
brush. The principal object kept in the
case is the inkstone (*suzuri*). Next in
importance are the brushes, the ink stick,
and the water dropper (*suiteki*), which is
used to contain the water necessary to
render the ink liquid. Other tools include
a small paper knife, an awl to use as a
paper punch and tongs for holding the ink
stick.

This inkstone case bears a design of
lions and peonies in *maki-e* and gold and
silver inlay boldly distributed across the
entire surface. On the inside of the lid is
depicted a dragon among clouds rising
from the midst of the sea.

The original brushes, ink stick and
tongs are unfortunately now lost.

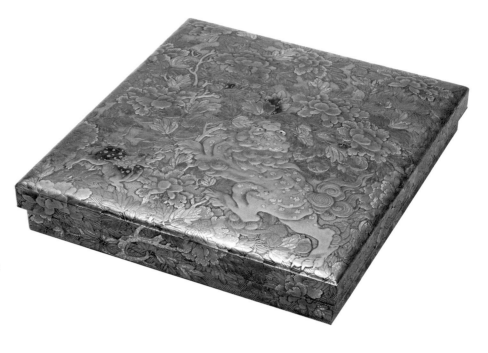

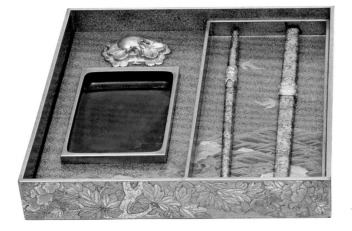

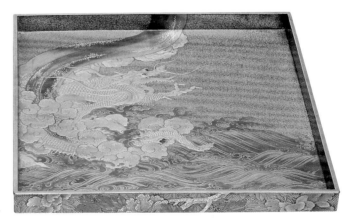

201

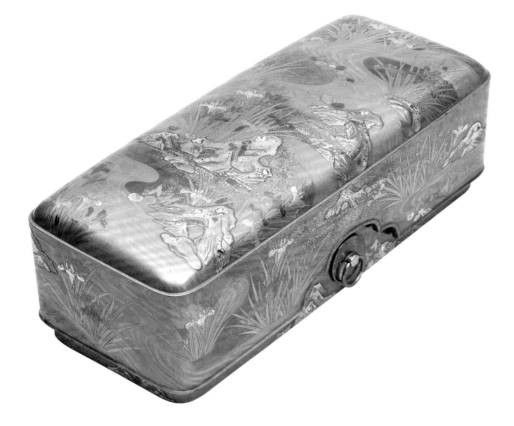

## 202

### DOCUMENT CASE

*Maki-e* designs on an aventurine lacquer ground
30.8 × 11.2 × 10.4 cm
Edo period, 18th century

*Fubako* are elongated cases with lids used to store letters, documents and written petitions to the deities of a temple or shrine. There are two kinds of *fubako* — short ones, like the one seen here, and long ones, called *naga-fubako*. The lids of these boxes were secured by knotted cords that were looped through the metal ring on either side of the box. *Fubako* were usually fitted with overlapping lids, so as to provide full protection for the valuable documents contained within.

The term *fubako* is an abbreviation of the word *fumi-bako* (literally, "letter case"). No *fubako* have survived from ancient times, but the fact that they are mentioned in the *Tale of Genji* indicates that they were produced as early as the eleventh century. They were widely used from the Muromachi period on, and during the Edo period many outstanding examples were produced, often decorated with elaborate *maki-e* lacquer or inlaid mother-of-pearl. *Fubako* eventually came to be added to the list of stationery items included in a wedding trousseau, and as a result their decoration became even more lavish. This eighteenth-century *fubako* — an example of one of these elaborate trousseau items — is decorated with water grasses and summer-blooming irises.

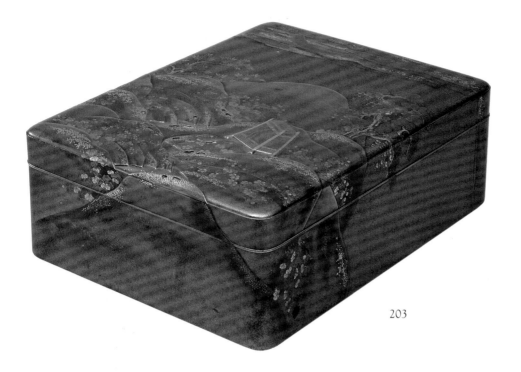

203

(top of lid)

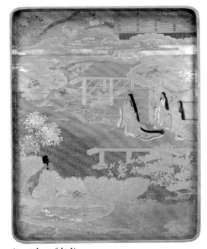

(inside of lid)

 203

## STATIONERY BOX

Gold and silver *maki-e*, cut gold and silver leaf and inlaid designs on an aventurine lacquer ground
15.7 × 40.9 × 42.4 cm
Edo period, 18th century

Against an aventurine lacquer ground, the decoration of this piece has been executed in a variety of techniques: gold paint, *kana-gai* (finely cut strips of gold and silver), *kiri-gan-e* (gold and silver dust) and inlay. The design, which represents a bamboo basket in the middle of an ivy-covered forest, is inspired by "Tsuta no hosomichi" (Ivy-covered Trails), the ninth part of the *Ise monogatari* (*Tale of Ise*). It depicts the scene in which Ariwara Narihira, overcome during his trip to the east by nostalgia for the capital (Kyoto), entrusts a letter to a *yamabushi* (itinerant mountain priest) whom he meets in the Suruga region, on the mountain known as Utsu. The basket symbolizes the *yamabushi*, who is not represented here. Certain of the box's decorative motifs, on the other hand, such as the crescent moon half hidden by the clouds, are not mentioned in the story.

A scene from the "Waka-murasaki" volume of the *Tale of Genji* (*Genji monogatari*) is depicted on the inside of the lid, and on the interior of the box is represented another episode from the same narrative, taken from the "Yūgao" volume. Objects in *maki-e* dating from the middle ages on frequently bear decorations depicting literary themes inspired by poems (*waka*) and narratives associated with the court.

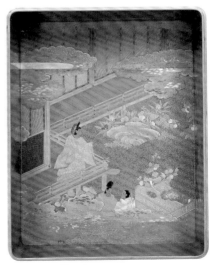

(interior of box)

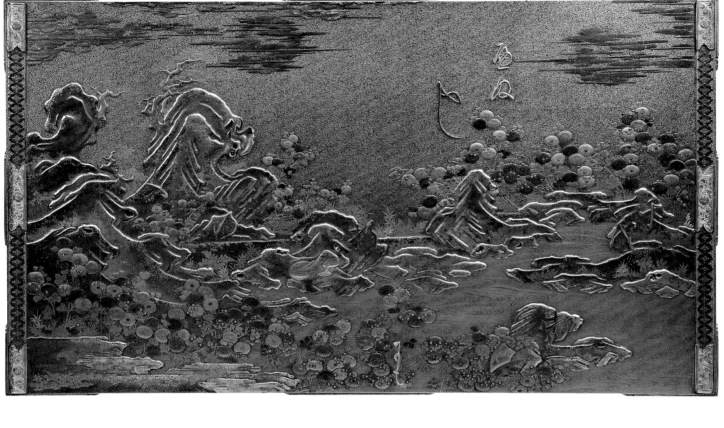

204

204

## WRITING TABLE, NAMED "KIKU-NO SHIRA TSUYU"

Gold and silver *maki-e* designs on a lacquer ground
9.1 × 33.3 × 57.9 cm
Edo period, 17th century

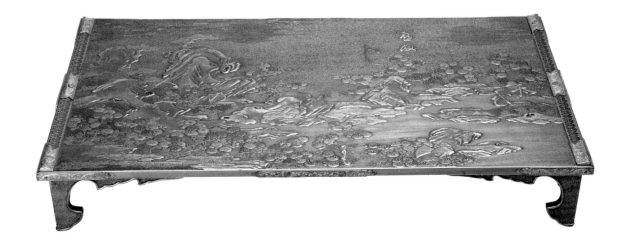

## STATIONERY BOX, NAMED "KIKU-NO SHIRA TSUYU"

Gold and silver *maki-e* and inlaid designs on an
aventurine lacquer ground
18.1 × 42.4 × 36.4 cm
Edo period, 17th century

The small, low four-footed table (*bundai*) seen here was used to write letters and as a support for *tanzaku* (decorative writing paper with a gold-flecked ground) and coloured paper. The stationery box was used to store manuscripts and letters. This particular box seems to have originally served as a make-up container.

The box, named "Kiku-no shira tsuyu" (chrysanthemums and white dew), is decorated with highly stylized gold and silver designs representing streams and rocks, against an aventurine lacquer ground. Chrysanthemum motifs can also be seen, and dew is depicted by small particles of silver. The overall design is inspired by the legend of Kiku-jidō, who became immortal after having drunk dew from chrysanthemum petals.

A short text in inlaid gold and silver characters follows the contours of the designs. The lines read: "In the space of a second the mountain hermit brushes the dew from the chrysanthemum petals with his sleeve, and the world ages a thousand years". This thirty-one syllable poem (*waka*), which was included in the *Shin kokin wakashū* (New Anthology of Ancient and Modern Poems), was composed by the famous court poet

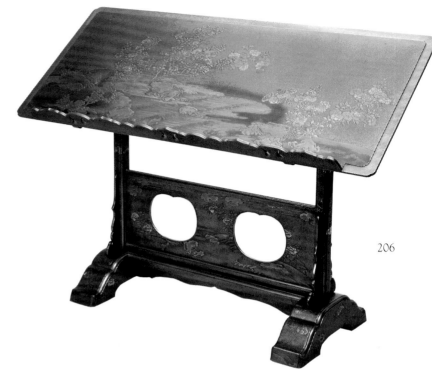

206

Fujihara Shunzei in the sixth year of the Bunji era (1190) to celebrate the marriage of the emperor.

According to the records of the Kōami, a famous family of *maki-e* painters, these objects were part of the dowry of Kame-hime, adopted daughter of the third Tokugawa shogun, Iemitsu, who married Maeda Mitsutaka, fourth lord of the Kaga domain, in the tenth year of the Kanei era (1633).

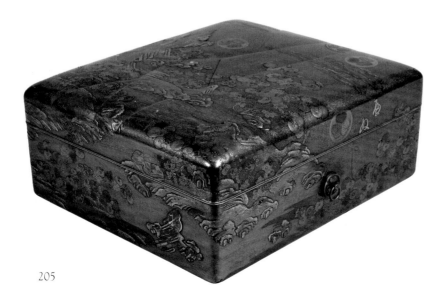

205

## 206

### BOOKREST

Gold and silver *maki-e* and inlaid designs on an
aventurine lacquer ground
28.9 × 70 × 52.2 cm
Edo period, 17th century

*K*endai were raised stands used to hold
books, musical scores or scripts during
performances, or simply when reading.
Books placed on a *kendai* are at eye level
for someone seated on the floor.

Depicted on this bookrest is a tranquil
spring scene, featuring blossoming roses
and bamboo grass growing among the
rocks that line the banks of a swiftly
flowing stream. The entire design has
been executed in gold and silver using the
techniques of *maki-e* and inlay. The
composition of the decoration and the
free use of *maki-e* suggest that this *kendai*
was produced in the middle Edo period,
towards the end of the seventeenth
century.

## 207

### BOX FOR *SHIKISHI*

Gold and silver *maki-e* designs on an
aventurine lacquer ground
18.4 × 18.4 × 4.5 cm
Edo period, 18th century

*T*his is a box for storing *shikishi*, the
thick, square paper used for painting
or writing poetry.

On the box are landscapes representing
the grasses, flowers, birds and farming
activities of each of the four seasons,
richly yet delicately depicted in the
traditional technique of silver and gold
*maki-e*. Increasingly, Edo period *maki-e*
objects tended to display technical
virtuosity rather than true aesthetic
quality. This *shikishi-bako*, however,
avoids ostentation and exhibits a dignified
and balanced composition.

The decorative border around the
outside edge demarcates the top of the
lid from its deep sides, which bear a
continuous decorative landscape band.
In its shape, size and composition, the
top surface of the box is itself not unlike a
decorative *shikishi*.

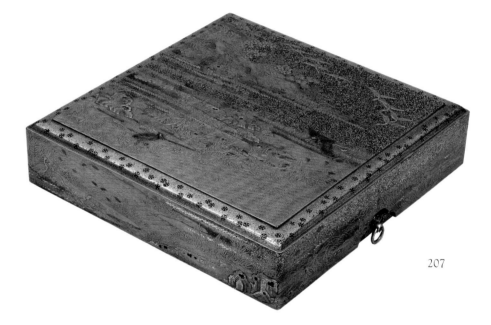

207

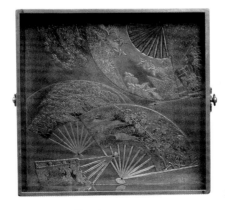

(interior of box)

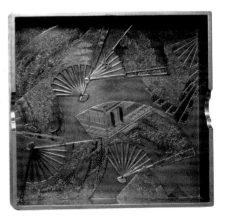

(inside of lid)

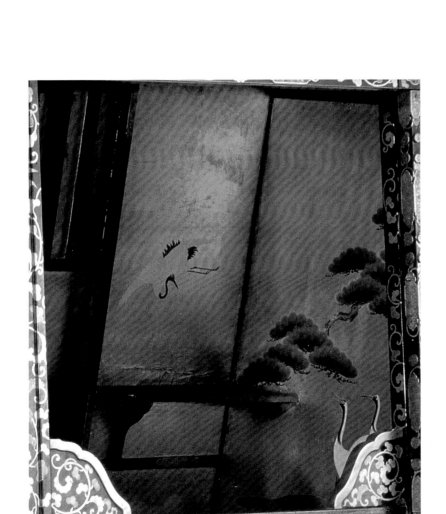

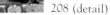
208 (detail)

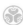

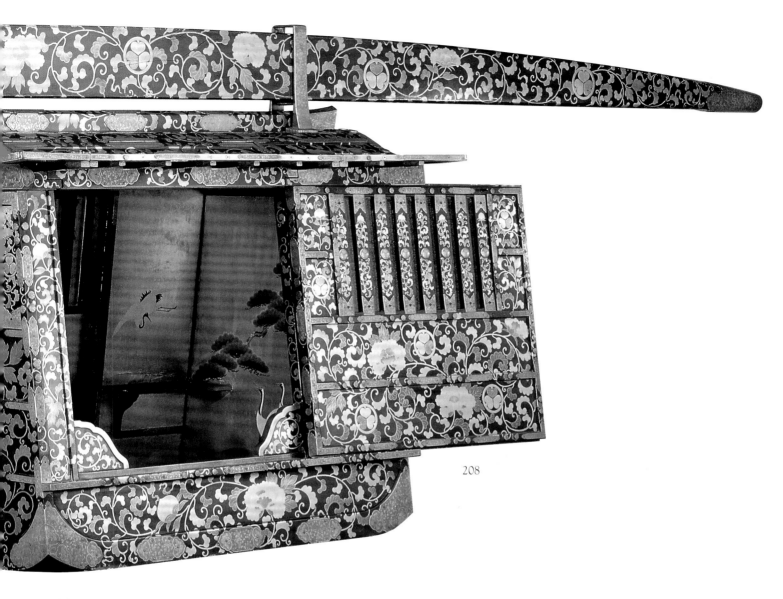

208

### 208

#### PALANQUIN

Gold and silver *maki-e* designs on a black
lacquer ground
Body: 109.4 × 67.3 × 105.4 cm
Roof: 133.9 × 106.6 cm
Carrying rod: 465.7 cm
Edo period, 19th century

During the Edo period, whenever
members of the upper classes
(nobility, shogun and daimyo) left their
residences, whether for short distances or
long journeys, they would be conveyed in
one of two kinds of vehicle: a *gissha* (a
small wagon pulled by a single ox) or a
*koshi* (palanquin). Illustrated here is an
*aoi*-crested palanquin of the most
luxurious type. Reserved for use by
women, this palanquin was carried on a

long rod, which passed through metal
fittings attached to the roof and onto the
shoulders of six men — three in the front
and three in the back. The palanquin has
two sliding doors, one on either side, and
the passenger sat facing forward with her
legs tucked underneath her. Although the
interior seems small and cramped, there
was sufficient room for reading and
writing, and the performance of other
small tasks. The lattices covering the
front and side windows could be opened
so that the passenger could enjoy the
passing scenery.

The entire exterior of this palanquin is
covered with black lacquer upon which
Tokugawa family crests and an arabesque

pattern have been decoratively applied
using gold and silver *maki-e*. The interior
is also lavishly decorated with auspicious
tortoise and foliage motifs painted on the
gold leaf that covers the walls, while the
ceiling is adorned with a large *aoi* crest
delicately executed in bright colours. The
vehicles used by warriors of low rank and
affluent merchants were more modest,
consisting of either a plain black-lacquered
palanquin or a simple woven bamboo
vehicle of the same shape.

It is said that this palanquin was used
by Kanehime (Teitoku-in), who was the
wife of Yoshikatsu, fourteenth lord of
Owari.

# Chronological Chart of the Edo Period
(main events)

Source: Shigehisa Yamasaki, ed. *Chronological Table of Japanese Art.* Tokyo: Geishinsha, 1981.

**1603**
Ieyasu becomes shogun and establishes Tokugawa shogunate.

**1604**
Seventh commemorative celebration at Hōkoku shrine in honour of Hideyoshi.

**1606**
Construction of Hikone Castle by Ii clan.

**1608**
Ikeda Terumasa rebuilds Himeji Castle.

**1609**
Permission given for Dutch to trade and they establish trading factory at Hirado.

**1610**
Beginning of the construction of Nagoya Castle for Ieyasu.

**1611**
Permission for Portuguese to resume trade.

**1612**
Prohibition of Christianity. Permission for Chinese from Ming to trade at Nagasaki.

**1613**
Expulsion of missionaries and Christians. English establish a trading factory at Hirado.

**1614**
Completion of Matsumoto Castle. Expulsion of Takayama Ukon and other Christians to Manila and Macao. Osaka Winter Campaign.

**1615**
Osaka Summer Campaign. Downfall of the Toyotomi clan. Ieyasu in uncontested supremacy. Promulgates the Rules for the Military Houses (*Buke sho-hatto*).

**1616**
Bakufu restricts foreign trade to Nagasaki and Hirado. Death of Ieyasu.

**1617**
Renewed persecution of Christians. Dutch given trading privileges.

**1618**
Nagasaki and Hirado opened to trade between British and Japanese.

**1619**
About sixty Christians burned at the stake in Kyoto.

**1620**
Beginning of construction of Katsura Rikyū (completed in 1624?).

**1622**
Kimura Sebastian and fifty-four others executed (Great martyrdom in Nagasaki).

**1623**
The English close factory in Hirado and leave Japan. Fifty Christians executed in Edo.

**1624**
Hidetada breaks all relations with Spanish. Kanei-ji temple built by Tokugawa Hidetada.

**1625**
*Ni no maru* quarters built in Nijō Castle. Production of Hagi pottery begins.

**1628**
More Christians persecuted in Nagasaki.

**1632**
Careful search for remaining Christians.

**1634**
Dejima built at Nagasaki and all foreigners forced to live there. Attempt at forcing Christians to recant by trampling on the crucifix (*fumi-e*).

**1635**
All foreign trading ships restricted to Nagasaki by third Sakoku (isolation) edict. All overseas Japanese shipping and travel prohibited. *Sankin-kōtai* system institutionalized.

**1636**
*Kanei tsūhō* coins minted. Famine occurs throughout Japan.

**1637**
Shimabara Rebellion breaks out.

**1638**
Shimabara Rebellion suppressed.

**1639**
Shogunate orders all daimyo to ban Christianity in their domains. Final isolation edict. Expulsion of Portuguese.

**1640**
Other Europeans expelled. Portuguese envoys from Macao beheaded.

**1641**
Dutch area moved from Hirado to Dejima in Nagasaki.

**1642**
Famine throughout Japan.

**1647**
Portuguese ship visits Nagasaki and demands trade. Shogun refuses.

**1649**
Promulgation of the Laws and Ordinances of Keian (*Keian ofuregaki*).

**1650**
Pilgrimage to Ise-Jingū shrine (*Okagemairi*) grows very popular. Completion of chronology of Japanese history, *Honchō tsugan*.

**1651**
Revolt of Yui Shōsetsu (*Keian jiken*). Shōsetsu killed.

**1654**
Zen priest Ingen arrives in Nagasaki from Ming and founds Ōbaku sect of Zen.

**1655**
Beginning of the construction of Shūgaku-in Rikyū.

**1657**
Great fire in Edo (Great fire of Meireki).

**1658**
Execution of 630 Christians by Ōmura Suminaga.

**1659**
Ingen builds Mampuku-ji temple.

**1660**
Rise of Mito school of historians under leadership of Tokugawa Mitsukuni to promote National Learning and Shinto studies.

**1668**
Reconstruction of Ashikaga school.

**1673**
Great Britain attempts to renew trade relations but fails.

**1678**
Great earthquake in Edo.

**1680**
Corrupt administration, great freedom in social mores.

**1682**
Restriction of various goods because of the rise in prices. Completion of *Kōshoku ichidai otoko* (The Life of an Amorous Man) by Ihara Saikaku.

**1684**
New calendar (*Jōkyōreki*) adopted. Completion of haiku anthology, *Fuyu no hi* (A Winter Day), by Matsuo Bashō.

**1685**
Bashō's *Nozarashi kikō* (Exposure in the Fields), Saikaku's *Kōshoku gonin onna* (Five Women Who Loved Love) and *Kōshoku ichidai onna* (The Life of an Amorous Woman).

**1686**
Haiku anthology, *Haru no hi* (A Spring Day), by Bashō.

**1687**
Shogun Tsunayoshi's "Dog Decree" laws prohibiting the killing of animals.

**1688**
Completion of Bashō's *Oi no kobumi* (Manuscript in My Knapsack), and Saikaku's *Nippon eitaigura* (The Japanese Family Storehouse).

**1690**
E. Kaempfer comes to Japan as physician to Dejima factory.

**1691**
Haiku anthology, *Sarumino* (The Monkey's Raincoat), by the Bashō School.

**1692**
*Seken mune sanyō* (Reckonings That Carry Men Through the World) by Saikaku.

**1694**
Restoration of Kamo festival. Renku (linked verse in Bashō's style) anthology, *Sumidawara* (A Sack of Charcoal), ed. by Shida Yaba, and *Oku no hosomichi* (The Narrow Road of Oku) by Bashō.

**1701**
Ogata Kōrin given title of *hokkyō*. Asano Takumi no kami strikes at Kira Kōzukenosuke in Edo Castle.

**1702**
Completion of clan chronology, *Hankanfu*, by Arai Hakuseki. Revised map of all Japan completed.

**1703**
**Jōruri** drama, *Sonezaki shinjū*, by Chikamatsu Monzaemon.

**1707**
Mt. Fuji erupts (eruption of Hōei era).

**1709**
Abolition of "Dog Decrees". Reaction against laxity of Tsunayoshi's regime. Financial reforms attempted.

**1714**
Widespread famine. Recoining of gold and silver (*Shōtoku kingin*).

**1715**
Completion of *Dai Nihon-shi* (Great History of Japan, commenced by Mito Mitsukuni). Promulgation of new laws governing Nagasaki trading.

**1716**
Attempt to strengthen national administration (beginning of Kyōhō reform). Relaxation of edicts against Western learning.

**1720**
*Jōruri* drama, *Shinjū ten no Amijima*, by Chikamatsu.

**1721**
Regulation of prices charged by rice dealers in Osaka. *Jōruri* drama, *Onna goroshi abura no jigoku*, by Chikamatsu.

**1734**
Permission given for daimyo to dispatch troops to suppress riots.

**1738**
Census taken in every province.

**1739**
Russian ships make several appearances off Mutsu and Awa.

**1742**
Great floods in Kinki and Kanto regions.

**1746**
Kabuki drama, *Sugawara denju tenarai kagami*, by Takeda Izumo and others.

**1747**
Kabuki drama, *Yoshitsune senbonzakura*, by Takeda Izumo.

**1748**
Kabuki drama, *Kanadehon chūshin-gura*, by Takeda Izumo.

**1750**
Census taken in every province.

**1755**
Completion of the manuscript on ideal society, *Shizen shin'eidō*, by Andō Shōeki. Great famine in the Ōu region.

**1756**
Restrictions on rice dealers in buying up rice to keep prices down.

**1758**
Outbreak of Hōreki incident.

**1765**
*Nishiki-e* form of colour print developed by Suzuki Harunobu.

**1767**
Beginning of the golden age of liberal administrator Tanuma Okitsugu.

**1771**
Maeno Ryōtaku and others perform first anatomical dissection of cadaver of an executed criminal at the execution ground of Kotsukappara.

**1774**
Publication of text of anatomy. *Kaitai shinsho* (translated Dutch work on medicine and surgery), by Maeno Ryōtaku and Sugita Gempaku.

**1776**
*Ugetsu monogatari* (Tales of Rain and the Moon) by Ueda Akinari.

**1782**
Beginning of great famine of Tenmei era.

**1783**
Shiba Kōkan begins to produce etchings. Matsudaira Sadanobu attempts economic and social reforms. Growing feeling against shogunate.

**1786**
Tanuma Okitsugu dismissed.

**1787**
Matsudaira Sadanobu becomes member of the shogun's council. Completion of the text on political ideas called *Tamakushige* by Motoori Norinaga.

**1788**
Great fire in Kyoto. Nijō Castle burns.

**1790**
Prohibition of foreign studies.

**1791**
American and Russian ships visit Japan but are driven away. Decrees against foreign shipping reissued (about 1792).

**1792**
Hayashi Shihei prosecuted for a military work, *Kaikoku heidan*.

**1794**
Great fire in Edo. Completion of educational and cultural essay *Tamakatsuma* by Motoori Norinaga.

**1796**
Completion of critical study of *Tale of Genji, Genji monogatari tama no ogushi*, by Norinaga.

**1797**
American ship *Eliza* calls at Nagasaki and allowed to trade. Slight relaxation of edicts for a few years, and then strict enforcement.

**1798**
Completion of the commentary on *Kojiki, Kojiki-den*, by Norinaga.

**1800**
Inō Tadataka begins topological and cartographical survey of Ezo (Ōu region and Hokkaidō).

**1801**
Inō Tadataka ordered to survey Japan's coastline.

**1802**
Completion of *Tōkaidō hizakurige* (Travels on Foot on the Tōkaidō) by Jippensha Ikku.

**1803**
American ship visits Nagasaki and demands trade but is refused by shogunate.

**1804**
Kitagawa Utamaro, painter, punished. Rezanov, Russian diplomat, arrives at Nagasaki and demands trade (rejected in 1805).

**1805**
Manager of Kanto area instituted.

**1808**
Discovery of Mamiya Straits. Posthumous publication of poem anthology, *Buson shichibu-shū*, by Yosa Buson.

**1811**
Russian naval officer V. Golovnin and others held prisoner in Matsumae (modern Hakodate).

**1812**
Takataya Kahei, *bakufu* trader, arrested by Russians.

**1814**
British ship arrives at Nagasaki. Sir Stamford Raffles sends ship in attempt to trade, is rebuffed. *Nansō satomi hakkenden* (Biographies of Eight Dogs) by Takizawa Bakin.

**1815**
Publication of *Rangaku koto-hajime* (Studies on Western Medicine) by Sugita Genpaku.

**1818**
Englishman Gordon arrives at Uraga for trade but is rebuffed by the shogunate.

**1821**
Completion of *Dai-Nihon enkaikōchi-zenzu* (Coastal Map of All Japan) by Inō Tadataka.

**1823**
P. F. von Siebold comes to Nagasaki.

**1825**
Expulsion edict against foreign ships. First performance of the Kabuki play, *Tōkaidō Yotsuya kaidan* (Ghost Story of Yotsuya on the Tōkaidō), by Tsuruya Namboku.

**1831**
Peasant uprisings in Chōshū province. Landscape print, *Fugaku sanjū rokkei*, by Katsushika Hokusai.

**1834**
Mizuno Tadakuni becomes an elder in shogun's council.

**1837**
American ship *Morrison* driven away from Edo Bay. Ōshio Heihachirō leads rebellion in Osaka.

**1838**
Shogunate in financial straits. Peasant uprising in Sado.

**1839**
Watanabe Kazan, Takano Chōei and others punished for demanding opening of Japan to foreign commerce (*Bansha no goku*).

**1840**
Census taken in every province.

**1841**
Mizuno Tadakuni begins attempt at economic and political reform (Tempō reforms).

**1842**
Permission given to supply water and fuel to foreign ships.

**1844**
French ship visits Ryūkyū islands for trade.

**1846**
American warships come to Uraga and demand trade.

**1852**
Publication of Kobayashi Issa's poems, *Ora ga haru* (The Year of My Life).

**1853**
Commodore Matthew Perry arrives with Black Ships off Uraga. Russian Admiral Putyatin arrives in Nagasaki.

**1854**
Perry returns. Treaties of Amity and Commerce concluded with America, England and Russia.

**1855**
Great Earthquake in Edo (*Ansei no daijishin*). Treaties of Amity and Commerce with France and Holland.

**1856**
Townsend Harris comes to Shimoda as consul-general of United States.

**1858**
Treaty of Amity and Commerce with U.S.A. Suppression of *Sonnō-jōi* (Revere the emperor, expel the barbarian) movement.

**1859**
Kanazawa, Nagasaki and Hakodate opened to foreign trade with Russia, France, Britain, Holland and America. Yoshida Shōin and others executed.

**1860**
Ii Naosuke assassinated by seventeen samurai of Mito fief (*Sakuradamongai no hen*).

**1864**
Allied fleets of four countries fire on Shimonoseki in Chōshū province (War of Shimonoseki). Chōshū clan submits to shogunate.

**1866**
Conclusion of military alliance between Satsuma and Chōshū clans.

**1867**
Imperial rule replaces shogunate. Armed conflict between shogunate troops and loyalists. Feudalism abolished.

**1868**
Edo renamed Tokyo. Battle of Toba-Fushimi near Kyoto.

# Glossary

**emaki**
Illustrated handscrolls usually of a narrative character. Most extant Japanese *emaki* date from the twelfth century or later.

**fusuma**
Sliding screens covered with thick paper on both sides and frequently decorated with paintings or calligraphy. They were used as partitions to divide a large interior space into smaller units.

**guri** See *chōshitsu*

**hakama** See *kamishimo*

**hatamoto**
Literally, "bannermen". In the Edo period, those retainers under the direct command of the shogun whose income was less than ten thousand but more than five hundred *koku* of rice.

**hyōmon**
Developed in China, this technique used in decorating lacquer was popular in the Nara period in Japan, when it was called *heidatsu*. During the Heian period, the technique was called *kanagai*. A thin sheet of metal was cut into the desired shape and then affixed onto the lacquer surface. Several subsequently applied layers of lacquer covered the total surface, including the metal appliqués, which were revealed by removing the lacquer overlay and polishing the entire surface with charcoal.

**inrō**
Literally, "seal caddy". A container originally designed to store and protect seals. This form later developed into the miniature medicine containers of the same name that were worn suspended from the waistband by men during the Edo period.

**iro-e**
In metalwork, especially sword accessories, used both as a specific term signifying the soldering of thin sheets of precious metal, such as gold or silver, onto the ground metal, and also as a generic term that includes decorative metalwork techniques such as inlay and overlay in which other metals are applied to the ground metal, regardless of the specific technique.

**jimbaori**
Campaign vests worn over armour from the beginning of the Sengoku period onward. Early examples were designed to afford the greatest protection against cold or inclem-ent weather during actual campaigns, but Edo period *jimbaori* were largely decorative overgarments worn on outdoor occasions.

**jūni-hitoe**
Formal women's costume consisting of numerous layers of unlined robes worn over an upper garment and skirt by high-ranking ladies of the imperial court.

**kaiseki**
A light meal served before the presentation of thick tea (*koi-cha*) in formal tea ceremonies. Developed from the vegetarian menus of Zen monasteries, the term which literally means "longing for the stone" originated from the custom of using a heated stone as a pocket warmer. Just as the stone helped one endure the bitter cold of winter, this light meal served to assuage one's hunger before the presentation of tea in the climax of the tea ceremony.

**kami**
Shinto deity, including apotheosized heros or ancestors and impressive natural phenomena. An *uji-gami* is the tutelary deity of a family or clan.

**kamishimo**
Literally, "upper and lower". A garment of two parts designed to be worn together and reserved for members of the samurai class during the Edo period. The upper garment consisted of a sleeveless, broad-shouldered *kataginu* that was tucked into the *hakama* or trousers, which could be either ankle-length for performing daily official duties or extending beyond the feet to trail behind as required for important formal functions.

**kaō**
Elaborate seal, primarily handwritten, that served as the signature of an individual. Generally divided into the two types used by the court nobility and the samurai class, respectively, the term is usually seen trans-lated as "monogram" or "cipher".

**kataginu** See *kamishimo*

**katana**
A long, curved sword blade measuring over sixty centimetres in length, mounted to be thrust into the sash of the wearer with the cutting edge facing upward. To differenti-ate an unmounted *katana* from a *tachi*, the inscription is always placed on the side that is meant to face outward when worn.

**aoi**
Generally speaking, the *aoi* family of plants corresponds to the mallow family, and the term is frequently seen translated as "holly-hock". When used in referring to family crests, however, the name *aoi* serves as an abbreviation for the *futaba-aoi*, which belongs to the birthwort family (*uma no suzukusa*), and is more accurately translated as "wild ginger". Since the term "holly-hock" has achieved widespread, if mis-taken, acceptance when referring to the *aoi* crest of the Tokugawa family, rather than using the less well-known "wild ginger", the term has been left in its original Japanese form to avoid confusion. Also, the precise form of the *aoi* crest used by the Tokugawa family has varied from generation to gener-ation, and the form adopted in the illustra-tions in this catalogue represents the well-known variant.

**chōshitsu**
Carved lacquer. A generic term used to encompass the numerous carved lacquer techniques, in which layers of lacquer are applied to a thickness of three to seven mil-limetres, then carved with a design in relief. Spiral patterns (*guri*), carved cinnabar lac-quer (*tsuishu*), and carved black lacquer (*tsuikoku*) belong within this category.

**daishō**
Literally, "large and small". The term refers to a pair of swords, usually consisting of a *katana* and a *wakizashi*. The custom of wear-ing a pair of swords, one long and one short, began during the late Momoyama period, and the practice was codified in the Edo period, limiting the wearing of the pair to members of the samurai class and regulating the types of mountings that could be used by samurai of different ranks.

### kiji-maki-e

Lacquer technique in which a *maki-e* design is placed directly on the bare wood surface to emphasize the natural pattern of the wood grain. The design is frequently produced by placing a lead sheet perforated with an openwork pattern on the wood surface and applying lacquer to the openwork areas. Gold powder is then sprinkled on the wet lacquer, and the lead sheet is removed after the lacquer has dried. Although practiced as early as the Heian period, this technique was not widely used until the end of the Edo period.

### kōgai

Sword fitting. Implement shaped like a paper knife that was originally used to arrange the hair. Not provided with a tempered blade, it was fitted flush against the scabbard on the outside of the sheath on the side away from the wearer. With the *kozuka* and *menuki*, it formed a set called *mi-tokoro-mono*.

### kōgō

A small, lidded container used for storing the aromatic wood that was burned as incense. Usually made of lacquer or ceramic, wood and metal containers were also used. Since the aromatic wood was highly prized, the containers in which it was placed were of commensurate aesthetic value and technical accomplishment.

### kosode

A *kimono* with narrow hand openings. Used as an outer garment during the Momoyama period, a version with large, more markedly rectangular sleeves was popularly worn during the Edo period. Usually wrapped tightly about the body and secured with an *obi*, long-trained *kosode* were also worn as loose, flowing outer robes.

### kozuka

Sword fitting. The handle of a small knife whose tempered blade measured about twelve centimetres in length. Placed flush against the scabbard on the inside of the sheath, with the *kōgai* and *menuki* it formed a set called *mi-tokoro-mono*.

### maki-e

Lacquer decorating technique in which fine, powdery filings of precious metal are scattered on a design first drawn in lacquer. The ground may be either lacquered or plain wood (see *kiji-maki-e*). The technique originated during the Heian period and can be largely divided into the categories of *togidashi-maki-e* (polished *maki-e*) in which

a further coating of transparent or black lacquer is applied over the flat, dried and powdered surface and polished with charcoal to reveal the design, *hira-maki-e* (flat *maki-e*) in which the sprinkled powders are applied directly on the smooth lacquered surface, and *taka-maki-e* (high relief *maki-e*) where the metallic powders are applied on a lacquer surface molded with relief designs.

### menuki

Sword fittings. Decorations affixed on both sides of the hilt that developed from the ornamental heads of pegs passing through the hilt to secure the blade. With the *kozuka* and *kōgai*, they formed a set called *mi-tokoro-mono*.

### mi-tokoro-mono

Set of sword fittings consisting of *kozuka*, *kōgai* and *menuki* that adorned the mountings used by samurai of high rank. Correctly fitted mountings used by the shogun, daimyo, and *hatamoto* were provided with *mi-tokoro-mono* produced by the Gotō family of metalworkers.

### monogatari

A narrative account or long prose literary work such as a novel or historical tale, frequently adopted for illustration in the handscroll or folding book format.

### nanako

Literally, "fish-roe". A metalwork technique in which fine, closely packed granulation is produced using a round-headed chisel. First seen in Japan during the early Nara period, the technique was used in metalwork of subsequent periods.

### nashi-ji

Literally, "pear-skin ground". A lacquer ground technique in which fine metallic powder is sprinkled onto a lacquered surface. Once dry, a coat of transparent or other lacquer is applied and polished lightly, leaving the powder well imbedded. The sparkling, stippled effect produced is reminiscent of the skin of a Japanese pear, hence the term *nashi-ji*. Originating during the Kamakura period, the technique was widely used in its many variations in subsequent periods.

### noshime

An inner robe worn under the *kamishimo* or *hitatare* whose name derives from the smooth, lustrous fabric woven with a raw warp and glossed weft.

### obi

A band or sash. Small, narrow bands (*kazura-obi*) were used to secure the wig of a Nō actor in a female role, while long sashes of varying widths (*koshi-obi*) were wound around the waist or hips to fasten the garment securely in place.

### otogi-zōshi

Short folktales, sometimes resembling fairy tales, that served to relay moral precepts. These tales were especially popular during the Muromachi period.

### raden

Inlaid mother-of-pearl. Practised in Japan since the Nara period, this technique involved the imbedding of thin, flat pieces of shell onto a surface by coating the entire surface with lacquer and scraping away the lacquer that obscured the pieces of shell. The surface would then be polished until perfectly smooth.

### sankin-kōtai

A system instituted by the Edo shogunate in which the daimyo and certain *hatamoto* were forced to spend every other year in Edo accompanied by a set number of retainers determined by the relative incomes of their fiefs. During their period of attendance in Edo, they were required to pay homage to the shogun. This system necessitated the maintenance of a substantial Edo residence in addition to their residences in their home domains. The exact period of attendance in Edo was codified in 1635 for the non-hereditary vassals (*tozama daimyō*), while the attendance period of the hereditary Tokugawa vassals (*fudai daimyō*) was regulated in 1642.

### shakudō

An alloy of copper and a small amount of gold (4-7%) finished by chemical means to produce a glossy dark blue-black shade on the surface.

### shikishi

Writing paper, generally square, whose size was later standardized to 19.4 by 17 centimetres for large *shikishi*, and 18.2 by 16 centimetres for small ones. Similar in thickness to cardboard, their surfaces were decorated with a variety of colours and designs. Their principal use was as formal decorative paper for the writing of short poems.

### shoin

A writing alcove or the study room in which this alcove was located. Also, the style of residential architecture that originated in

the Muromachi period and was widely adopted in the Momoyama and Edo periods for residences of members of the samurai class, guest halls of temples and Zen abbot's quarters. This style of architecture is characterized by the appearance of a *tokonoma*, staggered shelves, writing alcove and ornamental doors all often arranged on a raised platform area (*jōdan no ma*), and the incorporation of sliding screens and tatami flooring, among other elements.

### suzuri
An inkstone. Used for making and storing liquid ink, a small amount of water was poured into the depression and the ink stick was rubbed along the abrasive surface moistened with water. Made of porcelain, tile, metal or stone, the most common material used was shale, preferably from Anhui and Guangdong provinces in China, whose shale was considered to be of the highest quality.

### tachi
Long, curved sword blade measuring over 60 centimetres in length mounted to be slung from the sash with the cutting edge facing downward. To differentiate an unmounted *tachi* from a *katana*, the inscrip-

tion is always placed on the side that is meant to face outward when worn.

### tanzaku
Oblong formal decorative writing paper for either *tanka* or *haiku* poems. Usually about 35 by 6 centimetres, the surface was often elaborately decorated.

### tenmoku
Lustrous black-glazed stoneware bowls whose name derives from the Tian-mu mountains in Zhejiang province in China, which is supposed to have been the source of the first bowl of this type brought back to Japan by a Buddhist monk sometime during the Kamakura period. The different varieties of mottled glaze, such as "oil-spot" or "hare's-fur" provide one of the principal points of appreciation.

### tokonoma
Although originally a raised floor or bench, from the Momoyama period onward this term designated an alcove with a raised floorboard used for the display of hanging scrolls and articles such as vases, incense burners and candle stands.

***tsuikoku*** See *chōshitsu*.

***tsuishu*** See *chōshitsu*

### wabi
An aesthetic quality that embodies the simplicity associated with poverty, while at the same time transcending that state. The aesthetic values of *wabi* are manifested in the form of the tea ceremony perfected by Sen no Rikyū, in which host and guest shed the trappings of rank and enjoyed tea in a humble thatched hut using simple, unpretentious utensils.

### wakizashi
A smaller version of the *katana*, measuring more than 30 and less than 60 centimetres in length, of the Muromachi period or later. Forming a *daishō* pair with the *katana*, the use of this pair of swords was strictly reserved for members of the samurai class.

### Yamato-e
So-called "Japanese-style painting", as opposed to painting in the Chinese manner. At first used to connote paintings treating native Japanese themes, the term was later used to designate paintings executed in the highly polychromed, detailed style of paintings on Japanese themes produced during the Heian period.

# Index of Works in the Exhibition

St. Louis Community College
at Meramec
Library